ius, inquit, de principibus deus, penes quē sationum om-

expositio uersuum istorū Valerij Sorani sic se habet

omnia semina ex se emittere & in se recipere. Ipse est igitur

um dominatus est. Quid est Genius? Deus est, inquit,

bet omnium rerum gignendarum. Quem alium hāc uim

um, cui dictum est:

nitor genitrixcȝ?

t esse uniuscuiuscȝ animum rationalem, & ideo esse singu

mundi animum deum esse, ad hoc idem uticȝ reuocat, ut

mundi animus esse credatur. Hic est igitur quē appellant

eus, & omnis uiri ani nis uiri

abhorrere absurdita gulari-

n geniū, quē dicunt m em.

Pompeius: Genium ap rerum *Genius.*

Aufustius Genius, inqui inū, ex

erea Genius meus hom ud eru-

nentumcȝ nō simpliciter eus pa-

multi, quorum meminit us Me-

poralium rerum Genij su a, & ter

ocent, γενεϑλίᵃς quocȝ ϑεοὺς dicunt. cui non absimile est, quod Ma

aturæ, quod sint medius aër Iupiter, & infimus Iuno, & supremus

Iuno tecto Tarquinius Priscus tēplū uouit. Duodecim cœli signa

os aiant, & hi quidem Genij uniuersaliores, nam suus est cuicȝ loco

ere, quin & unicuicȝ hominū suus sic dictus, ut Censorinus, inquit,

cȝ natus est, uiuit, siue quod ut generemur, curet: siue quod una gi

quod nos genitos suscipiat, ac tueatur. Eūdem esse Genium & Laré

quis & C. Flaccus in libro quem ad Cæsarem de indigitamentis re

odum est apud Ouidium Gemini fuerunt filij Mercurij & Laræ, si *Lares.*

terum plericȝ inter quos Euclides, geminos singulis hominum ad

alterum malum. qualis ille fuit, quē Plutarchus, Florus, & Appianus

media nocte ad tenuem lucernam de bello cogitanti. Genium dicit

pedam.) Ab stabilitate sic est dictus, ut idem Augu
ribus innititur pedibus, & uelut fulcris. Est & uernis
lices Almum, melius, ut arbitror. nam alma & almus
eres, & terra alma. Quæ per se prosequi longum
longum est. Cōmentatores uerbi significationem in p
t, rati persequi solum dici de insectatione inimica
Tignus, unde tigillus trabs cui tectum innititur. Ari
ontinetur, & sistitur deum esse in mundo similiter,
aturæ ædificiū necesse est, ut ablato umbilico fornicis
o hoc proposito dissonum, quod Orpheus in hym

Et post

nim maiestate deorum.) Lib.iiij.Derisa est opinio eo
uebāt. Dicere oppe uoluissem.) In antiqs melius
s noie pecuniæ.) Ōmia quæ possident, noie pecuniæ
itducta appellatiō eut aut, Columella, Festus, & Ser
ot adhuc sunt multarū gentium. Erat tum fere pasto
Varro confirmat lib.de Lat.ling.iiij. postea ao opis
) Paradoxura Stoicum ...
nibus suadet. Idem magnis ingenijs philosophorum
m perorariue. Quiam nemo sapiens concupiuit.)
bet, quam nemo sapiens cōcupiuit, et quasi ueorum
uinat, semper infinita & infinibilis est, neq copia, ut
Vt nos uocamus.

nuncupetur. Cap. xii.
ein huius nominis reddiderunt, & pecunia, in
int omnia. O magnam rationem diuini nomi
omnia, uilissime & contumeliosissime pecunia
s sunt, quæ cœlo & terra cōtinentur, inter quæ
us, quæ ab hominibus nomine pecuniæ possi
nomen imposuit, ut quisquis amat pecuniam,

Quid est enim Saturnus
num dominatus est. N
uem esse mundum & eum
penes quem sationum
qui præpositus est, acui
habere credunt quàm
Iuppiter omnipotens pro
Et cum alio loco genium
los singulorum: talem au
ranq universalis genius
Iouem. nā si omnis geni
animus deus: quod si & ip
ter & excellenter dicant

Q Vid est Genius.) Fes
omnium gerendaru
rio nomines gygnuntur
diru, quis deus esset Genius
reus situs, & Genij sunt cœli
licentia, ut ait, Parthenius. &
ra Quæ Græcicum
crobius adducit de penatibu
ather Minerua, quis tribus
cum sole & luna sunt qui G
Genius, quem faciunt ei pra
siue quod in eius tutela, ut
gnatur nobiscum: siue etiam
multi prodiderunt ueterum
liquit. Porrò Lares quema
ue Larundæ nymphæ. Ide
dunt Lares, alterum bonu
scribunt oblatum M.Bru

MARKS
OF
GENIUS

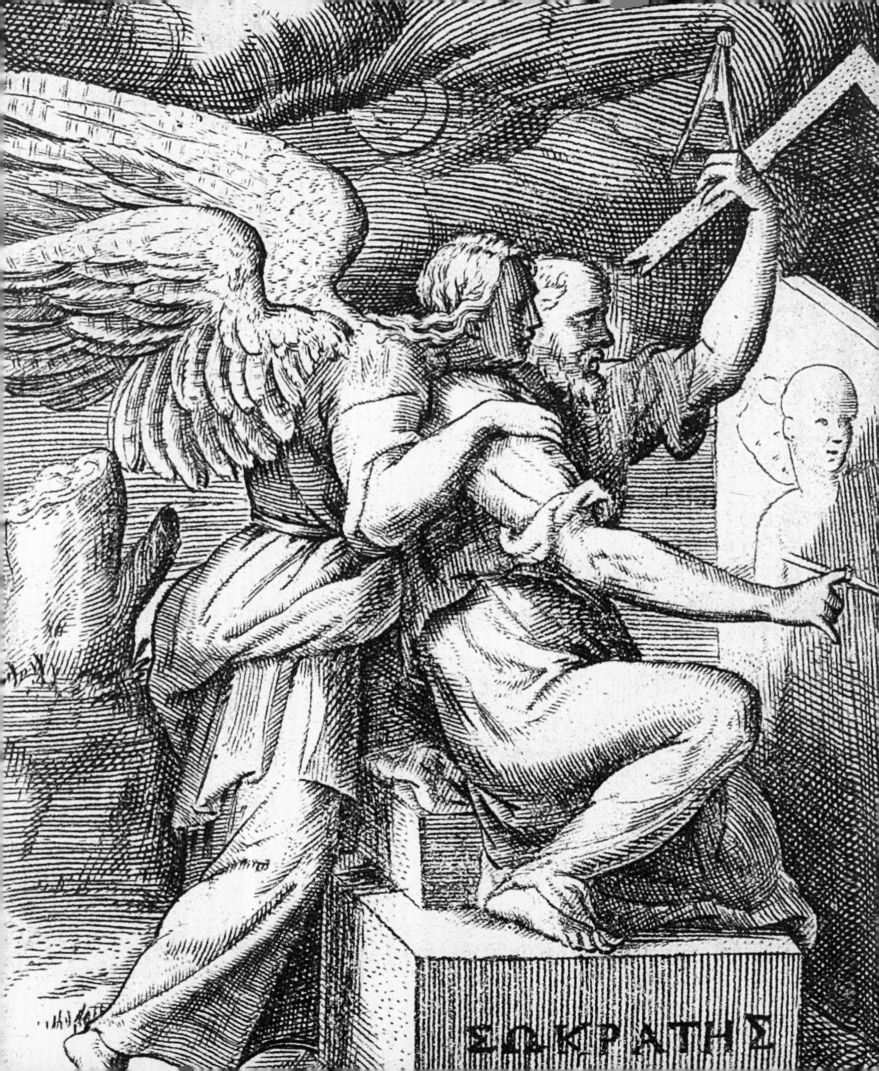

ΣΩΚΡΑΤΗΣ

MARKS

OF

Masterpieces from the Collections of the

BODLEIAN LIBRARIES

Stephen Hebron

Published to accompany the exhibition *Marks of Genius:*
Masterpieces from the Collections of the Bodleian Libraries
The Morgan Library & Museum, New York, 6 June to 14 September 2014
The Bodleian Library, Oxford, 21 March to 20 September 2015
The following items exhibited in Oxford only: cats 1–4, 6–9, 12–13, 18, 21, 25–6, 31,
34, 39–44, 54–6, 59–60, 73, 75, 77–86, 89–97, 102–6, 108–20, 122–9

Page 2: cat. 3, detail
Page 6: cat. 63 detail

Sponsored by Toby Blackwell as a tribute to his Grandfather and Father.

First published in 2014 by Bodleian Library Publishing
The Bodleian Library
Broad Street
Oxford
OX1 3BG
www.bodleianbookship.co.uk

ISBN 978 1 85124 266 5 (hardback)
ISBN 978 1 85124 403 4 (paperback)

British Library Cataloguing in Publication Data
A catalogue record is available from the British Library

PROJECT MANAGER Johanna Stephenson
DESIGNER Dot Little
PRODUCTION Nicola Denny
Colour reproduction by Dot Gradations Ltd, UK
Printed in Spain by Grafos SA, Barcelona

Contents

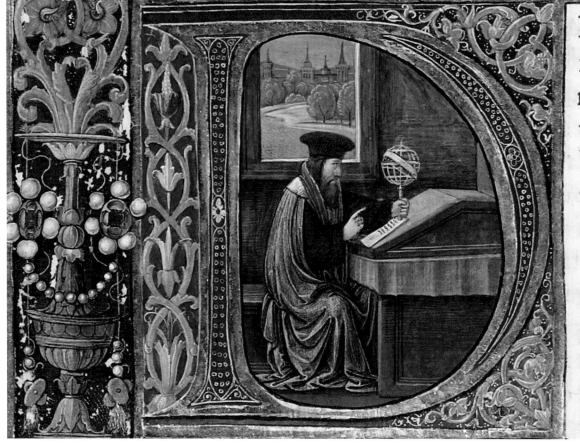

LIBRO PRIMO DELLA NATVRALE
PLINIO SECONDO TRADOCTA IN
TINA PER CHRISTOPHORO LAN
NO ALSERENISSIMO FERDINANDI
PREFATIONE

ITERMINA
imperadore co
narrarti elibri d
uella alle muse
lultima genitu
uerissima di te
dissimo tuo pa
Catullo mio co
re qualche cho
sta castrense &
sai mutando le
piu duro che n
familiari & ser

Preface

RICHARD OVENDEN

Bodley's Librarian

The *Marks of Genius* exhibition, and the catalogue which accompanies it, is an opportunity to celebrate the genius of writers, poets, scientists, philosophers, medics, artists, political thinkers, and men and women of intellectual and creative pre-eminence. The selection of books in manuscript and print shows how these individuals and moments of genius left their mark on paper and parchment, and also celebrates the genius of our founder, Sir Thomas Bodley. Furthermore, by enabling new intellectual encounters with its collections in both its physical and virtual spaces, the Bodleian nurtures and fosters future genius.

It is natural enough for a major research library to celebrate the completion of a new building project, but the opening of the Weston Library – which in 2014 becomes the newest of the Bodleian Libraries – provides a more considered opportunity for commemoration and reflection. This exhibition and catalogue are therefore a particularly fitting expression of the moment of celebration which the Weston Library heralds.

Viewed from one perspective, the Weston Library is the renewal of a building that has served the Bodleian and the University of Oxford well for almost eighty years. The New Bodleian building was completed in 1939–40, and served the war effort before becoming a key component in the Bodleian's overall provision of library services in Oxford. With the passing of time, the building has not only revealed a series of problems with its basic infrastructure, but has also failed to keep pace with the demands of the fast-changing world of academia. The Weston Library is, however, much more than merely a refurbishment project.

The interior structure itself has been dramatically changed and improved so that the Bodleian can continue to use it for at least another eighty years: the stacks provide a dramatically improved preservation environment, the facilities for researchers are vastly expanded and enhanced, and the building also provides an environment where the public can once again appreciate and enjoy the

Bodleian's great collections – as the original architect, Giles Gilbert Scott, had intended. The exhibition will be shown first, in a slightly shortened version, at the Morgan Library and Museum in New York, and we are enormously grateful to Bill Griswold and his colleagues for their care and expertise in staging the exhibition in their wonderful institution. The full version of the show will be the inaugural exhibition in the Weston Library's new exhibition spaces.

The Bodleian's history has been one of extraordinary efforts to raise funds for important new buildings. The Weston Library therefore joins earlier projects: the refurbishment of the medieval library in 1598–1602, the extensions to the library and the creation of the Schools' Quadrangle in 1613–40, the building of the Radcliffe Camera, completed in 1749, and the construction of the New Bodleian itself in 1938–40. The Weston Library has been the focus of a significant effort to provide the funds necessary for the building to be brought up to standard for the requirements of a library service and a university in the twenty-first century. This fundraising effort has been remarkable in the level of generosity, loyalty, commitment and creativity shown by donors large and small who have responded to the Bodleian's vision for the building and how it will help to transform the Library for the benefit of readers and researchers of every hue and shade: young or old, advanced or beginner. There are three donors whose support has been so steadfast that I must single them out in this preface for special mention.

In the academic year 2007/08 the Garfield Weston Foundation pledged support of £25 million towards the redevelopment of the New Bodleian Library. In recognition of this significant support it was decided that the building would be renamed the Weston Library when it reopens in 2014/15. We take this opportunity to extend our sincere gratitude to the Trustees of the Garfield Weston Foundation again for their generosity.

Oxford University Press has been a loyal collaborator and partner of the Bodleian since the seventeenth century and matched the donation of the Garfield Weston Foundation, and we express our very great thanks to Nigel Portwood and his colleagues.

Toby Blackwell was the first of the Bodleian's supporters to rally to the cause and make a significant contribution to the project, an act of great generosity and typical of his clarity of thinking and vigour of purpose. He has also been the chief supporter of the Marks of Genius project: his enthusiasm and commitment has been a fundamental element of the exhibition, catalogue and digital manifestation of the central idea. The Blackwell family themselves have nurtured individuals and ideas of genius throughout their history: Benjamin Henry Blackwell, Basil Blackwell, and the various publishing imprints associated with the family and the firm – especially, perhaps, the Shakespeare Head Press. This foreword allows me to pay a special and heartfelt tribute to Toby Blackwell on behalf of the Bodleian and the University of Oxford as a whole. Toby's long-standing loyalty to the Bodleian is almost a genetic feature of his family. His personal commitment, enthusiasm and vision helped to propel forward the project to refurbish the structure to the east of Blackwell's own iconic building on Broad Street right from the moment of its inception. It is entirely fitting that the main entrance hall of the Weston Library – the Blackwell Hall – will celebrate the intimate relationship between the two 'B's of Broad Street: the Bodleian and Blackwell's.

Foreword

TOBY BLACKWELL

Being involved with the wonderful transformation of the 1937 New Bodleian into the Weston Library, and with the *Marks of Genius* exhibition, is the most exciting and important project I have ever been part of in my life. This started at my meeting Sarah Thomas (then Bodley's Librarian), Richard Ovenden (then her deputy) and Jim Eyre, the architect. Jim explained his idea to transform the forbidding south face of the New Bodleian into a friendly and welcoming centre. Richard then took Jim and me into the grey library stack on the ground floor and showed me some of the astonishing treasures. It was Richard's scholarship, vision and his irresistible charisma that convinced me that if ever there was a team to be backed, a team driven by the legendary Vice Chancellor John Hood, then this was it. Now, with the strong support of Hood's successor, Vice Chancellor Andrew Hamilton, they have surpassed my every expectation.

The Blackwell family has been intimately connected with the Bodleian Library since my grandfather, Benjamin Henry Blackwell, opened his shop on Broad Street 134 years ago. Our relationship since then has been a close and happy one, the two institutions sharing the common goal of supporting the work of scholars and readers all over the world.

It was Benjamin Henry's ambition that Blackwell's should become a place for self-improvement, where academics and booklovers, whether from the University or the town, could read under the same roof. This spirit has been continued by his successors: my father, 'the Gaffer', had the greatest affection for the Bodleian, and numbered its Keepers among his closest associates. He marked the centenary of the Broad Street shop by making a gift to the Bodleian of the literary manuscripts, correspondence and personal papers of that great cultural figure William Beckford (1760–1844). His personal library has come to join the Beckford Archive and the countless millions of other volumes in the safe custody of the Bodleian, and will be available for the education and inspiration of future generations.

The *Marks of Genius* exhibition captures the elusive quality which marks out some of the finest achievements in the field of human endeavour. It gives us an opportunity not only to see some of the Bodleian Libraries' greatest treasures but also to explore the theme of genius running through each of these unique objects. It also highlights the Bodleian's role as one of the world's great libraries, which, since its foundation, has been one of the leading lights in the world of scholarship, research and learning. In the renovated Weston Library, the Bodleian has a new home, fit for the demands of the twenty-first century, in which to house and display its great collections, to welcome visitors from around the world, and to serve new generations of scholars.

Blackwell's and the Bodleian

REG CARR
Bodley's Librarian 1997–2006

This inaugural exhibition in the Bodleian's new Blackwell Hall marks the latest stage in a long and happy relationship between two great Oxford institutions: the Bodleian Library and its nearest Broad Street neighbour, Blackwell's Bookshop. While the Bodleian has played an important part in the education of generations of Oxford scholars since its foundation by Sir Thomas Bodley over four hundred years ago, Blackwell's is a relative newcomer on the Oxford book scene. Yet since the opening of Benjamin Henry Blackwell's tiny shop at 50 Broad Street on 1 January 1879 his bookselling business flourished, to become a household name in the world of academic bookselling and publishing.

Although Blackwell's is renowned for its bookselling services to the library world, it is perhaps less generally well known that the first 'Oxford' B.H. Blackwell (Benjamin Harris) was himself a librarian. He arrived in Oxford in the 1830s and set up his Teetotal Library on the ground floor of Oxford Town Hall. By 1846 he had opened a bookshop in St Clement's, on the edge of the city, and from here sent out annotated book catalogues around Britain and overseas. Thus began a very important international connection with libraries and collectors of books worldwide. But the excessively long hours in the library and the demands of running his own business took their toll on the first B.H. Blackwell; he died young and the shop in St Clement's was lost. It was his son, the second B.H. Blackwell, who founded the famous Broad Street shop and developed it into a major supplier to academic libraries worldwide. Before the shop had reached its twenty-first year, Lord Rosebery was heard to refer to it as 'a remarkable shop kept by a remarkable man'.

From the outset the relationship between the Bodleian and Blackwell's was osmotic. If neither Mr Blackwell nor his staff could answer a customer's enquiry, the most junior apprentice would be sent 'opposite' to the Bodleian, and

would be expected to return with an answer. To further their research, Blackwell's apprentices were equipped with Bodleian readers' tickets. By the same token, the Bodleian was not averse to sending its readers to Blackwell's, and many an expert librarian and scholar came to rely on Blackwell's ready expertise.

Benjamin Henry was eager to make Blackwell's accessible to all, a well-stocked place for self-improvement that was attractive to booklovers and scholars alike, whether from the town or the University. His shop was open to allcomers: it was for anyone interested in books and their own 'self'-education, formal or informal. Side by side with the colleges of the University, Blackwell's thus became a place of learning in its own right. In 1906 the *Morning Post* summed up Benjamin Henry's contribution:

Many men will aver that the greatest educative influence of Oxford resides neither in the Bodleian, nor schools, nor tutors, nor lectures, nor college societies, but in the excellent management and most liberal facilities of one of the best bookshops in the world – Mr. Blackwell's.

By the time of his death in 1924 the shop was world famous and its infant publishing house had among its authors names that would go down in the literary annals. It was now the turn of Benjamin Henry's son, Basil Henry, the third B.H. Blackwell, to develop the business further into a bookselling and publishing empire. In the 1960s an anonymous reader was heard to say that he could 'often get a book more easily at Blackwell's than at the Bodleian'.

Sir Basil Blackwell had the greatest affection for the Bodleian, and numbered its Keepers among his closest associates. When the Broad Street shop had its centenary in 1979, Sir Basil made a gift to the Bodleian of the literary manuscripts, correspondence and personal papers of William Beckford (1760–1844), a gifted travel writer, playwright,

novelist, collector and connoisseur. His enormous archive had been passed to his daughter, the Duchess of Hamilton, and was subsequently purchased by the firm of Blackwell's in 1977. The gift of the Beckford Archive is an abiding tribute to Blackwell's founders, and to Richard Blackwell, who died in 1980. It is also a fitting monument to Sir Basil Blackwell, who valued his own library above almost everything. He amassed it over a period of eighty years, starting with the Bible his mother gave him and his copy of *The Earthly Paradise*, chosen as a school prize in 1907.

Sir Basil always gave pride of place to books and urged others to consider the efforts that went into bringing books into their hands: 'Behind every book are all the bookmen: the researchers, the authors, the publishers, the typographers, the printers, paper-makers, binders, booksellers and librarians'. The librarians, in his view, had the happiest lot: 'if he is a Public librarian he is, to a certain extent, at the mercy of the Library Committee and of the public grant of money … But if he is a College or University Librarian,

he is perhaps happiest of all, should the bent of his mind be studious.'

Today's libraries, like bookshops, have to 'pay their way' by finding and generating the resources necessary to meet the demands of scholarship and to provide state-of-the-art facilities to preserve and display the collections entrusted to their care. The Bodleian is fortunate to have extraordinary collections and remarkably generous benefactors. The gift of Toby Blackwell and the creation of the Blackwell Hall further cement the relationship between Blackwell's and the Bodleian, giving it a visible, concrete dimension. Generations of readers and visitors to the Bodleian who pass through this space will owe a lasting debt to the Blackwells for their philanthropy. In turn, the generosity of the Bodleian's near neighbours will serve as an inspiration to benefactors to support the Library in its work of acquiring and preserving collections, and serving readers from around the world, just as it has over the past four centuries.

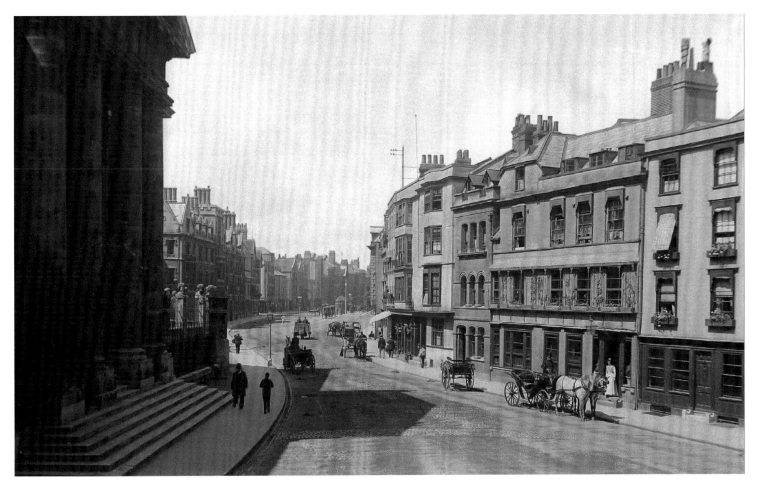

Fig. 1. Neighbours across Broad Street: Blackwell's in June 1892. Photograph by Sarah Angelina Acland. Minn negative 184/1

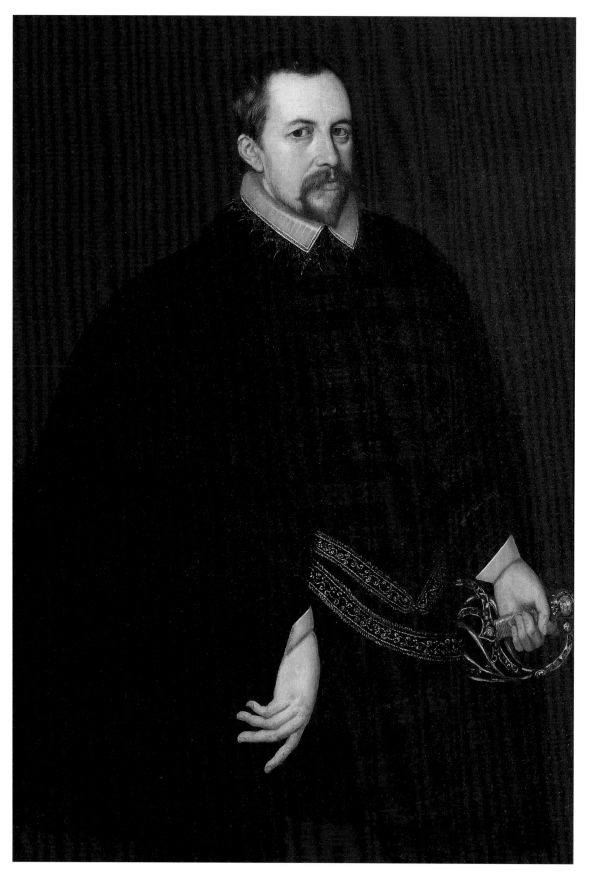

Fig. 2. Sir Thomas Bodley (1545–1613). Portrait by an unknown artist, 1590s (?). LP 71

The Genius of Sir Thomas Bodley: The Bodleian Library

RICHARD OVENDEN

The Bodleian Library was founded during a period of great upheaval and profound change in the world of learning and libraries. Sir Thomas Bodley's act of creating the library that would bear his name was an act of genius. It would be built on by others over the next four centuries, creating a unique institution that would have an impact on the intellectual and cultural life of the world far beyond that envisaged by Bodley at the end of the sixteenth century.

In 1545, the year of Sir Thomas's birth, the University of Oxford was a small provincial university on the margins of the world of learning that dominated the West. One of only five universities in the British Isles at the time, it had witnessed a decade of destruction of books, libraries and learning. One commentator remarked that 'books were dog cheap, and whole Libraries could be bought for an inconsiderable nothing'[1] during the decade of the 1540s, when the zeal of the Reformation overtook Oxford. The old university library, which had been greatly enhanced between 1435 and 1444 by the gift of the books of Humfrey, Duke of Gloucester (1390–1447), had been dispersed. Some of the 450 or so volumes were rescued by recusants and taken abroad. The remainder ended up being sold as waste to all manner of local tradesmen, with leaves taken from books and sold to be reused for such purposes as lining pie dishes, wrapping butter and strengthening bindings made by local bookbinders. Even the book-cases fitted in the library room in the 1480s were removed and sold to Christ Church in about 1556. A similar fate befell many of the college libraries in Oxford (as it did numerous libraries across Europe), leaving the University reshaped by the religious changes of the Reformation but lacking the intellectual infrastructure necessary to enable the institution to take its place among the leading centres of learning in Europe once again.[2]

Thomas Bodley was born in Exeter in 1545, the son of John Bodley, a publisher who had embraced with considerable enthusiasm the new religious ideas that we now term Protestantism. During the reign of Mary Tudor, the Bodleys had fled, first to Frankfurt and then to Geneva, where they were able to practise their religion in a city that was not only tolerant, but where the local religious leaders – Calvin and Zwingli in particular – were among the most learned Europeans of their age. The family returned to England on the accession of the Protestant Elizabeth I and settled in London. Thomas came to Oxford, matriculated at Magdalen College in 1559, graduated in 1563 and became a fellow of Merton College in 1564. Tiring of the academic life, he became increasingly involved in affairs of state and from 1585 served as a diplomat for Elizabeth I. In 1586 he married a rich widow, Ann Ball of Totnes, who delivered to him the fortune her first husband had accumulated in the pilchard trade. During his diplomatic missions abroad Bodley was able to witness at first hand the outstanding developments in the universities of Europe, which were part of a process of post-Reformation renewal across the Continent. In cities such as Heidelberg and especially Leiden (he was the Queen's Ambassador to the United Provinces from 1588 to 1597), the universities were developing new libraries which were modern and intellectually forward-looking institutions, capable of underpinning the learning being undertaken in the faculties of their parent universities.

Sir Thomas returned to his old university in 1598, a rich, powerful and successful courtier, politician, businessman and diplomat. His old college of Merton was going through a period of joyous renewal under the astonishing brilliance of its Warden, Sir Henry Savile. Visiting the site of the former university library, Bodley found the old library room 'laid waste' and was determined, according to a now famous passage in his letter of 23 February 1598 to the Vice-Chancellor, to improve the situation that he found:

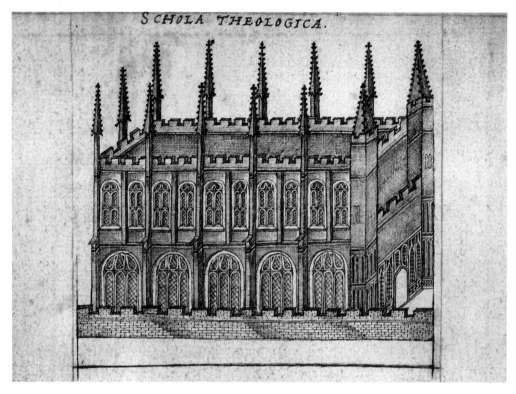

Fig. 3. John Bereblock, The Divinity School, with Duke Humfrey's Library above, 1588. MS. Bodl. 13, fol. 16v

Where there hath bin heretofore a publike library in Oxford, which, you know, is apparent by the rome it self remayning, and by your statute Records, I will take the charge and cost upon me, to reduce it again to his former use: and to make it fitte, and handsome with seates, and shelfes, and deskes, and all that may be needful, to stirre up other mens benevolence, to helpe furnish it with bookes.[3]

It may be seen from this passage that Bodley's foundation was not merely a beginning. He was conscious from the outset that what he was doing was 'for the benefit of posteritie'[4] and therefore required different thinking than was typical at the time. His analysis of the reasons why the earlier university library had failed was not that it was the result of the actions of religious zealots, but that it was the lack of endowment that made its decay possible. His solution to this problem was to suggest that he himself would 'so provide heerafter (if God doe not hinder my present designe) as you shall be still assured of a standing annual rent, to be disboursed every yere in buing of bookes, in officers stipends, and other pertinent occasions'.[5] This was a view and perception that would come

into its own in the latter part of the twentieth century, especially in North American libraries, and perhaps the first idea of genius that may be attributed to Sir Thomas Bodley. Sadly, the Library was to 'loan' a large part of its endowment to Charles I in 1642 in order to help fight the civil war, reporting it as a debt in its annual accounts until 1782 before writing it off.

Aside from the act of genius that resulted in the foundation of the Library, Sir Thomas may be attributed with several other ideas of genius which are elements of this broader visionary endeavour. The first of these surrounds the idea that we call today 'financial sustainability'. For Sir Thomas this was at the heart of the problems that befell the Bodleian's predecessor institution.

Associated with the idea of financial sustainability being critical to organizational stability and longevity was the notion, explicitly stated by Bodley, that the Library would be dependent on philanthropic support, and would need to 'stirre up other men's benevolence' to maintain its collections. Bodley already had an established circle of wealthy friends and contacts who could be encouraged to donate books and money to help establish his new institution. His first Librarian, Thomas James (fig. 4), was able to

build on this network and add others of his own, working with the university authorities as well as students and, in particular, dons. The success and strength of these exertions in what is now called 'development' may be seen in the pages of the benefactors' register (fig. 5), which was created in 1604 in order to 'conserve a perpetuall remembraunce of every giver and his gift'. The names of the early donors to the Library include many of the most influential members of the court and state officials: Lord Buckhurst, Earl of Dorset; the Earl of Essex; Lord Hunsdon; Sir Walter Raleigh; and Henry Wriothesley, Earl of Southampton. But the roll call also records important and influential intellectual figures, including members of the Society of Antiquaries of London: William Camden, Sir Walter Cope, Sir Robert Cotton, John, Lord Lumley, and Sir Kenelm Digby. Institutions also joined the list of donors, especially ecclesiastical ones such as the chapters of Exeter Cathedral and St George's Chapel, Windsor. Financial benefactions were very welcome to Bodley and

James too, especially those that were intended to support acquisitions; from 1600 to 1605 the vast sum of £1,700 was received from benefactors. These gifts allowed the Bodleian to pursue what was arguably the most aggressive collection development policy of any library in the British Isles in the seventeenth century: placing funds with the most prominent members of the Company of Stationers, and allowing them to be active in the book trade across Europe; making acquisitions of whole libraries (such as the Barocci Collection of Greek manuscripts in 1629); and permitting individual purchases. At auction in Amsterdam in 1604 Henry Featherstone bought for the Bodleian the first books in Chinese to come to any Western library, with funds given by the Duke of Northumberland.

Another idea of genius with which Sir Thomas has been credited was probably not his at all, but that of his Librarian, Thomas James. This is the arrangement formed with the Company of Stationers which we now refer to as 'legal deposit'. The story of the genesis and

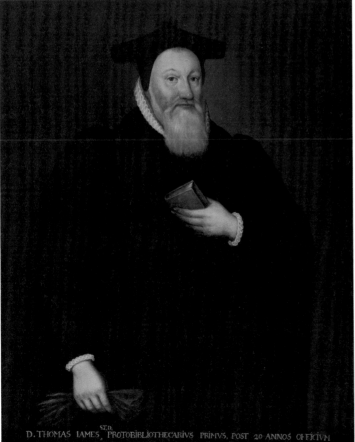

D. THOMAS IAMES, PROTOBIBLIOTHECARIVS PRIMVS, POST 20 ANNOS OFFICIVM
SPONTE DEPOSVIT MENSE MAIO MDCXX.

Fig. 4. Bodley's first Librarian, Thomas James (1573?–1629).
Portrait attributed to Gilbert Jackson. LP 88

Fig. 5. A page from the Bodleian Benefactors' Book, vol. 1, listing donations from 1600 to 1688. Library Records b. 903

implementation of this idea has been definitively told by John Barnard,[6] but in essence it was an idea considerably ahead of its time, associated with the notion of intellectual property and the modern notion of copyright. By a deed of 12 December 1610 the Company of Stationers, 'out of their zeale to the Advancement of good learning, and at the special request of the right worshipful Sir Thomas Bodley', ordered all members of their company to deliver a copy of every new book (in quires) to the Library on condition that they might borrow or copy any book so deposited, for reprinting. Although the early years of this arrangement were beset with problems of non-compliance, eventually it became more accepted. In 1710 it was enshrined in the Copyright Act of Queen Anne and extended to other libraries in the realm. In many ways, the deal that was agreed between Bodley, the University and the Company of Stationers and its enlightened Master, John Norton, set the standard by which national libraries round the globe would define themselves. It would also establish one of the qualities that would set the

universities of Oxford and Cambridge apart from other universities in the United Kingdom – and would be a key recruiting tool for students and academic staff.

Through the generosity of the numerous benefactors, encouraged by Bodley and James, the Bodleian grew in size from the five thousand volumes that were the foundation collection in 1602 to sixteen thousand on the retirement of Thomas James as Bodley's Librarian in 1620. By 1674 it had grown to over forty thousand volumes.

The library that Sir Thomas Bodley founded had another key element which, it may be argued, was an idea of genius: it encompassed in the execution of its vision many of the attributes which we today associate with national libraries. Indeed it has been asserted that from 1598 until 1753 the Bodleian was the *de facto* national library. The establishment of legal deposit was of course a development which we today associate with national libraries, but so too were other elements of the Bodleian's work in the earliest days of its existence. The collection of nationally important manuscripts and printed

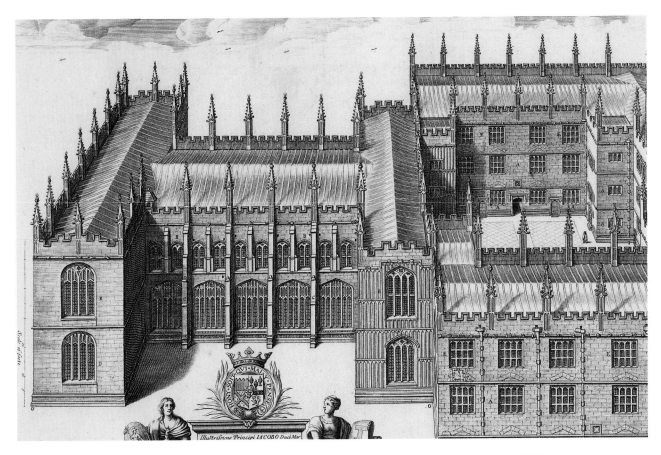

Fig. 6. David Loggan, view of the Bodleian Library. Detail from *Oxonia illustrata*, 1675. John Johnson: Oxford folder IV, 1

collections was a sign that the Bodleian was more than an ordinary university library. The early gifts of manuscripts which had been in the libraries of the monastic houses of pre-Reformation Britain (many solicited personally by Sir Thomas) and volumes of state papers of the fifteenth and early seventeenth centuries were encouraged by the fact that the new institution held key advantages over other libraries at the time: it had a handsome new building and – with guiding statutes that focused a great deal on the safety, security and preservation of the collections stored there – it had an endowment to ensure that the institution was staffed with high-quality scholar-librarians. It also allowed researchers from outside the University of Oxford to come and access the collections if they needed to. This combination proved highly attractive to donors of important materials, who also viewed the enterprise of the Bodleian as a national one, not simply the enlightened act of a provincial university: there was no institution with comparable attributes in London or any other British city in the early seventeenth century.[7]

Sir Thomas Bodley was passionately interested not just in the books which would form the foundation of his new library, but also in the staff who would oversee the institution and deliver services to readers. This attention to the professional administration of the library was a further act of genius, and not only because of the stipulations about how the library should be organized and managed. His appointment of Thomas James (1573?–1629; fig. 4) as the first Librarian was an inspired decision. James had been educated at Winchester and New College, and had become a prodigious scholar, making his mark in bibliographic circles through the publication in 1600 of his *Ecloga Oxonio-Cantabrigiensis*, the first union catalogue of manuscripts in both universities. James threw himself into his new role, following the precepts of his principal benefactor, who required that his librarian be 'Noted and knowen for a diligent Student, and in all his conversation to be trustie, active, and discreete, a graduat also, and a Linguist, not encombred with mariage, nor with a benefice of Cure'.[8] This concern for the qualities of the individual

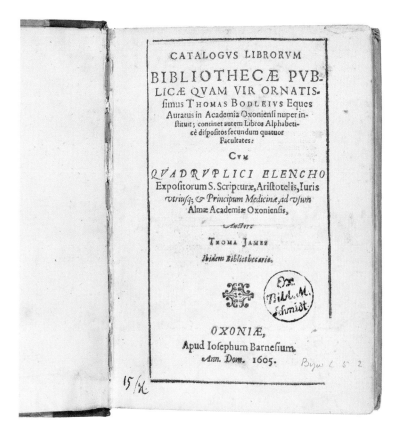

CATALOGVS LIBRORVM

BIBLIOTHECÆ PVB-
LICÆ QVAM VIR ORNATIS-
fimus Thomas Bodleivs Eques
Auratus in Academia Oxonienfi nuper in-
ftituit; continet autem Libros Alphabeti-
cè difpofitos fecundum quatuor
Facultates:

Cvm

QVADRVPLICI ELENCHO
Expofitorum S. Scripturæ, Ariftotelis, Iuris
vtriufq; & Principum Medicinæ, ad vfum
Almæ Academiæ Oxonienfis,

Auctore

Thoma James
Ibidem Bibliothecario.

OXONIÆ,
Apud Iofephum Barnefium.
Ann. Dom. 1605.

Fig. 7. The first printed catalogue of
the Bodleian Library, 1605. Byw. L 5.2

who would be responsible for his library – essentially establishing the need for a librarian who would be well educated, of a scholarly disposition and utterly dedicated to running the Library – was highly unusual for the time. Bodley's Librarian was to be elected in Convocation, and his duties were established by University Statute, also indicating the great importance of the Library and the role of the Librarian in the affairs of the University at large.[9]

The Bodleian Library was established by its founder not as a private library, accessible only to members of the University of Oxford, even if that was its prime constituency. Bodley placed a plaque above the door which made it clear that the audience for his activities was 'the whole republic of the learned', and the surviving archival evidence shows that even in the first year of being opened, 1602–3, about 10 per cent of the readers admitted to use the Library were 'extranei' – that is, non-members of the University, including French, German, Dutch, Scandinavian and Swiss students. This trend would continue throughout the history of the Bodleian, and today just over 50 per cent of the registered readers of the Library have no formal connection to the University.

In order to encourage knowledge of the contents of the new library, and therefore to enable those collections to be used, Bodley was keen to establish an up-to-date and accurate catalogue of the collections. The first of these (fig. 7) was published in 1605 – just three years after the formal opening of the Library itself (and produced chiefly at the expense of Sir Thomas Bodley). This was not the first catalogue of an institutional library to be published – that honour goes to the catalogue of Leiden University Library, 1595 – but it had a much wider circulation and impact than any other catalogue of the time. It was soon followed by a whole series of more advanced and innovative printed catalogues – including the first catalogue (1620) to be arranged alphabetically by author – throughout the seventeenth and eighteenth centuries. The Bodleian catalogue of 1674 was regarded as so important that it was interleaved and marked up to serve as the catalogue of many libraries around the world, including Cambridge University Library and the Bibliothèque Mazarine in Paris.[10]

The Bodleian celebrated its four-hundredth anniversary in 2002, a formal mark of the success of Sir Thomas

Bodley's vision, and of his commitment to establishing the direction of travel that would be adhered to throughout the history of the institution, including the first two decades of the twenty-first century. The Bodleian is still one of the largest stores of knowledge in the world, with over thirteen million volumes in its care; and with specialist collections of manuscripts, archives, maps, music, rare books and other formats that are unrivalled in any university library in the world and matched only by national libraries with greater financial resources at their disposal. The Bodleian continues to have a considerable endowment, despite the depredations of the seventeenth century – and although its endowment is small compared to the great research libraries in North America, it is by far the largest library in the United Kingdom. The Bodleian is still very heavily used by researchers from all over the world – not just in person but online – and the knowledge of its collections has been enhanced in recent years by a strong commitment to digitization, in direct descent from the desire of Sir Thomas to serve the 'whole republic of the learned'.

The Bodleian became a famous library very soon after it was formally opened, not least because of the extraordinary vision and commitment shown by its founder. Edward Chamberlayne, writing at the end of the seventeenth century in his *Angliae notitia*, described 'The most famous *Bodlean Library*, that for a Noble Lightsome Fabricke, number of choice *Books*, choice *Manuscripts*, diversity of *Languages*, liberty of *Studying*, [and] facility of finding any *Book*, equals, if not surpasses, the famous *Vatican*'.[11] The preface to *The Life of Sir Thomas Bodley*, published in 1647, remarked that 'his single worke clouds the proud fame of the Aegyptian Library and shames the tedious growth of the wealthy Vatican'.[12] External testimony to the greatness of the Bodleian also came early from no less a location than the University of Cambridge. In 1626 in Cambridge market a cod-fish was found to have a volume of printed tracts in its stomach, and a Cambridge wit of the time wrote: 'If fishes thus do bring us Books / Then we may hope to equal Bodlyes Library'.[13] More formal recognition of the envy felt in Cambridge comes from correspondence between two senior Cambridge figures in 1614, Thomas Lorkyn and Sir Thomas Puckering: 'There is an intention of erecting a new publique library in Cambridge in imitation of that in Oxford. The heads of the howses are the primi motores, who are allready about to buy the sole, and to provide the

materials.'[14] Perhaps more famously, Francis Bacon, one of the greatest minds of the period, described the Bodleian as 'an Ark to save learning from Deluge',[15] and Samuel Daniel as a 'storehouse … and everlasting granary'.[16]

The fame and praise for the act of founding the Bodleian Library that was bestowed upon its founder set a pattern for further development and innovation by the librarians, greater integration and interaction with the University of Oxford, and further support and benefactions from the wider world of scholarship, state and bibliophily over the four hundred years and more that have followed the re-founding of Oxford's ancient university library by Sir Thomas Bodley in 1602. The period would witness extraordinary feats of collecting, sustained over long periods of time, further enhancement of buildings through enlightened design and patronage of some of Britain's greatest builders and architects (such as Christopher Wren, Nicholas Hawksmoor, James Gibbs and Giles Gilbert Scott), and continued deep scholarship and professional leadership and innovation by librarians over four centuries, from Humfrey Wanley in the seventeenth century to Jonathan Alexander and Richard Hunt in the twentieth. The genius that is the Bodleian Library continues onward, thanks to the inspiration of Sir Thomas Bodley and the great figures who followed in his footsteps, always seeking to honour the tradition; follow the standards that were set long ago; and continue to grow, enhance, and move forward the institution that is still proud to bear the name of Bodley.

Notes

1 Wood 1796, vol. 2, p. 108.
2 See especially Ker 1986.
3 Bodley 1913, p. 24.
4 Ibid., p. 23.
5 Ibid., p. 25.
6 Barnard 2006.
7 Ovenden 2006.
8 Bodley's first draft of the Library Statutes, Bodley 1913, p. 31.
9 Ferdinand 2006.
10 Ovenden 2013.
11 Chamberlayne 1684, pp. 324–5.
12 Bodley 1647.
13 Oates 1986, p. 159.
14 Ibid.
15 Spedding 1861–74, vol. 3, p. 253.
16 From a specially printed poem inserted by Samuel Daniel into a copy of his *Works* presented to Bodley (Bodleian Arch. G d.47).

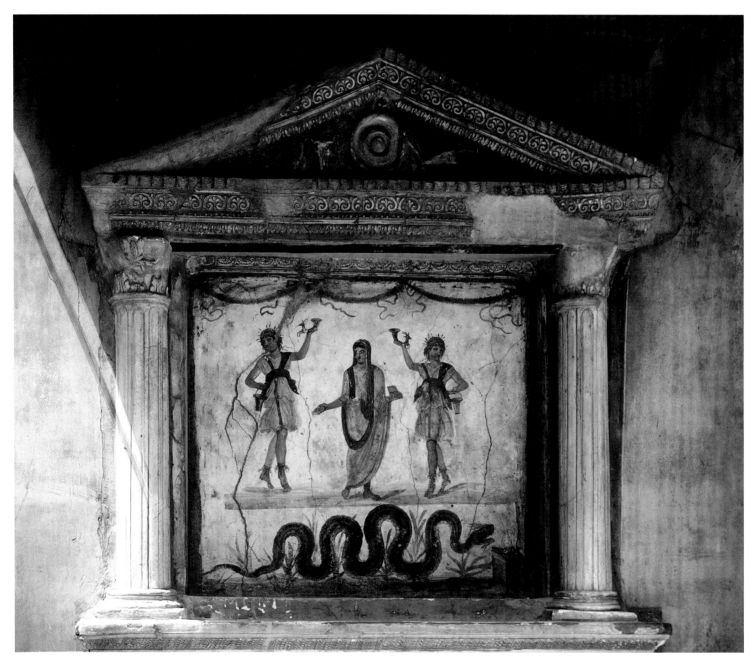

Fig. 8. Shrine of the household gods in an atrium of the House of the Vettii, Pompeii. The *genius* of the paterfamilias is the centre figure, flanked by *lares*, or guardians. The serpent was a traditional symbol of fertility.

The Character of Genius

STEPHEN HEBRON

In the final episode of his television series *Civilisation: A Personal View*, Kenneth Clark gave a summary of his beliefs. 'Order is better than chaos,' he said, 'creation better than destruction.' He preferred gentleness to violence, forgiveness to vendetta; human sympathy and courtesy were more valuable than ideology. 'Above all,' he concluded, 'I believe in the God-given genius of certain individuals, and I value a society that makes their existence possible.'[1] Recalling these words a few years later, Clark saw in them nothing striking or original, but he was pleased to observe that his intellectual approach was 'unconsciously different from that now in favour in universities which sees all historical change as the result of economics and communal pressures'. He, by contrast, was a hero-worshipper, and he believed that most of those who had watched *Civilisation* were too; they had been grateful for programmes that had 'emphasised outstanding individuals rather than economic trends'.[2] Clark's canvas is large and his cast is very diverse (the series begins with Charlemagne and Francis of Assisi, and ends with Isambard Kingdom Brunel and Tolstoy), but his heroes have one thing in common: genius. It is a word he frequently employs and never pauses to define, confident that his audience will know what he means. Clark's confidence was hardly misplaced as 'genius' easily comes to mind when one considers an artist such as Michelangelo, or a composer as Mozart; but a look at the history of genius reveals a rather complex and protean figure.[3]

The Latin word *genius* derives from *gignere*, to beget, and has the literal meaning 'that which is just born'. *Genii* were everywhere in ancient Rome. Every man had his *genius*, a spirit who accompanied him from his birth to his death. Equally, every woman had her *iuno*. The *genius* and the *iuno* were guardians and tutors; what is more, they controlled a person's horoscope and thereby determined their destiny and character. The Roman poet Horace, observing that brothers might have very different personalities, remarked: 'Why so, the Genius alone knows – that companion who rules our star of birth, the god of human nature, though mortal for each single life, and changing in countenance, white or black.'[4] A *genius* could be capricious, beneficial one moment, and harmful the next; or an individual might have two geniuses, one good, one evil. The *genius* of the paterfamilias, or head of the family, was especially influential, and was worshipped in Roman households and depicted in domestic shrines (see fig. 8). The first Roman emperor, Augustus (63 BC – AD 14), boldly brought this worship into the civic sphere by portraying himself as the head of the Roman family. His *genius* became one of the state gods, and observance of it became an expression of loyalty. In accordance with a decree passed by the Senate in 30 BC, it was worshipped with libations of wine at every public or private banquet, and crossroad shrines were restored to include its image.[5]

The *genius* was not confined to individuals: deities had their *genius* too, and so did places, in the form of the *genius loci*. Some identified the Roman *genius* with the Greek *daimon*, and particularly with the *daimon* of Socrates; in Plato's *Apology* (fourth century BC) Socrates describes it as a 'divine or spiritual sign … This began when I was a child. It is a voice, and whenever it speaks it turns me away from something I am about to do, but it never encourages me to do anything.'[6] Elsewhere Plato speaks of the *daimon* as a guardian spirit, and as an intermediary between the gods and humans.

This is no more than a brief outline of classical genius; it takes myriad forms in literary works by Plautus, Horace, Virgil and Ovid among many others, and in surviving frescoes, sculptures and coins. To these may be added the work of Late Antique philosophers, commentators and grammarians, and of Christian writers such as St Augustine who criticized and reinterpreted pagan mythology according to the new religion (cat. 2). The

combined picture is rich, sometimes contradictory, and rather bewildering; and in the early Middle Ages, when literacy in Latin was at a low ebb in the West, it was largely unknown. Genius reappeared with the revival of learning in the twelfth century – not, however, as a muddled synthesis of classical and late-classical sources, but as a vividly reimagined figure.

De mundi universitate, or *Cosmographia*, by Bernardus Silvestris was written between 1145 and 1153. It is an allegorical account in poetry and prose of the ordering of the universe. On her journey through the heavens in search of Urania, with whom she will collaborate on the creation of man, Natura meets Genius. A venerable god who bears the signs of old age, Genius is 'devoted to the art and office of delineating and giving shape to the forms of things':

> *For the whole appearance of things in the subordinate universe conforms to the heavens, whence it assumes its characteristics, and it is shaped to whatever image the motion of the heavens imparts. For it is impossible that one form should be born identical with another at points separate in time and place.*[7]

We are in the spheres of the medieval cosmos. In the outermost sphere are the fixed stars; then come the successive spheres of the planets which move, one within the other, in perfect circles. Beneath the moon, in the central, and lowest point of the cosmos, is the earth and the world of matter, birth and death, change and decay. The shape and course of the sub-lunar realm, and of the lives within it, are determined by the outer spheres. In the cosmos of Bernardus, Genius is still an agent of astrological influences, but he is not the personal attendant of the Romans – he is a kind of celestial overseer, designing, from his place in the firmament, the forms of all creatures in the subordinate world of humanity.

The alliance between Genius and Nature is found in another twelfth-century work, Alain de Lille's *De planctu natura* (*The Plaint of Nature*). St Augustine's enquiry into the nature of genius in the *City of God* included a quotation from the Roman writer Varro which identified Genius as 'the god who has command and control of everything that is begotten'. Augustine's work was highly influential in the Middle Ages, and in Alain's poem Genius is Nature's priest, conferring divine authority and dignity on the creativity both of nature itself, and of mankind. In his priestly guise Genius takes the formless, flickering energies of nature and invests them with individual substance and suitable definition, as a scribe gives material form to thought:

> *His garments … seemed now aflame with purple, now to have the brightness of hyacinth, now to be afire with scarlet, now to have the clear white of linen. On these garments images, lasting but a moment, faded so quickly that they eluded the pursuit of our minds. In his right hand he held a pen, close kin of the fragile papyrus, which never rested from its task of enfacement. In his left hand he held the pelt of a dead animal, shorn clear of its fur of hair by the razor's bite. On this, with the help of the obedient pen, he endowed with the life of their species images of things that kept changing from the shadowy outline of a picture to the realism of their actual being.*[8]

When these forms die, Genius brings others into life as part of the continual process of annihilation and new birth, just as men and women keep death at bay through their sexual union.

As Nature's priest, Genius must also restore humanity to order when it abuses her gifts (this is Nature's complaint), and at the end of the poem Genius puts on his sacerdotal robes and descends to earth to excommunicate the offenders. He performs the same role at the conclusion of the most popular poem of the Middle Ages, the *Roman de la Rose*, written in thirteenth-century France by Guillaume de Lorris and Jean de Meun (cat. 7). Having heard Nature's confession Genius flies to earth, where an army of barons is laying siege to the castle of love. He is welcomed by the god of Love (who dresses him up as a bishop) and berates the barons in a sermon, telling them to plough their furrows with due energy and diligence (see fig. 9). The barons storm the castle and the poem's narrator, a young lover, finally plucks the rose, the object of his desire.

Genius makes a third appearance as a priest in John Gower's *Confessio Amantis*, a poem written by at the end of the fourteenth century. Here, as a priest of Venus, he hears the confession of a lover, Amans, and shrives him of his sins. Henceforth, however, Genius mostly appears in his Roman guise as a tutelary spirit of persons and places, a guise that became more familiar to readers thanks to the work of Renaissance humanist scholars and mythographers. In Act Two of Shakespeare's *Julius*

Fig. 9. Genius delivering a sermon to the barons. Illustration from a fifteenth-century manuscript of *The Romance of the Rose*. MS. Douce 195, fol. 139v

Caesar Brutus contemplates the murder of Caesar; he is torn between his better conscience ('The Genius') and his lower instincts ('the mortal instruments'):

> *Between the acting of a dreadful thing*
> *And the first motion, all the interim is*
> *Like a phantasma, or a hideous dream:*
> *The Genius and the mortal instruments*
> *Are then in council; and the state of man,*
> *Like to a little kingdom, suffers then*
> *The nature of an insurrection.* (II, i, 63–9)

The classical *genius* fits easily into a play which is, after all, set in ancient Rome, but the attendant spirit was no longer a separate being existing somewhere between the heavenly and earthly realms; it was a part of human nature. Genius was one's disposition, inclination and natural bent. 'I was inclin'd by my genius from my childhood to the love of antiquities', wrote John Aubrey in *Monumenta Britannica* (1663–93), 'and my fate dropt me in a countrey most suitable for such enquiries'. The genius of a people or a nation was not a deified object

of allegiance like the *genius* of Augustus, but a country's distinctive spirit and prevailing opinions. 'The People of *England* are of a Genius and Temper, never to admit slavery among them', wrote Jonathan Swift in 1701.[9] Similarly, when eighteenth-century gardeners assured their patrons that their improvements would observe 'the genius of the place' they were referring to the natural character of a landscape, not to a resident deity.

This internalization led, in the eighteenth century, to a new figure: the exalted genius. It is an obvious truth that individuals differ from one another not only in their inclinations and preferences, but in their abilities to do particular things. It is also easily observed that some people's abilities are so outstanding that they seem god-given. Genius thus rose through the ranks; it came to mean not only inclination but talent, and then something more than talent: an extraordinary, apparently effortless, and inexplicable capacity for invention. Genius, once owned by everyone, became the property of a very few.

Classical writers explored the relationship between *ars*, the craftsmanship acquired through study, and *ingenium*, a person's natural ability. 'Do good poems

Fig. 10. Albrecht Dürer, *St Jerome in his Study*, 1514. The British Museum, London (E,4.109)

come by nature or by art?' asked Horace in his *Ars poetica* (*The Art of Poetry*). 'This is a common question. For my part, I don't see what study can do without a rich vein of talent, nor what good can come of untrained genius. They need each other's help and work together in friendship.'[10] *Ingenium*, like *genius*, came with one's birth. In his *Divina Commedia* (*Divine Comedy*), Dante, on his great journey through Paradise, acknowledges the stars of Gemini, his birth sign, as the source of his *ingegno*, his talent (cat. 8).

In the Renaissance a concentration on the nature of individual man included a fascination with the exceptional ability of a few 'divine' artists, especially Leonardo da Vinci and Michelangelo. 'The greatest gifts

often rain down upon human bodies through celestial influences as a natural process,' Giorgio Vasari began his life of Leonardo, 'and sometimes in a supernatural fashion a single body is lavishly supplied with such beauty, grace and ability that wherever the individual turns, each of his actions is so divine that he leaves behind all other men and clearly makes himself known as a genius endowed by God (which he is) rather than created by human artifice.'[11] Divine inspiration is beautifully conveyed in Albrecht Dürer's 1514 engraving of St Jerome, who sits utterly absorbed in his work in a tranquil, light-filled study (fig. 10). Dürer's companion print, *Melencolia 1* (fig. 11), conveys by contrast a remarkably vivid mood of

Fig. 11. Albrecht Dürer, *Melencolia 1*, 1514. The British Museum, London (1910, 0212.303)

suppressed, brooding energy. A winged figure stares into the distance, idly holds a pair of dividers and a closed book, and is surrounded by the unused instruments of construction. Plato had seen poetic inspiration as a kind of frenzy close to madness, and *Melencolia 1* has been read as a portrayal of the melancholy temperament and mental disturbance that often seems to be the companion of great creativity.

The quality Vasari revered in the *divino* Leonardo and Michelangelo was called genius by eighteenth-century writers and artists. It became their preoccupation, and problems – now all too familiar – soon became apparent. How does one agree on what genius is, and how does someone qualify as such? Are there grades of genius? In a *Spectator* article published on 3 September 1711, Joseph Addison complained that the word was used with no discrimination:

There is no Character more frequently given to a Writer, than that of being a Genius. I have heard many a little Sonneteer called a fine Genius. There is not an Heroick Scribler in the Nation, that has not his Admirers who think him a great Genius; and as for your Smatterers in Tragedy, there is scarce a Man among them who is not cried up by one or other for a prodigious Genius.

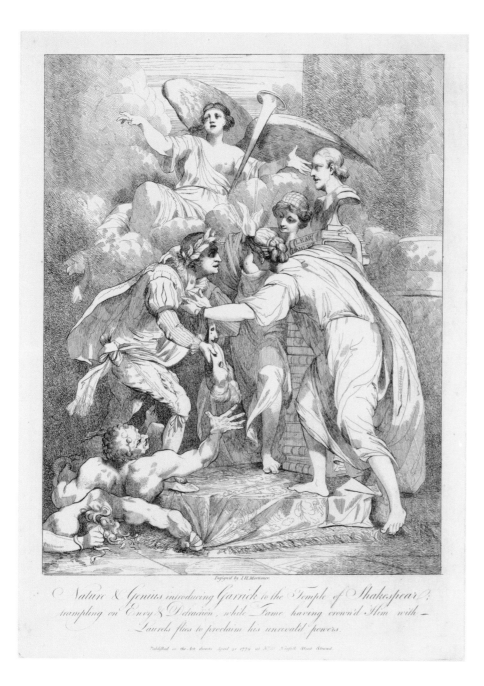

Fig. 12. After John Hamilton Mortimer, *Nature and Genius introducing Garrick to the Temple of Shakespeare*, 1779. The British Museum, London (1871,0812.3292)

The purpose of his article, Addison wrote, was 'to consider properly what is a great genius'. In the first place, there were such writers as Homer, Pindar and Shakespeare, who without any assistance from practice or learning produced wondrous works:

> *Among great Genius's, those few draw the Admiration of all the World upon them, and stand up as the Prodigies of Mankind, who by the meer Strength of natural Parts, and without any Assistance of Art of Learning, have produced Works that were the Delight of their own Times and the Wonder of Posterity. There appears something nobly wild and extravagant in these great natural Genius's, that is infinitely more beautiful than all the Turn and Polishing of what the* French *call a* Bel Esprit, *by which they would express a Genius refined by Conversation, Reflection, and the Reading of the most polite Authors. The greatest Genius which runs through the Arts and Sciences, takes a kind of Tincture from them, and falls unavoidably into Imitation.*

There was another kind of great genius, Addison continued: 'those that have formed themselves by Rules, and submitted the Greatness of their natural Talents to the Corrections and Restraints of Art. Such among the *Greeks* were *Plato* and *Aristotle*, among the *Romans Virgil* and *Tully*, among the *English Milton* and Sir *Francis Bacon*.'

The idea of the wild, unschooled genius had been articulated in the first century AD in a treatise attributed to 'Longinus', *On the Sublime*. In the eighteenth century it became the subject of numerous essays and pamphlets, of which the most celebrated was Edward Young's *Conjectures on Original Composition* (1759). 'A *Genius* differs from a *good understanding*, as a magician from a good architect', maintained Young, '*that* raises his structure by means invisible; *this* by the skillful use of common tools. Hence Genius has ever been supposed to partake of something Divine.' Pindar and Homer were fine examples of this kind of genius, but the 'star of the first magnitude was Shakespeare'. His genius had a kind of purity; he never 'lowr'd his genius' by imitating others. The preeminence of Shakespeare became a universally held belief in Britain. Edward Gibbon described it as the 'idolatry for the Gigantic Genius of Shakespeare which is inculcated from our infancy as the first duty of an Englishman'.[12] In his jubilee *Ode to Shakespeare* the actor David Garrick praised the poet as 'the God of our idolatry', and his own idolatry of Shakespeare was well-known (fig. 12).[13]

The eighteenth-century notion of genius would find its apogee in the *Sturm und Drang* movement in Germany and the apotheosis of Goethe as the country's national genius by the poet Johann Gottfried Herder; so superior was genius that it was not bound by either the normal laws of human nature or the laws of the land. It would eventually settle into the rather more sober usage familiar today, employed by Kenneth Clark's in *Civilisation*, and defined as follows in the *Oxford English Dictionary*:

Native intellectual power of an exalted type, such as is attributed to those who are esteemed greatest in any department of art, speculation, or practice; instinctive and extraordinary capacity for imaginative creation, original thought, invention, or discovery. Often contrasted with talent.[14]

This definition of genius did not entirely replace earlier usages of the word. 'Consult the Genius of the Place in all', wrote Alexander Pope in his epistle to Lord Burlington, published in 1731. 'Every Age has a kind of Universal Genius, which inclines those that live in it to some particular Studies', wrote John Dryden.[15] During the French Revolution anti-Jacobin cartoonists such as James Gillray showed Britannia (with Magna Carta) on her knees before the evil Genius of France (fig. 18, p. 66). Shakespeare was seen not only as a man of genius but as the representative of the genius of England; and in 1816 the young poet John Keats even saw him as a tutelary spirit: 'I remember your saying that you had notions of a good Genius presiding over you', he wrote to the artist Benjamin Robert Haydon in 1817. 'I have of late had the same thought. … Is it too daring to Fancy Shakspeare this Presider?'[16] Furthermore, not everyone was convinced by the exaltation of genius. Samuel Johnson believed that it made the hopeful student despondent, and that it discouraged personal ambition and hard work. He saw genius as like 'the fire in the flint, to be produced by collision with a proper subject'. It was everyone's duty to test their faculties against their desires, 'and since they whose proficiency he admires, knew their own force only by the event, he needs but engage in the same undertaking with equal spirit, and may easily hope for equal success'.[17] Two cartoons published in 1812 are no more reverential. Thomas Rowlandson depicts an artist's 'Chamber of Genius' as a squalid garret (fig. 13). *The Genius of the Times* shows a group of dissolute and venal writers, including Wordsworth and Byron, engaged in an unseemly and ridiculous attempt to mount a hill and reach the 'temple of fame' (fig. 14).

Nevertheless, many writers and artists of the Romantic period worked with the spectre of great genius before them. They saw it in the supreme figures of the past (with Shakespeare the shining exemplar), in a few of their contemporaries and, more furtively, in themselves. Samuel Taylor Coleridge in *Biographia Literaria* (1817) contrasted genius with 'mere *talent*', and '*commanding* genius' with 'the creative and self-sufficing power of absolute *Genius*'.[18] Benjamin Robert Haydon revered the heroic genius of both the Duke of Wellington and Napoleon Bonaparte ('I fear the glitter of his genius rather dazzled me'), as well as the poetic genius of William Wordsworth and John Keats; but most of all he was obsessed with the idea of his own genius, which determined the course of his difficult life. A history painter of religious integrity and considerable vanity, he describes movingly in his diary his struggle to realize his gigantic ambitions in the face of chronic debt, public indifference and the persecution

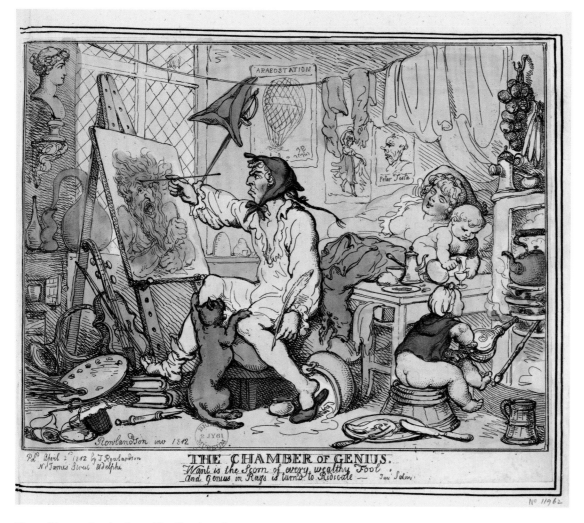

Fig. 13. Thomas Rowlandson, *The Chamber of Genius*, 1812. The British Museum, London (1935,0522.5.217)

of his 'enemies' in the Royal Academy. 'Genius is sent to the world not to obey laws, but to give them', he wrote;[19] his inner voices drove him forward, but to a tragic end. In 1846 he exhibited two large paintings, *The Banishment of Aristides* and *Nero at the Burning of Rome*, at the Egyptian Hall in London. They were shown at the same time as the performances, next door, of the dwarf General Tom Thumb. In the first week Haydon took £7 13s, Thumb £600. 'I closed my Exhibition this day, & have lost 111. 8. 10.' Haydon wrote in his diary on 18 May. 'No man can accuse me of shewing less energy, less spirit, less genius than I did 26 years ago. I have not decayed, but the people have been corrupted. I am the same, they are not, & I have suffered in consequence.'[20] A month later he committed suicide. 'Poor Haydon!' wrote Elizabeth Barrett to Robert Browning. 'Think what an agony life

was to him, so constituted! – his own genius a clinging curse! the fire and clay in him seething and quenching one another!'[21] The artist's final failure was mercilessly satirized, albeit posthumously, by George Cruikshank in his cartoon 'Born a genius – born a dwarf' (fig. 15).

In America, nine years before Haydon took his own life, Ralph Waldo Emerson described a more democratic kind of genius. In an oration delivered to the Phi Beta Kappa Society at Harvard University on 31 August 1837 he averred that the one thing of value was 'the active soul': 'This every man is entitled to; this every man contains within him, although, in almost all men, obstructed, and as yet unborn. The soul sees absolute truth; and utters truth, or creates. In this action, it is genius; not the privilege of here and there a favorite, but the sound estate of every man.'[22] But the concept of genius as something rare

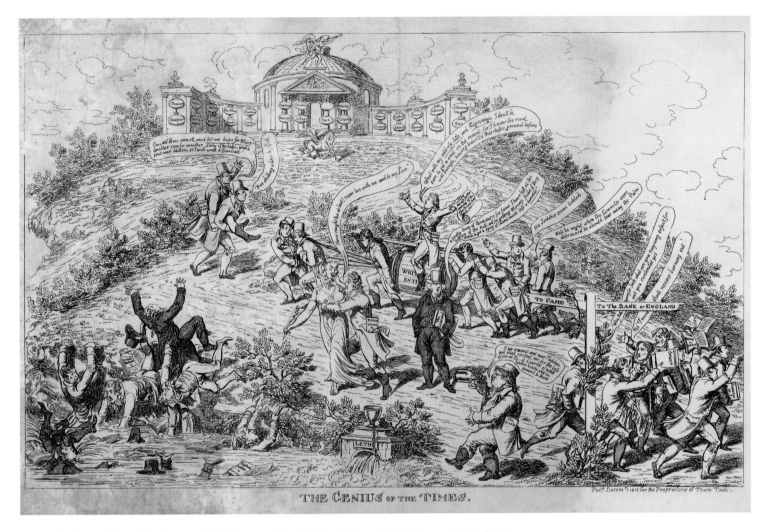

Fig. 14. Charles Williams, *The Genius of the Times*, 1812. The Bodleian Library. John Johnson, Political Cartoons 2, 100

and inexplicable, which cannot be taught or acquired through hard work and remains the property of a select few, continued to act as a compelling challenge to ambition. In Anton Chekhov's 1894 story 'The Black Monk' the life of a successful man of letters is ruined by his visions of a ghost who assures him that his outstanding scholarship and life 'have a heavenly, celestial bearing'. Initially this inspires him to work tirelessly, to the point of madness; but following a nervous breakdown he abandons his ambitions and becomes a disappointed man. 'Why did you not believe me?' the ghost asks him shortly before his premature death. 'If you had believed me back then when I said that you were a genius, then these two years would not have been so miserable and unfulfilling for you.'[23]

The notion of genius that so tormented Haydon and the protagonist of 'The Black Monk' has remained elusive.

In 1869 the scientist Francis Galton, a cousin of Charles Darwin, published *Hereditary Genius: An Inquiry into its Laws and Consequences*, in which he explored the question of 'nature versus nurture', but he rarely employs the word genius, and in a second edition maintained that its use was always 'indefinite'. Psychology, psychoanalysis and neuroscience have all made advances in our understanding of exceptional ability, but genius has never been scientifically explained or located; thus its presence can never be either proved or refuted. The genius of a particular person may be hotly promoted and equally hotly denied, according to taste. And one cannot reasonably or decently award genius to oneself. 'No great man really ever thought himself so', William Hazlitt began his essay 'Whether Genius is Conscious of its Powers?' (1826). 'The definition of genius is that it acts unconsciously; and

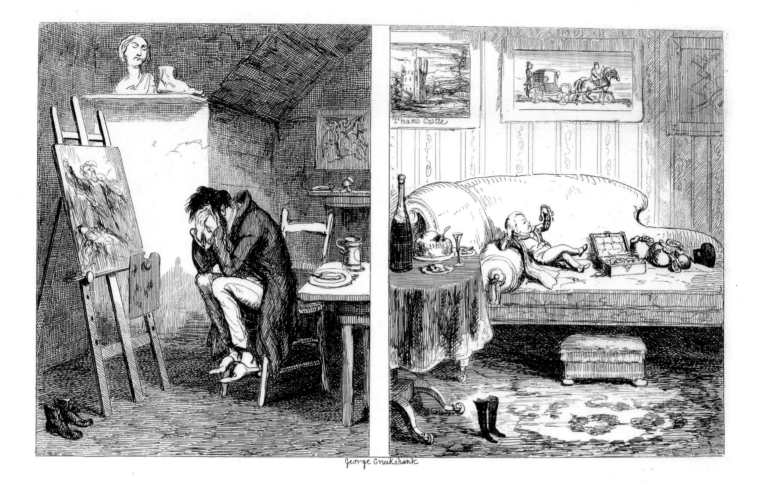

Fig. 15. George Cruikshank, *Born a genius – and born a dwarf*, 1847. The British Museum, London (1978,U.2856)

those who have produced immortal works, have done so without knowing how or why.'[24]

The word 'genius' may be employed freely or sparingly. On the one hand, it is a part of everyday conversation, and is generously applied to express one's admiration for impressive achievement in all walks of life; it can be called upon to sell something; it can still be used to describe the particular character of a place or a nation. On the other hand, it is kept in reserve for the truly special. In a television interview Orson Welles amusedly dismissed it as 'one of those words' and suggested that there were perhaps three geniuses of the twentieth century: Einstein, Picasso and 'somebody from China we've never even heard of'.[25] He was modestly ducking a suggestion that he

possessed genius himself, but his witty remark shows that genius may be refined and exalted almost out of existence, and so become rather meaningless.

If the various forms the character of genius has taken over the centuries have anything in common, it is that they celebrate the variety and creativity of human beings. Genius, a deity familiar to the Romans and present in medieval poetry, gave form and character to individuals. As a property, however vague, of men and women, it gives rise to great works that can be seen, read and heard; and they exist in sufficient plenitude to satisfy all preferences and beliefs. 'This series has been filled with great works of genius', said Kenneth Clark at the end of *Civilisation*. 'There they are; you can't dismiss them.'

Notes

1 Clark 2005, p. 246.
2 Clark 1977, pp. 222–4.
3 See, for example, Nitzsche 1975, Murray 1989, Robinson 2011, Smith 1928, Virtanen 1981, Wiley 1936.
4 Fairclough 2005, pp. 438–9.
5 See Taylor 1931.
6 Plato, *Apology*, 31d; trans. G.M.A. Grube (Cooper 1997, p. 29).
7 Bernardus Silvestris, *Cosmographia*, 'Microcosmus', iii, 11; trans. Winthrop Wetherbee (Wetherbee 1973, p. 96).
8 Alain de Lille, *De planctu natura*, prose 9; trans. James J. Sheridan (Sheridan 1980, pp. 215–16); see also Wetherbee 2013. For the medieval concept of genius and priesthood see Baker 1976, Economou 1970, Knowlton 1920 and 1924, Starnes 1964, and Wetherbee 1969.
9 Swift 1701, p. 50.
10 Horace, *Ars Poetica*, 408–10; trans. D.A. Russell (Russell and Winterbottom 2008, p. 108).
11 Trans. Bondanella and Bondanella (Bondanella and Bondanella 2008, p. 284).
12 Gibbon 1837, p. 46.
13 Bate 2008, p. 185.
14 'genius, n.'. OED Online. September 2013. Oxford University Press.
15 *Of Dramatick Poesie, An Essay*; Dryden 1668, p. 9.
16 11 May 1817 (Rollins 1958, vol. 1, p. 142).
17 *The Rambler*, 12 June 1750.
18 Engell and Bate 1983, pp. 31–2
19 Taylor 1926, vol. 1, p. 81.
20 Pope 1960–1963, vol. 5, p. 544.
21 9 July 1846 (Kelley and Lewis 1995, p. 142).
22 Porte and Morris 2001, p. 59.
23 Trans. Rosamund Bartlett (Bartlett 2004, p. 91).
24 Paulin and Chandler 2000, pp. 422–3.
25 In conversation with Michael Parkinson, 1973.

The first part of this exhibition and catalogue looks at ways in which common attitudes towards genius are manifested in the physical form of a number of remarkable books and manuscripts. The creative intensity and singular character of a writer or composer, or of an historical moment, is intimately expressed by the hand-written page. The commercial, technical and artistic innovations of certain printed books are testimony to the endless invention of genius. The pre-eminence accorded to a few individuals, or 'giants', among the many who contributed to the artistic and intellectual life of any given age, is reflected in manuscript and printed copies of their work and in subsequent endeavours based on their achievements. Books and manuscripts which are works of art in their own right are a reminder that genius is not necessarily solitary and self-sufficient; it can equally be collaborative, and is always embedded in the tastes and traditions of its time.

The second part of the exhibition considers the relationship between genius and learning, and in particular explores ways in which the works of genius found in a university library can be acquired, collected and read. Some have seen learning as secondary, even irrelevant, to supreme genius. 'Genius leaves but second place, among men of letters, to the Learned', wrote Edward Young in 1759. 'It is their Merit and Ambition, to fling light on the works of Genius, and point out its charms…. Genius is from Heaven, Learning from man.'[1] Others have disagreed. 'The mental disease of the present generation', maintained Samuel Johnson in 1751, 'is impatience of study, contempt of the great masters of ancient wisdom, and a disposition to rely wholly upon unassisted genius and natural sagacity'. A person should first look to 'the intellectual treasures which the diligence of former ages has accumulated, and then endeavour to increase them by his own collections'.[2]

Notes

The date and place of origin of each exhibit is given, together with a brief physical description. Unless otherwise indicated, the language in which a book or manuscript is written is English, and the material is paper. The number of leaves or pages is given, according to whether it has been foliated or paginated; the sizes are of the individual leaves. The 'literature' section directs readers, in the first place, to the relevant Bodleian catalogues (listed separately in the Bibliography, p. 346), and in the second place to published works that are concerned wholly, or principally, with the exhibit in question.

1 Young 1759, p. 21.
2 *The Rambler*, no. 154 (7 September 1751).

CATALOGUE

MARKS OF GENIUS

WHAT IS GENIUS?

VIVITVR
INGENIO,
CAETERA MORTIS
ERVNT.

'What is genius?' asked St Augustine in the fifth century AD. It has never been a simple question to answer – for two thousand years genius has been a changeable and subjective concept, and has never been confined to a single definition. A small selection of manuscripts and books in which genius is described, depicted or embodied illustrates some of the myriad ways in which it has been conceived over the centuries.

Renaissance mythographies, commentaries and emblem books (cats 1–3, 5) described and depicted Greek and Roman concepts of genius, and its Greek relation, the *daimon*, finding a rich variety of definitions in the classical texts that had not been known to readers in the Middle Ages (cat. 4). Pilgrimage maps and souvenirs illustrate the sacred topographies of the great Abrahamic religions (cats 5 and 6) and while direct links cannot be drawn between the holy lands of Judaism, Christianity and Islam and the classical *genius loci*, there is a shared belief that certain places are favoured by the spiritual.

A manuscript of a medieval allegorical poem, *The Romance of the Rose* (cat. 7), shows Genius as a winged priest who attends to Nature and acts as her energetic spokesman on earth; while in a manuscript of Dante's *Divine Comedy* (cat. 8) the author is depicted in Paradise with Gemini, his birth sign, to which he owes his talent (*ingegno*, derived from the Latin *ingenium*). Two centuries later the anatomist Vesalius portrayed a skeleton musing on *ingenium* while contemplating, Hamlet-like, a human skull (cat. 9).

In the early eighteenth century, as genius came to be considered the highest form of creativity, Alexander Pope commented on the consequent expectations and motives of critics (cat. 10). At the end of that century Magna Carta (cat. 11) came to embody the distinctive national genius of Great Britain, while William Blake insisted that genius resided 'in the human breast' (cat. 12).

1

VINCENZO CARTARI (*c.* 1531–1569)

Le Imagini de i Dei de gli Antichi (*Images of the Ancient Gods*)

Lyon: Bartholomeo Honorati, 1581

Woodcuts
In Italian; 526 pages, 168 × 110 mm
Late eighteenth- or early nineteenth-century British binding: brown sheepskin with blind tooling[1]

Provenance: From the Skene Library formed by Sir John Skene of Curriehall (*c.*1540–1617) and kept at Mar Lodge, Aberdeenshire until the 1920s, after which it was dispersed

Vet. E1 e.162 [pp. 380–381 illustrated]

Vincenzo Cartari was one of several Renaissance mythographers who wrote popular studies of the classical gods. His *Imagini* combines extensive quotation from Greek and Latin texts with commentary. It was first published in Venice in 1556; an expanded edition with copper plates was published in 1571, and thirty subsequent editions are listed. It was translated into Latin, French and German; an English abridgement, *The Fountaine of Ancient Fiction*, appeared in 1599.[2]

The *Imagini* includes a summary of the various types of classical genius. It was a protective spirit who accompanied an individual through life, as well as a power that produced life. All places and cities had their genius, as did the collective body of the Roman people. A genius could be changeable, benevolent one moment and evil the next; and an individual had two geniuses – one good, one bad. Cartari was particularly interested in the physical appearance of the ancient gods, and an engraving shows three personifications of genius. On the left is an evil genius, similar to those that appeared before Brutus and Cassius:

tall, dark, bearded and dishevelled. Temesa in Italy was haunted by the ghost of one of Odysseus's sailors, who had been executed for violating a maiden; according to Pausanias the ghost was 'horribly black in colour, and exceedingly dreadful in all his appearance, he had a wolf's skin thrown round him as a garment'.[3]

The child and serpent in the centre of the engraving also relate to an episode from Pausanias. The land of Elis had been invaded by the Arcadians. A woman with a baby came to the Elean generals, saying that in a dream she had been told to give the child to the Elean army. Believing her, the generals set the child at the front of the army, naked. When the Arcadians approached the child turned into a snake, the Arcadians fled and the Elean army won a great victory. After the battle the snake disappeared into the ground, and there they built a sanctuary.[4] The *genius loci* often took the form of a serpent, the symbol of new life. Aeneas saw one at the shrine of his father, Anchises, and did not know 'whether to deem it the genius of the place or the attendant spirit of his sire'.[5]

The right-hand figure is the *genio populi Romani* – the god, or genius, of the Roman people. It was a symbol of the fruitfulness of the Roman state, and often appeared on coins (fig. 16). In the genius's left hand is a cornucopia – a goat's horn overflowing with flowers, fruit and corn. In his right hand is a patera, a shallow dish used in sacrifices.

Traditionally, a genius was honoured with libations of wine, and in Roman households libations were poured to the genius of the *paterfamilas*, the male head of the family.

Renaissance readers derived a good deal of their knowledge of classical genius from books such as this. Cartari's *Imagini* was very widely read, particularly in its Latin form, and among the English authors who referred to it are Sir Thomas Browne and Robert Burton.

Notes
1 I am grateful to Andrew Honey for the binding descriptions in the catalogue.
2 Mulryan 1981.
3 *Description of Greece,* 6.6.11; Jones 1933, vol. 3, pp. 42–3.
4 *Description of Greece,* 6.20.4–5.
5 Virgil, *Aeneid,* 5.95; Fairclough 1978, vol. 1, pp. 478–9.

Fig. 16. Roman *follis,* minted in Carthage during the reign of Maximinus II, Emperor of Rome 309–313, and depicting the *genio populi Romani.* Private collection

costui, bench'egli si cangiasse in serpente, come ho detto, di fan-
ciullo con veste intorno di varij colori, e carica di stelle, che porge-
ua con mano il corno della copia, perche tale apparue gia, come
dice Pausania, ad vno che lo riferi poi. Vedesi in alcune medaglie
antiche di Adriano, e di altri Imperadori ancora il Genio fatto
in guisa di huomo, che porge con la destra mano vn vaso da bere,
quale mostra di versare sopra vn'altare, tutto ornato di fiori, e
gli pende dalla banda sinistra vna sferza. Et in altre medaglie pu-
re di Adriano è la imagine di vn'huomo di guerra con veste at-
torno inuolta giù fino a mezza gamba, che nella destra tiene co-
me vna tazza a modo di chi sacrifica, & ha il Corno della copia
nella sinistra, e sonoui lettere intorno, che dicono, Al Genio del Po-
polo Romano: che doueua forse forse mostrare quel Nume tenuto
tanto secreto da Romani, che non voleuano à modo, che fosse, che
se ne sapesse il nome, come altra volta ho detto. Faceuano oltre
di ciò gli antichi ghirlande al Genio de i rami del Platano, le
cui foglie sono poco dissimili da quelle della vite, & alle volte
anchora di diuersi fiori, come si legge appresso di Tibullo, oue
così scriue.

*Platano
dato al
Genio.*

 Hor cinto de bei fior le sante chiome,
 Venga il Genio à veder quelch'à suo honore
 Facciamo, celebrando il lieto nome.

Ma, perche ho detto gia, che due erano i Genij, come vuole Euclide
Socratico, secondo che riferisce Censorino, hora vediamo l'altro
cioè il rio, come fosse fatto, che il buono è quello, che fin qui habbi-
amo disegnato. Di questo non ho trouato, che gli antichi habbi-
no fatta statoa, ne imagine alcuna: ma ben si legge, ch'egli
apparue gia a molti, & io così lo ritrarrò, come essi lo videro se-
condo l'essempio, che ci hanno seruato le historie. Scriuono Plu-
tarco, Appiano, Floro, & altri, che ritiratosi di notte Bruto in
camera tutto solo, ma ben col lume, à pensare tra se, come egli
era vsato di fare, vide apparirsi dauanti vna imagine di huomo
tutta negra, e spauēteuole, la quale disse à lui, che gliene dimandò,
che

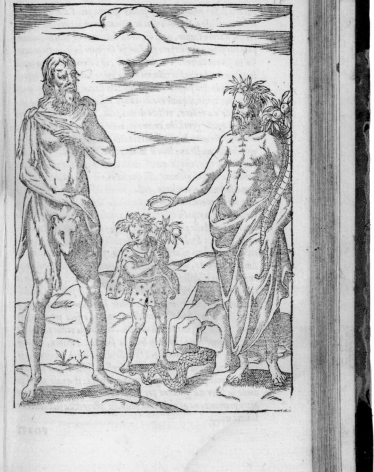

2

De civitate Dei (*City of God*)

Basle: Johann Froben, 1522

Edited by Johannes Vives (1493–1540)
Metalcut border by Hans Holbein the Younger (1497–1543); woodcuts
In Latin; 810 pages, 353 × 235 mm
Possibly contemporary wooden-boarded binding which has been re-covered in the seventeenth or early eighteenth century, and provided with new endleaves: brown calfskin with blind tooling

Provenance: Bequeathed to the Bodleian in 1952 by Helen Mary Allen (1872–1952) in accordance with the wishes of her husband, Percy Stafford Allen (1869–1933)

Literature: Hollstein 1988, no. 44a

Allen c.5 [p. 207 and title page illustrated]

Augustine wrote the *City of God* in Roman north Africa between AD 413 and AD 426. He was writing in a time of upheaval: the Goths had sacked Rome in 410. The *City of God* was Augustine's urgent response to a claim among pagans that Rome had fallen because it had abandoned the old heathen gods in favour of the new Christian religion. With great deliberation Augustine rejects the classical tradition, moving from the polytheistic beliefs and moral values that had formed the basis of the Roman empire to the one God of Christianity. Christian truths emerge, as if of their own accord, from his erudite, elaborate interrogation of pagan philosophy, literature and religious lore.

This edition of Augustine's monumental work was edited by the learned Spanish humanist Johannes Vives, and his commentary was an influential source of information for Latin readers in the sixteenth and seventeenth centuries. An English translation, by John Healey, was published in 1610. 'What is genius?' asks Augustine in book 7, chapter 13. It is, first, the god 'who has command and control of everything that is begotten' and, secondly, 'the rational soul of each man'. To these concise definitions Vives added an elaborate commentary, which illustrates the variety and extent of the available classical texts. Healey's translation reads:

Genius is 'The lord of all generation, Fest. Pompey. *The sonne of the gods and the father of men, begetting them: and so it is called my* Genius. *For it begot me:* Aufustius. *The learned have had much to doe about this* Genius, *and finde it manifoldly used. Natures* Genius *is the god that produced her: the heavens have many* Genij, *reade them in Capella his* Nuptiae. *Melicerta is the seas* Genius: Parthen. *The foure elements, fire, ayre, water, and earth are the* Genij *of all things cor-porall. The* Greekes *call them* στοιλεια, *and* Θευς γενεθλιους *Geniall gods. Such like hath Macrobius of natures* Penates; Jupiter *and* Juno *are the aire, lowest, and meane:* Minerva *the highest, or the aethereal sky: to which three* Tarquinius Priscus *erected one temple under one roofe. Some call the moone and the 12. signes* Genij: *and chiefe* Genij *too, (for they will have no place without a predominant* Genius). *Every man also hath his* Genius, *either that guardeth him in his life, or that lookes to his generation, or that hath originall with him, both at one time:* Censorin. Genius, *and* Lar, *some say are all one.* C. Flaccus de Indigitamentis. *The* Lars (*saith* Ovid) *were twinnes to* Mercury *and* Nymph Lara, *or* Larunda. *Wherefore many Philosophers and* Euclide *for one, gives each man two* Lars, *a good and a bad: such was that which came to* Brutus *in the night, as he was thinking of his warres he had in hand:* Plutarch. Flor. Appian …[1]

Vives' commentary on the *City of God* informed writers like Edmund Spenser (*c.*1552–1599), who twice includes the figure of Genius in his long poem *The Faerie Queene*. Among the other works accessible to Spenser in which Genius is described were the commentary on Virgil's *Aeneid* by Servius, the encyclopedic *De nuptiis Philologiae et Mercurii* by Martianus Capella, the Renaissance mythographies assembled by Giovanni Boccaccio and Natalis Comes, and the *Tabula Cebetis.*[2]

This last work was extremely popular in the sixteenth and seventeenth centuries. Written in Greek probably in the first or second century AD, the *Tabula Cebetis* (*Tablet of Cebes*) is an allegory of human life. A group of visitors enter a sanctuary and puzzle over an enigmatic painting showing figures moving round a series of enclosures. An old man explains that it represents the journey towards purity and that the figures personify various virtues and vices. He goes on to describe how souls enter the first enclosure under the supervision of Genius. This passage was translated as

est amicitiæ præses, & ξένιθ hospitalis, & ἱκεσίθ
quæ ad naturam eius potius pertinent quàm ad usum
xurus Terracinæ q. ἄσευ ἔυρθ, sine nouacula, imberbis, un
us. Erat Apomyias in Olympio, quem sacrauit Hercules
crificandum infestaretur: & Athenis Iupiter φερέν
Caria λαθασδεύθ, q. securarius, in cuius dextra nó fulm
apud Plutarchum in problematis. Erat etiam in Gracia
rsarū liberasset: in Asia minore Milesius: in Chaonia Dou
μηλίχιθ cui nullum sacrificabatur animal, sed frugibu
αφεσιθ q. dimittens: & κόκκυξ Argis hoc est cuculus, &
ubi & deorum eius nomen accepit, quam Apolloniū: & Aratrius apud
uit Dagoni nomen, aratri inuentor, unde cognomina
æciæ communis. In Sicilia ἀγοραῖθ forensis, quod foro
erodotus. Erat Romæ præter 'ea nomina quæ commu
ndis spolijs opimis, sacratus à Romulo: Capitolinus à
tino ab eliciendo è mentibus diuinis quomodo procu
anibus, quos de capitolio iactarunt obsessi Roma capta
Viminali: Prædator prædæ adiutor, cui & aliquid dd
crauit Agrippa: Tonans, quē Augustus post bellum Cin
Latialis à Tarquinio superbo in mõte Albano: Iouib
ra prope portam Trigeminã, sacratus ab Hercule inuit
ui sacrificabatur in nuptijs. Liuius, Dionysius, Plutarch
bit Iouem de nominibus hospitum suorum esse plerunq
oriandum à quibus in bello est adiutus, tum Laprium
esium Iouem, & eius sacra instituit in Attica terra de no
tumpedam.) Ab stabilitate sic est dictus, ut idem Aug
p pluribus innititur pedibus, & uelut fulcris. Est &
ij codices Almum, melius, ut arbitror. nam alma & alma
& Ceres, & terra alma. Quæ per se prosequi longum
sequi longum est. Cõmentatores uerbi significationem pu
arunt, rati persequi solum dici de infestatione inimica.
ret.) Tignus, unde tigillus trabs cui tectum innititur. Ar
nix continetur, & sistitur deum esse in mundo simdem at,
nus naturæ ædificiū necesse est, ut ablato umbilico fornic
est ab hoc proposito dissonum, quod Orpheus in hym

Et post

Si enim maiestate deorum.) Lib. iiij. Densa est opinio eo
li tribuebat. Dicere qppe uoluissem.) In antiqs melius
inibus noie pecuniæ.) Omnia quæ possidẽt, noie pecuniæ
cude deducta appellatió eut aiūt, Columella, Festus, & Se
iæ, sicut adhuc sunt multarū gentium. Erãt enim ferè pasto
tiam Varro confirmat lib. de Lat. ling. iiij. postea ad opu
uites.) Paradoxum Stoicum ὅτι δι σοφοι μᾶνοι πλϕσι
rationibus suadet. Idem magnis ingenis philosophoru
cuniam perorarunt. Quam nemo sapiens concupiuit
um habet, quam nemo sapiens cõcupiuit, ea quasi uenens
um effœminat, semper infinita & insatiabilis est, neqp copia
tur.) Vt nos uocamus.

unia nuncupetur. **Cap. XII.**

rationem huius nominis reddiderunt, & pecunia, iu
eius sint omnia. O magnam rationem diuini nomi
sunt omnia, uilissime & contumeliosissime pecunia
Iouis sunt, quæ cœlo & terra cõtinentur, inter quæ
o rebus, quæ ab hominibus nomine pecuniæ possi
Ioui nomen imposuit, ut quisquis amat pecuniam,
non

non quemlibet deum, sed ipsum regem omnium sibi amare uideatur. Longe aut aliud esse si diuitiæ uocaretur. aliud nácp sunt diuitiæ, aliud pecunia. Nam dicimus diuites sapientes, iustos, bonos, quibus pecunia uel nulla est, uel parua. Magis enim sunt uirtutibus diuites: per quas eis etiam in ipsis corporalium rerū necessitatibus satis est quod adest: pauperes uero auaros dicimus semper inhiantes, & egentes. Qualibet enim magnas pecunias habere possunt, sed in earum quátacunqp abundantia nó egere nó possunt. Et deum ipsum uerum recte dicimus diuitem, non tamen pecunia, sed omnipotétia. Dicuntur itacp & diuites pecuniosi, sed interius egeni, si cupidi. Item dicitur paupes res pecunia carentes, sed interius diuites, si sapientes. Qualis ergo ista Theologia debet esse sapienti, ubi rex deorum eius rei nomen accepit, quam nemo sapiens concupiuit? Quanto enim facilius si aliquid hac doctrina, quod ad uitā pertineret æternā, salubriter disceretur, deus mundi rector nó ab eis pecunia, sed sapientia uocaretur, cuius amor purgat à sordibus auariciæ, hoc est ab amore pecuniæ.

Quod dum exponitur quid Saturnus, quidue sit *Genius uterque unus Iupiter esse doceatur. **Cap. XIII.**

Ap. *Ianus,

S Ed quid de hoc Ioue plura, ad quem fortasse cæteri referendi sunt, ut inanis remaneat deorum opinio plurimorum, cum hic ipse sit omnes: siue quãdo partes eius, uel potestates existimantur: siue cum uis animæ quam putant per cuncta diffusam ex partibus molis huius in quas uisibilis mundus iste consurgit & multiplici administratione naturæ, quasi plurium deorū nomina accepit? Quid est enim Saturnus? Vnus, inquit, de principibus deus, penes quē sationum omnium dominatus est. Nónne expositio uersuum istorū Valerij Sorani sic se habet: Iouem esse mundum & eum omnia semina ex se emittere & in se recipere? Ipse est igitur penes quem sationum omnium dominatus est. Quid est Genius? Deus est, inquit, qui præpositus est, ac uim habet omnium rerum gignendarum. Quem alium hãc uim habere credunt quàm mundum, cui dictum est:

Iuppiter omnipotens progenitor genitrixcp?

Et cum alio loco genium dicit esse uniuscuiuscp animum rationalem, & ideo esse singulos singulorum: talem autem mundi animum deum esse, ad hoc idem uticp reuocat, ut tancp uniuersalis genius ipse mundi animus esse credatur. Hic est igitur quē appellant Iouem. nã si omnis deus, & omnis uiri animus genius, sequitur ut sit omnis uiri animus deus: quod si & ipsos abhorrere absurditas ipsa cõpellit, restat ut eū singulariter & excellenter dicant deum geniū, quē dicunt mundi animum, ac per hoc Iouem.

QVid est Genius.) Festus Pompeius: Genium appellabant deum, qui uim obtineret rerum omnium gerendarum. Aufustius Genius, inquit, est deorum filius, & parens hominū, ex quo homines gignuntur, propterea Genius meus hominatur, quia me genuit. Quæsitū apud eruditos quis deus esset Genius inuentum qp nó simpliciter id dici. Nam Genius naturæ est deus parens illius, & Genij sunt cœlorū multi, quorum meminit Capella in nuptijs: & Maris Genius Melicerta, ut ait, Parthenius, & corporalium rerum Genij sunt elementa quatuor, ighis, aër, aqua, & terra. Quæ Græci cum σιχεια uocent, γενεθλιοι quocp θεους dicunt. cui non absimile est, quod Macrobius adducit de penatibus naturæ, quod sint medius aër Iupiter, & infimus Iuno, & supremus æther Minerua, quis tribus sub uno tecto Tarquinius Priscus templū uouit. Duodecim cœli signa cum sole & luna sunt qui Genios aiant, & hi quidem Genij uniuersaliores. nam suus est cuicp loco Genius, quem faciunt ei præsidere, quin & unicuicp hominū suus sic dictus, ut Censorinus, inquit, siue quod in eius tutela, ut quisqp natus est, uiuit, siue quod ut generemur, curet: siue quod una gignatur nobiscum: siue etiam, quod nos genitos suscipiat, ac tueatur. Eūdem esse Genium & Larem multi prodiderunt ueterum, in quis & C. Flaccus in libro quem ad Cæsarem de indigitamentis réliquit. Porrò Lares quemadmodum est apud Ouidium Gemini fuerunt filij Mercurij & Laræ, siue Larundæ nymphæ. Ideo ueterum pleriqp inter quos Euclides, geminos singulis hominum addunt Lares, alterum bonum, alterum malum. qualis ille fuit, quē Plutarchus, Florus, & Appianus scribunt oblatum M.Bruto media nocte ad tenuem lucernam de bello cogitanti. Genium dicit

Genius.
Lares.

esse

IO·FROBENIVS
LECTORI S. D.

EN HABES optime lector abſolutiſſimi doctoris
Aurelij Auguſtini, opus abſolutiſſimum, de Ciuitate
dei, magnis ſudoribus emēdatum ad priſcæ ueneran
dæꝗ uetuſtatis exemplaria, per uirum clariſſimum
& undequaꝗ doctiſſimum Ioan. Lodouicũ Viuem
Valentinũ, & per eundem eruditiſſimis planéꝗ diuo
Auguſtino dignis commentarijs ſic illuſtratum, ut
opus hoc eximiũ, quod antehac & deprauatiſſimum
habebatur, & indoctis commentarijs miſerabiliter cō
taminatum, nunc demũ renatum uideri poſſit. Frue／
re lector, ac faue tũ illius non æſtimandis uigilijs, tum
noſtræ induſtriæ: cuius officina ſemper aliquid parit,
maiore profecto fructu publicorum ſtudiorum quā
priuato meo compendio: ſimulꝗ agnoſce, quantum
etiam Theologia debeat bonis literis. Vale.

Baſileæ ex officina noſtra, pridie Calendas
Septembreis, An. M. D. XXII.

follows by Sir Francis Poyntz in his 1531 English version of the *Tabula Cebetis*:

He toke then a rod, and poincted to
the picture. See you not, quoth he, this
circuite. We see it. This ye must first
know, that this place is called lyfe :
And the great company, that standeth
before the dore, be those that shall entre
in to lyfe. The olde man that standeth
above havyng in his one hande a
paper, and with the other, as it were
shewyng somewhat, is called Genius. He
comandeth the entrers, what they muste
do, if they wyl be kept safe in the lyfe.[3]

The *Tabula Cebetis* was not mentioned by Vives in his 1522 edition of the *City of God*, but it is present on the title page in the form of a decorative border by Hans Holbein (illustrated opposite), in which we see, in the bottom right corner, Genius ushering a crowd of infant souls into the first enclosure.

Genius first makes an appearance in *The Faerie Queen* in book II (canto xii, 47–9). Spenser takes pains to point out that this Genius is 'Not that celestiall powre, to whom the care / Of life, and generation of all / That liues', but on the contrary 'The foe of life … That secretly doth vs procure to fall, / Through guilefull semblaunts'. In the next book, however (canto vi, 30–2), Genius appears again, and this time is much more like the figure found in the *Tabula Cebetis* and in Holbein's engraving. The poet is describing the Garden of Adonis:

In that same Gardin all the goodly flowres,
 Wherewith dame Nature doth her beautifie,
 And decks the girlonds of her paramoures,
 Are fetcht: there is the first seminarie
 Of all things, that are borne to liue and die,
 According to their kindes. Long worke it were,
 Here to account the endlesse progenie
 Of all the weedes, that bud and blossome there;
But so much as doth need, must needs be counted here.

It sited was in fruitfull soyle of old,
 And girt in with two walles on either side;
 The one of yron, the other of bright gold,
 That none might thorough breake, nor ouer-stride:
 And double gates it had, which opened wide,
 By which both in and out men moten pas;
 Th'one faire and fresh, the other old and dride:
 Old Genius the porter of them was,
Old Genius, the which a double nature has.

He letteth in, he letteth out to wend,
 All that to come into the world desire;
 A thousand thousand naked babes attend
 About him day and night, which doe require,
 That he with fleshly weedes would them attire:
 Such as him list, such as enternall fate
 Ordaineth hath, he clothes with sinfull mire,
 And sendeth forth to liue in mortall state,
Till they againe returne backe by the hinder gate.

Notes

1 Healey 1610, pp. 271–2.
2 See Knowlton 1928.
3 Poyntz 1531, pp. 3–[3v]. See also Fitzgerald and White 1983.

3

Symbolicarum Quaestionum (Symbolic Questions)

Bologna: Apud Societatem Typographiæ Bononiensis, 1574

Copper engravings probably by Giulio Bonasoni (*c.* 1498 – after 1574)
In Latin; 406 pages, 204 × 148 mm
Late sixteenth-century centrepiece binding: calf parchment with gold tooling; with an added early nineteenth-century gold tooled leather spine
Provenance: Francis Douce (1757–1834), who bequeathed it to the Bodleian

Douce BB 411 [pp. viii–ix illustrated]

This is an example of a sixteenth-century emblem book, in which combinations of words and images draw upon classical sources to make moral, political and religious points, sometimes of considerable subtlety. Symbol III (opposite) is a defence of artistic expression. Imagery and metaphor do not conceal meaning but make it more accessible: 'I have decided to imitate Nature', writes Bocchi, 'and to clothe my thoughts in various forms, in order that none of my creations may be insipid, and that none, whether in action or speech, may be without value.'[1]

The accompanying engraving shows Socrates painting. Above the image is the legend: 'A picture shows how great is the profundity of weighty matters; whatever lies hidden, is revealed through the picture's demonstrative openness.' Standing intimately behind Socrates is a winged figure, below whom is a caption reading 'Daimon Eudaimon'. The Greek *daimon* was an intermediary being who moved back and forth between humans and the gods. It also acted as a person's guardian spirit through life and advocate after death. 'We are told that when each person dies', says Socrates in Plato's *Phaedo*, 'the guardian spirit who was allotted to him in life proceeds to lead him to a certain place, whence those who have been gathered together there must, after being judged, proceed to the underworld'.[2] Socrates refers to his own *daimon* in Plato's *Apology*: 'This began when I was a child. It is a voice, and whenever it speaks it turns me away from something I am about to do, but it never encourages me to do anything.'[3]

In the second century AD Apuleius, in *On the God of Socrates*, cautiously translated *daimon* as *genius*:

In our language, as I would translate it on my own account, if not perhaps accurately, you could call the daemon a 'Genius', since that particular type of divinity, identical with the mind of each and every person, is (though itself immortal) nevertheless born in some sense together with a human being. Consequently, those well-known prayers in which men call upon their Genius and their knees [genium et genus] *seem to me to give evidence of this coalescence and connection of ours, embracing under these two names body and mind, the elements which make up our human conjunction and combination.*[4]

In the fifth century AD, in book 9, chapter 3 of the *City of God*, Augustine called the soul a *daimon*. Johannes Vives, in his 1522 commentary on this passage (see cat. 2), hesitated to identify *daimon* with *genius*, 'because that God which is a man's soule, though he be immortall, yet hath originall after a certaine manner with each: and thither tend the praiers wee offer to our *genius* at carnall conjunctions'.[5] *Daimon* nevertheless became analogous with *genius*, and the *daimon* of Socrates was the best-known example of it.[6] In Bocchi's emblem book it appears to signify artistic inspiration, and Socrates' statement in the *Apology* that his *daimon* only ever dissuaded him from acting is balanced by the inclusion in the caption of the *eudaimon*, traditionally a good and encouraging *daimon*.

Notes

1 Watson 1993, pp. 81–6.
2 *Phaedo*, 107d–e; Cooper 1997, p. 92.
3 *Apology*, 31d; Cooper 1997, p. 29.
4 *On the God of Socrates*; Harrison et al. 2001, p. 207.
5 Healey 1610, pp. 330–31.
6 See Lavin 1974.

PICTVRA GRAVIVM OSTENDVN-
TVR PONDERA RERVM.

QVÆQ. LATENT MAGIS, HÆC PER
MAGE APERTA PATENT.

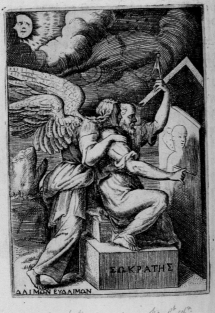

much the same as in the 1st ed.

AD ALEXANDRVM FARNESIVM
CARD. AMPLISSIMVM.

Symb. III.

Ivdicio Phœbi sapientum maximus ille
Et fons, & lumen, si fortè obscura prophani
Vulgi in cognitionem olim deducere vellet,
Quæque sibi in primis notissima proponebat.
Sic etenim haud ab re firmissima cuncta putabat
Ac tutissima, non modò lucida, de quibus ipse
Disserere aggrediebatur. Sic magnus Homerus
Securum oratorem Ithacum laudauit Vlyssem.
Quippè animos hominū trahere his quocunq; liberet,
Concilians sibi passim omnes per maximè aperta.
Propterea quicunq; bonis fæliciter essent
Progressim studijs, non sunt tam arcana secuti
Omnia, Vt assequerentur prorsus: at esse putabant
Quædam pauca satis, possent si attingere parcè,
Quæ ipsa irritamenta forent gratissima deinceps
Veri indagandi. Vates sic condidit ille
Fabellas Phrygius bellas. sua symbola quondam
Panthoides samius. Sic dia poemata vates
Pinxere, atq; homines mirè allexere, libenter
Auribus ut uellent aurire, & credere honesta,

 B

4

Fortune-telling tracts

St Albans, *c.* 1250–55

In the hand of Matthew Paris (d. 1259); miniatures, also by Paris

In Latin, on parchment; seventy-two leaves (some leaves missing), 172 × 128 mm

Nineteenth-century English binding for the Bodleian: half brown calfskin over marbled boards

Provenance: In the possession of Thomas West in 1602; inscription (by Edward Lhuyd, 1659/60?–1709): 'Ex dono –Vaughan, Coll. Æn. Nasi schol.' ['Vaughan, scholar of Brasenose College']; transferred to the Bodleian from the Ashmolean Museum in 1860

Exhibitions: Brussels 1973, no. 47; Oxford 1980, no. 53; London 1981a, no. 18; London 1987, no. 315

Literature: Black, cols 213–16; P & A, vol. 3, no. 437; Brandin 1932; Morgan 1982–8, vol. 1, no. 89; Wormald 1969; Burnett 1996; Iafrate 2012

MS. Ashmole 304 [fols. 31v–32r illustrated]

The texts for fortune-telling in this volume are the *Liber Experimentarius* of Bernardus Silvestris (*fl.* twelfth century) and the *Prognostics* (or divinations) ascribed to Socrates and Pythagoras. The latter attributions were spurious, but gave the texts classical authority; they are in fact of Arabic origin. The fortune-telling takes the form of a question-and-answer system arranged in tables.

The text (with the exception of a few pages) is in the hand of Matthew Paris, a learned monk of St Albans Abbey, the author of histories, hagiographies and genealogies, and a map-maker. Paris has also decorated the text with flora and fauna and drawn a number of author-portraits: Euclid (with sphere and telescope); Pythagoras (at his writing-lectern); the eleventh-century polymath Herman Contractus of Reichenau (with astrolabe); and Plato and Socrates (illustrated opposite). The final miniature, a drawing of the twelve sons of Jacob, provided biblical authority for the divinations. A fourteenth-century copy of the manuscript[1] reveals that pages which are now missing contained four further portraits (of Anaxagoras and Cicero, and two of Bernardus Silvestris).

The drawing of Plato and Socrates is curious in that the artist has reversed their roles: Socrates, who famously wrote nothing, is shown holding a pen; while Plato, whose beautifully written dialogues are the primary source for Socrates' life and thought, seems to be dictating to him. We do not know why Paris drew them in this manner, but his knowledge of Plato and Socrates would have been meagre; of Plato's dialogues only a Latin translation of the *Timaeus* was then available in England; and Socrates was regarded as a sage and soothsayer rather than a philosopher. The similarity the drawing bears to the engraving in Bocchi's *Imagini* (cat. 3) is superficial but nevertheless striking.

In the latter Socrates's *daimon* provides artistic inspiration; here, Socrates is an intermediary between divine fortune and the textual prophecies contained in the manuscript; and divination is, in fact, one of the activities Socrates assigns to the *daimon* in Plato's *Symposium* (unknown to Paris):

There are messengers who shuttle back and forth between the two, conveying prayer and sacrifice from men to gods, while to men they bring commands from the gods and gifts in return for sacrifices. Being in the middle of the two, they round out the whole and bind fast the all to all. Through them all divination passes, through them the art of priests in sacrifice and ritual, in enchantment, prophecy and sorcery. Gods do not mix with men; they mingle and converse with us through spirits instead, whether we are awake or asleep.[2]

In the 1970s the French philosopher Jacques Derrida saw a postcard of this manuscript and later the manuscript itself; in 1980 he published *La carte postale: De Socrate à Freud et au-delà*.

Notes
1 Bodleian MS. Digby 46.
2 *Symposium*, 202e–203a; Cooper 1997, p. 486.

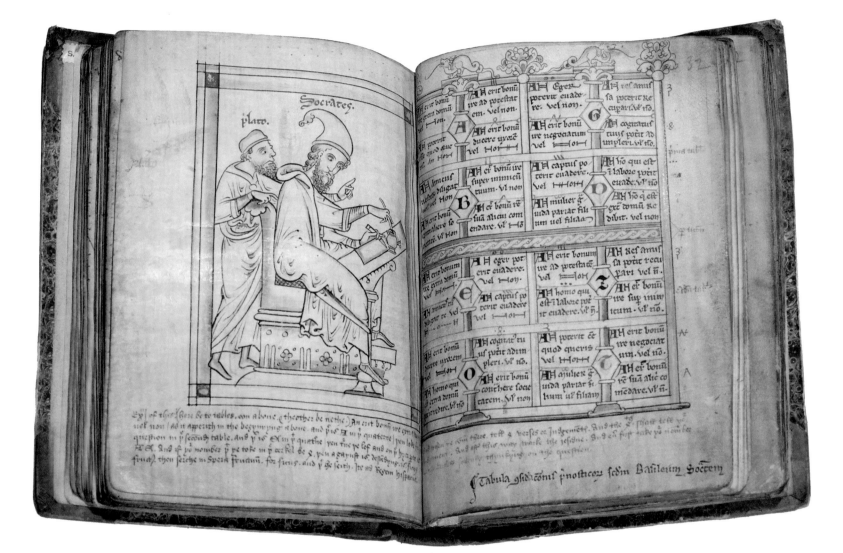

Plato. Socrates.

Ey of these there be tô tables, con a bone & theothez be nethe. An erit bonū ire erit
uel non. As it apperith in the begynnyng abone. and f is AH if quaterne then lok...
question in f seconde table. And f is CH if quarte yen lok the ye lef and on f...
HC. And if yo nombre f pe toke in f cc kl be S. yen a gaynst it desid... ne f in...
fine), then seiche in Spera fructus. for fieris. and f he seith. See as Regen hispane.

Tabula gudicōnis gnosticoꝝ sedm Basileum Poetem

5

Map of the Holy Land

England, late fourteenth century

In Latin, on parchment (three membranes, glued together); 405 × 2150 mm

Provenance: Francis Douce (1757–1834), who bequeathed it to the Bodleian

Exhibitions: Oxford 1984, no. 89; Oxford 1994, no. 6

Literature: SC 21964; P & A, vol. 3, no. 751; Harvey 2012, no. 11

MS. Douce 389

This medieval map of the Holy Land is oriented with east at the top, and shows Palestine from Damascus in the north to Hebron in the south. The few, boldly applied colours – still vibrant after six centuries – provide immediate clarity. Rivers are shown in blue, as are the Sea of Galilee in the north and the Dead Sea in the south. Mountainous areas are painted green. The buildings drawn to represent towns are highlighted in red (Jerusalem, to the lower left of the Dead Sea, is the largest and most elaborate). The map was drawn on three separate pieces of parchment by three different artists; the place names, however, were written by a single scribe, who also provided, on the left-hand side of the map, a list of places and the distances between them. The medieval traveller used itineraries of this kind, rather than maps, to get from place to place, and this particular map is in any case far too large to be of practical use on the road.

What, then, was its purpose? The scribe filled the blank areas of the map with a series of inscriptions, taking the text mostly from a popular account of the Holy Land written sometime between 1274 and 1285 by Burchard of Mount Sion. Burchard travelled extensively, convinced that one's understanding of the events of the Bible was enriched when one saw where they took place:

Is not the tomb of Jesus Christ … worthy of our respect, which whenever one enters one sees in the mind's eye the Saviour wrapped in a linen cloth? And when one has proceeded a little further one sees the rolled-back stone, the angel sitting on it and showing to the women the handkerchief with the linen cloth? What Christian having seen these things

would not hasten to come to Bethlehem and contemplate the Child crying in the manger, Mary giving birth in the lodging place beneath the hollow rock which is to be seen to this day, the angels singing …[1]

Burchard's descriptions of the Holy Land are not remote and pious but direct and engaging. He stresses that they are based on his direct observations and that he obtained his information from the local inhabitants. He wants the reader to follow in his footsteps, to see the places of the Bible through his eyes.

It has been argued that this map, and several others like it, derive from a single earlier map which has not survived.[2] It may have been constructed from direct knowledge of Palestine, from Burchard's text, or from a combination of the two, but its close connection with Burchard's description of the Holy Land is clear. Nearly all the place names on it are mentioned by him and, what is more, it offers a detailed representation of an actual region and identifies certain locations with biblical events. There are water-pots at Gaza, Jacob's Ladder is drawn at Bethel, Job's tomb is marked, fish swim in the Sea of Galilee, in the Dead Sea are the outlines of Sodom and Gomorrah and the other drowned cities of the plain.

The belief that such places – particularly those associated with the life and death of Christ – were not merely of historical interest but were inherently sacred was not universally accepted within the Christian church. Some commentators welcomed the idea that holiness was something one could see and touch; others thought physical sanctity irrelevant to a spiritual religion. But the existence of maps such as this, and the long and complicated history of pilgrimage, attest to a lasting belief that parts of the world are especially imbued with the *genius loci*, or spirit of the place.

Notes

1 Pringle 2011, p. 241.
2 See Harvey 2012.

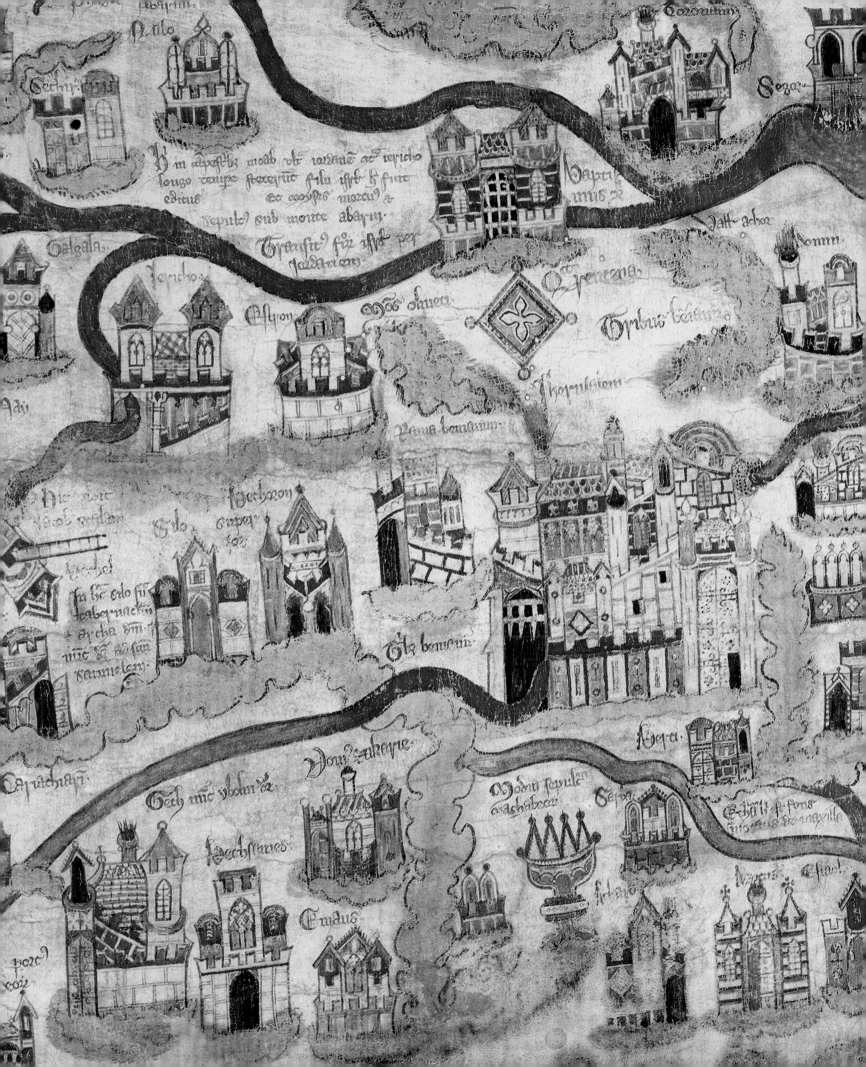

6

A hajj pilgrim's scroll

Probably Ottoman Arabia, mid-seventeenth century

Ink and coloured wash on eight sheets of paper laid on later linen backing, 2190 × 200 mm

Provenance: Perhaps received by the Bodleian *c.* 1640

Literature: SC 923

Or. long D.77

For Muslims, certain locations are imbued with the spirit of the place, and are visited as part of the hajj. This is one of the Five Pillars, or basic religious duties, of Islam. Physically and financially able adult Muslims are required, at least once in their lives, to perform a series of ancient and arduous rituals in Mecca and the nearby holy sites of Mina, Muzdalifah and Arafat. It is often combined with visits to Medina, where the Prophet Muḥammad lived in exile, and the site of his mosque and tomb; and to Jerusalem, a city made holy by its association with the earlier prophets, and as the locus of the miraculous night ascension, or miʿrāj, of the Prophet.

This scroll was a seventeenth-century pilgrim's souvenir of the hajj. It contains images of Jerusalem, Medina and Arafat and (illustrated here) a traditional two-dimensional illustration of the holy sanctuary in Mecca. At its centre is the Kaʿbah, a cubic temple built by Abraham (or, as some believe, built by Adam and then rebuilt by Abraham). Contained in its north-east corner is the sacred Black Stone. When Mecca surrendered to the Prophet he cleansed the Kaʿbah of idols which had been placed there by Arab tribes and reinstated the original

pure faith. It is the spiritual centre of the Islamic world and all Muslims pray in its direction. The hajj begins with the *ṭawāf*, during which pilgrims circumambulate the Kaʿbah seven times and may try to touch or kiss the Black Stone. On the western face of the Kaʿbah a semicircular wall encloses the *ḥijr*, an area of particular sanctity. To the north-east of the Kaʿbah is the well of Zamzam, which miraculously

appeared to Hagar and Ishmael and saved their lives.

Though not ornate, this keepsake would have been important to its owner. On completing the hajj, pilgrims acquire a new title: *hajji* for a man, *hajja* for a woman. In a village the impact of an inhabitant completing the hajj could be great, and on their return they would be greeted with great ceremony and celebration.

1 Kaʿbah
2 Black Stone
3 *Ḥijr*
4 Well of Zamzam
5 Abraham's place of prayer
6 The Ḥanbalites' place of prayer
7 The Malikites' place of prayer
8 The Ḥanafites' place of prayer
9 Stairs
10 Pulpit
11 Watering place of ʿAbbās
12 Treasury

The holy sanctuary at Mecca

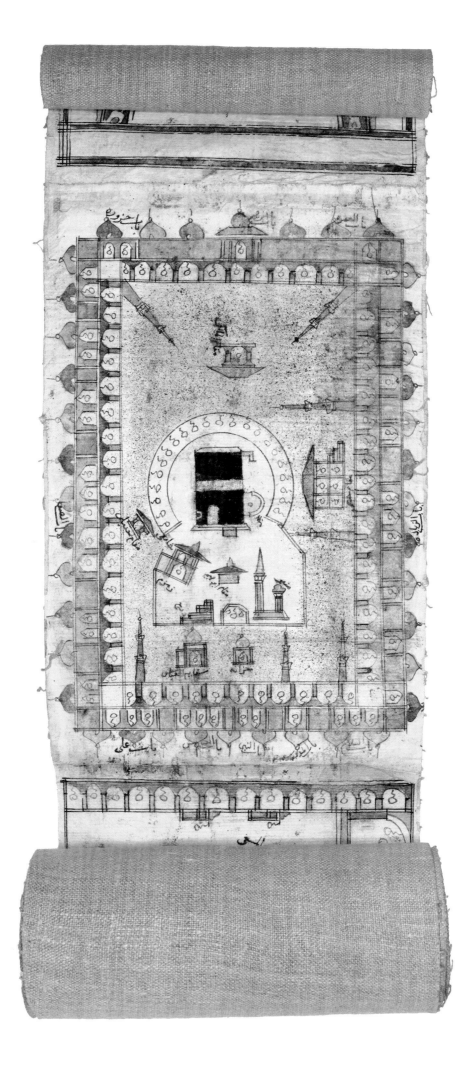

7

GUILLAUME DE LORRIS (*fl.* 1230) and JEAN DE MEUN (*fl.* 1270)

Roman de la Rose (*The Romance of the Rose*)

France, probably second half of the fifteenth century

Miniatures attributed to Robinet Testard (*fl.* 1475–1523), borders, initials
In French, on parchment; 156 leaves, 345 × 235 mm
Early nineteenth-century English binding by Charles Lewis: maroon sheepskin with gold tooling

Provenance: Louise of Savoy (1476–1531); Justin MacCarthy Reagh, count MacCarthy in the French nobility (1744–1811); his sale, January 1817: purchased by George Hibbert (1757–1837); his sale, March–April 1829: purchased by Francis Douce (1757–1834), who bequeathed it to the Bodleian

Exhibition: Oxford 1984, no. 232a

Literature: SC 21769; P & A, vol. 1, no. 787; McGrady 2001; <http://romandelarose.org>

MS. Douce 195 [fol. 139r illustrated]

The *Roman de la Rose* was among the most popular poems of the Middle Ages. In the first part, written between 1225 and 1230 by Guillaume de Lorris, the narrator describes a dream he had as a young man, 'in which the whole art of love is contained'.[1] In a beautiful walled garden he is shot with five arrows by the god of Love and sets out in pursuit of the Rose. The second, much longer part of the poem was written between 1262 and 1278 by Jean de Meun; he continues Guillaume's courtly narrative, but expands it to embrace all aspects of medieval life and thought, and introduces a rougher, more disputatious tone.

The characters of the poem are allegorical, with names such as Courtesy, Fair Welcome, Rebuff, False Seeming and Constrained Abstinence, but the precise meanings of the allegory in which they perform their roles are elusive. Genius appears towards the end of the poem as the priest of Nature, a role given to him by an earlier poet, Alain de Lille. Gentle, compassionate Nature keeps death at bay in her forge, 'hammering and forging and renewing individuals through new generations'; but she confesses to Genius, 'god and master of the organs of reproduction', that human beings are neglecting the tools she has given them and are not creating new generations. Genius flies off to share Nature's complaints with the god of Love and to lend him his assistance. The god of Love welcomes Genius, who immediately delivers a sermon to Love's army of barons. He tells them to make energetic use of Nature's gifts – the stylus and tablet, the hammer and anvil, the plough and field – and berates those enemies of love who spurn them:

They ought to be deeply ashamed, those disloyal ones of whom I speak, who will not deign to put their hands to the tablets to write a letter nor to make any visible mark upon them. Their intentions are extremely evil, for the tablets will grow very mossy if left unused. When the anvils are allowed to go to rack and ruin without a single hammer-blow being struck, then rust can attack them and no sound of hammering or beating will be heard. If no one drives the ploughshares into the fallow fields, they will remain fallow.

Heartened by Genius's words, the barons attack the Castle of Jealousy and the narrator finally gains entrance: 'I plucked with joy the flower from the fair and leafy rose-bush. And so I won my bright red rose.'

This fine manuscript of the *Roman de la Rose* was made in France, probably in the second half of the fifteenth century, for Louise of Savoy, the countess of Angoulême and regent queen of France, 1515–16. The miniatures are attributed to Robinet Testard, who illuminated several books for Louise's husband, Charles d'Orléans, count of Angoulême. Four lively images show Genius in action. In the first (see opposite), he exchanges his priestly robes for secular garments, 'as if he were going to dance', before donning his wings for the journey; in the second, he is welcomed by the god of Love and by Lady Venus; in the third image the god of Love hands Genius a crosier and arrays him in a chasuble and mitre. A fourth miniature (illustrated on p. 23) depicts Genius delivering his sermon.

Note

1 All quotations are from Horgan 2008.

Pour genius changie dabillemant
Qui remaint nature en la forge
Pud ses martiaulx z fiert z forge
Trestout ainsi come devant.
Et genius plus tost que vent.
Ses elles bat et plus nactend.
Et tost sen est venus atant.
Mais nulp semblant np trouua pas.
Coups sen est plus q le pas
Des elles q la vielle fu prise
Qui monter hors de la pointe.
Et tait mot fait auant aller.
A ma tel acueil me fault parler.
Il np voult onaps plus atendre.
Car sen fourt las conte prendre.
Mais las taille cest chose afaire.
Il treuue abstinence contrainte.
Qui de tout son pouoir sapreste.
De courir apres a si grant beste.
Quant el voit le prestre venue.
Quanis sa peult sen tenir.
Que on propre ne se meist.
Pou ce que mil aultre la voilt.
Qui lup sonnast. un. beslas.
Se faulx semblant ne fust prelas.
yeu las plus de demeure.
En icelle mesme heure.
Si come il dit tous les salue.
Et lacharson de la venue.

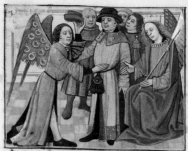

Larriuee de gens vers le dieu damours.
St le dit et q tout ce monte.
Je ne vous dit ia faire compte.
De la grant ioye qls lup firent.
Quant les nouuelles entendirent.
Ains vueil ma parolle abreger.
Pou vos oreilles alleger.
Car maintes fois tel q preesche.
Quant breefment ne le depresche.
Et fait les auditeurs aller.
Pour trop prolixement parler.

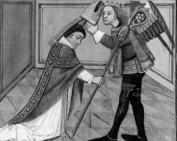

Cõt le dieu damours abille gens.
Tantost le dieu damours attuble.
A gens vne chasuble
Et lup baille z crdre et mitre.
Plus clere q cristal ne vitre.
Ne quierent aultre paremant.
Taint ont grãt entalentemãt.
Dourz ceste sentence liure.
Veng qui ne cessoit de rire.

DANTE ALIGHIERI (1265–1321)

La Divina Commedia (*The Divine Comedy*)

Naples or northern Italy, mid- to third quarter of the fourteenth century

Miniatures, initials
In Italian, on parchment; 154 pages (some leaves from *Purgatorio* and *Paradiso* missing), 355 × 235 mm
Nineteenth-century English binding for Thomas William Coke: green sheepskin with blind and gold tooling, and Coke's gold-tooled centrepiece

Provenance: Thomas William Coke, 1st Earl of Leicester of Holkham (1754–1842); by descent to Thomas Coke, 5th Earl of Leicester of Holkham (1908–1976); accepted by HM Treasury from the executors of the 5th Earl of Leicester in part satisfaction of capital transfer tax and allocated to the Bodleian by the Secretary of State for Education and Science, 1981

Exhibition: Oxford 1994, no. 42

Literature: Brieger et al. 1970, vol. 1, pp. 252–7; Hassall 1970, pp. 2–4, 26; Rotili 1972, pp. 53–6, 72–7; de la Mare 1982

MS. Holkham misc. 48 [pp. 58–59, 141 illustrated]

Dante's masterpiece is a *summa*, or encyclopedia, of Western medieval science, philosophy and theology. It is also a personal narrative: the reader is made a confidant of the poet's intimate thoughts and feelings as he travels through the regions of Hell, Purgatory and Paradise. This is one reason why the *Commedia*, some seven centuries after its composition, seems so modern.

Dante often admits his inability to capture in words the intensity of his vision and calls on his *ingegno* – his natural talent or wit – to aid him in his great task. In canto 2 of the *Inferno*, as he prepares to describe his descent through the nine circles of Hell, Dante identifies his *ingegno* with the muses: 'O muse, o alta ingegno, or m'aiutate' ('O muses, O high wit, now help me').[1] As Dante ascends through the celestial spheres in the *Paradiso*, the strain on

his linguistic and imaginative resources grows ever greater. In canto 22 he reaches the firmament, or sphere of fixed stars. Looking down upon the planets he invokes Gemini, his birth sign and, as such, the source of his *ingegno*:

*O glorïose stelle, o lume pregno
di gran virtù, dal quale io riconosco
tutto, qual che si sia, il mio ingegno*

(*O glorious stars, O light pregnant with great power, from which I acknowledge that all my talent comes, whatever it may be*)

Dante thought that natural talent, unlike the intellect, was a function of the body, and was therefore determined by celestial influences. It was not an entirely passive process, however, and Dante therefore requests the aid of his natal star in the hope that it will increase his powers, and so help him accomplish his great task:

*A voi divotamente ora sospira
l'anima mia per acquistar virtute
al passo forte che a sé la tira*

(*To you now my soul devoutly sighs, to acquire power for the difficult pass that draws me to itself.*)[2]

Dante's writing is embedded in the principles and assumptions of his time. His invocation of the muses, and his confessed inability to do justice to his theme, were conventional; the

shaping of one's character and talent by the stars was a generally held belief; but the language is so inventive, lucid and beautiful that the remote forms of medieval rhetoric and cosmography come to life. Dante's *ingegno*, what we now call his genius, is no longer considered the work of the stars, but it has survived the test of time.

This manuscript of the *Commedia* is notable for its early date (just a few years after Dante's death) and for its wealth of illustration. Illumination is more usually limited to the opening cantos of each of the poem's three parts; here, the text is illustrated, apparently by more than one artist, with coloured miniatures along the bottom margin of every page (this style of illustration is quite rare but is found in some other Dante manuscripts). Figures and scenes are usually identified by inscriptions in red ink, and the colouring is particular to each part of the poem: the terrible claustrophobia of Hell is conveyed by dark rocks and enclosing flames; the airy mountain of Purgatory is shown against a clear sky; in Paradise blue, the colour of the blessed realm, predominates.

Illustrated opposite is a page from *Paradiso* canto 22. Dante converses with Beatrice, his heavenly guide. From the eighth sphere, the sphere of fixed stars, they look down on the seven moving bodies of the Ptolemaic system that circle the earth. They are shown according to their distance from earth: in the outermost sphere is Saturn,

Tu non auresti in tanto tracto e messo
nel suo udito inquanto uidi il segno
che seque il tauro e fui tenuto ella esso.

O gloriose stelle o lume pregno
di gran uirtu dal quale io riconosco
tucto qual che sia lomio ingegno.

Con noi nasceua e sascondeua nosco
quel che padre dogni mortal uita
quando senti da prima laire tosto.

E poi quando mi fu gratia largita
dentrar nel alta rota che uigira
lauostra ragion mi fu sortita.

A uoi diuotamente hora sospira
lanima mia per acquistar uirtute
al passo forte che a se la tira.

Tu se si presso alultima salute
comincio beatrice che tu dei
auer leluci tue chiare e agute.

E pero pria che tu piu tinlei
rimira ingiu e uedi quanto mondo
sotto li piedi gia esser ti fei.

Si chel tu cor quantunque puo giocondo
sapresenti ala turba triumphante
che lieta uien p queste etera tondo.

Col uiso ritornai p tucte quante
le septe spere e uidi questo globo
tal chi sorrisi del suo uil senbiante.

E quel consiglio p miglior aprobo
chela p meno e chi adaltro pensa
chiamar si puote ueramente probo.

Uidi lafiglia dilatona incesa
sança quel ombra che mi fu cagione
p che gia lacredetti rara e tensa.

Laspecto del tu nato yperione
qui sostenni e uidi consi moue
circa e uicine allui maia e dione.

Quindi ma pse il temperar di ioue
tra l padre el fillio e quindi mi fu chiaro
iluariar che fanno di lor doue.

E tucti e septe mi si mostraro
quanto son grandi e quanto son ueloci
e come sono in distante riparo.

Laiuola che cisa tanto feroci
uolgendom io colli etterni gemelli
tucta ma parue di colli ale foci.

Poscia riuolsi li occhi aliocchi belli.

Comincia il .xxiij. cap. doue tracta lo collio delli apsi
et delli altri sci che alterço di rso triumphao. et tracta della
beantidie di ma donna

Come laugello intra lamate fronde
posato al nido de suoi dolci nati
la nocte che le cose cina sconde.

Che p ueder li aspecti disiati
e per trouar locibo onde li pasca
in che graui labor li sono agrati.

Pre uiene il tempo in su aperta frasca
e con ardente affecto il sole aspecta
fiso guardando pur chel alba nasca.

Cosi la donna mia staua erecta
e attenta riuolta inuer la plaga
sotto la quale il sol mostra men frecta.

Si che ueggendola io sospesa e uaga
fecimi quale quei che disiando
altro uorria e sperando sapaga.

Ma poco fu tra uno e altro quando
del mio attender dico e del uedere
lo ciel uenir piu e piu rischiarando.

E beatrice disse ecco le schiere
del triumpho di cristo e tuctol fructo
ricolto del girar di queste spere.

Paruemi chel suo uiso ardesse tucto
e lioocchi auea di letitia si pieni
che passar me conuien sença costructo.

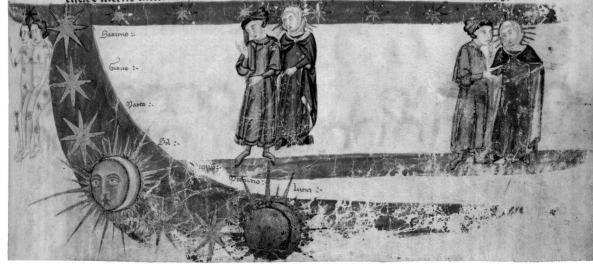

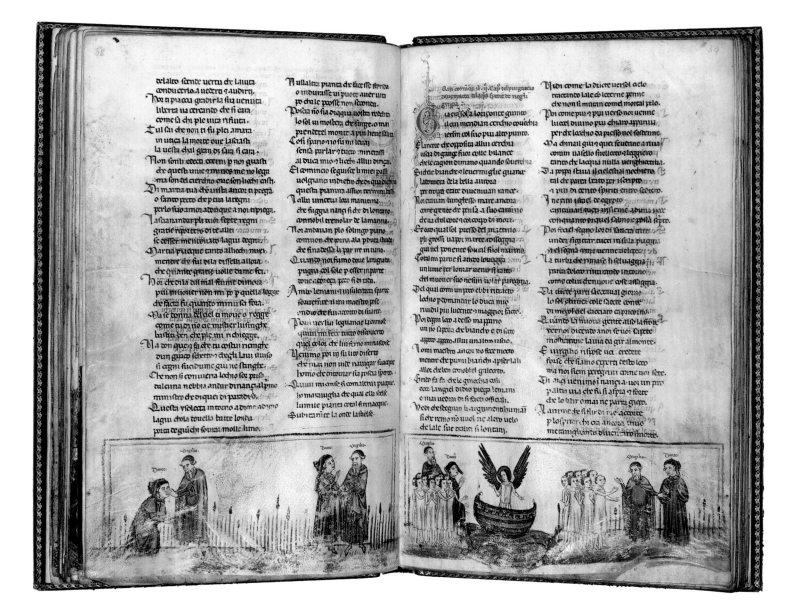

beneath which is Jupiter, then Mars, the Sun, Venus, Mercury and finally the Moon. To their left are Gemini, the starry twins.

At the beginning of the *Purgatorio* Dante imagines his *ingegno* in the form of a boat, sailing more freely after the terrible journey through Hell:

Per correr migliol acque alza le vele
Omai la navicella del mio ingegno,
che lascia dietro a sé mar sì crudele

(*To run through better waters the little ship of my wit now hoists its sails, leaving behind it a sea so cruel.*)[3]

Another boat appears in the next canto, bringing a host of souls to the island of Purgatory. Dante watches it approach with miraculous speed, and as it gets nearer he realizes that its sails are in fact the wings of an angel, and that it barely touches the water (see the illustration above). This marvellous sight is in

marked contrast to the laboured passage of the wingless Charon, who ferries damned souls to Hell.

Notes

1 *Inferno* 2.7; Durling and Martinez 1996–2011, vol. 1, pp. 40–41.
2 *Paradiso* 22.112–14, 121–3; Durling and Martinez 1996–2011, vol. 3, pp. 442–3.
3 *Purgatorio* 4.1–3; Durling and Martinez 1996–2011, vol. 2, pp. 18–19.

9

ANDREAS VESALIUS (1514–1564)

De humani corporis fabrica (*On the Fabric of the Human Body*)

Basle: Johann Oporinus, 1543

Woodcuts
In Latin; 712 pages, 405 × 270 mm
Contemporary wooden-boarded binding: re-covered with brown sheepskin with blind tooling, and provided with new endleaves, in the late eighteenth or early nineteenth century

Provenance: Purchased by the Bodleian in 1912 from the German bookseller Otto Harrassowitz (1845–1920)

Literature: Cushing 1962; <http://vesalius.northwestern.edu>

B 1.16 Med [pp. 164–165 illustrated]

Andreas Vesalius produced his great exploration of the human body when he was only twenty-eight years old. Leonardo da Vinci had made his anatomical studies decades earlier but had never published his incomparable drawings. Vesalius, however, brought together the skills of artist, engraver and printer to produce an illustrated work of the highest quality. The engravings were made on pearwood in Venice, then carefully transported over the Alps to Basle, where the book was printed. The artist has never been fully identified, although Vasari stated in the second edition of the *Lives of the Artists* (1568) that the artist was Jan Stephan van Calcar, a pupil of Titian, and he remains a plausible candidate.

The most celebrated illustrations in the book are the full-page skeletons and 'muscle-men', which adopt the most striking poses. One skeleton (illustrated overleaf) is perhaps the most famous of all, and irresistibly brings to mind Hamlet's graveyard meditations in Shakespeare's play, which was, of course, still to be written ('Alas, poor Yorick! I knew him, Horatio, a fellow of infinite jest, of most excellent fancy').

The words inscribed on the plinth ('Vivitur ingenio, cætera mortis erunt') are taken from a classical Roman text, an elegy in the *Appendix Vergiliana*:

Honouring the Muses and Apollo in luxurious gardens, he reclined babbling verse among the tuneful birds. Aonian writings will eclipse marble monuments: genius means life, all else will belong to death.[1]

A contemporary reader, seeing these words (which were then almost proverbial) together with Vesalius's musing skeleton, may have inferred that the genius, or essence, of a person was to be found in the head. In the *Timaeus* Plato had written that the highest, rational part of the soul held sway over the lower parts, the spirited and appetitive:

the most sovereign part of our soul as god's gift to us, given to be our guiding spirit … resides in the top part of our bodies. It raises us up away from the earth and toward what is akin to us in heaven.[2]

Servius had written in his commentary on Virgil's *Aeneid* that 'the forehead is the Genius, hence we touch our forehead as we venerate the god'.[3] More recently, Leonardo had concluded that the soul was to be found in the brain: 'The soul apparently resides in the region of judgement, and the region of judgement is to be located where all the senses run together, which is called the *senso comune*, and not all throughout the body as many have believed.'[4]

Vesalius referred to the Platonic division of the soul in a remark on the strength and solidity of the skull:

It is extremely advantageous that the brain, the seat of reason (which like a queen rules in the highest part of the body and holds sway over two desirous spirits), is kept under safe protection. For this purpose, the provident Maker of things imparted protection to the brain, made not just of skin and fleshy parts, as in the abdomen, or of bones separated from each other at intervals as in the thorax, but he surrounded it on all sides with a helmetlike bone.[5]

Perhaps, however, the inscription is a playful reference to the book itself, which, as a work of great ingenuity, was destined to outlive its maker; or to the science of medicine, which was, Vesalius maintained, 'of all the arts that human genius has discovered … by far the most useful, indispensible, difficult, and laborious'.[6]

Notes

1 Lines 35–8; Duff and Duff 1982, pp. 124–5.
2 *Timaeus*, 90a; Cooper 1997, pp. 1288–9.
3 Commentary to book 3, l. 607 ('frontem genio, unde venerantes deum tangimus frontem').
4 London 2011, p. 81.
5 <http://vesalius.northwestern.edu>
6 Ibid.

HVMANI COR- PORIS OSSIVM CAE
TERIS QVAS SV- *STINENT PARTIBVS*
LIBERORVM, SVA'QVE *SEDE POSITORVM EX*
latere delineatio.

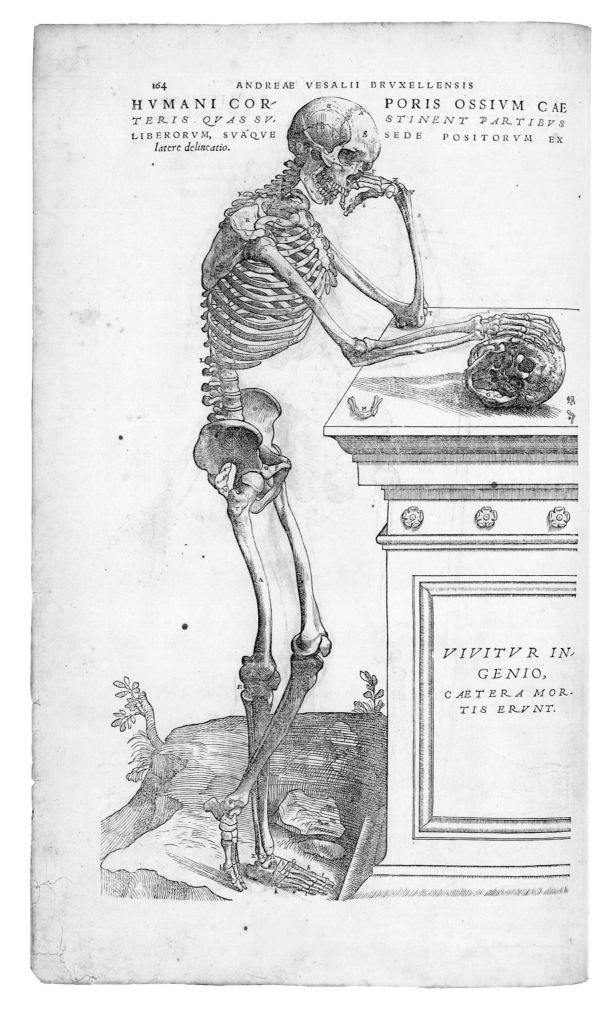

VIVITVR IN-
GENIO,
CAETERA MOR-
TIS ERVNT.

CORPORIS HVMANI OSSA
POSTERIORI *FACIE PROPOSITA.*

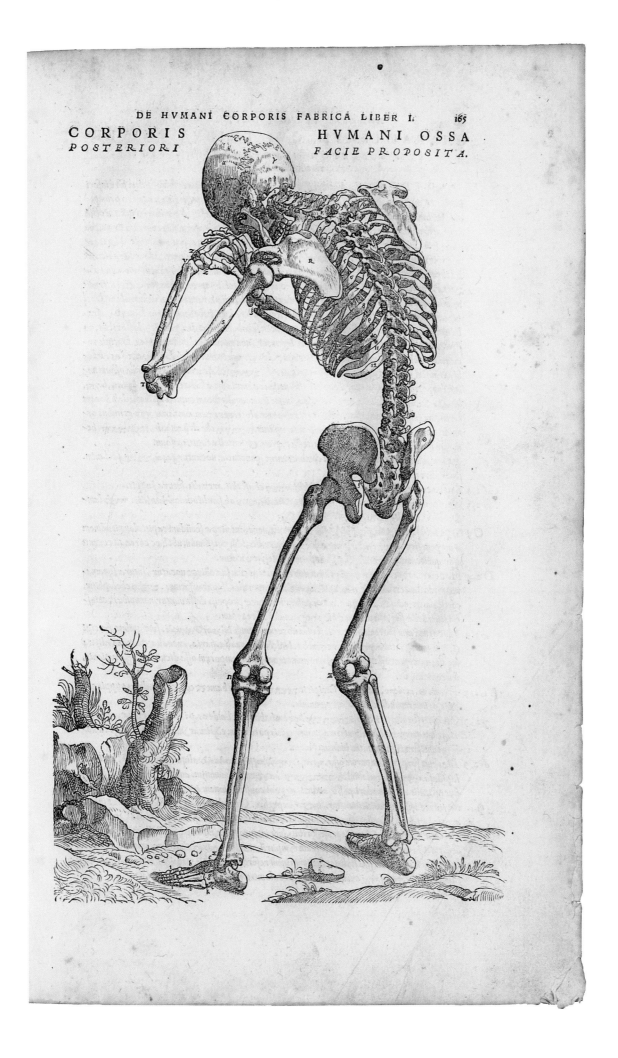

ALEXANDER POPE (1688–1744)

An Essay on Criticism

1709–11

Autograph
Fourteen leaves in contemporary blue wrapper,
324 × 208 mm
Twentieth-century Bodleian binding

Provenance: Charles Chauncy (1709–1777); William Nassau Lees (1825–1889); his sale, 30 July 1889: purchased by the Bodleian

Exhibition: Oxford 2002b, no. 4

Literature: SC 30047; Schmitz 1962 (facsimile)

MS. Eng. Poet c. 1 [fol. 2r illustrated]

Alexander Pope wrote his *Essay on Criticism* at a time when genius was becoming a preoccupation of writers, artists and critics. What had been thought of as an inborn inclination, possessed by everyone, was increasingly looked upon as an extraordinary ability, God given and possessed by very few. Critics argued over who had genius; writers and artists nursed it as an ultimate goal. 'The highest ambition of every Artist is to be thought a man of Genius', Sir Joshua Reynolds bluntly began one of his *Discourses on Art*. 'As long as this flattering quality is joined to his name, he can bear with patience the imputation of carelessness, incorrectness, or defects of any kind.'[1]

This idea of genius brings with it high expectations, and with characteristic wit Pope considers it in connection with the quarrels between writers and their critics, whose strictures are so often prompted by vain ambition, envy and 'an itching to deride'. True taste in the critic is as rare as true genius in the poet, maintains Pope ('Both must alike from Heav'n derive their Light'), and critics should be aware of their limits when pronouncing judgement. Know 'your own Reach', Pope counsels, and 'How far your Genius, Taste and Learning go',

One Science only will one Genius fit;
So vast is Art, so narrow Human Wit;[2]

Pope mounted another defence against the critics in the preface to the 1717 edition of his collected poems. He suggested that readers were perhaps 'a little unreasonable in their expectations' when it came to genius. Not only was it uncommon; it was difficult for fledgling writers to know whether or not they possessed it: 'What we call a Genius is hard to be distinguish'd by a man himself, from a strong inclination.' The only way for them to find out was to publish. If they failed they were ridiculed and if they succeeded they were envied: 'for it is with a fine Genius as it is with a fine fashion, all those are displeas'd at it who are not able to follow it'. For the majority of readers, 'those of ordinary or indifferent capacities', the truly original poet was an object of hatred or suspicion: they feared his intelligence and satirical wit. The only solace for literary genius, Pope concluded, was a private one: 'the agreeable power of self-amusement when a man is idle or alone; the privilege of being admitted into the best company; and the freedom of saying as many careless things as other people, without being so severely remark'd upon'.[3]

This manuscript of *An Essay on Criticism* is in Pope's own hand and was used by the printer for the first edition of the poem, published in 1711. It shows what a close interest Pope took in the printed appearance of his work. The title is a carefully rendered imitation of type; the main text is written in a beautifully even italic, with proper names and nouns, and words that were to be stressed, underlined. Pope also indicates where a page break should fall, thereby telling the printer how many lines he wished to appear on the page. He also carefully inserts footnotes at the bottom of the pages. 'Who can doubt that a man capable of such calligraphy would insist on comparable workmanship from the printer?'[4]

Essay on Criticism was Pope's first separately published poem, appearing as an edition of a thousand copies on 15 May 1711.

Notes
1 Discourse XI, 10 December 1782; Wark 1997, p. 191.
2 Lines 46–51, 60–61.
3 Butt 1963; pp. xxv–xxix.
4 Foxon 1991, p. 163.

AN
ESSAY
ON
CRITICISM.

—— Si quid
Candidus imperti; si

'TIS hard to say, i
Appear in Wr
But, of the two,
To tire our Patie
Some few in t
Ten censure
A Fool m
Now On
Go
Poet. C. 1

Prose.]
atches, none
s own.
tick's share;
rive their Light,
those to write.
Let

Magna Carta

Issue of 1217, sent by the royal chancery to Gloucester

In Latin, on parchment; approx. 490 × 422 mm
William Marshal's equestrian seal in green wax on the
right (well preserved); Cardinal Guala's seal in white
wax on the left (entirely defaced)

Provenance: Stored at St Peter's Abbey, Gloucester
(now Gloucester Cathedral); Richard Furney
(1694–1753), who bequeathed it to the Bodleian

Exhibition: Tokyo 1990, no. 30

Literature: Vincent 2007, p. 63

MS. Ch. Gloucs. 8

Magna Carta (the Great Charter) was agreed between King John and his barons at Runnymede near Windsor on 15 June 1215. The document contains sixty-three clauses which described and regulated the feudal customs of the kingdom. This was a concession to the barons by King John, who had hitherto overridden custom in a capricious and tyrannical manner and exploited his feudal rights as it suited him. Magna Carta was never intended to be a lasting legal document, and most of its clauses have been superseded. It has, however, become one of the great symbols of freedom and the rule of law, and the words of the thirty-ninth clause are particularly celebrated:

No free man may be taken or imprisoned, or dispossessed of his home … except through the lawful judgement of his equals or through the law of the land.'

If there was a first, master charter to which King John put his seal in 1215, it has not survived. Instead there are a number of later 'engrossments' or exemplifications of the text, revised according to the political priorities of the time, which were officially issued to English counties by the royal chancery. Seventeen such documents survive from the reign of King John and the succeeding reigns of Henry III (1216–72) and Edward I (1272–1307). This is one of four now in the Bodleian, and has survived in fine condition.[1] It was issued in November 1217 in the name of the boy king Henry III, then just ten years old. It carries the seals of his guardians, William Marshal the elder and the papal legate Cardinal Guala Bicchieri (the latter is now defaced but has been preserved in an engraving published in 1759 – see fig. 17). It must have been sent to Gloucestershire, for later medieval endorsements on the back are characteristic of St Peter's Abbey (now Gloucester Cathedral). Here it would not have been opened

Left: Detail of cat. 11, the seal of William Marshal

Far left: Fig. 17. Engravings of the seals attached to cat. 11, from W. Blackstone, *The Great Charter* (1759). Broxb. 49.7, p. 46

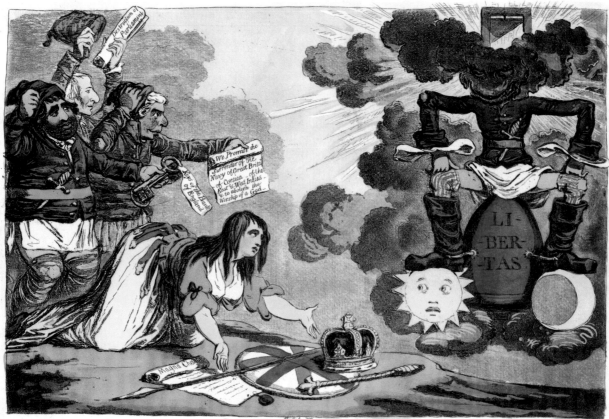

The Genius of France Triumphant. _ or _ BRITANNIA petitioning for PEACE . _Vide . The Proposals of Opposition . _
To the Patriotic Advocates for Peace, this Seemly sight is dedicated.

London Pub. Feb.ʸ 2.ᵈ 1795, by H. Humphrey N.º 37. New Bond Street.

Fig. 18. James Gillray, *The Genius of France Triumphant, – or – Britannia petitioning for Peace*, 1795. The British Museum, London (1868,0808.6409)

out and displayed in the manner that it is today, but would have been kept folded, and stored together with other important documents. At some point it left the archive of Gloucester Cathedral. It next appears in the hands of Richard Furney, a master of the Crypt School at Gloucester and later archdeacon of Surrey. He bequeathed it to the Bodleian.

The survival of these issues of Magna Carta has ensured that it is present in the imagination not only as a symbol of the rule of law, but also as a physical object which, much like the American Declaration of Independence, somehow embodies the spirit, or genius, of a nation. The lawyer and politician Sir Edward Coke (1552–1634), in his battle

against the Stuart kings, referred to Magna Carta as the product of an ancient and immutable law of the land. He also invoked its spirit when he drew up the first charter of the Virginia Company in 1606, which promised that the colonists 'shall have and enjoy all Liberties, Franchises, and Immunities, within any of our other Dominions, to all Intents and Purposes, as if they had been abiding and born, within this our Realm of England'.[2]

During the French Revolution a number of cartoonists employed Magna Carta as a symbol of good English genius, which was under threat from the evil genius of France. In James Gillray's 1795 cartoon 'The genius of France triumphant, – or – Britannia

petitioning for Peace' (fig. 18), Britannia, prostrate before the monstrous figure of the French Republic, lays before her the symbols of her sovereignty: her shield and spear, the crown and sceptre, and 'Magna Charta'.

In a cartoon of 1819 the reforming politician Sir Francis Burdett takes the hand of 'The Genius of Honour and Integrity', and points dismissively to a hideous figure, 'The Monster of Corruption' (fig. 19). He wears a ribbon inscribed 'Magna Charta Bill of Rights'. Burdett was closely associated with Magna Carta and was often portrayed with a copy of it. Ten years earlier, on 15 June 1809, he had addressed the House of Commons on his plan for

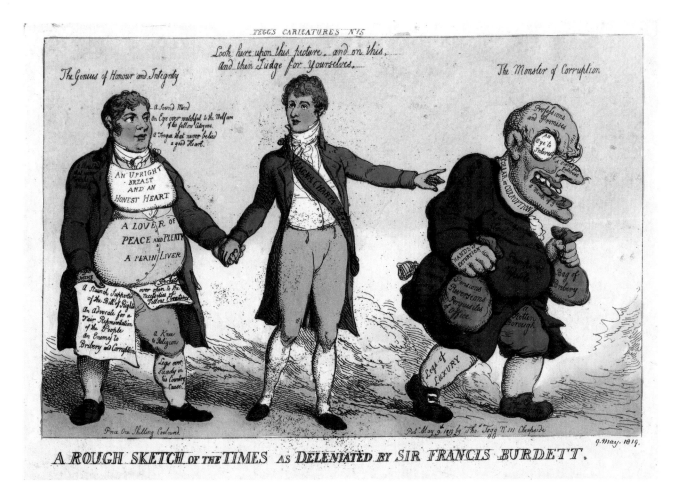

Fig. 19. Thomas Rowlandson, *A Rough Sketch of the Times as deleniated by Sir Francis Burdett*, 1819. The British Museum, London (1868,0808.8443)

parliamentary reform, and had cited Magna Carta, 'the birth of our liberties', as the only authority he needed: 'This question is so completely decided by Magna Charta, "which," as Lord Coke says, "is such a fellow that he will "bear no equal," so strongly fortified by all our constitutional laws, that no inferior authority can be required.'[3] The following April he had been arrested for breach of parliamentary privilege, and, famously, had been seized from his home while listening to his schoolboy son translating Magna Carta from Latin into English.

Notes

1 The others are Bodleian MS. Ch. Oxon. Oseney 142b, MS. Ch. Oxon. Oseney 142c and MS. Ch. London 1.
2 Vincent 2007, p. 82.
3 Reported in Hansard, vol. 14 cc1041-70.

Proverbs of Hell

The head Sublime, the heart Pathos, the genitals Beauty
the hands & feet Proportion.
As the air to a bird or the sea to a fish, so is contempt
to the contemptible.
The crow wishd every thing was black, the owl, that eve-
ry thing was white.
Exuberance is Beauty.
If the lion was advised by the fox. he would be cunning.
Improvent makes strait roads, but the crooked roads
without Improvement, are roads of Genius.
Sooner murder an infant in its cradle than nurse unact-
ed desires
Where man is not nature is barren.
Truth can never be told so as to be understood, and
not be believed.
Enough! or Too much

The ancient Poets animated all sensible objects
with Gods or Geniuses, calling them by the names and
adorning them with the properties of woods, rivers,
mountains, lakes, cities, nations, and whatever their
enlarged & numerous senses could perceive.
And particularly they studied the genius of each
city & country, placing it under its mental deity.
Till a system was formed, which some took ad-
vantage of & enslav'd the vulgar by attempting to
realize or abstract the mental deities from their
objects: thus began Priesthood.
Choosing forms of worship from poetic tales.
And at length they pronounced that the Gods
had orderd such things.
Thus men forgot that All deities reside
in the human breast.

12

WILLIAM BLAKE (1757–1827)

The Marriage of Heaven and Hell

London: William Blake, *c.* 1790

Hand-coloured copper engravings
Fifteen leaves, 235 × 150 mm
English binding, first half of nineteenth century: half red sheepskin over marbled boards replacing original stab-stitching

Provenance: Acquired by Francis Douce (1757–1834) in April 1821 from 'Dyer' (probably the Exeter bookseller Gilbert Dyer); bequeathed by him to the Bodleian

Exhibitions: Oxford 1984, no. 137; Paris 2009, no. 16

Literature: Eaves et al. 1993; Phillips 2011 (facsimile); <http://www.blakearchive.org>

Arch. G d.53 [pp. 11–12 illustrated]

William Blake began an early work, *All Religions are One* (*c.* 1788), with the following two principles:

PRINCIPLE 1st
That the Poetic Genius is the true Man. and that the body or outward form of Man is derived from the Poetic Genius. Likewise that the forms of all things are derived from their Genius, which by the Ancients was call'd an Angel & Spirit & Demon.

PRINCIPLE 2nd
As all men are alike in outward form, So (and with the same infinite variety) all are alike in the Poetic Genius [1]

Genius, for Blake, is a matter of truth, inspiration, prophecy, the imagination. It was an essential property of, and born with, the free individual. 'I say Taste & Genius are not Teachable or Acquirable but are born with us'.[2] Genius is vigorous, disobedient and impolite; its enemies are systems, tyranny and convention. 'Never!' he wrote against Sir Joshua Reynolds's assertion in the *Discourses* that 'the *degree* of excellence which proclaims *Genius* is different, in different times and different places'; and 'Damned fool!' next to a phrase on the following page, 'genius is not taken for inspiration, but as the effect of close observation and experience'.[3]

In *The Marriage of Heaven and Hell* 'genius' appears in several of the deliberately provocative 'aphorisms of Hell': 'As I was walking among the fires of hell, delighted with the enjoyments of Genius; which to Angels look like torment and insanity …'; 'Improvement makes strait roads, but the crooked roads without Improvement are roads of Genius'; 'The worship of God is, Honouring his gifts in other men each according to his genius, and loving the greatest men best, those who envy or calumnate great men hate God, for there is no other God'.

On one page, illustrated here, Blake describes the way genius has been used by institutions to subdue individual freedom. In the beginning, the 'ancient Poets' imbued the natural world with 'Gods or Geniuses', as well as cities and nations. This is illustrated in a headpiece showing spirits arising from the landscape. But then these 'animations' are formed into a system, abstracting genius from its original, organic nature and enslaving the vulgar. Such are the outward forms and figures of religion, or 'priesthood'. A small vignette shows worshippers kneeling before an imposing figure. At the foot of the page a bearded god stretches out his arms in a threatening gesture while a human figure runs away. Thus, writes Blake, 'men forgot that All deities reside in the human breast'.

Notes

1 Bindman 2000, pp. 21–2.
2 Bentley 2001, vol. 2, p. 1493.
3 Ibid., p. 1488.

Written in their own Hands

'How warmly we respond whenever we receive letters from friends or scholars written in their own hands!' wrote Erasmus. 'We feel as if we were listening to them or seeing them face to face.' Handwriting is prized because it contains the character of an individual, what Erasmus might have called their *genius*. The more exceptional the person, or the work, the more prized the manuscript. 'For since visual experience is indispensable to me,' wrote Goethe, an avid collector of autographs, 'remarkable men are made present to me in a magical way through their handwriting.'[1]

Philip Larkin found two qualities in literary manuscripts – the magical and the meaningful. The latter is contained in the various alterations and corrections the writer makes. We look over the shoulder of Moses Maimonides (cat. 14), George Frideric Handel (cat. 15) and Franz Kafka (cat. 16) as they draft and revise, as they shape and reshape the work. The magical value, said Larkin, 'is the older and more universal: this is the paper he wrote on, these are the words as he wrote them, emerging for the first time in this particular miraculous combination.'[2] Fair copies, intended for presentation, are more carefully written and less intimate than drafts, but the magic is retained in the poem John Donne gracefully wrote out on light paper for two aristocratic ladies (cat. 17), in the volume of her juvenilia the adult Jane Austen created for her family's amusement (cat. 18), and in the song Felix Mendelssohn copied for a friend and then adorned with an exquisite watercolour (cat. 19).

Other manuscripts embody the character not only of a person, but the spirit of a particular time: the fervently scribbled speech notes by William Wilberforce in the campaign to abolish slavery (cat. 20); the affectionate and resolute letter Mahatma Gandhi wrote to an English friend from a British prison (cat. 21); the heavily revised drafts for Harold Macmillan's landmark 'wind of change' speech to the South African parliament (cat. 22).

Books that belonged to saints, and which were subject to miracles, can be revered as holy relics (cat. 23). A similar reverence is sometimes extended to the handwritten document, whether it be by the young Elizabeth I (cats 24–5), or the poet Percy Bysshe Shelley, whose papers and effects received idolatrous devotion in a *sanctum sanctorum* at the family home (cats 26–32).

Notes
1 Quotations taken from Ganz 1997, pp. 292, 299.
2 Larkin 1983, p. 99.

qui uorte flāma pascatur. Siquis q̄ habet inconscientia sua zizania que inimicus homo dormiente patre familias sup seminauit. hec ignis exuret. hec uorabit incendiū. & o mīa scōr oculis eor supplicia mostrab untur. qui pauro & argento & lapide p̄cioso edificauer sup fundamūtū dm̄ senū. ligna. stupulā. ignis pabulū sempiterni. Porro q̄ uolunt supplicia aliquando finiri. & licet post multa tēpora. tamen habe terminū tormīta his utuntur testimonīis. Cū intrauerit plenitudo gentū. tunc omīs isr̄l saluus fiet. Ocrium. Conclusit dī omīa sub peccato. ut omnib mſereat̄. Oc in alio loco scr̄ e. Irā dm̄ suſtinebo. q̄n peccaui ei. donec iudicet causā meā. & auferat iudicii meū. & educat in lucē. Oc rurſū. Benedici te dn̄e q̄n iratus es m. Auertiſti faciē tuā amer. & miser tus es mei. Dn̄s quoq̄ loquitur ad peccatores. Cū ira furoris mei fuerit. rursum sanabo. Oc hoceſt q̄d inalio loco dicitur. Quāta multitudo bonita tis tue dn̄e. quā abscondiſti timētib te. Que omīa replicant. affirmare cupientes poſt cruciatus atq̄ tormīta futura refrigeria. que nunc abscondita sunt ab iis quib timor utilis est. ut dū supplicia reformident. peccare desiſtant. Oc dn̄os dī solius debemus scierītie derelin quere. cui nonsolī miserelie. sed & tormīta imponere sint. & nourt quē q̄ modo. aut quamdiu debeat iudicare.

Soliiq̄ dicamus. q̄d humane conuenit fragilitati. Dn̄e ne infurore tuo arguas me. neq̄ inira tua corripias me. Et sicut diaboli & o mīu negatou atq̄ improx qui dixerunt incorde suo non est dſ.

N

credimus eterna tormenta. sic peccatox atq̄ improx & eorm xpianou quor opa igne p̄banda sunt atq̄ purganda. moderata arbitramur & mixta dementie sentonia iudicis.

EXPLICIT LIBER BEATI
IHERONIM SUP YSAIAM

13

ST JEROME (*c.* 342 – *c.* 420)

Commentary on Isaiah

Normandy (Jumièges?), late eleventh century

Miniatures, historiated and other initials
In Latin, on parchment; 293 leaves, 350 × 245 mm
Early eighteenth-century binding for the Bodleian:
brown calfskin with blind tooling

Provenance: Exeter Cathedral Library (fourteenth
century ex-libris inscription and inventory of 1327);
given to the Bodleian in 1602 by the Dean and Chapter
of Exeter

Exhibition: London 1984a, no. 5

Literature: SC 2631; P & A, vol. 1, no. 441; Pächt 1950;
Gameson 2001

MS. Bodl. 717 [fol. 287v illustrated]

This manuscript was made in a Norman
monastery, perhaps at Jumièges, in the
late eleventh century, and may have
been given to Exeter Cathedral by the
first post-Conquest Norman bishop,
Osbern (1072–1103), as one of a number
of manuscripts produced after the
Conquest for export to England. The
long patristic text was written by four
scribes and decorated by two artists.
There are two large frontispieces: the
first is a portrait of Isaiah holding a
scroll on which is written his prophecy
'Therefore the Lord himself shall
give you a sign; Behold, a virgin shall
conceive, and bear a son, and shall call
his name Immanuel' (Isaiah 7:14); the
second shows St Jerome writing in front
of Eustochium, one of the pious female
patrons who went with him from
Rome to the Holy Land. There are large
historiated initials for the preface and
the start of the main text, and decorated
initials for the openings of each book.

On the final page of the manuscript
(illustrated) there is a small portrait of
a tonsured monk. With his left hand

he dips a pen into an inkhorn, and in
his right hand he holds a knife (used
to sharpen the point of the quill); a
manuscript sits on the lectern in front
of him. The rubric reads: 'Hugo pictor /
Imago pictoris & illuminatoris huius
operis' ('Image of Hugo painter and
illuminator of this work').

The self-portrait is a familiar genre
in post-medieval art but rare in
manuscripts of this period, and this has
been called the earliest signed example.[1]
It has enabled scholars to attach
Hugo's name to further manuscripts in
Durham, Paris, Rouen and Stockholm.

His self-portrait (from which we can
see that he was apparently left-handed),
bestows a sense of individuality on
this volume, like a modern autograph;
but one must be careful not to ascribe
anachronistic motives to a product
of the monastic scriptorium, where
communal enterprise and spiritual
devotion were more important than
artistic reputation, let alone celebrity.[2]

Notes

1 Pächt 1950.
2 Gameson 2006.

14

MOSES MAIMONIDES (1135–1204)

Draft of a part of the *Mishneh Torah* (*Repetition of the Law*)

Cairo, twelfth century

Autograph
In Hebrew; ten leaves, 225 × 155 mm

Provenance: Bought in 1890 from the Cairo Genizah through the Revd G.J. Chester

Literature: Neubauer and Cowley, vol. 2, no. 2794; Atlas 1940 (facsimile); Stern 1952

MS. Heb. d. 32, fols. 47–56 [fols. 53b–54a illustrated]

Rabbi Moses Ben Maimon, known as Moses Maimonides, was the greatest Jewish scholar of the Middle Ages. Born in Cordoba in Spain, he studied in Morocco, then settled in Fustat (Old Cairo), where he became the official head of the Jewish community and a pre-eminent philosopher, physician and rabbinic authority. In philosophy his *magnum opus* was his *Guide to the Perplexed*, written in Arabic and then translated into Hebrew, which draws on the work of Aristotle and the major Muslim philosophers. As a physician he was familiar with the texts of the ancient Greeks and wrote treatises on drugs, poisons and asthma.

Maimonides' first rabbinic work was a commentary on the *Mishnah* (Jewish law), but his greatest achievement in this area was the *Mishneh Torah* or *Repetition of the Law*, a classification by subject matter of the entire talmudic and post-talmudic literature of Jewish law. Completed in 1180, it

is an astonishing feat. Maimonides succeeds in assimilating a vast amount of material and shaping it into a lucid intellectual system, all in beautiful Hebrew. Nothing like it had previously been attempted in Judaism.

The *Mishneh Torah* had canonic authority, and authoritative copies of the text were greatly valued. A manuscript in the Bodleian of books 1 and 2 is signed and approved by the author: 'It was proofread from [my own original] book. I am Moses the son of Rabbi Maimon of blessed memory.'[1] The present manuscript is very different. It is a fragment of ten leaves containing drafts, in Maimonides' own hand, of parts of the *Mishneh Torah*: the end of the section on Laws of Hire and the beginning of the section on Laws of Borrowing and Deposit. In a letter Maimonides described his way of working: he wrote his first draft largely from memory, then checked the sources and made any corrections. Here we may see his interlinear revisions and a number of marginal notes (Maimonides complained that these were sometimes put in the wrong place by copyists).

The stained fragment is an accidental survival. It was discovered, together with other Maimonides autographs, in the *genizah* in Cairo. A *genizah*

is a special chamber attached to a synagogue where discarded pages containing the name of God were stored, to protect that name from profanation. The Cairo Genizah was discovered in the 1890s during rebuilding work on the Ben Ezra Synagogue. Jewish works of all kinds had accumulated there since the tenth century, kept intact by the dry climate of Egypt. Inevitably, they included papers belonging to Fustat's most important, and most prolific, resident.

Three hundred thousand Hebrew, Judaeo-Arabic and Yiddish fragments from the Cairo Genizah are now in libraries round the world, with about two thirds of them in Oxford and Cambridge. The Maimonides fragments are among the most precious. The author probably discarded them once a fair copy of the text had been made, thinking they were of no further use. Today they are valued for the insight they provide into the making of one of the great texts of Judaism. A comparable Christian manuscript might be Thomas Aquinas's drafts for his *Summa Theologica*.

Note
1 Bodleian MS. Hunt. 80

בריך רחמנא דסייען

15

GEORGE FRIDERIC HANDEL (1685–1759)

Original conducting score of *Messiah*

September–October 1741

In the hand of John Christopher Smith, Sr (1683–1762/3), with Handel's annotations and revisions
222 leaves in two volumes, 230 × 290 mm
London binding by Rivieres, 1867: brown calfskin with gold tooling, the original eighteenth-century blind-tooled covering leather mounted as doublures in 1930

Provenance: John Christopher Smith, Sr (1683–1762/3); John Christopher Smith, Jr (1712–1795); Leigh, Sotheby's sale, 17 August 1838: purchased on behalf of the Ottley family; William Young Ottley (1771–1836); his sale, 1836: purchased by his son Edward Ottley, who gave it to Sir Frederick Gore Ouseley (1825–1889) in 1867; bequeathed by him to the Trustees of St Michael's College, Tenbury Wells; acquired by the Bodleian in 1985

Exhibition: Oxford 1985, no. 41

Literature: Shaw 1967; Shaw 1974 (facsimile); Fellowes 1934, p. 60; Burrows and Ronish 1994, p. 305

MS. Tenbury 346, 347 [MS. Tenbury 346, fol. 66r illustrated]

Handel looked after his scores, or 'Musick books', carefully, for they were central to his life as a hard-working composer. When planning the next concert season he would regularly look them over and, where necessary, make revisions.

First among Handel's music books were around eight thousand leaves of original scores in his own hand. On the composer's death they passed to his principal copyist, J.C. Smith, and then to Smith's son, J.C. Smith, Jr, who on his retirement in 1774 presented them to George III. They are now in the British Library. Next came the composer's *Direktionspartituren* or conducting scores (also known as performance or harpsichord scores), which were written out by professional copyists, chief among whom was J.C. Smith, Sr. As their name indicates, they were used for rehearsals and performances.

The conducting scores of Handel's larger vocal works were dynamic documents. They were continually revised and annotated to reflect the composer's latest thoughts and to suit the resources of the next venue. The fact that almost all of them survive from the 1720s onwards is proof of their importance. They were bequeathed by Handel to J.C. Smith, who continued to use them for the annual oratorio seasons in London. Only when it ceased to be of practical use was a conducting score sold or given away. This, the first conducting score of *Messiah*, dated 1742, was probably one of the first to be auctioned.

Handel drafted *Messiah*, his most celebrated oratorio, in an astonishing twenty-four days during August and September 1741. Its first performance was on 13 April 1742, at a charity matinée in the New Musick Room, Fishamble Street, Dublin, 'For Relief of the Prisoners in several Gaols, and for the Support of Mercer's Hospital in Stephen's St, and of the Charitable Infirmary'. As expected, there was a capacity audience; the ladies had been requested not to come in hoop-framed skirts and the gentlemen were asked to leave their swords at home. *Messiah* attracted superlatives from the start. The *Dublin Journal* reported on a previous public rehearsal that it was 'allowed by the greatest Judges to be the finest Composition of Musick that ever was heard'.[1] Around seven hundred people were reported to have been in the room.

The conducting score now exists in two leather-bound volumes. It was probably copied out by J.C. Smith in September–October 1741 before he and Handel left for Dublin. While it is not absolutely certain that it stood on the harpsichord in front of Handel when he conducted the first performances, it was certainly used by him for their preparation. In addition, it served as the basis for the performance materials (the scores used by the largely local orchestral players and singers), and has several layers of singers' names and transposition directions, entered by Handel and his immediate successors as guides to music copyists as they prepared these materials.

The score also contains detailed musical revisions in Handel's hand.[2] Old passages were ejected and new music inserted. Handel himself produced thirty-six further performances of *Messiah* (the first in England was on 23 March 1743, to which some of the names in this manuscript refer), and never performed it exactly as composed in 1741, altering it for almost every revival depending on the resources available to him, especially the soloists.[3]

Notes

1 Burrows 1991, p. 18.
2 Ibid., pp. 21, 104.
3 Burrows 1996.

16

FRANZ KAFKA (1883–1924)

Journal

Prague, May–September 1912

Autograph
In German; forty-six leaves, 245 × 195 mm
Early twentieth-century stationer's notebook with
brown book-cloth cover

Provenance: After Kafka's death ownership of his
papers was shared among his four nieces: Gertrude
Kaufmann (the daughter of Kafka's sister Elli, one
third), Marianna Steiner (the daughter of Kafka's sister
Valli, one third), and two other nieces (the daughters
of Kafka's sister Ottla, one sixth each). In 1961
Marianna Steiner (acting also on behalf of the other
owners) deposited at the Bodleian most of the papers,
including the present notebook. Gertrude Kaufmann
bequeathed her share to the Bodleian in 1972, and
Marianna Steiner hers in 2001. At present, the majority
of the collection is owned jointly by the Bodleian and
the children of Ottla's daughters.

Exhibition: Oxford 1983, no. 19

Literature: Brod 1992, pp. 200–219; Reed 2008

MS. Kafka 6 [fols. 26v–27r illustrated]

Franz Kafka wrote some of the most
haunting and idiosyncratic works of the
twentieth century. Much of his writing
was unpublished in his lifetime, and he
asked his friend Max Brod to destroy
his manuscripts after his death. Brod
disregarded Kafka's instructions and
preserved his papers.

Kafka's journals record his deep
introspection, his sense of alienation,
and his struggles with composition.
This slim exercise book contains
his journal entries from 6 May to
September 1912. Then aged twenty-nine,
Kafka was preoccupied with his first
novel, *Der Verschollene* (*The Man who
Disappeared*). There are numerous days

where he records having wasted the
mornings and afternoons, and written
nothing. Family matters are a continual
distraction, as is the publication – at
the persistent urging of his friends – of
his first work, *Meditations*: 'How much
time the publishing of the little book
takes from me and how much harmful,
ridiculous pride comes from reading
old things with an eye to publication.'[1]

Dramatically, on 22 September
the diary became a literary notebook
when Kafka wrote, in one sitting
from 10 at night to 6 in the morning,
his short story 'Das Urteil' ('The
Judgement'). The lightly revised pages
show the sudden fluency of Kafka's
writing and also its intensity – the
heavy cross-strokes he gives to the
't's are particularly expressive. At the
completion of 'The Judgement' the
notebook reverts to its original role
of diary, and Kafka, exhausted but
exultant, describes his slow emergence
from this bout of furious composition.
He records how he had been so stiff
that he could hardly draw his legs from
under the desk; 'it turned blue outside
the window'; a wagon had rolled by;
two men had walked across the bridge;
the maid had walked in as he wrote
the last sentence and he had stretched
and said to her: 'I've been writing until
now'. Then, trembling, he had gone
into his sister's room and read to her

aloud. 'Only *in this way* can writing
be done,' Kafka concluded, 'only with
such coherence, with such a complete
opening out of the body and the soul.
Morning in bed. The always clear eyes.'[2]

A week before writing 'The
Judgement' Kafka had thought
about works of genius. In a beautiful
metaphor he describes them as an
encouragement to his own writing:
'The hollow which the work of genius
has burned into our surroundings is a
good place into which to put one's little
light. Therefore the inspiration that
emanates from genius, the universal
inspiration that doesn't only drive one
to imitation.'[3] Kafka's own peculiar
genius is everywhere on the pages of
this journal, but it remains elusive. It
was a mystery even to himself. Five
months later he looked back over the
handwritten words of 'The Judgement'
and tried to unravel the meaning of
what he had written: 'This is necessary
because the story came out of me like a
real birth, covered with filth and slime,
and only I have the hand that can reach
to the body itself and the strength of
desire to do so.'[4]

Notes
1 11 August 1912; Brod 1992, p. 205.
2 23 September 1912; Brod 1992, pp. 212–13.
3 Ibid., p. 210.
4 Ibid., p. 214.

Und lauter: Jetzt weißt Du also was es noch außer Dir gab, bisher wußtest Du nur von Dir! Ein unschuldiges Kind warst Du ja eigentlich aber noch eigentlicher warst Du ein teuflischer Mensch! —

Und darum wisse: Ich verurteile Dich jetzt zum Tode des Ertrinkens!

Georg fühlte sich aus dem Zimmer gejagt, den Schlag, mit dem der Vater hinter ihm aufs Bett stürzte, trug er noch in den Ohren davon. Auf der Treppe, über deren Stufen er wie über eine schiefe Fläche eilte, überrumpelte er seine Bedienerin, die im Begriffe war heraufzugehen, um die Wohnung nach der Nacht aufzuräumen. Jesus! rief sie und verdeckte mit der Schürze das Gesicht, aber er war schon davon. Aus dem Tor sprang er, über die Fahrbahn zum Wasser trieb es ihn. Schon hielt er das Geländer fest, wie ein Hungriger die Nahrung. Er schwang sich über, wie der ausgezeichnete Turner, der er in seinen Jugendjahren

zum Stolz seiner Eltern gewesen war. Noch hielt er sich mit schwächer werdenden Händen fest, erspähte zwischen den Geländerstangen einen Autoomnibus der mit Leichtigkeit seinen Fall übertönen würde, rief leise: liebe Eltern ich habe Euch doch immer geliebt und ließ sich herabfallen.

In diesem Augenblick gieng über die Brücke ein geradezu unendlicher Verkehr.

$$\frac{\begin{array}{r}56\\392\\982\\1208\end{array}}{} \quad 24:17:56:\times \quad 24\colon 3$$

23 Diese Geschichte »das Urteil« habe ich in der Nacht vom 22 zum 23 von 10 Uhr abends bis 6 Uhr früh in einem Zug geschrieben. Die vom Sitzen steif gewordenen Beine konnte ich kaum unter dem Schreibtisch hervorziehn. Die fürchterliche Anstrengung und Freude, wie sich die Geschichte vor mir entwickelte wie ich in einem Gewässer vorwärts kam. Mehrmals in dieser Nacht trug ich mein Gewicht auf dem Rücken. Wie alles gewagt werden kann, wie für alle, für die fremdesten Einfälle ein großes Feuer bereitet ist, in dem sie vergehn und auferstehn. Wie es vor dem Fenster blau wurde. Ein Wagen fuhr. Zwei Männer über

17

JOHN DONNE (1572–1631)

Verse epistle to Lettice, Lady Carey, and Essex Rich

1612

Autograph
Single leaf, 215 × 156 mm

Provenance: Dedicatees; by descent to Alexander Montagu, 10th Duke of Manchester (1902–1977), from whom purchased by the Bodleian in 1970

Exhibition: Oxford 2002b, no. 2

Literature: Gardner 1972 (facsimile); Barker 2003, pp. 7–14

MS. Eng. poet. d. 197 [recto illustrated]

In his lifetime John Donne was known to the public as the venerable Dean of St Paul's and a preacher of powerful sermons. His poetic achievements were not widely known until the publication of *Poems, by J.D.* in 1633, two years after his death. It contained 350 pages of poetry and concluded with a number of tributes by fellow writers, including Thomas Browne, Izaak Walton and Thomas Carew. Lucius Carey praised Donne as

a two-fold Priest; in youth,
Apollo's; afterwards, the voice of Truth,
Gods Conduit-pipe for grace.

Prior to 1633 just two of Donne's poems had appeared in print; the others existed only in manuscript collections which were circulated among small groups.

Of his English poems, precisely one manuscript has apparently survived in Donne's own hand. It is a verse epistle to two well-born ladies who were personally unknown to him. Lettice and Essex Rich were the daughters of Robert Rich, 1st Earl of Warwick of the third creation (1559?–1619) and his second wife, Penelope Devereux (1563–1607), the 'Stella' of Sir Philip Sidney's sonnet sequence *Astrophel and Stella*. The former was the wife of Sir George Carey and is addressed by Donne as 'Lady Carew'. Their brother, Sir Robert Rich (1587–1658), later the 2nd Earl of Warwick, crossed paths with Donne in early 1612 at Amiens, where the poet was staying with his friend and patron Sir Robert Drury.

The epistle was probably written at Sir Robert's suggestion. It is, essentially, an exercise in flattery. Donne compares Lady Carey's virtue to the firmament, the outer region of the heavens where the stars were immutable and fixed.

Her virtue is not, as it was in others, the temporary, shallow manifestation of one of the four humours thought to direct human behaviour: the phlegmatic (stolid, unresponsive), sanguine (rashly hopeful), melancholy (lasting gloom) or choleric (explosive and biting). Instead, it is her soul, the essence of her character: 'true virtue is soul, always in all deeds all'. Essex Rich, Lady Carey's 'noble worthy Sister', is praised at the end of the poem for possessing the same virtue and beauty.

It is not one of Donne's most inspired poems, but one has to admire the apparent ease with which he contributes to this courtly world, and the skill with which he interweaves formal compliments and moral argument. The manuscript may be Donne's original and only version of the poem, or it may be a fair copy of a rougher early draft; either way, it is gracefully written on thin, gilt-edged paper, which was then folded into a strip measuring just 23 × 68 mm and addressed 'To the Honorable lady / the lady Carew'.

Madame

Here where by all all Saints invoked are,
T'were too much scisme to bee singulare,
And gainst a practise generall to warr,

Yett turninge to Saints, should my Humilitee
To other Saint then yow directed bee,
That were to make my scisme Heresee.

Nor would I bee a Convertite so cold
As not to tell yow, If thys bee to bold,
Pardons are in thys market cheaply sold;

When because fayth ys in too lowe degree,
I thought yt some Apostleship in mee
To speak thinges wch by fayth alone I see:

That ys, of yow, who are a firmament
Of vertues, where no one ys growen, nor spent,
Thay'are yr materialls, not yr Ornament.

Others, whom wee call vertuous, are not so
In theyr whole Substance, but theyr vertues grow
But in theyr Humors, and at Seasons show.

For when through tastles flatt Humilitee
In Doe bakd men some Harmelesnes wee see
Tis but hys fleigme that's vertuous and not hee.

So ys the Blood sometymes, who euer ran
To Danger vnimportund, hee was than
No better then a Sanguine vertuous man.

So Cloystrall Men who in pretence of fear
All Contributions to thys Lyfe forbear,
Haue vertu in Melancholy, and onely there.

Spirituall Cholerique Critiqs, wch in all
Religions find faults, and forgiue no fall
Haue, through thys Zeale, vertu, but in theyr Gall.

We'are thus but parcell-gilt; To Gold we'are growen,
When vertu ys our Soules Complexione.
Who knowes hys vertues Name, or Place, hath none.

Vertu ys but Aguishe when tis seuerall,
By'Occasion wakd, and Circumstantiall;
True vertu ys Soule allwayes in all deeds all.

Thys vertu, thinkinge to giue Dignitee
To yr Soule found then no infirmitee;
For yr Soule was as good vertu as shee.

Shee therfore wrought upon that part of yow
wch ys scarse lesse then Soule, as shee could doe,
And soe hath made yr Beauty vertue too;

18

JANE AUSTEN (1775–1817)

Volume the First

1792–3

Autograph
184 pages, 199 × 160 mm
Late eighteenth-century English notebook: quarter brown sheepskin over marbled boards

Provenance: Bequeathed in 1817 to the author's sister Cassandra Austen (1773–1845); on her death passed to their youngest brother, Charles (1779–1852), and then by descent to his eldest daughter, Cassandra Esten (1808–1897), and to Cassandra Esten's nieces, the daughters of Charles's son Charles John Austen; purchased by the Bodleian in January 1933 through the Friends of the Bodleian

Exhibition: Oxford 2002b, no. 5

Literature: Sutherland 2013 (facsimile); <http://www.janeausten.ac.uk>

MS. Don. e. 7 [pp. 22–23 illustrated]

This is the first of three books of juvenilia copied out by Jane Austen in 1792–3, when she was thirty-six.[1] Apart from a brief extract published in the *Memoir* of the novelist by her nephew James Edward Austen-Leigh, the text of this volume remained hidden from the public gaze until the manuscript came to light in the early twentieth century. When R.W. Chapman published *Volume the First* in 1932, 'from the Manuscript in the Bodleian Library', he forestalled any charges of frivolity by prefacing the text with some cautionary remarks:

It will always be disputed whether such effusions as these ought to be published; and it may be that we have enough already of Jane Austen's early scraps. The author of the MEMOIR *thought a very brief specimen sufficient. But perhaps the question is hardly worth discussion. For if such manuscripts find their way into great libraries, their publication can hardly be prevented. The only sure way to prevent it is the way of destruction, which no one dare take.*[2]

No such apology would be considered necessary today, when a great writer's juvenilia receive close scholarly attention.

The manuscript eloquently expresses the circumstances in which Jane Austen wrote. Contrary to the myth that she composed her novels in secret, hiding her paper and pen whenever someone came into the room, it shows that she was a member of a supportive and highly literary household. Literature was entertainment, a part of daily life, and the copies of the stories in this manuscript – originally written when Austen was aged between twelve and fifteen – were 'trifles' intended for the amusement of family and friends.

A convivial, gently satiric humour characterizes *Volume the First*. Some of the dedications, for example, are parodies of the more obsequious type of letter penned by authors to their patrons. 'Madam You are a Phoenix', Austen prefaces her tale 'The Beautifull Cassandra', which she dedicates, 'by permission', to 'Miss Austen' (her sister Cassandra). 'Your taste is refined', she continues, 'your Sentiments are noble, & your Virtues innumerable. Your Person is lovely your Figure, elegant, & your Form, magestic. Your manners, are polished, your Conversation is rational & your appearance singular.'

Just as romantic novels were then usually published anonymously, so Jane Austen does not give her name anywhere in the manuscript; she is simply 'The Author'.

Volume the First is open here at the beginning of 'Jack and Alice', a satire on the Gothic novel. It is dedicated to Jane Austen's favourite brother, Francis Austen, a midshipman in the Royal Navy who would rise to the rank of Admiral.

Notes

1 *Volume the Second* and *Volume the Third* are now in the British Library, Add. MSS. 59874, 65381.
2 Chapman 1933, p. ix.

22

Jack & Alice

a novel.

To respectfully inscribed to Francis William Austen
Esq.r Midshipman on board his Majesty's Ship the Perseverance
by his obedient humble
Servant The Author

Chapter the first

Mr Johnson was once upon a time about
53; in a twelvemonth afterwards he was
54, which so much delighted him that he
was determined to celebrate his next
Birth day by giving a Masquerade to his
Children & Freinds. Accordingly on the
Day he attained his 55th year tickets
were dispatched to all his Neighbours
to that purpose. His acquaintance indeed
in that part of the World were not very
numerous as they consisted only of Lady

23

Williams, Mr & Mrs Jones, Charles Adams
& the 3 Miss Simpsons, who composed
the neighbourhood of Pammydiddle &
formed the Masquerade.

Before I proceed to give an account
of the Evening, it will be proper to
describe to my reader, the persons and
Characters introduced to his acquaintance.
of the party

Mr & Mrs Jones' were both rather tall
& very passionate; but were in other
respects, good tempered, well behaved Peo:
:ple. Charles Adams was an amiable,
accomplished & bewitching young Man;
of so dazzling a Beauty that none
but Eagles could look him in the Face.

Miss Simpson was pleasing in
her person, in her Manners & in her Disposi:
:tion;

19

FELIX MENDELSSOHN (1809–1847)

Schilflied (*Reed Song*)

Frankfurt, March 1845

Autograph
Two leaves (bifolium), 212 × 285 mm

Provenance: Given by the composer to Henrietta Keyl; probably Giselda Selden-Goth (1884–1975); Albi Rosenthal (1915–2004); purchased by the Bodleian in 2007

Exhibition: Oxford 1997, no. 74

MS. M. Deneke Mendelssohn c. 101 [fol. 1r illustrated]

Mendelssohn and his wife Cécile spent the winter of 1844–5 in the Frankfurt area, where Cécile had been born. While there Mendelssohn made a beautiful copy of a song he had composed in 1842: *Schilflied* (*Reed Song*), which sets to music words by Nikolaus Lenau (1802–1850).[1] Not only did he write it out in his best hand, he also illustrated it with a meticulous watercolour depicting the song's opening line: 'On the lake's unruffled surface rests the moon's fair beam.'

It was a present for Henrietta Keyl (née Steinhäuser), who had married a Frankfurt wine merchant, Friedrich Wilhelm Keyl, in about 1813. Not much is known about the friendship between the Mendelssohns and the Keyls, but an inscription indicates that Mendelssohn meant it for Henrietta's album. A compiler of such albums himself (see cat. 113), he would frequently copy out lines of his music for friends, but there is only one other example that he also illustrated – the song *Im Walde*, which he gave to his sister-in-law, Julie Jeanrenaud, in 1839.[2] Perhaps this exquisite copy of *Schilflied* was made in return for a drawing that the Keyls' son, Wilhelm Friedrich, had presented to Cécile the previous summer.[3]

Like many educated people of the time, Mendelssohn was a skilful draughtsman from an early age. He sketched continually while on his extensive travels, filling albums with his landscape views; it was the best way of recording his impressions, and also a form of relaxation. Sometimes, indeed, drawing took precedence over composing. On an 1842 tour of Switzerland Mendelssohn wrote to his friend Carl Klingemann: 'In all Switzerland I composed not even a bit of music, but rather drew entire days, until my fingers and eyes ached.'[4] It was a convivial activity: he sketched with friends, and with his wife on their honeymoon; and on a tour of Scotland in 1829 he made landscapes to accompany words specially written by his travelling companion, Carl Klingemann. It was also a means of relieving anxiety or grief: some of Mendelssohn's finest watercolours were made on a tour of Switzerland soon after the sudden death of his beloved sister Fanny in 1847.

Typically, Mendelssohn would make pencil sketches on the spot, and then sometimes work them up into full watercolours at a later date. Like everything else he did, he took to drawing with considerable speed, but he did not have a high opinion of his artistic skill and in the course of his life he engaged a number of professional artists as teachers. As a boy he was taught by J.G.S. Rösel (1768–1843), an instructor at the Berlin Bauschule and an acquaintance of Goethe. He later engaged Johann Wilhelm Schirmer, a landscape specialist ('He is giving me lessons, and teaching me to use purple for my distances, and how to paint sunlight'),[5] and Friedrich Wilhelm von Schadow, a specialist in figures – with which Mendelssohn always struggled.

Notes

1 Published in 1847 as Op. 71, no. 4.
2 Bodleian MS. M. Deneke Mendelssohn c. 47, fols. 11–12.
3 Bodleian MS. M. Deneke Mendelssohn b. 2, fol. 87.
4 Todd 2003b, p. 440.
5 Brown 2003, pp. 47–8.

WILLIAM WILBERFORCE (1759–1833)

Notes for an address to Parliament

1822

Autograph
Two leaves (bifolium), 302 × 188 mm

Provenance: Bequeathed by the author to his son Samuel Wilberforce (1805–1873); by descent to Octavia Wilberforce (1888–1963), from whom it was purchased by the Bodleian in 1965/6

MS. Wilberforce c. 4, fols. 76–77 [fols. 76r + 77v illustrated]

Born in Hull, the son of a wealthy merchant, William Wilberforce entered Parliament at the age of just twenty-one. He was converted to evangelical Christianity four years later, and his parliamentary career was guided by his religious convictions. Chief among his several reforming causes was slavery. From 1788 until his retirement in 1825 Wilberforce led the parliamentary campaign first for the abolition of the slave trade in the British West Indies (finally achieved in 1807), then for the abolition of the slave trade abroad, and ultimately for the abolition of slavery itself and the emancipation of all slaves. He died shortly before the passing of the Slavery Abolition Act in 1833.

During these years Wilberforce became one of the most respected members of the House of Commons (the conscience of the nation in many ways) and one of its most effective orators. William Pitt praised his 'natural eloquence', and his voice, observed another contemporary, was 'beautiful; deep, clear, articulate and flexible'.[1] When, during the great debate in the Commons on the Abolition Bill on 23 February 1807, Romilly paid tribute to Wilberforce, the whole house gave him a standing ovation – a remarkable and almost unprecedented tribute.

A thick sheaf of Wilberforce's original speech notes is testament to the industry that lay behind his achievements as an orator. As a speaker he avoided ornate rhetoric, and he eschewed fine turns of phrase in favour of a few carefully chosen and well-supported facts. His speech notes often take the form of lists, with individual points either clearly numbered or put in boxes. Shown here are the jottings Wilberforce made for a speech given to Parliament on 25 July 1822,[2] by which time he was exhausted and in poor health. His subject was the establishment of English settlements in southern Africa (the Cape colonies), and the necessity that they should not introduce slavery as that would inevitably be an encouragement to the trading that already existed in that part of Africa. Britain was a moral leader in this issue, Wilberforce insisted, and should not be seen violating its own principles when it came to this new colonial presence. The few existing slave holders should be bought off. The native Hottentots were at risk and should be protected, particularly as the recent explorations of John Barrow had shown them to be a sensitive and civilized people, not at all the savages of popular imagination.

The notes have a staccato-like force. Wilberforce seems to have recorded a few initial thoughts on one side of the folded sheet (illustrated overleaf), and then on the other side composed fuller, but still concise, notes from which one may pick out the powerful phrases with which he aimed to convey the moral imperatives of his position: 'My Motion a Warning', 'Slavery wod produce Slave-Trade – temptation infallible'; 'But Slavery's Evil immense Worse from being of Blacks', 'Our Crime greater because Hottentots now vindicated', 'We should be a Curse [to?] Africa, not a Blessing', 'venom', 'How shod we deceive our Emigrants, tellg them They should enjoy the British Constitution & sending them to a Slave Colony'.

The notes betray signs of enforced haste: the hurried writing, heavy crossings-out and revisions render them barely legible in places, and the sheet was originally folded several times, as if to be thrust into a pocket. Wilberforce's exertions wore him out, but he was driven by intensity and evangelical zeal. Idealism, for him, was the essence of genius. A cryptic note at the bottom of the page ('πηρω Importance of Motion all hearts with me needless to argue Reynolds applied') is clarified by a passage in the speech he eventually delivered:

But surely, Sir, it cannot be necessary for me to enlarge upon the innumerable mischiefs of slavery, in a British House of Commons. I may appeal rather to that instinctive love of freedom which burns in every British bosom. It was a remark of one of our greatest painters, Sir Joshua Reynolds, that every artist of true

Last Address. Foreign Sla Trade.

My Present. proper Consequency

W I Registry. not clear abont.
but — I pass it by for Unanimity

my Motion a Warning Nárt
Principius obsta — and to be Index doa
Slavery not to be extended —
no one would commence

Slavery wod produce Slave
Trade. North Boundary
madagascar & Mauritius

But Slavery itself immense
loose from being of Blacks

mutual Antipathies of the time
inveterate Border quarrels

(2)

Gov't Condition no Slaves
& Registry Bill — futile

Our Time greater because
Hottentots now vindicated

Buy out of few Slave Holders
Ceylon — St Helena — Malacca
Johnstone & Brownriss — Hudson
Lowe & Raffles.

We should be a Curse
to Africa not a Blessing —
venom diffusing

Our true policy cultivate Xty
(1) Beat out Mahomedanism

The w importance of Motion by
all Heart with me needless
to argue Reynold applies

|| Albrecht. Moses successful Industry —

Barrows Eulogy on
Cottenham

(2) North American
Slave & Non Slave Colonies

Now shod we deceive our
Emigrants. telly them
they should enjoy the
British Constitution & send
em to a Slave Colony
0

genius had in his mind an ideal form of excellence, which all the exertions of his pencil could never fully equal, and that he should have but a low opinion of the genius of him who could do justice to his own conceptions. In like manner, I may state that I should deem that man's sense of the worth of liberty to be shamefully defective, which was not far superior to any eulogium which I could pronounce on it. I will only, therefore, call upon the House on this occasion, to adopt a line of conduct conducive at once to their country's honour and the interests of mankind.

At a dinner arranged by a fellow campaigner, Thomas Clarkson, back in 1787, Sir Joshua Reynolds had been among the guests who had unanimously urged Wilberforce to take up the cause of Abolition in Parliament.

Notes

1 Furneaux 1974, pp. 284, 286.
2 Reported in Hansard, vol. 7, cc1783–801.

21

MOHANDAS KARAMCHAND GANDHI (known as MAHATMA GANDHI; 1869–1948)

Letter to Charles Freer Andrews (1871–1940)

Pune, 20 October 1932

Autograph
Two leaves (bifolium), 180 × 114 mm

Provenance: William McGregor Ross (1876–1940) and Isabel Ross (1885–1964); given to the Bodleian in April 1998 by their son Hugh McGregor Ross and daughter-in-law Sylvia Ross

MS. Afr. s. 2305 Box 7, item 9

Gandhi wrote this affectionate letter to his English friend C.F. Andrews when he was engaged in his second great campaign against British rule in India. In 1931 he visited England and attended the second round-table conference on constitutional reform. In January 1932 he resumed civil disobedience and was sent to Yerwada Prison in Pune. In August Ramsay MacDonald's Communal Award granted separate electorates to the minority communities of India, including the Dalits, or untouchables. Gandhi opposed it; he wished to remove untouchability by embracing the Dalits within Hinduism, and announced his intention to fast. He maintained his fast for six days, until 25 September, by which time he had brokered a deal from inside the prison with the Dalit leader B.R. Ambedkar. The Pune Pact established a single Hindu electorate, with seats reserved for the Dalits.

Andrews was an author and campaigner for Indian independence. He had first gone to India in 1904 as a missionary and befriended Rabindranath Tagore; but it was in Durban in 1914 that he met, and became the confidant of, Gandhi. The two men did not always agree, but up until his death in 1940 Andrews remained Gandhi's friend and supporter, and was a vocal advocate for Indians, particularly indentured labourers and expatriates.

Andrews was in England when he heard of Gandhi's 1932 hunger strike, and immediately announced his intention to go to India; but Gandhi persuaded him to remain in England, saying he would be of more use there. In this letter, written a few weeks after he had broken his fast, Gandhi tells Andrews of his intention to continue his fight against untouchability: 'it is a life and death struggle for me. The fast has to be a fast to the finish or untouchability has to go now. It is a tremendous task.' Only Gandhi's earliest letters from prison were written, like this one, entirely in his own hand. Later letters were written out by his secretary, Mahader Desai, or typed on a machine provided by the British, who

endeavoured to weaken the symbolic power of Gandhi's imprisonment by allowing him to establish a makeshift office and to live in relative comfort. The prison name is stamped at the head of the letter, and the red mark shows that the letter was passed by the prison censor before being sent. Gandhi's letters were also read by Bombay Special Branch.

Gandhi adopts a style and a vocabulary befitting his correspondent, an English Christian. Although a Hindu all his life, Gandhi drew on aspects of other religions, particularly the non-violence of Christ, and the language he uses in his letters to Andrews reveals his love of Christian mystical hymns such as Cardinal Newman's 'Lead, Kindly Light'. The unusually personal tone of the letters was a consequence of his writing in English. Gandhi would not have signed them, as here, 'Mohan' if he had been writing to one of his countrymen, but with the more patriarchal 'Bapu' or 'little father'.[1]

Notes
1 I am grateful to Judith Brown for her assistance with this entry.

9

My dearest Charlie,

I have your letter. God's grace has been wonderful. Those days were days of basking in the sunshine of His presence. There was not one step taken out of self will. Never have I experienced such an immediate, definite response to prayer.

Yes, it was well you stayed there. I knew what it would mean for you to remain there. And yet I did not take a moment to decide in reply to your

you speak of is far subtler + wears the cloak of respectability. Ours in India looks what it is + therefore in a way less difficult perhaps to fight.

I have almost regained my lost strength.

Our love to you and all the members of the ever growing family,

Yours
Mohan
70° 10/32

Cat. 21

cable. Vallabhbhai
Mahadev too had never
any doubt about the
correctness of the decision.
Indeed it is wonderful
how they instinctively
felt the soundness of
all the fateful decisions
that had to be taken
during those terrible
days.

But the work has only
first begun. It is a life
and death struggle for me.
The past has to be a past
to the finish or untoucha-
bility has to go now. It is
a tremendous task. I must

test the affection of the
millions who have flocked
to those meetings. I have
to wrestle with God Him-
self. But He is both in-
dulgent and exacting.
He will have full surrender
or none. The late fast
was possibly only
a prelude to what is yet
to come. But no more of
this speculation. His
will not mine be done.
I can but try to prove
worthy of the sacrifice
if it has to come.

And you have still to be
there. The untouchability

22

Draft of a speech given by Harold Macmillan (1894–1986) to the South African parliament, 1960

1959/60

Typescript, heavily revised – mostly in pencil
Fifteen leaves, 329 × 203 mm

Provenance: Deposited at the Bodleian on 13 October 1994 by the Macmillan family

MS. Macmillan dep. c. 788, fols. 150–164 [fol. 155r illustrated]

On 3 February 1960 the British Prime Minister, Harold Macmillan, made a speech before both houses of the South African Parliament in Cape Town. It was the conclusion to a six-week tour of the African continent that had included Ghana, Nigeria, and what were then Rhodesia, Northern Rhodesia and Nyasaland.

Macmillan began his speech with a summary of the fruitful historical relations between the two countries. He then turned to the 'deep preoccupation' he had encountered in South Africa with what was happening in the rest of the continent: 'We have seen the awakening of national consciousness in peoples who have for centuries lived in dependence on some other power', Macmillan said; then came the passage in the speech which would become celebrated:

The most striking of all the impressions I have formed since I left London a month ago is of the strength of this African national consciousness. In different places it may take different forms. But it is happening everywhere.

The wind of change is blowing through this Continent. Whether we like it or not, this growth of national consciousness is a political fact. We must all accept it as a fact. Our national policies must take account of it.

Macmillan described the British approach to these problems and explained how it differed from the policies adopted by South Africa, implying that the difference was, essentially, its attitude towards race. He sat down to a smattering of polite applause.

The speech, which has been called 'one of the finest and bravest speeches of the twentieth century',[1] had a deep

Fig. 20. Harold Macmillan delivering his 'Wind of Change' speech in the Parliamentary Dining Room, Cape Town, 3 February 1960. MS. Macmillan dep. c. 788, fol. 60v

~~tide is now turning a little. Many nations are coming~~

~~to believe in closer association one~~ with ~~another. There~~

~~is a sense of greater inter-dependence. I shall have~~

~~more to say of this later on.~~ But nationalism is not [today]

~~con~~fined to Europe. ~~All over the world this century~~
[In the twentieth century, and especially since the end of the war, the processes]

~~and the past few years in particular have seen a~~
[have been repeated all over the world.]

~~repetition of the process~~ which gave birth to the

~~European~~ nation states [of Europe]. We have seen the awakening of

national consciousness in peoples who have for

centuries lived in dependence [on] ~~of~~ some other power. To-

[Fifteen years ago ~~answer~~ this movement spread through Asia. Many countries then, of different races & civilisations, pressing their claim to an independent national life.]

day ~~this~~ [the same thing] is happening ~~all over~~ [in] Africa. ~~And~~ The most

striking of all the impressions I have formed since I

left London ~~just~~ a month ago is of the strength of this

African national consciousness. In different places it

may take ~~somewhat~~ different forms. But it is happening

everywhere. [The wind of change is blowing ~~throughout~~ throughout the continent.] Whether we like it or not ~~it~~ is a

political fact. ~~of the first importance.~~ [We must all accept it as a fact.] [Our national] ~~We ignore it~~
[policies must take account of it.] ~~at our peril.~~ [this growth of national consciousness]

Of course you understand this as well as any-

one. You are sprung from Europe, [the home of nationalism. And] ~~But~~ here in Africa

you have [yourselves] created a new nation. [Indeed, in] ~~In~~ history yours will be

[recorded as] the first of the African nationalisms. And ~~the~~ [this] tide of

national consciousness which is now rising ~~all over the~~ [in Africa]

~~Continent~~ is a fact for which you and we and the other

nations of the Western world are ultimately responsible.

For its causes are to be found in the [achievements] ~~successes~~ of

Western civilisation in ~~throwing~~ [pushing] forward the frontiers

of knowledge, applying science in the service of human

-6-

effect on the anti-apartheid struggle in South Africa and the cause of colonial independence. Its composition, a slow and incremental process, may be traced in the surviving drafts and related memos.[2] On 16 December 1959 Macmillan was sent an initial draft by Sir John Maud, the British High Commissioner in South Africa, which was largely the work of the Deputy High Commissioner, John Johnstone.[3] This formed the basis of a subsequent meeting, after which it was extensively redrafted by David Hunt of the Foreign Office. On 27 December Macmillan sent a memo to his Principal Private Secretary, Tim Bligh, reminding him of a letter published in the *Observer* newspaper the previous week, in which four prominent South African signatories had asked the Prime Minister 'that you will not say one single word that could be construed to be in praise of [apartheid]'. Macmillan wanted to know if the speech satisfied this request. David Hunt sent his assurances that it would: 'It seems … that the speech as it stands now should have a good reception from most people in this country or elsewhere who are opposed to *apartheid*; and from the High Commissioner's endorsement we can assume that it will not be too strong meat for its intended audience.' James Robertson of the Colonial Office

welcomed the fact that the speech showed that 'the South Africans are some embarrassment to us', adding: 'I have been asked to say to you that if the Prime Minister had not been able to take this sort of line when he was in South Africa, we think the repercussions in many colonial territories might have been serious.' Meanwhile, a telegram arrived from the High Commission in South Africa requesting several changes. The speech then went through numerous further drafts, including the one here, which is heavily revised in pencil (by Tim Bligh), and in which the famous 'wind of change' phrase is inserted by hand.

The speech as delivered was thus the result of numerous draftings and redraftings, and addressed the various concerns of politicians, diplomats and officials. It is the joint product of several committees, and contingent on a set of political circumstances. It may lack the private intensity of some manuscripts, but it nevertheless captures the spirit of a particular time and place, and an historical moment of great significance.

Notes

1 Thorpe 2010, p. 457.
2 Bodleian MS. Macmillan dep. c. 788, fols. 1–268.
3 Thorpe 2010, p. 457n, p. 772.

23

St Margaret's Gospel lectionary

English, mid-eleventh century

Miniatures, borders, initials
In Latin, on parchment; thirty-eight leaves,
172 × 111 mm
Bound by Christopher Clarkson at the Bodleian, 1993:
white tawed calfskin over wooden boards

Provenance: St Margaret; next heard of in the
ownership of John Stow (1524/5–1605), antiquary;
by the end of the sixteenth century in the possession
of Lord William Howard (1563–1640), third son of
Thomas Howard, 4th Duke of Norfolk; by the early
eighteenth century owned by Fane Edge, vicar of
Nedging in Suffolk, who had inherited it from his
mother, Catherine Fane; he bequeathed it to the parish
library of nearby Brent Leigh; William Brice; his sale,
Sotheby's, 26 July 1887: purchased by the Bodleian

Exhibition: Canberra 2009, pp. 38–9

Literature: SC 29744; P & A, vol. 3, no. 44; Forbes-Leith
1896 (facsimile); Rushforth 2007

MS. Lat. liturg. f. 5 [fols. 21v–22r illustrated]

St Margaret was an eleventh-century
queen of Scotland. She was the wife
of Malcolm III and the mother of
Mathilda, who married Henry I.
Renowned for her piety and good
works, and for the civilizing influence
she had on matters of politics and
religion, Margaret was canonized by
Pope Innocent IV in 1249–50.

A life of Margaret written in about
1100–1107 by Turgot, prior of Durham
(later bishop of St Andrews), records
that King Malcolm, 'although he could
not read, would turn over and examine
books which the queen used either
for her devotions or her study, and
whenever he heard her express especial
liking for a particular book, he also
would look at it with special interest,
kissing it, and often taking it into his
hands.'

The present book was reportedly
Margaret's favourite. It is a gospel
lectionary – that is, a selection of
passages from the Gospels. Each of the
four series of extracts is preceded by a
beautifully illuminated page containing
the first words of the relevant gospel
and a miniature of the evangelist.
Small and therefore portable, it was a
book for everyday devotion, and the
extracts it contains reveal an interest
in the women of the Gospels, and
particularly the Virgin Mary. The book
would originally have had a 'treasure
binding'. Such bindings, made of metal
and decorated with gold and jewels,
reflected the importance of the book
inside. Few examples have survived
from the Middle Ages, but we know
that Margaret also had a silver Gospel
lectionary which, according to Reginald
of Durham, she used to decorate the
shrine of St Cuthbert.

According to Turgot's life of
Margaret, the book was the subject of a
miracle. While Margaret was crossing
a ford one of her retinue unwittingly
dropped into the water a book 'covered
all over with jewels and gold, in which
pictures of the four evangelists were
embellished with paint mixed with
gold'. Sometime later the book was
found

*lying at the bottom of a deep river, its
pages constantly swept back and forth
by the rapid motion of water.… Who
would think that the book was worth
anything any longer? Who would believe
that even one letter would still appear
in it? But without a doubt, it was drawn
up from the middle of the river intact,
incorrupt, and undamaged, so much so
that it scarcely seemed to have been in
the water!* [1]

The whereabouts of the book after
Margaret's death are unknown until
it appears in the collection of the
sixteenth-century antiquary John
Stow. It was owned by Lord William
Howard of Naworth, from whose
collection it was sold in the 1720s. [2]
In the early eighteenth century it was
owned by Fane Edge, vicar of Nedging
in Suffolk. He bequeathed it to a nearby
parish library, and it was acquired by
the Bodleian in 1887 for just £6. Its
connection to St Margaret was by then
long forgotten, and it was wrongly
dated in the sale catalogue to the
fourteenth century.

Shortly after its purchase by the
Bodleian the book's provenance
was rediscovered, and a fine but not
exceptional manuscript became a
precious relic of a revered saint. While
it was being catalogued in the Library,
Lucy Hill, the 22-year-old daughter
of George Birkbeck Hill, the editor
of Boswell's *Life of Johnson*, noticed a
close correspondence between Turgot's
account of the miracle and a Latin
poem written in the front of the book,
probably in the late eleventh or early
twelfth century. On 6 August 1887

SCS LU
EUAH
CAS
GET.

INCIPIT EUANGELIU SE
CUPDU LUCAM.

QUIDEM
MULTI COUATI

ordinare narrationem quae in
nobis completae sunt rerum.
sicut tradiderunt quia binitio
ipsi uiderunt & ministri fuerunt
Uisum est & mihi asecuto aprin
cipio omia diligenter exordine
tibi scribere optime theophile.
ut cognoscas eorum uerborum
dequibus eruditus es ueritatem.

Secundum LUCAM.

Bodley's Librarian, Falconer Madan, gave an account of the discovery in the *Academy*, and he proposed a physical explanation for the reported miracle:

the last leaf but one shows signs of contraction and crinkling from the action of water; but with respect to the miracle itself, one would like the opinion of Mr. Maunde Thompson, whether the immersion of an illuminated parchment MS. for a few hours … would necessarily affect its condition, if carefully dried, without the application of heat. It might be thought no otherwise miraculous than was the bursting out of a spring through the prayers of St. Frideswide, at the well of another St. Margaret, at Binsey, in a water-meadow so low-lying that the later pilgrims to the scene had to construct a cause-way in order to approach it.

Madan nevertheless celebrates the book as 'a relic which must always have an interest for students of the Latin texts of the Gospels, of palaeography and illumination, and of the early history of the English and Scottish churches'.

The poem written at the front of the book, and which enabled its identification as a favourite possession of St Margaret, reads:

*Ever to you, O Christ, we render thanks
who shows us miracles in our own time!
Some people who took this book to swear an
oath carried it off uncovered and unfastened;
a priest conveyed it tucked into his robes.
Crossing a river, the bearer unaware,
the book fell in the torrent, pierced the depths.
A soldier some time later saw it there
and wanted at once to pull it from the flow;
but faltered when he saw the book was open,
thinking that it would be completely ruined.
But still, head-first he dived into the rapids
and fetched the Gospel open from the gulf.
O virtue clear to all! O, great glory!
For, the whole book remained immaculate
except for the two leaves seen at either end
which, buckled by the waves' effect, proclaim
Christ's intervention for the holy book.
That this should seem to us more marvellous
the waves had washed a cloth out of the centre.
May ever the king and holy queen be well
whose book was lately rescued from the waves!
All glory be to God who saved this book!* [3]

Notes

1 Rushforth 2007, p. 11.
2 Ovenden 2006, pp. 540–41.
3 Ibid., p. 14, quoting Gameson 1997.

24

MARGARET OF NAVARRE (1492–1549)

'Le miroir de l'âme péchéresse' ('The Mirror of the Sinful Soul')

1544

In the hand of Princess (later Queen) Elizabeth (1533–1603), who also translated the text from the French
On parchment; sixty-six leaves, 188 × 140 mm
Contemporary English binding possibly by Princess Elizabeth: silver and gold stitches on a blue silk ground, the queen's initials 'KP' (Katherine Parr) in the centre of each cover and heart's-ease in each corner; later stiffened with millboard and flyleaves

Provenance: Katherine Parr (1512–1548); Francis Cherry (1682–1713); received by the Bodleian through his daughter Anne in 1729

Exhibition: Oxford 2002b, no. 41

Literature: SC 9810; Ames 1897 (facsimile); Shell 1993 (facsimile); Woudhuysen 2007

MS. Cherry 36 [fol. 2r illustrated]

25

BERNARDINO OCHINO (1487–1564)

Sermo de Christo (Sermon of Christ)

c. 1552

In the hand of Princess (later Queen) Elizabeth (1533–1603), who also translated the text from the Italian
In Latin, on parchment; forty-two leaves, 224 × 115 mm
Nineteenth-century English binding: red velvet over boards

Provenance: Dedicated to Edward VI; inscription: 'J. Bowle, Idmerston. July 25, 1759'; given to the Bodleian in 1761

Exhibition: Tokyo 1990, no. 32

Literature: SC 27877; Woudhuysen 2007

MS. Bodl. 6 [fols. 19v–20r illustrated]

These two manuscripts show the early development of Elizabeth I's calligraphy. The first (cat. 24) was made when she was just eleven years old. It is her own translation of a French devotional poem – 'Le miroir de l'âme péchéresse' by Margaret of Angoulême, sister of the French king and wife of the king of Navarre. The young princess dedicated it to her stepmother, Katherine Parr (who had a fine italic hand), as a new year's gift for 1545, inviting her to 'rubbe out, polishe and mende – the wordes', and asking her not to let anyone else see it until it had been corrected, 'lesse my faultes be knowne of many'.

Tradition has it that Elizabeth was also responsible for the embroidered binding (illustrated opposite). There is a similar volume by Elizabeth in the British Library. Dated 30 December 1545, it is a collection of prayers translated by Elizabeth into Latin, French and Italian, preceded by a Latin dedication to her father Henry VIII.

Its embroidered binding has the king's and queen's initials in monogram and, in the corners, a white Tudor rose.[1] In both these manuscripts the young princess writes in a formal, if rather clumsy hand, modelled on that of her half-brother Edward's tutor, Jean Bellemain.

Between 1544 and 1550 Elizabeth was taught calligraphy by two royal tutors: William Grindall and then Grindall's former teacher, Roger Askham. Under their influence she abandoned Bellemain's French italic in favour of the Cambridge italic. This development is shown in Elizabeth's copy of her Latin translation of an Italian sermon (cat. 25), dating from around 1552, in which she displays considerable skill. Askham was highly complimentary about the young princess's calligraphic ability. In 1550 he told his friend Johann Sturn: 'Nothing can be more elegant than her handwriting whether in the Greek or Roman character.'[2]

Elizabeth's handwriting deteriorated noticeably in later life, to her own regret; but she always made a strong distinction between documents written by professionals, those signed by her, and those entirely in her own hand. The first suited official papers; the second conferred extra authority on the document; the third expressed particular intimacy, and such manuscripts were often treated as precious relics by their recipients. 'It is that sense', writes H.R. Woudhuysen, 'that what is written is somehow deeply personal, that it conveys presence, and that the private writings of public individuals, especially divinely ordained royal ones, are particularly powerful.'[3]

Notes

1 London, British Library Royal MS 7 D X; see Pryor 2003, p. 19.
2 Woudhuysen 2007, p. 2.
3 Ibid., p. 25; see also Allinson 2011.

Cat. 24

TO OVR MOST ENNOBLE AND
vertuous quene KATHERIN, Eliza
beth, her humble daughter wisheth:
perpetuall felicitie and euerlasting ioye

NOT ONELY knowing the affe
ctuous wille, and feruent zeale, the
wich your highnes hath towardes
all godly lerning, as alfo my ductie
towardes you (most gracious and
fouueraigne *princes* but knowing alfo that
pufilanimite, and ydlenes, are most
repugnante vnto a reafonable crea
ture, and that (as the philofopher
fayeth) euen as an inftrument of yron

MAGNA
...ifferentia inter
...Christum.
...OISES E
...is Dei seruus
...s ut filius.
...ER MOI
...ndo legem, per
...ratiam.
...OISES
...ota dedit, &
...onum solum-
...OISES
...littere, Chris,

tus spiritus.

MOISES

scripsit in tabulis, et Chris
tus in corde

MOISES

promisit, & Chris tus
obseruauit.

IVGVM MO

isis graue fuit, asperum, &
intollerabile, et illud Chris
ti, suaue iucundum et leue.

MOISES.

lege sua nos seruos fecit,
& Chris tus filios.

SI QVALIS

sit igitur Chris tus a nobis

MARY WOLLSTONECRAFT (1759–1797)

Notes to William Godwin (1756–1836)

London, 30 August 1797

Autograph
Three single leaves; 120 × 200 mm

Provenance: Bequeathed to Mary Shelley (1797–1851) via Godwin's widow, Mary Jane Godwin (1768–1841); bequeathed by her to Sir Percy (1819–1889) and Jane, Lady Shelley (1820–1899); by descent through their adopted daughter Bessie Scarlett (1852–1934) to James Scarlett, 9th Baron Abinger (b. 1959), from whom purchased by the Bodleian in 2004

Literature: Todd 2003a, nos 353–4

MS. Abinger c. 40, fols. 209, 210, 211 [fol. 209r illustrated]

William Godwin, the radical philosopher, and Mary Wollstonecraft, author of *A Vindication of the Rights of Woman*, corresponded from July 1796 to September 1797. In the course of these fourteen months they became lovers and, in March 1797, husband and wife. On 30 August Mary Wollstonecraft gave birth to a daughter, also called Mary, the future author of *Frankenstein* and wife of the poet Percy Bysshe Shelley. After the birth she developed puerperal fever and died several days later.

Even after their marriage Godwin and Wollstonecraft preferred to live independently during the day and communicate by correspondence. They regularly exchanged anything from long, carefully composed letters to short notes dashed off on scraps of paper. Their exchanges form an eloquent record of their relationship, its sympathies and disagreements, assertions and vulnerabilities, intimacies and misunderstandings.

After Mary Wollstonecraft's death Godwin carefully preserved their correspondence. Methodical by nature, he arranged the letters and notes chronologically, numbered them from 1 to 160, and dated them. After Godwin's death Mary Shelley went through them for her planned, but never completed, biography of her father; but they were not known to the public until 1876, when Charles Kegan Paul included a good number of them in his *William Godwin: His Friends and Contemporaries*.

Particularly touching are Mary's last three notes to Godwin, written while she was waiting impatiently for the delivery of her child ('the animal') and seeking reassurance from the midwife, Mrs Blenkinsop. In her final note Mary Wollstonecraft half-quotes her mother's last words: 'Have a little patience, and all will be over.' Godwin annotated this last written communication from his wife with the date, as usual, but also the time, 'three o'clock'.

I have no doubt of seeing the animal to day; but must wait for Mrs. Blenkinsop to guess at the hour – I have sent for her – Pray send me the newspaper – I wish I had a novel, or some book of sheer amusement, to excite curiosity, and while away the time – Have you any thing of the kind?

*

Mrs. Blenkinsop tells me that Every thing is in a fair way, and that there is no fear of the event being put off till another day – still, at present, she thinks, I shall not immediately be freed from my load – I am very well – call before dinner-time, unless you receive another message from me –

*

Mrs. Blenkinsop tells me that I am in the most natural state, and can promise me a safe delivery – But that I must have a little Patience

I have no doubt of seeing the animal
to day; but must wait for Mrs Blenkinsop
to guess at the hour — I have sent for
her — Pray send me the news paper —
I wish I had a novel, or some
book of sheer amusement, to
excite curiosity, and while away
the time — Have you any thing of the kind?

27

PERCY BYSSHE SHELLEY (1792–1822)

Notebook

Italy, 1818–19

Autograph; seventy-eight leaves, 157 × 106 mm
Nineteenth-century Italian binding: half parchment over marbled boards

Provenance: Mary Shelley (1797–1851); bequeathed by her to Sir Percy (1819–1889) and Jane, Lady Shelley (1820–1899); bequeathed by Lady Shelley to John C.E. Shelley, later Sir John Shelley-Rolls (1871–1951), who gave it to the Bodleian in 1946

Exhibition: Oxford 1992a, no. 79

Literature: Jones 1990 (facsimile); Tokoo and Barker-Benfield 2002, p. 43, no. A21

MS. Shelley adds. e. 11 [fol. 79r illustrated]

Shelley's notebooks show him intensely at work, and their richness and variety reveal both a wide-ranging intellect and exceptional literary gifts. They show him disciplining and shaping his thoughts to create highly crafted poetry and prose. The notebooks were meant for no one but Shelley himself, and at first glance they appear chaotic. Ever since his death they have baffled and challenged editors of his work. Shelley seldom worked with only one notebook at a time; instead he used two or more concurrently, and might put one aside for a time, only to return to it later. In addition, he often started from both ends of a notebook, working towards the middle. Snatches from several works are mixed together on the same page, while individual poems thread their way fitfully through one or more notebooks. The various poems, prose pieces and fragments are anything from initial drafts to intermediate fair copies. Mixed up with literary composition are reading notes, memoranda, draft letters, accounts and the numerous doodles – typically of trees or sailing boats – that Shelley habitually drew during intervals of thought.

After Shelley's death in 1822 his widow, Mary Shelley, gathered together all the manuscripts of his that she could find. Determined that the poet's name should be better known, she made editions of his poetry and prose. They were heroic achievements, for the work was emotionally demanding, and the manuscripts themselves were a huge challenge. Mary told her publisher, Edward Moxon, 'you cannot imagine how confusing & tantalizing is the turning over Manuscript books – full of scraps of finished or unfinished poems – half illegible'. She compared the work to cracking a code: 'The M.S. … consisted of fragments of paper which in the hands of an indifferent person would never have been deciphered – the labour of putting it together was immense.'

After Mary's death the notebooks took their place in the 'sanctum' her daughter-in-law, Jane, Lady Shelley, created at the family home, Boscombe Manor.

This notebook was purchased by Shelley soon after his arrival in Italy in April 1818. Most of the drafts it contains probably date from between the summer of 1818 and the spring of 1819, when the poet and his family were often on the move, spending time in Bagni di Lucca, Venice, Naples and Rome. As always, Shelley used it unsystematically for numerous pieces of work, and its contents show the great range of his intellectual interests and literary projects. There are drafts of prose works: 'On Love', 'Discourse on the Manners of the Antient Greeks' (probably written as an introduction to his translation of Plato's *Symposium*, on which he was working) and 'A Future State'. There are drafts of poems: 'Julian and Maddalo', a few fragments connected with *Prometheus Unbound*, and some lyrics. There is also Shelley's draft of a scene for his projected drama on Tasso, some lyric and prose fragments, his reading notes (including Herodotus), and, creeping in here and there, some household accounts. The draft of 'Julian and Maddalo' is of the greatest poetic interest. The poem was written while he was living at Venice near Lord Byron, and is an exploration of their conversations and contrasting opinions of human nature.

Said Maddalo, and ever, at this hour

I hear . . . cross the waters I just may hear

Which call the maniacs, each one from his cell

To their stern Maker . . . I replied — Oh fish

as in years past — said Maddalo

Men never change — And you were ever still,

Among . . . such a poor born infidel

Beware of . . .

MARY WOLLSTONECRAFT SHELLEY (1797–1851), with PERCY BYSSHE SHELLEY (1792–1822)

Journal

Paris, 28 July – London, 13 May 1815

Autograph
Seventy-three leaves, 192 × 128 mm
Nineteenth-century French binding: quarter leather over boards

Provenance: Bequeathed by Mary Shelley to Sir Percy (1819–1889) and Jane, Lady Shelley (1820–1899); by descent through their adopted daughter Bessie Scarlett (1852–1934) to James Scarlett, 9th Baron Abinger (b. 1959), from whom purchased by the Bodleian in 2004

Exhibition: Oxford 1992a, no. 45

Literature: Feldman and Scott-Kilvert 1987, vol. 1, pp. 5–79; Tokoo and Barker-Benfield 2002, pp. 30–31, no. A2

MS. Abinger d. 27 [upper pastedown + fol. 1r illustrated]

Shelley and Mary eloped at 4.15 in the morning of 28 July 1814, accompanied by Mary's stepsister Jane Clairmont (who later that year began to call herself Clary or Clara, then settled on Claire). They were pursued by Mrs Godwin (Claire's mother), who caught up with them the following day at Calais, but failed to persuade them to return. On 2 August Shelley, Mary and Claire reached Paris, where they purchased this notebook, and began a journal. Illustrated opposite is the first page of the journal, in which Shelley writes up their dramatic flight from England, the stormy crossing (during which he began 'to reason upon death') and their arrival in France. In the top left corner of the facing pastedown is the label of the Parisian stationer from whom they bought the notebook. Next to this is a jokey attempt to make some sense of

the complications of the continental currency: the French sous and franc, and the Swiss batz and livre.

Mary made her first contribution to the journal on the second page by lightly completing a sentence: 'Mary was there. Shelley was also *with me*.' As they continued their journey through France, Switzerland and Germany, she began to add entries of her own, and took turns with Shelley at writing up the day's events. They returned to England on 13 September and the journal entries up to that date were later published (in a revised form) as part of *History of a Six Weeks' Tour Through a Part of France, Switzerland, Germany, and Holland*, 1817.

Mary maintained a journal, on and off, until 1844. She was a reticent woman, and her entries are mostly a factual account of daily events and a record of her extensive reading. Occasionally, however, the journal becomes exceedingly private. After Shelley's sudden death by drowning in 1822 she began what she called her 'Journal of Sorrow', and for a while this served as her closest confidant:

For eight years I communicated with unlimited freedom with one whose genius far transcending mine, awakened and guided my thoughts.... Now I am alone! Oh, how alone! The stars may behold my tears and the winds drink my sighs – but my thoughts are a sealed treasure which I can confide to none. White paper – wilt thou be my confident?[1]

Mary kept this and subsequent journals close by her throughout her life. Her daughter-in-law, Jane, Lady Shelley, recalled her final moments: 'She turned her beautiful great grey eyes on us and towards her desk so often with a longing and beseeching look in them as if she wanted to speak and tell us something.' A year later Sir Percy opened the desk and for the first time learned its contents. 'There we found the private journal kept by her and Shelley from 1814, together with other precious relics.' There was also a copy of Shelley's poem *Adonais*, in which they found some ashes: 'we then knew what Mary had so longed to tell us: all that was left of Shelley's heart lay there'.[2]

Lady Shelley subsequently published parts of Mary's journal, but the text was carefully edited, and the publication took the form of privately printed volumes, entitled *Shelley and Mary*, that were circulated to no more than a privileged few.

Notes

1 Rolleston 1925, pp. 30–31.
2 Bodleian MS. Abinger d. 30, fol. 1r.

2 m. 0

3 sous makes 4 Catz
6½ make 1 franc

3 francs in one murder Kay
6 francs in a head light eater
39 bratz in liver & light eater
19½ bratz in a murder bloody
bratz 2 francs sous sous
1 bratz 6, liver & light eater

£10.

not

Shelley and Mary's journal book

Lionetta

England — 1814

July 28. The night preceding this morning, all being
decided I ordered a chaise to be ready by 4 o Clock. he came pale.
watched until the lightning & the storm he came pale.
at length it was 4. I believed it not possible
that we should succeed: still there appeared to lurk
some danger even in certainty. I went. I saw
her. She came to me. Yet one quarter of an hour
remained. Still some arrangements must be made, &
she left me for a short time. How dreadful did this
time appear. It seemed that we trifled with life
life — a few minutes past she was in my arms
we were safe, we were on our road to Dover. —

Mary was ill as we travelled. Yet in that
sleep what pleasure & security did we not share!
The heat made her faint it was necessary at
every stage that she should repose. I was divided
between anxiety for her health & terror lest our
pursuers should arrive. I reproached myself with
not allowing her sufficient time to rest, with
conceiving any evil so great that the slightest
portion of her comfort might be sacrificed to
avoid it. —

At Dartford we took four horses that we
might outstrip pursuit. We arrived at Dover
before 4 o Clock. Some time was necessarily spent
in consideration, in dinner in bargaining with
sailors & custom house officers. At length we

29

REGINALD EASTON (1807–1893) after ANTOINE-PHILIPPE, DUC DE MONTPENSIER (1775–1807)

Portrait of Percy Bysshe Shelley (1792–1822)

Sometime between 1885 and 1893

Watercolour and bodycolour on ivory laid on card,
oval, 96 × 76 mm
In an ornate gilt frame made by Asprey of London
(matching cat. 30)

Provenance: Commissioned by Sir Percy (1819–1889)
and Jane, Lady Shelley (1820–1899); given to the
Bodleian in 1893 by Lady Shelley

Literature: Garlick, p. 286

Shelley relics (a)

This is a version of a miniature by the
duc de Montpensier which perhaps
depicts the young Percy Bysshe
Shelley while he was a pupil at Syon
House Academy in Twickenham.[1]
Sir Percy and Lady Shelley bought
Montpensier's portrait at the sale of the
art collector Edward Cheney, of Badger
Hall, Shropshire, and commissioned
Reginald Easton, a miniaturist highly
regarded for his portrayals of children,
to make this copy. It was clearly
intended as a partner for Easton's
miniature of Mary Shelley (cat. 30); the
two portraits are in matching Asprey's
frames and leather boxes. Easton has
colourized the more delicate original,
and has apparently followed advice
given to Lady Shelley by the poet's sister
Hellen to keep Shelley's forehead white
and his eyes deep blue.

Note
1 Bodleian Shelley relics 7.

30

REGINALD EASTON (1807–1893)

Portrait of Mary Shelley (1797–1851)

Sometime between 1851 and 1893

Watercolour and bodycolour on ivory laid on card, oval,
110 × 88 mm
In an ornate gilt frame made by Asprey of London
(matching cat. 29)

Provenance: Commissioned by Sir Percy (1819–1889) and
Jane, Lady Shelley (1820–1899); given to the Bodleian in
1894 by Lady Shelley

Exhibition: Oxford 1992a, no. 109

Literature: Garlick, p. 283

Shelley relics (d)

According to Lady Shelley this
posthumous miniature of Mary was
ultimately based upon a death-mask,
though presumably the artist was also
informed by Sir Percy and Lady Shelley's
personal knowledge and their (probably
idealized) recollections of Mary's
appearance. Mary wears blue-and-yellow
pansies, the symbol of remembrance
that she adopted after Shelley's death in
July 1822, and a circlet in her hair which
can also be seen in a portrait of Mary by
Richard Rothwell exhibited in 1840.[1]

This miniature, and the matching
portrait by Easton of Shelley as a boy
(cat. 29), were displayed alongside
other precious family relics in the room
which Lady Shelley called her 'sanctum'.
A number of these relics were given
similarly ornate gilt frames.

Note

1 National Portrait Gallery, London, NPG 1235.

31

Watch owned by Percy Bysshe Shelley

London, 1814

English movement, with pierced balance cock, twice engraved 'French Royal Exchange London', no. 1085; case eighteen-carat gold, with the goldsmith's initials 'TC'

Provenance: By descent to Jane, Lady Shelley (1820–1899), who gave it to the Bodleian in 1894

Exhibitions: Tokyo 1990, no. 81; Oxford 1992a, no. 112; Oxford 1998, no. 13; Canberra 2009, pp. 98–9

Shelley relics (g)

32

Bivalve locket

Nineteenth century

Inscribed on the outside of the locket: 'Beati gli occhi che lo vider vivo' ('Blessed the eyes that saw him alive')

Provenance: As cat. 31

Shelley relics (f)

On 4 August 1814, while in Paris with Mary and Claire Clairmont, Shelley wrote in his journal: 'Mary told me that this was my birth day. I thought it had been the 27th of June. Tavernier breakfasted. He is an idiot. I sold my watch, chain, &c which brought 2 napoleons 5 francs.' The gold watch shown here, dated 1814 on the case, was presumably purchased by Shelley on his return to England.

Attached to the gold chain are five seals (illustrated below): a bloodstone with the Shelley arms of three shells; an oval onyx with a 'Judgement of Paris' (often used by Shelley and Mary for their correspondence); a rectangular amethyst with 'Mary Shelley' in reversed gothic letters; a bloodstone engraved with perhaps a winged horn or shell; and an oval cornelian marked 'LATHAM'.

Shelley and Mary are commemorated together in a bivalve locket (cat. 32) containing a lock of Mary's hair from 1816, and of Shelley's from 1822, the last year of his life. Mary habitually collected locks of hair belonging to family and friends, keeping them in named and dated packets. In this she was following a custom evidently inherited from her father; William

Godwin had sent out at least one lock of Mary Wollstonecraft's hair to a friend in the days after her death.

Inscribed on the outside of the locket is a line adapted from Petrarch's *Canzoniere*, no. 309 ('Blessed the eyes that saw him alive'; the object of Petrarch's original line is female – 'beati gli occhi che la vider viva'). Mary Shelley often turned to Petrarch when remembering her life with Shelley. In a notebook containing her fair copies of Shelley's work[1] she wrote beneath the title two quotations from Petrarch's great collection of love poems, the *Canzoniere*:

In nobil sangue vita umile e queta
Ed in alto intelletto un puro core;
Frutto senile in sul giovenil fiore,
E in aspetto pensoso anima lieta[2]

Ma ricogliendo le sue sparte fronde
Dietro le vo pur cosi passo passo —[3]

Notes

1 Bodleian MS. Shelley adds. d. 9.
2 'In noble blood a humble and quiet life / with a high intellect a pure heart / the fruit of age in the flower of youth / and with thoughtful aspect a happy soul'.
3 'But that, gathering up her scattered leaves / I still follow her step by step'.

The Most
Ingenious Books

In January 1665 Samuel Pepys sat up until two in the morning reading Robert Hooke's newly published *Micrographia* – 'the most ingenious book that ever I read in my life', he noted in his diary.[1] Most books and manuscripts are self-effacing vessels for the words and images of writers and artists. As one goes back in time it becomes increasingly difficult, and eventually impossible, to know how interested these writers and artists were in the reproduction of their work. The poems of Sappho, for example, now survive in fragmentary form on pieces of ancient papyrus (cat. 33) dating hundred of years after the poems were first composed. But it is possible to see how the possibility of printing – what might be called the genius of the printed book – has been superbly realized since the innovations of Johann Gutenberg in the mid- fifteenth century.

Gutenberg's Latin Bible (cat. 34) is a remarkable technical and artistic accomplishment – the successful rendering of a manuscript page in type. William Caxton, who introduced printing to England, brought an entrepreneurial spirit into the incipient book trade. In the sixteenth century the humanist scholar Erasmus grasped the opportunity to reach large numbers of readers through the printing press, wrote the first bestsellers, and oversaw the printing of works by his friends (cats 36 and 37).

By engaging directly with printing techniques, writers and artists were able to control with great precision the reproduction of their work. Albrecht Dürer brilliantly developed the potential of engraving to establish a new visual language of great power (cat. 38). Hooke's *Micrographia* (cat. 39), which so delighted Pepys, made the microscopic world newly accessible with its combinations of engraving and descriptive prose. William Blake and John Audubon succeeded in translating their visionary and unusual projects into print, the former working in miniature (cat. 40), the latter at the largest possible scale (cat. 41). Though modest about his artistic abilities, J.R.R. Tolkien illustrated *The Hobbit* himself and was reluctant for any artist to illustrate *The Lord of the Rings*, 'whether genius or not' (cat. 45).

The close relationship between the printed book and technical innovation was demonstrated when Henry Fox Talbot introduced his experiments in photography in book form (cats 42–4), anticipating the photographic techniques that would dominate book production in the twentieth century.

Note
1 Latham and Matthews 1970–83, vol. 6, p. 18.

33

SAPPHO (*c.* 620 – *c.* 550)

Fragments of poems

Graeco-Roman Egypt, second century AD

In Greek, fragments from a papyrus roll, in a frame
255 × 305 mm

Provenance: Excavated at Oxyrhynchus (P. Oxy. x.1231
+ xviii.2166[a]); given to the Bodleian by the Egypt
Exploration Society in 1923

Exhibition: Oxford 1975, no. 39

Literature: Grenfell and Hunt 1914, no. 1231; Lobel 1951,
pp. 122–6; Pack 1965, no. 1445; Turner 1971, no. 17

MS. Gr. class. c. 76(P)/2

Sappho was born on the island of
Lesbos in the seventh century BC. Little
is known for certain about her life,
but she was the most celebrated lyric
poet of the day, and Plato is said to
have referred to her as the 'tenth muse'.
Her work, however, only survives in
fragments. Just one poem from the nine
books of poetry she is known to have
written is now complete, as a quotation
in an essay on literary composition.
Parts of other poems exist either as
quotations or on pieces of papyrus, as
seen here.

A marsh plant which grew in
plentiful quantities in the Nile delta,
papyrus was the most common writing
material of ancient Greece and Rome.
Its triangular-shaped stems were cut
into vertical strips and then arranged
in a lattice. When beaten, the strips
released a juice that glued everything
together into a sheet. According to
Pliny, twenty sheets formed a roll,
which was read in sections, the
reader scrolling from right to left.
Like paper, papyrus disintegrates
rapidly when damp and most of the
fragments we have today were found
in the dry sands of Egypt. The largest
single find was made in 1897 by two
Oxford archaeologists, B.P. Grenfell
(1869–1926) and A.S. Hunt (1871–1934).
They discovered an ancient rubbish
dump belonging to the Egyptian city of
Oxyrhynchus; it yielded a vast number
of papyrus fragments, including over
70 per cent of surviving literary papyri.

Papyrologists recover ancient texts
by painstakingly reassembling small
pieces of papyrus in the manner
shown here. These are fragments from
Sappho's first book of poems, written
by a professional scribe in a medium-
sized, informal and upright hand. A
small horizontal line (or *paragraphus*)
separates the four-line stanzas from
each other. The fragment in the lower
right corner contains the concluding
lines of a poem celebrating a wedding:

*… night … maidens … all night long …
might sing of the love between you and
the violet-robed bride. Come, wake up:*

*go (and fetch) the young bachelors of
your own age, so that we may see (less)
sleep than the clear-voiced (bird).*[1]

An elaborately curling line (or
coronis) in the left margin indicates
that this is the end of the book. The
title, 'Book One', is then given, and
below it a number, 1320. Known as a
'stichometric', it indicates the number
of verses in the book, and was provided
by the scribe to allow the amount of
money he was owed to be calculated. It
is known that Sappho wrote nine books
of poems so, assuming that each book
was roughly the same length, it may be
estimated that she wrote around nine
thousand verses.

Our knowledge of Sappho's work
is greatly limited by the fragmentary
nature of the evidence. Some have
made a virtue of this and have treated
the gaps in the poems as invitations
to conjecture possible readings.
Their interpolations are not so much
historical reconstructions as products
of the imagination.

Note

1 Campbell 1982, pp. 78–9.

The Gutenberg Bible

Mainz: Johann Gutenberg for Johann Fust, *c.* 1455

Hand-drawn initials

In Latin; 643 leaves in two volumes, 400 × 286 mm
French binding by Nicolas-Denis Derôme le jeune
(1731–1790) in 1785 (his ticket): green goatskin with
gold tooling

Provenance: Erhard Neninger (*c.* 1420–1475), Mayor
of Heilbronn; given by him to the Carmelites of
Heilbronn not later than 1474; given by the city of
Heilbronn to Axel Oxenstierna (1583–1654) in 1633;
Cardinal Étienne Charles de Loménie de Brienne
(1727–1794); purchased by the Bodleian in 1793

Exhibition: Oxford 2002b, no. 24

Literature: Bod-inc. B-237

Arch. B b.10,11 [Arch. B b.11, fols. 234v–235r illustrated]

The Gutenberg Bible was the first substantial book to be printed in Europe. The man after whom it is named, Johann Gutenberg, was a citizen of Mainz in Germany. Born sometime between 1394 and 1406, he may have begun experimenting with metal-casting while living in Strasbourg in the 1430s, but the great Bible was produced after his return to Mainz. In 1450 and 1452 he borrowed money from Johann Fust, a Mainz lawyer and his partner in 'the work of the books'. The partnership ended when Gutenberg failed to repay Fust's loan; the latter foreclosed and set up his own successful printing shop with one of Gutenberg's former employees, Peter Schoeffer, who later married Fust's daughter. Gutenberg is thought to have carried on printing, though never on the same scale. He died in 1468.

The Bible is a large folio, and almost every page has two text columns of forty-two lines each (hence it is often referred to as 'the forty-two-line Bible'). A number of copies were printed on parchment and the rest on paper. It is usually bound in two volumes, and in perfect copies the first volume has 324 leaves and the second 319. Space was left for illuminators to add decorative initials at the head of books and chapters and at the beginning of each of the Psalms. The nature and extent of the decoration was thus a question for the customer rather than the printer. The Bible was probably intended for churches or monasteries (the majority of traceable copies have a monastic provenance), and despite the huge financial value of copies today, it was not intended to rival the most sumptuous illuminated manuscripts.

The production of the Bible is largely undocumented, although an important eye-witness account is provided by Enea Silvio Piccolomini (later Pope Pius II), who in October 1454 saw a display of several unbound gatherings of the Bible in Frankfurt. In a letter to Cardinal Juan de Carvajal he wrote that he had seen 'several ten-leaf quires of different books', and that the type was of sufficient size and legibility to be read without glasses. Some had told him that 158 copies had been made, others 180, but however many were printed it was clearly popular, for when Piccolomini tried to purchase a copy he was told that buyers had been found for the entire projected print run.[1] A copy of the Bible now in the Bibliothèque Nationale in Paris was dated 15 August 1456 by the rubricator, but the exact date of publication is not known.

When it came to the manufacturing of the Bible, Gutenberg had to solve a large number of problems. First among them was the type. The various pieces had to be precisely cast in a material that had a low melting point and which would solidify quickly, making it easily mouldable. The pieces also had to be sufficiently durable to be used again and again. The many individual letters, punctuation marks and spaces, no more than a few millimetres high, had to vary in width according to the letter forms but work together harmoniously. They then had to be precisely aligned and secured in a wooden chase to create a 'forme', which needed to be easy to disassemble so that the type could be reused.

Gutenberg's solutions to these problems remain something of a mystery. We do not know, for instance, precisely how he moulded and cast the type, nor the recipe for his ink. We do not know how the book was printed, how many press men Gutenberg employed, how many presses he had, nor how long the Bible took to print. Gutenberg kept the secrets of his Mainz printing shop to himself, and its doors have remained closed.

Basic techniques of letterpress printing were, however, eventually established in Europe, and these

vidit linthiamina sola posita: z abijt
secu mirans qd factum fuerat. Et ecce
duo ex illis ibant ipsa die in castellu
quod erat in spacio stadior sexagita
ab iherusale nomine emaus: et ipi
loquebant ad inuicem de hijs omni-
bus que acciderant. Et factum est dum
fabularentur z secu quererent: et ipse
ihesus apropinquas ibat cu illis. Ocu-
li aut illor tenebantur ne eum agno-
scerent. Et ait ad illos. Qui sut hij ser-
mones quos conferris ad inuicem am-
bulates: et estis tristes? Et respondens
vn9 cui nomen cleophas: dixit ei. Tu so-
lus peregrin9 es i iherusale z non cogno-
uisti que facta sunt in illa hijs diebus?
Quibus ille dixit. Quae? Et dixerunt. De
ihesu nazareno qui fuit vir ppheta:
potens in opere z sermone: coram deo
et omni pplo. Et quomo eu tradiderut
sumi sacerdotes z principes nostri in
damnatione mortis: et crucifixerut eu.
Nos aut sperabam9: quia ipse esset re-
dempturus israhel. Et nunc super hec
omnia tercia dies est hodie: op hec facta
sunt. Sed z mulieres quedam ex nris
terruerut nos: que ante lucem fuerunt
ad monumentu: z non inuento corpo-
re ei9 venerut dicentes se etiam visione
angelor vidisse: qui dicut eum viuere. Et
abierunt quidam ex nris ad monu-
mentu: ita inuenerut sicut mulieres
dixerut: ipsum vero non inuenerut. Et
ipse dixit ad eos. O stulti z tardi corde
ad credendu in omnibus q locuti sunt
prophete. Nonne hec oportuit pati
christu: et ita intrare in gloriam sua? Et
incipiens a moyse z omnibus ppheriis:
interpretabat illis in omnibus scriptu-
ris que de ipo erant. Et apropinqua-
uerut castello quo ibant: z ipse se finxit
longius ire. Et coegerut illu dicentes.

Mane nobiscu quoniam aduespera-
scit: z inclinata est iam dies. Et intrauit
cum illis. Et factum est dum recumbe-
ret cum eis accepit pane: z benedixit ac fre-
git: z porrigebat illis. Et aperti sunt ocu-
li eor: z cognouerut eu: z ipse euanu-
it ex oculis eor. Et dixerut ad inuicem.
Nonne cor nostru ardens erat in nobis: dum
loqueretur in via: z aperiret nobis scri-
pturas? Et surgentes eadem hora re-
gressi sunt in iherusale: z inuenerut
congregatos vndecim: z eos qui cu illis
erant dicentes op surrexit dns vere: et
apparuit simoni. Et ipsi narrabant
gesta erant i via: z quomo cognouerut
eum in fractione panis. Dum autem
hec loquuntur: stetit ihesus in medio eo-
rum z dixit. Pax vobis. Ego su: nolite
timere. Conturbati vero z conterriti:
estimabant se spiritu videre. Et dixit
eis. Quid turbati estis: z cogitationes
ascendunt in corda vestra? Videte ma-
nus meas z pedes: quia ego ipse sum.
Palpate z videte: quia spiritus carne
et ossa non habet: sicut me videtis ha-
bere. Et cum hoc dixisset: ostendit e-
is manus z pedes. Adhuc aut illis
non credentibus z mirantibus pre gau-
dio dixit. Habetis hic aliquid quod
manducet? At illi obtulerut ei parte
piscis assi: z fauu mellis. Et cum madu-
casset coram eis: sumens reliquias de-
dit eis. Et dixit ad eos. Hec sunt verba
q locutus su ad vos cu adhuc essem vo-
biscu: quoniam necesse est impleri omnia
que scripta sunt in lege moysi et prophe-
tis z psalmis de me. Tunc aperuit illis
sensum: ut intelligerent scripturas: z di-
xit eis. Quoniam sic scriptu est: z sic opor-
tebat christu pati z resurgere a mortuis
tercia die: z pdicari in nomine ei9 peni-
tentiam z remissione peccator in omnes

gentes: incipientibus ab iherosolima.
Vos aut testes estis hor. Et ego mit-
tam promissum patris mei i vos: vos
aut sedete in ciuitate: quoadusq indu-
amini virtute ex alto. Eduxit aut eos
foras in bethaniam: z eleuatis mani-
bus suis benedixit eis. Et factum est
dum benediceret illis recessit ab eis: z fereba-
tur in celum. Et ipsi adorantes regressi
sunt in iherusalem cum gaudio ma-
gno: et erant semper in templo lau-
dantes et benedicentes deum amen.
Explicit euangeliu secundum lucam. Incipit
prologus in euangeliu secundum Johanem.

Hic est iohannes euange-
lista vn9 ex discipulis dni:
qui virgo a deo electus e:
que de nuptijs volentem
nubere vocauit deus. Cui virginitatis
in hoc duplex testimoniu datur in eu-
angelio: op z pre ceteris dilectus a deo
dicit: z huic matrem sua de cruce com-
mendans dns: ut virgine virgo serua-
ret. Denique manifestans in euangelio
op erat ipse incorruptibilis verbi opus
inchoans: solus verbu carne factum
esse: nec lumen a tenebris comprehensu
fuisse testatur: primu ponens op d
in nuptijs fecit dns ostendens op ipse
erat: ut legentibus demonstraret op ubi
dns inuitatus sit deficere nuptiar vi-
num debeat: z veteribus immutatis
noua omnia que a christo instituunt
appareat. Hoc aut euangeliu scripsit in
asia: postea op in pathmos insula apo-
calipsim scripserat: ut cui i principio ca-
nonis incorruptibile principiu pnotat
in genesi: ei etia incorruptibilis finis
p virgine i apocalipsi redderet dicente
christo ego sum alpha et o. Et hic e io-
hanes: qui sciens superuenisse diem re-
cessus sui. Conuocans discipulos suos

in ephesu: per multa signor experimen-
ta: pmens cristu descendens i defossu
sepulture sue locu facta oratione: po-
situs est ad patres suos: tam extrane-
us a dolore mortis op z a corruptione car-
nis inuenitur alienus. Tamen post o-
mnes euangeliu scripsit: z hoc virgini
debetur. Quor tamen vel scriptor tepo-
rio dispositio: vel libror ordinatio ideo
a nobis per singula non exponitur:
ut sciendi desiderio collato et queren-
tibus fructus laboris: z deo magiste-
rij doctrina seruetur. Explicit prologus
Incipit euangeliu secundum iohannem.

In principio erat verbu: z verbu erat
apud deu: et de9 erat verbu. Hoc erat
in principio apud deu. Omnia p ipm
facta sunt: z sine ipo factum est nichil.
Quod factu est in ipo vita erat: z vita
erat lux hominu: et lux in tenebris lu-
cet: z tenebre eam non comprehenderut. Fu-
it homo missus a deo: cui nomen erat io-
hanes. Hic venit i testimoniu: ut testi-
moniu phiberet de lumine: ut omnes
crederent per illu. Non erat ille lux: sed ut
testimoniu phiberet de lumine. Erat
lux vera: que illuminat omne homi-
nem venientem in hunc mundu. In mu-
do erat: z mundus p ipm factus est: et
mundus eu non cognouit. In propria ve-
nit: z sui eu non receperut. Quotquot aut
receperut eu: dedit eis potestatem filios
dei fieri: hijs qui credunt in nomine ei9.
Qui non ex sanguinibus neq ex volun-
tate carnis: neq ex voluntate viri: sed
ex deo nati sunt. Et verbu caro factum
est: z habitauit in nobis. Et vidimus
gloriam ei9: gloriam quasi unigeniti a
patre: plenum gratie z veritatis. Iohan-
nes testimonium phibet de ipo: z cla-
mat dicens. Hic erat que dixi: op post
me venturus est: ante me factus est:

aut sedere in ciuitate · quoadusq; induamini virtute ex alto. Eduxit aut eos foras in bethaniam: ⁊ eleuatis manibus suis benedixit eis. Et factū est dū benediceret illis recessit ab eis: ⁊ ferebatur in celum. Et ipsi adorantes regressi sunt in iherusalem cum gaudio magno: et erant semper in templo laudantes et benedicentes deum amen.

Explicit euāgeliū scdm lucā. Incipit prologus ī euangeliū scdm Iohannē.

Ic est iohannes euangelista vn⁹ ex discipulis dn̄i: qui virgo a deo electus ē: quē de nuptijs volentem nubere vocauit deus. Cui virginitatis in hoc duplex testimoniū datur in euangelio: q̄ et pre ceteris dilectus a deo dicit: et huic matrem suā de cruce commendauit dn̄s· ut virginē virgo seruaret. Deniq; manifestans in euangelio q̄ erat ipe incorruptibilis verbi opus inchoans· solus verbū carne factum esse· nec lumen a tenebris cōprehensū fuisse testatur: primū signū ponens qd in nuptijs fecit dn̄s ostendens q̄ ipe erat: ut legentibz demonstraret q̄ ubi dn̄s inuitatus sit deficere nuptiaz vinum debeat: et veteribus immutatis· noua omnia que a cristo instituunt appareat. Hoc aut euāgeliū scripsit in asia· postea q̄ ī pathmos insula apocalipsim scripserat: ut cui ī principio canonis icorruptibile principiū p̄notat

positus est ad patres suos: tam extranea dolore mortis q̄ a corruptione carnis inuenitur alienus. Tamen post omnes euāgeliū scripsit: ⁊ hoc virgini debetur. Quorz tamē uel scriptoz temporis dispositō· uel libroz ordinatio ideo a nobis per singula non exponitur: ut sciendi desiderio collato et querentibus fructus laboris: ⁊ deo magisterij doctrina seruetur. Explicit prologus. Incipit euangeliū scdm iohannem.

A principio erat verbū: ⁊ verbū erat apud deū: et de⁹ erat verbū. Hoc erat in principio apud deū. Omnia p ipm facta sunt: ⁊ sine ipo factum est nichil. Quod factū est in ipo vita erat: ⁊ vita erat lux hominū: et lux in tenebris lucet: ⁊ tenebre eā nō comphenderūt. Fuit homo missus a deo: cui nomē erat iohānes. Hic venit ī testimoniū ut testimoniū phiberet de lumine: ut omnes crederent p illū. Nō erat ille lux: sed ut testimoniū phiberet de lumine. Erat lux vera: que illuminat omnē hominem venientem in hūc mundū. In mūdo erat: ⁊ mūdus p ipm factus est: et mūdus eū non cognouit. In propria venit: ⁊ sui eū nō receperūt. Quotqt aut receperūt eū· dedit eis potestatem filios dei fieri: hijs qui credūt in nomine ei⁹. Qui nō ex sanguinibz neqz ex voluntate carnis· neqz ex volūtate viri: sed ex deo nati sunt. Et verbū caro factum est: et habitauit in nobis. Et vidimus

remained essentially unchanged for centuries. A letter form was carved in relief at the end of a steel punch. The letter was punched into a matrix, which was then placed in a width-adjustable hand-mould. A hot lead alloy was poured into the mould, and when it cooled the type was cast. Pieces of type were then assembled in formes, and covered with an oil-based ink which would stick to the metal. Impressions of the inked forme were made on paper or parchment by applying considerable force using an apparatus like a wine press with a large, flat platen.

The printing of the Gutenberg Bible was a turning-point in European culture, but what is truly remarkable is that the first large-scale printed book in Europe should also be one of the finest. Gutenberg's type is a faithful rendering of the Gothic Textura script used for handwritten bibles and liturgical books at this period in Germany. It contains around 270–80 different characters, including capital and lower-case letters, punctuation marks, ligatures, abutting sorts, and the innumerable abbreviations familiar to readers at the time. For every page of the Bible about 2,500 of these small pieces of metal were set tightly together and, when, printed, produced black-and-white pages that are eminently readable and have an abstract beauty. The quality of the printing itself is uniformly high and the ink is a rich black. Rarely has a new technology been used with such sure-footed skill and artistry.

Of the copies of the Gutenberg Bible that once existed, forty-eight survive reasonably intact today, twelve on parchment and the rest on paper. Another dozen or so are preserved only as fragments. The present, perfect copy is on paper. It is shown open at the beginning of St John's Gospel.[2]

Notes

1 Ing 1998, pp. 66–8.
2 I am grateful to Eric White for his assistance with this entry.

35

WILLIAM CAXTON (*c.* 1415–1492)

Advertisement for the Sarum *Ordinal* or *Pye*

Westminster: William Caxton, *c.* 1477

Single leaf; 80 × 146 mm

Provenance: Francis Douce (1757–1834), who bequeathed it to the Bodleian

Exhibitions: Oxford 1984, no. 113; London 1976, no. 32

Literature: Bod-inc. C-155

Arch. G e.37 [recto illustrated]

This small notice was designed for public display on a wall or a door. The English text reads:

If it plese any man spirituel or temporel to bye any pyes of two and thre comemoracions of Salisburi use enpryntid after the forme of this present lettre whiche ben wel and truly correct, late hym come to westmonester in to the almonesyre at the reed pale and he shal have them good chepe

Below it is a request in Latin: 'Supplico stet cedula' ('Pray do not remove this notice'). It is the earliest surviving advertisement for a printed book in English publishing history,[1] and comes from the Westminster print shop of the man who brought printing to England – William Caxton. Ironically, the book it promotes, the Sarum *Ordinal* or

Pye, a guide to the annual liturgy for the priests of Salisbury and elsewhere, has not survived. Just eight leaves of it remain, found by chance among the press-waste that made up the binding of a copy of Caxton's edition of Boethius.

Readers of the notice are invited to Caxton's premises, a house named The Red Pale at the almonry near Westminster Abbey. This was an excellent place to capture a passing trade of clergy, courtiers and politicians. Caxton was a former merchant and ambassador who learned the art of printing in late middle age, in Bruges. He set up his shop in England very much as a business enterprise, and maintained a balanced list of titles, both religious and lay ('spirituel or temporel'), for 'many and diverse gentylmen' as he puts it in his second edition of Chaucer's *Canterbury Tales*. He also published his own translations of Latin and French texts.

Caxton's lively entrepreneurial instincts are illustrated not only in this advertisement but in the engaging prefaces and epilogues which he included in his books. In the epilogue

to *Tullius of Olde Age* (1481), for instance, he writes:

This endeth the boke of Tulle of olde age translated out of latyn in to frenshe by laurence de primo facto at the comaundement of the noble prynce Lowys Duc of Burbon and enprynted by me symple persone William Caxton in to Englysshe at the playsir solace and reverence of men growyng in to olde age the xij day of August the yere of our lord. M.CCC.lxxxj:[2]

Sometimes Caxton would enter into a dialogue with his readers and critics. He apologized for his 'rude and common English', but equally, he often employed the most ornate style. He found himself, he said in the prologue to the *Eneydos*, caught between those who wished for 'curious' expressions, and those who preferred 'old and homely' terms.

Notes

1 There is one other copy, in the John Rylands Library, University of Manchester (JRL 23122).
2 Crotch 1928, p. 44.

If it plese ony man spirituel or temporel to bye ony pyes of two and thre comemoracios of salisburi vse enpryntid after the forme of this preset lettre whiche ben wel and truly correct, late hym come to westmonester in to the almonesrye at the reed pale and he shal haue them good chepe ·∴·

Supplico stet cedula

36

After HANS HOLBEIN THE YOUNGER (1497–1543)

Desiderius Erasmus (1466–1536)

Late Tudor copy of original portrait of 1523

Oil on English oak panel, 724 × 533 mm

Provenance: Given to the University of Oxford in 1721 by Sir James Thornhill (1675/6–1734)

Literature: Lane Poole, vol 1, no. 26; Garlick, p. 122

LP 26

This is a copy of a portrait of Erasmus by Hans Holbein in the Longford Castle Collection, currently on loan to the National Gallery, London. It was given to Oxford University by the painter Sir James Thornhill, best known for his decorations of the dome of St Paul's Cathedral and the Painted Hall in the Royal Naval Hospital, Greenwich.

Appropriately, Erasmus is shown in the company of books, for the reputation he enjoyed as the foremost intellectual and humanist of his day was thanks in no small part to his brilliant use of the printing press. Realizing that with affordable printed books he could reach large audiences, he produced the first European bestsellers: *Adages*, a slim collection of proverbs, first published in 1500, and his satire *Praise of Folly*, written in just one week in 1509 and first published in 1511.

A book on the back shelf in the original portrait bears a Latin couplet which translates as: 'I am Johannes [i.e. Hans] Holbein, whom it is easier to denigrate than to emulate'. This is a witty reference to one of the proverbs Erasmus had examined at length in the *Adages*, and which, in the portrait, is written on the book under his hands: *The Labours of Hercules*. Erasmus observes how often excellence, the fruit of great labour, inspires envy and mean-minded criticism:

Here's your chance then, here's a splendid reward on offer for all those protracted nights of study, all those efforts, all those sacrifices. Cut yourself off from the pleasures of human life that all men share, neglect your worldly affairs, have no mercy on your appearance, sleep, or health. Never mind loss of eyesight, bid old age come before its time, think nothing of the life you've lost; and the result will be to arouse the dislike of very many people and the ill-will of even more, and in return for all those nights of toil to win a few snorts of contempt.[1]

A second, greatly enlarged, edition of the *Adages* was published in Venice in 1508 by Aldus Manutius, the brilliant scholar-printer of Venice. It is an example of what can be achieved when an author and a printer collaborate closely. Erasmus made the journey to Venice and became in effect a member of Aldus's household, taking full advantage of the printer's private library ('Aldus had nothing in his treasure-house that he did not share with me').[2] At Aldus's printing works he would sit in one corner writing text, which he would then pass to the compositor to set up. Meanwhile in another corner Aldus would sit looking over proofs. Erasmus recalled that they worked together like this for nine months. When it was printed, the *Adages* contained 3,260 proverbs accompanied by Erasmus's learned explanations. It sold in large numbers and spread Erasmus's name throughout Europe.

Notes
1 Barker 2001, p. 224.
2 Ibid., p. 148.

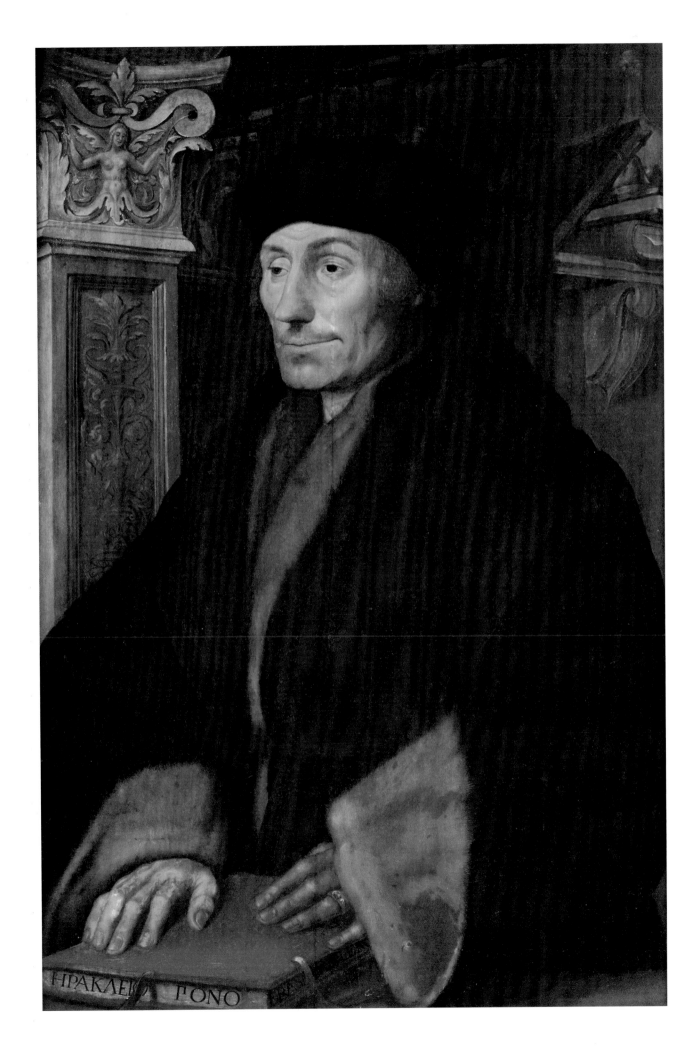

37

SIR THOMAS MORE (1478–1535)

Utopia

Louvain: Thierry Martens, 1516

In Latin; 108 pages, 192 × 136 mm
Nineteenth-century English binding by Thompson: green goatskin with blind and gold tooling

Provenance: Purchased by the Bodleian in 1952

Exhibition: Oxford 2002b, no. 9

Arch. B e.44 *[pp. 2–3 illustrated]*

In Thomas More's famous work an explorer and sailor called Raphael Hythloday describes his visits to an island called Utopia ('Nowhere land'). The authoritarian laws of English society are critically compared to those on Utopia, where all things are owned in common, there is universal state education for men and women, and differences in religious beliefs are tolerated. It is not so much a vision of an ideal state, however, as an enquiry into the possibility of good government, and it provokes as many questions as it answers.

More entrusted the task of seeing *Utopia* through the press to his friend Erasmus, asking if the book could be 'handsomely set off with the highest of recommendations, if possible, from several people, both intellectuals and distinguished statesmen'.[1] Erasmus duly asked friends to write letters and poems praising the book, in a manner similar to the cover quotes used by publishers today.

Preceding the text was a letter from More to his friend Peter Giles (*c.* 1486–1533), a humanist scholar and the city clerk of Antwerp. More wittily

maintains that *Utopia* is not the product of his imagination but a verbatim account of a real encounter he and Giles had with Hythloday. He regrets not asking Hythloday where the island of Utopia is located, and asks Giles to send the sailor a copy of the text for his approval. Giles maintains this pretence in a letter by him to Jérome de Busleyden, a Burgundian statesman and patron of learning, published after the main text:

As often as I read it, I seem to see even more than I heard from the actual mouth of Raphael Hythloday – for I was present at his discourse as much as More himself…. It was perfectly plain that he wasn't just repeating what he had heard from other people but was describing exactly what he had seen close at hand with his own eyes and experienced in his own person, over a long period of time…. For the rest, I can add nothing to what he has written. There is, indeed, a quatrain written in the Utopian tongue, which Hythloday showed to me after More had gone away. I've prefixed to it the alphabet of the Utopians, and added to the volume some marginal notes.[2]

The vagueness of the location of Utopia Giles explains as follows: Hythloday mentioned it only briefly, and while he was doing so More was distracted by a servant whispering something in his ear; and he (Giles) could not hear

Hythloday because one of the company, 'who I suppose had caught a cold on shipboard', coughed loudly. But he would not rest, he said, until he had discovered the exact latitude.

The book also included a map of the island and, on the opposite page, a Utopian alphabet devised by Giles. A quatrain was printed in Utopian characters, with a gloss in roman and a Latin translation, which may itself be translated as follows:

Me, once a peninsula, Utopus the king made an island.
Alone among all nations, and without complex abstractions,
I set before men's eyes the philosophical city.
What I give is free; what is better I am not slow to take from others.[3]

In addition, there was a six-line poem of unknown authorship purporting to be by the Utopian poet laureate, but also provided by Giles.

Utopia was enormously popular. Further editions followed in 1517 (Paris) and 1518 (Basle), and it was translated into English, French, German, Italian and Spanish.

Notes

1 Logan 2011, p. 127.
2 Ibid., pp. 129–31.
3 Ibid., p. 68.

VTOPIAE INSVLAE FIGVRA

VTOPIENSIVM ALPHABETVM.

a b c d e f g h i k l m n o p q r s t v x y

Tetrastichon vernacula Vtopiensium lingua.

Vtopos ha Boccas peu la

chama polta chamaan

Bargol he maglomi baccan

soma gymno sophaon

Agrama gymnosophon labarembacha

bodamilomin

Voluala barchin heman la

lauoluola dramme pagloni.

Horum versuum ad verbum hæc est sententia,
Vtopus me dux ex non insula fecit insulam
Vna ego terrarum omnium, absq; philosophia
Ciuitatem philosophicam expressi mortalibus
Libéter impartio mea, nó grauatim accipio meliora.

38

ALBRECHT DÜRER (1471–1528)

Apocalypsis (The Apocalypse)

Nuremberg: Hieronymus Höltzel, 1511

Woodcuts
In Latin; sixteen leaves, 480 × 322 mm
Bound with reissues of Dürer's *Life of the Virgin*
and *Large Passion* in contemporary Nuremberg roll
binding: brown calfskin over wooden boards with
blind and metal foil tooling (now tarnished)

Provenance: Probably purchased from Hans Adam von
Reisach in 1820 by Francis Douce (1757–1834), who
bequeathed it to the Bodleian

Exhibitions: Oxford 1984, no. 138; Oxford 1994, no. 21

Douce D subt. 41 [fol. 5r illustrated]

Dürer was the first major artist to realize the visual potential of the technology of printing. He took the wood engraving and the woodcut to new levels of technical virtuosity and artistic expression. When he set up his print workshop in Nuremberg in 1495 it was with the express purpose of making a living, and indeed the engravings of the Apocalypse he published three years later in 1498 did make him a good deal of money; but engraving had the additional benefit of artistic independence. What he published himself was probably closer to his own vision than larger commissions such as altarpieces, where he was guided by the wishes of his patron.

The fifteen full-page woodcuts that made up Dürer's *Apocalypse* are in the tradition of the great medieval illuminated manuscripts of the book of Revelation (see cat. 122). Their immediate impact can hardly be overestimated, and their long-term influence was profound; copies appeared not only in Germany, but in France, Italy and Russia.

This is the second edition of the *Apocalypse*, which Dürer published in 1511 along with new editions of two other series of engravings, the *Life of the Virgin* and the *Large Passion*. He drew these different works together by giving each a new frontispiece of a similar style. They were carefully aimed at a wealthy local audience, and here the *Apocalypse* is bound together with the other two series in a contemporary Nuremberg fine binding.

With each engraving Dürer concentrates several episodes into a single, highly dramatic image. Shown here is the most celebrated of these images. The four horsemen of the Apocalypse arrive when the Lamb with Seven Horns and Seven Eyes takes a scroll from Christ and breaks its seven seals. In the Book of Revelation (6:2–8), the horsemen appear one after the other; in Dürer's astonishing engraving they arrive all at once, and trample humanity underfoot with an irresistible forward movement and a terrible implacability:

And I saw, and behold a white horse: and he that sat on him had a bow; and a crown was given unto him: and he went forth conquering, and to conquer.

And when he had opened the second seal, I heard the second beast say, Come and see.

And there went out another horse that was red: and power was given to him that sat thereon to take peace from the earth, and that they should kill one another: and there was given unto him a great sword.

And when he had opened the third seal, I heard the third beast say, Come and see. And I beheld, and lo a black horse; and he that sat on him had a pair of balances in his hand.

And I heard a voice in the midst of the four beasts say, A measure of wheat for a penny, and three measures of barley for a penny; and see thou hurt not the oil and the wine.

And when he had opened the fourth seal, I heard the voice of the fourth beast say, Come and see.

And I looked, and behold a pale horse: and his name that sat on him was Death, and Hell followed with him. And power was given unto them over the fourth part of the earth, to kill with sword, and with hunger, and with death, and with the beasts of the earth.

Obſerv. XXXIX. *Of the Eyes*
and of ſeveral other creatures.

I took a large grey *Drone-Fly*, tha
ſlender body in proportion to it, a
the forepart or face upwards upon n
or rather then the head of a great blu
about the eyes, I found this Fly to h
in proportion to his head, of any ſma
being ſomewhat inclining towards
Next, becauſe there is a greater v
cluſter, then is of any ſmall Fly) The
manner, by varying the degrees of
kinde of light, I drew that repreſe
the 24. *Scheme*, and found theſe th
notable and pleaſant.

Firſt, that the greateſt part of the
but two large and *protuberant* bunch
ſurface of each of which was all cov
of ſmall *Hemiſpheres*, plac'd in a *tria*
moſt compacted, and in that order
eye in very lovely rows, between e
long and regular trenches, the botto
intire, and not at all perforated or d
was aſſured of, by the regularly ref
I mov'd to and fro between the he
the *Cornea* or outward ſkin, after I
ſtances that lay within it, and by lo
the light.

Next, that of thoſe multitudes
two degrees of bigneſs, the half of
toward the ground or their own
pretty deal ſmaller then the other,
upward, and ſide-ways, or forerigh
not found in any other ſmall Fly.

Thirdly, that every one of theſe
ty neer the true ſhape of a *Hemi*
ſmooth and regular, reflecting as
any Object from the ſurface of the
that bigneſs would do, but nothing
being very languid, much like the
Glaſs, Cryſtal, &c. In ſo much th
been able to diſcover a Land-ſcap

39

ROBERT HOOKE (1635–1703)

Micrographia

London: the Royal Society, 1665

Copper engravings
292 pages and thirty-eight plates, 295 × 195 mm
Contemporary English binding: brown calfskin with
blind tooling

Provenance: Martin Lister (1638–1712); bequeathed by
him to the Ashmolean Museum; transferred to the
Bodleian in 1860

Exhibition: Tokyo 1990, no. 68

Lister E 7 [plate xxiv illustrated]

Micrographia: or some Physical Descriptions of minute Bodies made by Magnifying Glasses was the first work in English to publish observations made under the microscope. Among the minute natural structures it revealed for the first time were 'the Sting of a Bee'; 'Peacocks Feathers'; 'the Feet of Flyes, and other Insects'; 'the Head of a Fly'; 'the Teeth of a Snail'; 'the Beard of a wild Oat' and 'Diamonds in Flints'.

Hooke exploited the possibilities of the printed book to produce something that was both scientifically ground breaking and accessible. One prominent reader of the work was Samuel Pepys, who dabbled in microscopy. On 2 January 1665 he noted the newly published *Micrographia* in his diary: 'Thence to my bookseller's and at his binders saw Hookes book of the Microscope, which is so pretty that I presently bespoke it.' On 20 January Pepys received the book he had ordered: 'so to my booksellers and there took home Hookes book of Microscopy, a most excellent piece, and

of which I am very proud … Before I went to bed, I sat up till 2 a-clock in my chamber, reading of Mr Hookes Microscopicall Observacions [*sic*], the most ingenious book that ever I read in my life'.[1]

'Ingenious' was a favourite word of praise among the gentlemen scientists of the Royal Society and is particularly apt for *Micrographia*. At the end of his *Experimental Philosophy* (1664), the first part of which dealt with microscopy, Henry Power noted:

These are the few Experiments that my Time and Glass hath as yet afforded me an opportunity to make … But you may expect shortly from Doctor Wren, and Master Hooke, two Ingenious Members of the Royal Society at Gresham, the Cuts and Pictures drawn at large, and to the very life of these and other Microscopical Representations.

In *Micrographia* Hooke refers to 'the ingenious Dr Power' as well as to 'the most ingenious *Des Cartes*', 'the eminently Ingenious and Learned Physician, Doctor *Ent*', 'the ingenious Monsieur *Hugens van Zulichem*' and 'the most Ingenious and Excellent *Physician*, Doctor *Clark*'.

It has been suggested that some of the drawings for *Micrographia* were made by Hooke's friend Christopher Wren (whose 'ingenious Invention … of injecting liquors into the vein of

an animal' is praised in the text). The engraving shown here, one of the most striking in the book, illustrates Observation XXXIX, 'Of the Eyes and Head of a Grey drone-Fly, and of several other creatures'. The compound eyes are wonderfully rendered in the engraving, as are the textures of different parts of the head, creating something extraordinarily immediate. The engraving is accompanied by a characteristically lively text:

every one of these Hemispheres, as they seem'd to be pretty neer the true shape of a Hemisphere, so was the surface exceeding smooth and regular, reflecting as exact, regular, and perfect an Image of any Object from the surface of them, as a small Ball of Quick-silver of that bigness would do, but nothing neer so vivid, the reflection from these being very languid, much like the reflection from the outside of Water, Glass, Crystal, &c. In so much that in each of these Hemispheres, I have been able to discover a Land-scape of those things which lay before my window, one thing of which was a large Tree, whose trunk and top I could plainly discover, as I could also the parts of my window, and my hand and fingers, if I held it between the Window and the Object …

Note
1 Latham and Matthews 1970–83, vi,
 pp. 2, 17–18.

40

WILLIAM BLAKE (1757–1827)

Songs of Innocence

London: William Blake, 1789

Hand-coloured copper engravings
Fifteen leaves, 190 × 138 mm
Early twentieth-century binding (before 1940) by
Zaehnsdorf: brown goatskin

Provenance: Miss A.G.E. Carthew; bequeathed by her
to the Bodleian in July 1940

Exhibitions: Oxford 1984, no. 137; Paris 2009, no. 16

Literature: Eaves et al. 1993

Arch. G e.42 [fols. 9v–10r illustrated]

In a prospectus of 1793 the artist and
poet William Blake made the following
confident announcement:

*The Labours of the Artist, the Poet,
the Musician, have been proverbially
attended by poverty and obscurity; this
was never the fault of the Public, but was
owing to a neglect of means to propagate
such works as have wholly absorbed
the Man of Genius. Even Milton and
Shakespear could not publish their own
works.*

*This difficulty has been obviated by
the Author of the following productions
now presented to the Public; who has
invented a method of Printing both
Letter-press and Engraving in a style
more ornamental, uniform, and grand,
than any before discovered, while it
produces work at less than one fourth of
the expense.*[1]

Blake's great claim was to have
discovered a means whereby
the products of genius, formerly
condemned to obscurity, could reach
the public without the dilutions and
distortions of middle-men such as
publishers. Instead of employing the
usual methods of printing (text was
produced with moveable metal type,
images were engraved onto separate
copper plates or woodblocks), Blake
devised a form of etching in relief on
copper which allowed him to arrange
text and images on the same plate in
complex compositions. His wholly
original approach enabled him to
produce 'illuminated books' which were
written, illustrated, printed, coloured
and distributed by himself – a complete
form of self-publishing.

The plates could, in theory, be used
again and again to produce sizeable
editions. In practice, however, the
process was difficult, laborious and
time consuming and did not produce
the kind of revolution that Blake had
foreseen in his 1793 prospectus. Each
production was in effect a combination
of the mechanized and the handmade.
Nevertheless, Blake's illuminated
books provided the ideal vehicle for his
singular prophetic vision in a way that
conventional printed books never could
have, and encouraged his stubborn
belief, against all experience, that he
was a public artist who could reach the
largest possible audience.

Blake developed his illuminated
printing method around 1788 and
first used it with complete success in
Songs of Innocence, which appeared the
following year, 'The Author & Printer
W Blake'. It is a collection of charming
pastoral poems which, compared to
the obscurities and complexities of
his large prophetic books, are highly
approachable. It was a title he could
turn to when he needed money and
he produced copies of it for the rest of
his life in various forms, sometimes
together with his complementary *Songs
of Innocence*. This copy contains 'Voice
of the Ancient Bard' and 'The School
Boy' (usually in *Songs of Experience*),
but it is missing 'A Dream'.

Note

1 Bentley 2001, vol. 1, p. 201.

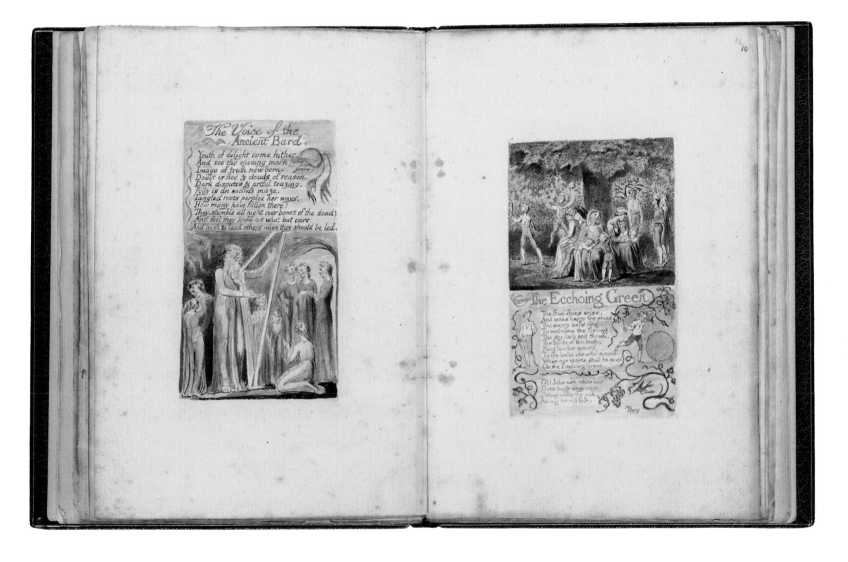

JOHN JAMES AUDUBON (1785–1851)

The Birds of America

London: John James Audubon, 1827–38

Hand-coloured copper engravings by W.H. Lizars (1788–1859), Robert Havell, Sr (1769–1832) and Robert Havell, Jr (1793–1878)
435 plates (645 × 975 mm) in four volumes, arranged according to families, as listed in Audubon's *A Synopsis of the Birds of North America*, 1839
English binding, *c*. 1900: half calfskin over blue linen boards

Provenance: Radcliffe Library, University of Oxford, by subscription ('Dr Williams, for Radcliffe College'); the Bodleian assumed responsibility for the Radcliffe Library in 1927

Literature: Fries 1974, pp. 29, 146, 167, 175, 338, 447

Arch. G a.1 [plate 76 illustrated]

'I have finally determined to break through all bonds and pursue my ornithological pursuits', the 39-year-old John James Audubon wrote in his journal in 1823:

My best friends regarded me as a madman, and my wife and family alone gave me encouragement. My wife determined that my genius should prevail, and that my final success as an ornithologist should be triumphant.[1]

Audubon's final success was indeed triumphant: his monumental *Birds of America*, which he completed in 1838. The enormous scale of this enterprise is best summed up by the facts: eleven years in the making (not counting years of preliminary drawing); 435 plates containing 497 species, all presented life-size on the largest paper available at the time, double elephant folio, and all painstakingly engraved and hand-coloured from Audubon's original drawings; five accompanying text volumes detailing each species. According to an account drawn up afterwards by Audubon, the cost of all this was £28,910 13s 7d ('Not calculating any of my expense, or that of my family for upwards 14 years').[2]

The genius of Audubon's work – the accuracy, the detail and above all the drama of his images – is as astonishing now as it was at the time. Never cheap (Audubon initially priced each five-plate set at 2 guineas), in 2010 *Birds of America* became the most expensive printed book ever sold at auction. And it was the prevailing genius of Audubon's singular personality that drove the publication forwards against all the odds. Much of the work was done in Britain, for only there could he find engravers with the skill to transfer his large drawings onto copper. And he did not make the engraver's life easy. In his search for perfection he put extreme pressure first on William Lizars of Edinburgh, and then on Robert Havell of London, and he complained constantly about the hand-colouring.

Audubon travelled Britain in search of subscribers, obtaining introductions to the great and the wealthy and mounting exhibitions of his drawings. With his flowing hair, frontier dress and strong accent (he was of Haitian descent and grew up in France) he had a magnetic presence; but he was out of his true element – the backwoods of North America – and spent untold hours finding and maintaining subscriptions and chasing customers for money. He also had to make three trips to America to make new drawings and find subscribers, and in all crossed the Atlantic eight times. 'Who would believe that a lonely individual, who landed in England without a friend in the whole country, and with only sufficient pecuniary means to travel through it as a visitor, could have accomplished such a task as this publication?' he wrote in his journal in 1831, with seven years of work still ahead of him.[3]

This complete set of *Birds of America* dates from Audubon's visit to Oxford in March 1828. The subscriber was George Williams, Regius and Sherardian Professor of Botany, on behalf of the Radcliffe Library. When he delivered the first set of plates to Dr Williams, Audubon was dismayed to find that they were below the required standard. 'Ah! Mr. Lizars was this the way to use a man who paid you so amply and so punctually?' he wrote in his journal, and sent a new set of five engravings as a replacement. Other than the Radcliffe Library, Audubon found only one other subscriber in Oxford, 'the Anatomical School of Christ Church College', and he left disappointed: 'I have been most hospitably treated, but with so little encouragement for my work there is no reason for me to remain.'[4]

Notes
1 Fries 1973, p. 3.
2 Ibid., p. 114.
3 Ibid., pp. 54–5.
4 Ibid., p. 29.

PLATE 76.

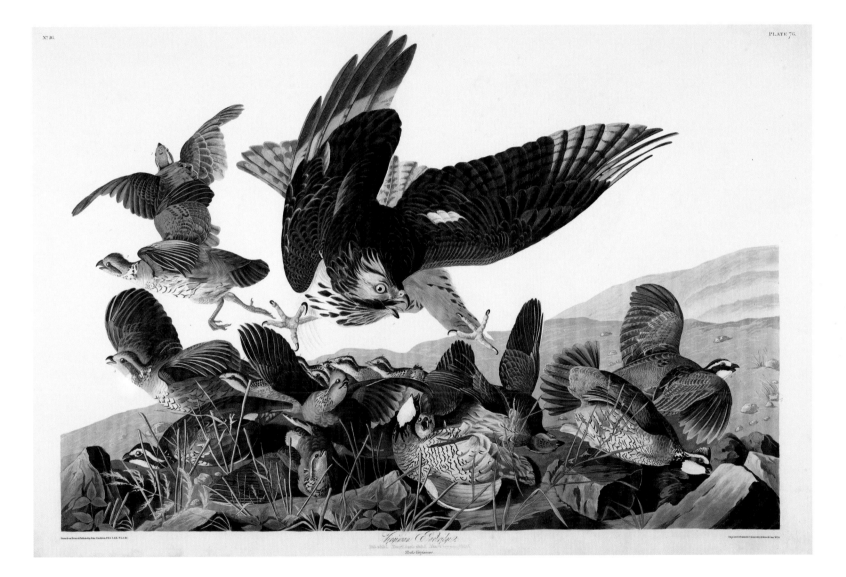

Virginian Partridge.

Hawk attacking a covey of Quail.
Perdix Virginiana

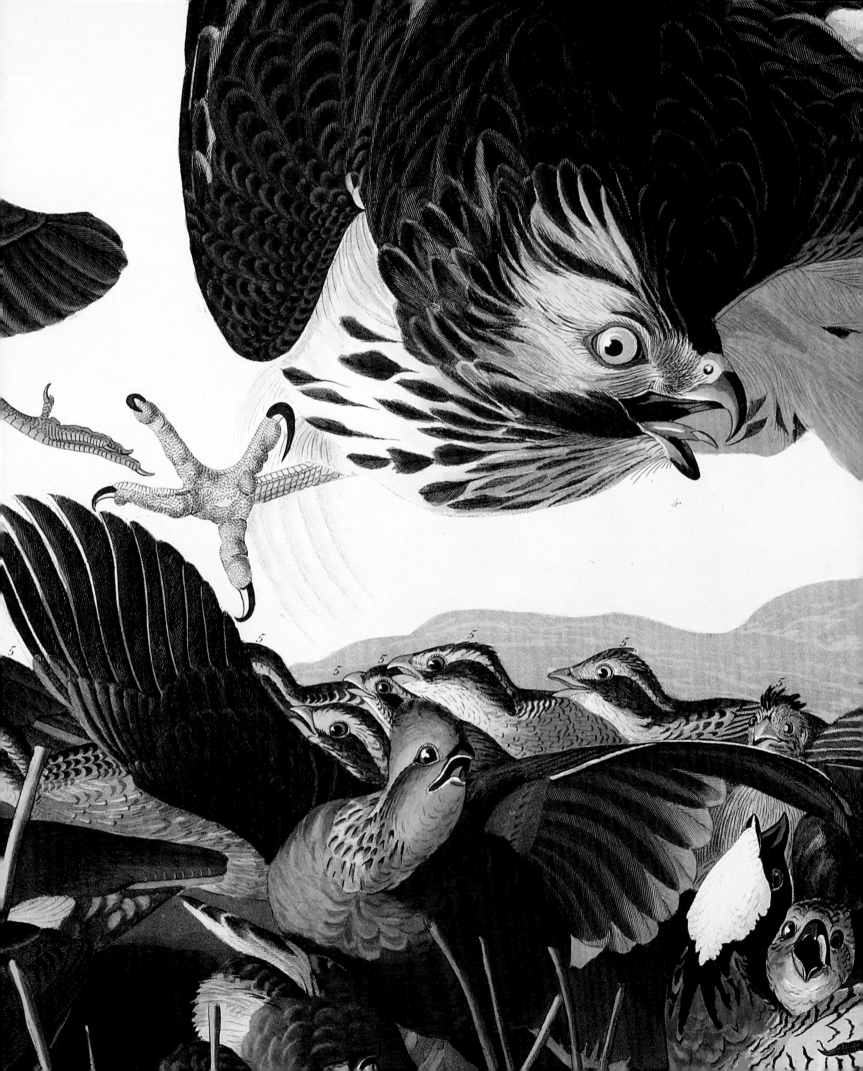

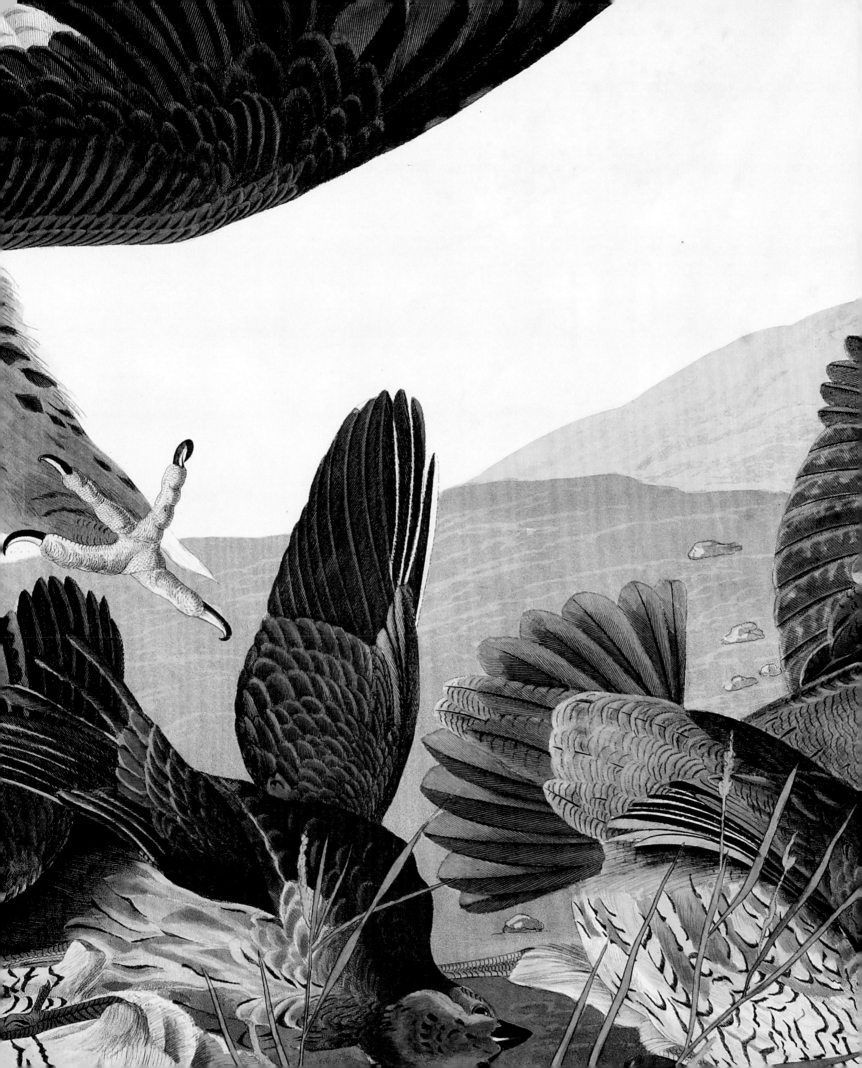

Cat. 42

42

WILLIAM HENRY FOX TALBOT (1800–1877)

Imitation of Printing

c. 1844

Paper contact negative, 187 × 223 mm

Provenance: Kept in the Talbot family archive; acquired by the Bodleian in 2013 with the assistance of the Art Fund (with a contribution from the Wolfson Foundation); the National Heritage Memorial Fund; the Friends of the National Libraries; PRISM, Arts Council England; Seven Pillars of Wisdom Trust; Headley Trust; and Friends of the Bodleian

Literature: R. Roberts, M. Gray and A. Burnett-Brown, *Specimens and Marvels: William Henry Fox Talbot and the Invention of Photography*, Aperture, New York, 2000, pp. 39–40

W.H.F. Talbot Archive, FT10008

43

Articles of Glass

Provenance: As cat. 42

Literature: L.J. Schaaf, *The Photographic Art of William Henry Fox Talbot*, Princeton University Press, Princeton, 2000, pp. 192–3

W.H.F. Talbot Archive, FT11198–11202

44

WILLIAM HENRY FOX TALBOT (1800–1877)

The Pencil of Nature

London: Longman, Brown, Green and Longmans, 1844–47

Pasted-in calotypes
Eighty leaves and twenty-four plates, 295 × 235 mm
Second half of nineteenth-century Oxford binding for the Bodleian: half brown calfskin over plain book-cloth; kept with original part wrappers

Provenance: Paget Toynbee (1855–1932), who presented it to the Bodleian

Exhibition: Oxford 2000, no. 1

Literature: L.J. Schaaf, 'Third Census of H. Fox Talbot's *The Pencil of Nature*', *History of Photography*, vol. 36, no. 1 (winter 2012), pp. 99–120; this copy is no. 14

Arch. K c.1,1 [plate IV illustrated]*

When William Henry Fox Talbot conducted his photographic experiments in the 1830s and 1840s, books were still produced using the centuries-old methods of movable type and relief and intaglio engraving on woodblocks or metal plates. Cat. 42, illustrated opposite, is the negative of a photograph taken by Talbot of a piece of printed type, which aptly reads 'Imitation of Printing'.

Here, and in *The Pencil of Nature* (cat. 44), which appeared in instalments between 1844 and 1847, Talbot was experimenting with photography's ability to reproduce different kinds of object. Each of the twenty-four plates that make up *The Pencil of Nature* is accompanied by a prose description written by Talbot. They evince his keen interest in the texture and composition of physical things, and in photography's unique ability to capture those textures.

In 'Imitation of Printing', and the photographs of printed pages and original drawings he included in

The Pencil of Nature, Talbot was also anticipating the scaleable photographic techniques that would eventually replace traditional printing. 'All kinds of engravings may be copied by photographic means', he wrote,

and this application of the art is a very important one, not only as producing in general nearly fac-simile copies, but because it enables us at pleasure to alter the scale, and to make the copies as much larger or smaller than the originals as we may desire.

Talbot admitted that his photographs were unlike the reproductions achieved by engraving in one respect: every one of them, he explained, was unique, for 'each plate is separately formed by the light of the sun', and the quality of the photographic paper varied. But the images had an objectivity that engravings lacked: 'plates of the ordinary kind [owed] their existence to the united skill of the Artist and the

Engraver', whereas photography created images 'without any aid whatever from the artist's pencil … [it is] the mere action of Light upon sensitive paper'. The abraded stone surfaces of old buildings, the endlessly repeated details of a thatched roof – these are things an artist would never trouble to reproduce precisely: 'contenting himself with a general effect, he would probably deem it beneath his genius to copy every accident of light and shade; nor could he do so indeed, without a disproportionate expenditure of time and trouble, which might be otherwise much better employed.'

Furthermore, argued Talbot, photographs were impartial, they were not influenced by an artist's visual or social prejudices: 'A whole forest of chimneys borders the horizon: for, the instrument chronicles whatever it sees, and certainly would delineate a chimney-pot or a chimney-sweeper with the same impartiality as it would the Apollo of Belvedere.' Human faces

Cat. 43

captured by the camera were bound to be truer than the painted portrait, which so often flatters the subject: 'What would not be the value to our English Nobility of such a record of their ancestors who lived a century ago? On how small a portion of their family picture galleries can they really rely with confidence!'

Shown here is the plate from *The Pencil of Nature* showing articles of glass, together with some of the original glassware (cat. 43) that has been preserved in the Talbot family archive. Talbot writes in his accompanying text:

The photogenic images of glass articles impress the sensitive paper with a very peculiar touch, which is quite different from that of the China in Plate III. And it may be remarked that white china and glass do not succeed well when represented together, because the picture of the china, from its superior brightness, is completed before that of the glass is well begun. But coloured china may be introduced along with glass in the same picture, provided the colour is not a pure blue: since blue objects affect the sensitive paper almost as rapidly as white ones do. On the contrary, green rays act very feebly – an inconvenient circumstance, whenever green trees are

Cat. 44

to be represented in the same picture with buildings of a light hue, or with any other light coloured objects.

Talbot's antiquarian interests are revealed in the later prints in *The Pencil of Nature*, which include a view of his home Lacock Abbey, and a number of views of Oxford colleges. He paints a pleasing picture of Oxford as it used to be in the summer months:

Those who have visited Oxford and Cambridge in vacation time in the summer must have been struck with the silence and tranquillity which pervade those venerable abodes of learning. Those ancient courts and quadrangles and cloisters look so beautiful so tranquil and so solemn at the close of a summer's evening, that the spectator almost thinks he gazes upon a city of former ages, deserted, but not in ruins: abandoned

by man, but spared by Time. No other city in Great Britain awakes feelings at all similar. In other towns you hear at all times the busy hum of passing crowds, intent on traffic or on pleasure – but Oxford in the summer season seems the dwelling of the Genius of Repose.

45

J.R.R. TOLKIEN (1892–1973)

Dust-jacket design for *The Hobbit*

1937

Pencil, pen and ink, watercolour and gouache,
250 × 380 mm

Provenance: Presented to the Bodleian in 1977 by the trustees of Tolkien's estate

Exhibitions: Oxford 1992b, no. 99; Canberra 2009, pp. 136–7

Literature: Scull and Hammond 1995

MS. Tolkien drawings 32

In 1967 J.R.R. Tolkien received a letter from Germany that appeared to propose an illustrated edition (either in German or English, he wasn't quite sure) of *The Lord of the Rings*. 'As far as English edition goes', he wrote to his publisher Rayner Unwin on 14 March, 'I myself am not at all anxious for *The Lord of the Rings* to be illustrated by anybody whether a genius or not.'[1] Illustrations by others were an invasion of his keenly imagined world.

Tolkien had illustrated his earlier book, *The Hobbit*, himself. Ten of his pen-and-ink drawings, and a map, were included in the first edition of 1937, published by Allen & Unwin. The Houghton Mifflin Company, Tolkien's American publisher, wanted to include colour plates in their edition and Allen & Unwin suggested to Tolkien that he draw these himself. Tolkien hesitated, as he was modest about his talents as an artist, but eventually made five watercolours in the summer of 1937, four of which were published in an American edition in 1938, and four in the second English impression that year.

Despite Tolkien's doubts, his artwork was sufficiently impressive for Allen & Unwin to ask him to design the dust jacket for *The Hobbit*. After several attempts Tolkien produced this watercolour, carefully sized according to the proportions of the covers and the width of the spine. This was the watercolour from which the printing was done, and Tolkien's detailed suggestions may be read in the margins, together with a few comments, more roughly written, by the printer. Tolkien had originally wanted the sun and the dragon to be printed in bright red and his marginal notes refer to this, as does Allen & Unwin's instruction to the printer (bottom left): 'Ignore red'. The long forest road to the Lonely Mountains is depicted on the spine, with night, the moon and the dragon on the left (i.e. the back of the book) and daylight, the sun and the eagles on the right (the front cover).

Tolkien also advised his publishers on the typography and binding, and made several revisions to the illustrated binding case.

Note

1 Scull and Hammond 2006, vol 2 (chronology), p. 692.

Perched on the Shoulders of Giants

In hindsight, the religious, artistic and scientific endeavours of any given period are dominated by a number of pre-eminent works and by a few commanding names, designated 'the greatest geniuses' by eighteenth-century writers. Leading figures have taken knowledge forward, but never claimed that their abilities surpassed those of their great predecessors. The twelfth-century theologian Bernard of Chartres, as reported by John of Salisbury, had a memorable phrase:

Bernard of Chartres used to compare us to dwarfs perched on the shoulders of giants. He pointed out that we see more and farther than our predecessors, not because we have keener vision or greater height, but because we are lifted up and borne aloft on their gigantic stature.[1]

These words were echoed in the seventeenth century by Isaac Newton, the greatest scientist of his day (cat. 52).

A lasting authority has been bestowed on certain works, and this is eloquently expressed in copies that have been made of them. A fine ninth-century manuscript of Euclid's *Elements*, copiously annotated by its first owner (cat. 46), was a part of a movement then flourishing in Byzantium in which the most highly regarded texts of classical Greece were copied and preserved. A beautiful manuscript of the Rule of St Benedict (cat. 47) was made with devotion in early eighth-century England, when the Benedictine order was still fully to establish itself in that country. A translation of Gregory I's *Pastoral Care* (cat. 48) was commissioned by Alfred the Great at the end of the ninth century as part of his revival of English learning after years of war.

Important scientific developments have taken authoritative texts for their starting-point. Ptolemy's great mapping of the earth and the heavens served as the models for astronomical and geographical work for centuries, and formed the basis of works by tenth-century Islamic court astronomer al-Ṣūfī (cat. 49) and the twelfth-century Arab geographer al-Idrīsī (cat. 50). Ptolemy's *Geography* dictated the form of the first atlases printed in the West, even after the discoveries of the great fifteenth-century explorers (cat. 51). The work of the classical Greek physician Dioscorides was absorbed by Islamic scholars (cat. 54) and inspired one of the most ambitious publishing ventures of the nineteenth century, John Sibthorpe's *Flora Graeca* (cats 55–6).

Notes
1 McGarry 1955, p. 167.

46

EUCLID (*fl.* 300 BC)

Stoicheia (Elements)

Constantinople, completed September AD 888

This version edited by Theon of Alexandria
(*c.* 335 – *c.* 405)
In the hand of Stephanos the clerk, with extensive
marginal notes by Arethas of Patrae (Bishop of
Caesarea from 902 – *c.* 939); further notes added
tenth–fourteenth centuries
In Greek, on parchment; 391 leaves, 215 × 180 mm
Early nineteenth-century English binding probably for
the Bodleian: brown calfskin with blind tooling and
gold-tooled Bodleian centrepiece

Provenance: Bought for 14 *nomismata* (gold coins)
by Arethas of Patrae; Jacques Philippe D'Orville
(1696–1751); his son Jean, and then grandson, also Jean;
sold to J. Cleaver Banks, from whom it was purchased
by the Bodleian in 1804

Exhibitions: Oxford 1975, no. 55; Oxford 1994, no. 28

Literature: SC 17179; http://www.claymath.org/library/
historical/euclid/index.html

MS. D'Orville 301 [fol. 114r illustrated]

Euclid's *Elements* was a standard
mathematical textbook for more than
two thousand years, and has been
copied out and printed countless times.
This manuscript of the *Elements* was
finished in September 888 by the scribe
Stephanos Clericus, and was bought by
Arethas of Patrae, Bishop of Caesarea.
It is the oldest manuscript of a classical
Greek author to bear a date, and the
oldest surviving manuscript of the most
widely studied version of Euclid – by
Theon of Alexandria.

Euclid may have lived and taught at
Alexandria, the great Egyptian centre of
learning, sometime between the fourth
and third centuries BC, but nothing is
known for certain about his life. Nor is
it possible to identify his own words, or
his own mathematics, in the *Elements*
for, in the first place, it is not so much
an original text as a compilation,
synthesis and clarification of the work
of earlier Greek mathematicians such
as Eudoxus and Theaetetus. The Greek
philosopher Proclus (*fl.* AD 450)
described Euclid as one 'who put
together the "Elements", arranging in
order many of Eudoxus's theorems,
perfecting many of Theaetetus's,
and also bringing to irrefutable
demonstration the things which
had been only loosely proved by his
predecessors'.

In the second place, the editions
of the *Elements* which have survived
are not Euclid's own, but critical
revisions (recensions) by later editors.
Theon of Alexandria, who also wrote
a commentary on Ptolemy's *Almagest*,
is thought to have made his recension
with the help of his brilliant daughter
Hypathia. Made sometime in the
fourth century AD, it was the sole
basis of all printed editions of the
Elements until the early nineteenth
century. Comparison with a different
version of the *Elements*, contained in a
manuscript discovered in the Vatican
in the nineteenth century, reveals that
Theon corrected what he thought
(sometimes wrongly) were mistakes
in the mathematics, standardized the
forms of expression, expanded various
arguments and added propositions to
make the text more accessible. It may
well have been used by Theon's pupils
at Alexandria, and was certainly used
by generation after generation of pupils
subsequently, right up to the mid-
twentieth century.

The texts of the *Elements* are
thus the result of a long tradition of
compilation and critical revision. This
manuscript is a product of the great
revival of scholarship in ninth-century
Byzantium, in which many classical
Greek texts were copied and thereby
preserved for future generations.
The text is beautifully written in a
newly introduced cursive minuscule
and accompanied by precise line
drawings. In the margins its original
owner, Arethas, has written substantial
annotations. Arethas may have been a
pupil of Photius, twice the patriarch of
Constantinople and a leading figure in
the classical revival. Another annotated
volume from Arethas's library, an
extremely important manuscript of
Plato, is also in the Bodleian.[1] His
manuscript of Euclid was much used,
and further annotated, from the tenth
to the fourteenth centuries.

The *Elements* is divided into thirteen
books. The first six books are concerned
with plane geometry; books 7 to 9 deal
with number theory; book 10 with
the theory of irrational numbers, and
books 11 to 13 with three-dimensional
geometry. The manuscript is open at
book 6, to show Euclid's definition of
the golden ratio, or divine proportion:
'A straight line is said to have been cut
in extreme and mean ratio when, as the
whole line is to the greater segment, so
is the greater to the less.'

Note
1 Bodleian MS. E. D. Clarke 39.

τῷ π̅ ὅμοιον ἔσται τῷ δ̅. ὡς ἄρα τῷ ϛ̅λ̅ ἕξει ὅμοιον τὸ ο̅π̅
ὅπερ ἔδει ποιῆσαι :—

τὴν δοθεῖσαν εὐθεῖαν ὑπεράσμβλη . αἴρομεν μετασχ
λόγον τῷ δῷ . δεδόχθω ἔσται ὑπεράσμβλη
ἡ α̅β̅ . δεῖ δὴ τὴν α̅β̅ εὐθεῖαν αἴρομεν μετασχ λόγον τὸ
μμ . ἀναγεγράφθω ἀπὸ τὴν α̅β̅ τετράγωνον τὸ β̅γ̅
ἴσον παραλληλόγραμμον παρὰ τὴν α̅γ̅ τῷ β̅γ̅ ἴσον πα̅
ραλληλόγραμμον τὸ γ̅δ̅ ὑπερβάλλον εἴδει τῷ δ̅α̅ ὁ̅
μοίῳ τῷ β̅γ̅ . τετράγωνον δεδεί τὸ β̅γ̅ τετράγωνον
ἄρα ἐστὶ καὶ τὸ δ̅α̅ καὶ ὡς ἴσον ἐστὶ τὸ β̅γ̅ τῷ γ̅δ̅ . λοιπὸν
ἀφειρήσθω τὸ γ̅ε̅ . λοιπὸν ἄρα ἐστὶ ζ̅β̅ λοιπὸν πρὸς τῷ
λ̅δ̅ ἐστὶν ἴσον ἐστὶ δὲ αὐτῷ καὶ ὀρθογώνιον ἐστὶ τῷ β̅ζ̅ λ̅δ̅
ἄρα ἀντὶ παρθεύαι αἱ τετραγ αἱ ὑπὲρ τὰς ἴσω
γωνίας . ἔτι γὰρ ἄρα ὡς ἡ ζ̅ε̅ πρὸς ε̅λ̅ . οὕτως ἡ δ̅ε̅
πρὸς ε̅β̅ . ἴση δὲ ἡ μὲν ζ̅ε̅ τῇ δ̅ε̅ τουτέστι τῇ δ̅β̅
ἴσης ε̅λ̅ τῇ δ̅ε̅ ἄρα
ὡς ἡ β̅δ̅ πρὸς τὴν δ̅ε̅ . οὕτως
ἡ δ̅ε̅ πρὸς τὴν ε̅β̅ . μέζων δε
ἡ α̅β̅ τῆς δ̅ε̅ . μέζων ἄρα καὶ
ἡ δ̅ε̅ τῆς ε̅β̅ . ἡ ἄρα α̅β̅ δ̅
θεῖσα . αἴρομεν μετασχ λόγον
τέτμηται κατὰ τὸ ε̅ . καὶ μείζ
ζον αὐτῶν τμῆμά ἐστι τὸ δ̅ε̅ . ὅπερ ἔδει ποιῆσαι :—

† ἄλλως ἡ ἀπόδειξις :—

ἔστω ἡ δοθεῖσα εὐθεῖα ἡ α̅β̅ . δεῖ δὴ τὴν α̅β̅ . αἴρομεν
μέσον λόγον τέμνω . τετμήσθω γὰρ ἡ α̅β̅ κατὰ τὸ γ̅

τίνες ἄπορ λέγουσιν ὅτι ἐν τῷ
ια̅ θεωρήματι τῆϛ ε̅ βιβλίου δεῖ
ζετ τὰ δοθεῖσαν εὐ . καὶ κϛ̅ καὶ
ὅτι πάλιν τὰ αὐτῷ δεικνύ γεν α
τὰ ὑ . καὶ κϛ̅ καὶ οὐκ ἔασι τίνες
ἄλλοις ῥητὸν ἐϛὶν . καὶ εἰσὶ τίνεϛ
 διὰ ἀνήκ ἐν τῷ δ̅ ἀϛ̅ θαυμασιώ
τῇ δ̅ καὶ κϛ̅ καὶ ϛ̅υ . θαυνάϛι
ἢ ναι τᾶι τουχάριν ϛ̅ ἄριϛ̅ δοθ
ὅτι κατ᾽ ἡμῶν ἢ τοῦτο τῆϛ τμήϛ

47

Regula Sancti Benedicti (*The Rule of St Benedict*)

England, early eighth century

In Latin, on parchment; seventy-seven leaves, 305 × 215 mm

Eleventh-century (?) English binding: white tawed leather over wooden boards

Provenance: At Worcester Cathedral Priory by the end of the eleventh century, and still there in *c.* 1622–3; probably came into the possession of Christopher Hatton, 1st Baron Hatton (bap. 1605, d. 1670) in *c.* 1643; bought with his library by the Bodleian through the London bookseller Robert Scot in 1671

Exhibitions: Oxford 1980, no. 1; Oxford 1994, no. 17

Literature: SC 4118; P & A, vol. 3, no. 1; Farmer 1968 (facsimile); Rogers 1991, pp. 138–9

MS. Hatton 48 [fols. 14v–15r illustrated]

St Benedict of Nursia put together his Rule for monks in about 540. He intended it for his own community of Monte Cassino, but it spread to become the principal monastic code of Western Europe. It eloquently expresses the principles of monastic life; it also provides a practical guide to daily observance, stressing humility, obedience and the centrality of prayer.

This is the earliest surviving manuscript of the Rule. It was made in England around AD 700 and is of the highest quality. The fine script is an example of English uncial which draws on both Roman and Celtic (Insular) traditions, and is probably the work of a single scribe. The chapter headings are written in a vermilion red; the elegantly shaped initials are outlined in black and surrounded by red dots in the characteristic manner of Insular decoration. The origins of the manuscript are obscure, although the beauty of the script and the generous use of the parchment, an expensive material, indicate a wealthy patron. St Benedict's Rule was yet to establish itself fully in the country, so perhaps the manuscript was intended to promote its status and to provide an authoritative version of the text. Clearly, different versions of the Rule were still in circulation, for alternative readings have been inserted into this manuscript in a small, neat hand by the same scribe, and these could only have been taken from another manuscript then in England.

There can be no doubt that the manuscript was prompted by a reverence for the Rule, although Benedict, who never attempted to found an order, made only humble claims for the work. It was 'a little Rule for beginners', a guide for small, autonomous communities like his own, not a major organization with an international reach. He drew on earlier texts by writers such as Basil, John Cassian, Augustine and Caesarius, and at the end of the Rule modestly referred readers to those writings if they wished for more accomplished guides to monastic life:

This Rule has been written in order that, by practising it in monasteries, we may show that we have attained some degree of virtue and the rudiments of monastic observance. But for him who would hasten to the perfection of the monastic life, there are the teachings of the holy Fathers, by observing which a man is led to the summit of perfection. For what page or what utterance of the divinely-inspired books of the Old and New Testament is not a most unerring rule of human life? Or what book of the holy Catholic Fathers is not manifestly devoted to teaching us the straight road to our Creator? Then the Conferences of Cassian and his Institutes, and the Lives of the Fathers, as also the Rule of our holy father Basil …[1]

Note

1 McCann 1995, p. 78.

OEDIRE ETIAM
SIIPSEALITERGO
ABSITACAP DE
MORESILLUDDO
MINICUMPRAE
CEPTUMQUAE
DICUNTFACITE
QUAEAUTEMFA
CIUNTFACERE
NOLITE NON
UELLEDICISCN
ANTEQUAM
USESSEQUOD
UERIUSDICITUR
PRAECEPTASI
FACTISCOTIDIE
ADIMPLERECA
STITATEMAMA
RENULLUMO
DIRE ZELUMEL
ANUIDIANON

HABERE CONTEN
TIONEMNONA
MARE ELATIONA
FUGERE ETSEN
ORESUENERAR
IUNIORESDILIGE
REINXPIAMORE
PROINIMICISO
RARE CUMDIS
CORDANTEANTE
SOLISOCCASUM
INPACEMREDI
RE EIUODDIMI
SERICORDIANU
QUAMDESPE
RARE ECCEHAEC
SUNTINSTRU
MENTAARTIS
SPIRITALIS QUI
CUMFUERINT
ANOBISDIENO
TUQUEINCESO

BILITERADIMPLE
TAETINOIEIUDI
CIIRECONSIGNA
TAILLAMERCES
NOBISADNORE
CONPENSABITIR
QUAMIPSEPRO
MISIT QUODO
CULUSNONUIDI
NECAURISAUDI
UITNECINCOR
HOMINISASCEN
DITQUAEPRAE
PARABITQSHIS
QUIDILICUNT
EUM OFFICINA
UEROUBIHAEC
OMNIADILIGEN
TEROPEREMUR
CLAUSTRASUNT
MONASTERIIUEL
STABILITASIN

CONGREGATIONE

PRIMUS
HUMILIT
TIS GRADUS
EST OBOEDI
ENTIASINE
MORA HAEC
CONUENITHIS
QUINHILSIBI
AXPOCARIUSAB
QUIDEXISTI
MANT PROPTER
SERUITIUMSCM
QUODPROFES
SISUNT SEUPRO
PTERMETUM
GEHENNAE UEL
GLORIAMUITAE
AETERNAE MOX
UTALIQUIDAMA

oedire etiam
siipsealiterqd
absitacat me
moresilluddo
minicumprae
ceptum quae
dicuntfacite
quaeautemfa
ciuntfacere
nolite non
uelledicisscm
antequam
ositsedpri
usesseqquod
ueriusdicatur
praeceptadi
factiscotidie
adimplere ca
stitatemama
re nullumo
dire zelumel

habere conten
tionemnon a
mare elationi
fugere etsen
oresuenerari
junioresdilige
reinxpiamore
proinimiciso
rare cummois
cordanteante
solisocasua
inpacemredi
re etdediui
sericordianum
quamdispe
rare eccehaec
suntinstru
mentaartis
spiritalis qua
cumfuerint
anobisdienoc

BILITERADIMPLE
TAETINDIEIUDI
CIIRECONSIGNA
TAILLAMERCES
NOBISADNORE
CONPENSABITIR
QUAMIPSEPRO
MISIT·QUODO
CULUSNONUIDIT
NECAURISAUDI
UITNECINCOR
HOMINISASCEN-
DITQUAEPRAE
PARABITDSHIS
QUIDILIGUNT
EUM·OFFICINA
UEROUBIHAEC
OMNIADILIGEN
TEROPEREMIR
CLAUSTRASUNT
MONASTERIIET

CONGREGATIONE·

[V] QUODBOEDIENTIA

PRIMUS
PHUMILITA
EO·OTISGRADU
ESTOBOEDI
ENTIASINE
MORA·HAEC
CONUENITHIS
QUINIHILSIBI
AXPOCARIUSAL
QUIDEXISTU
MANT·PROPTER
SERUITIUMSCM
QUODPROFES
SISUNT·SEUPRO
PTERMETUM
GEHENNAE·UEL
GLORIAMUITAE
AETERNAE·MOX

ST GREGORY THE GREAT (*c.* 540–604)

Liber pastoralis (*Pastoral Care*)

c. 890–97

King Alfred's West Saxon version
In Old English, on parchment; ninety-nine leaves,
292 × 222 mm
Late seventeenth- or early eighteenth-century Oxford
binding for the Bodleian: brown leather with blind
tooling

Provenance: Copy sent to Werferth (Wærferth)
(d. *c.* 907–15), Bishop of Worcester; still at Worcester
in *c.* 1622–3; probably came into the possession of
Christopher Hatton, 1st Baron Hatton (bap. 1605,
d. 1670) in *c.* 1643; bought with his library by the
Bodleian through the London bookseller Robert Scot
in 1671

Exhibitions: Oxford 1980, no. 10; London 1984b, no. 1

Literature: SC 4113; P & A, vol. 3, no. 18; Ker 1956
(facsimile); Rogers 1991, pp. 140–41

MS. Hatton 20 [fol. 1r illustrated]

Alfred the Great is one of the most
revered figures of English history, and
this manuscript is the only surviving
book which may be linked to the king
himself. The oldest book entirely in the
English language, it is not a declaration
of royal power, but part of Alfred's
determination to restore English
learning, which had suffered grievously
during the previous, violent decades
of invasion and warfare. Central to
this programme were translations into
Old English of important Latin texts,
for many of the literate were able to
read their native language only. The
texts Alfred selected were the Psalms,
St Augustine's *Soliloquies*, Boethius's
Consolation of Philosophy, Orosius's
History, Bede's *Ecclesiastical History* and
Gregory the Great's *Pastoral Care*.

The last work was written by Pope
Gregory I in about AD 590–91. It

takes the form of a long letter to a
brother-bishop, and is a guide to the
clergy on their pastoral duties. Alfred
commissioned an English translation
(or, conceivably, made one himself),
and had copies of it sent to his bishops.
This copy was sent to Werferth, Bishop
of Worcester, where it remained for
more than seven hundred years. 'King
Alfred bids greet bishop Wærferth with
his words lovingly and with friendship',
Alfred begins a preface attached to the
manuscript. He proceeds to explain
the motives behind the translation.
It had occurred to him 'what wise
men there formerly were throughout
England … and also the sacred orders
how zealous they were both in teaching
and learning'; whereas now hardly
anyone could translate from Latin
into English, and there were books
piled up in churches which no one
could read, as they were not written
in English. It struck him that learned
men of the past had not thought to
translate these books, because they 'did
not think that men would ever be so
careless, and that learning would so
decay'. Thankfully there were now more
teachers in England: 'And therefore I
command thee to do as I believe thou
art willing, to disengage thyself from
worldly matters as often as thou canst,
that thou mayest apply the wisdom
which God has given thee wherever
thou canst.' Now 'it seems better to me,
if ye think so, for us also to translate
some books which are most needful

for all men to know into the language
which we can all understand'. Then 'let
those be afterwards taught more in the
Latin language who are to continue
learning and be promoted to a higher
rank'.[1] Alfred then describes how he
had embarked on translating Gregory's
work 'sometimes word by word and
sometimes according to the sense', as
he had learnt it from two of his bishops
and two of his priests:

*Augustine brought this work from the
south over the salt sea to the island-
dwellers, exactly as the Lord's champion,
the pope of Rome, had previously set it
out. The wise Gregory was well versed
in many doctrines through his mind's
intelligence, his hoard of ingenuity.
Accordingly, he won over most of
mankind to the guardian of the heavens,
this greatest of Romans, most gifted of
men, most celebrated for his glorious
deeds.*[2]

The manuscript is evidence of the poor
state of English penmanship during this
period. The calligraphy is somewhat
crude and uneven; the scribes (royal
clerks, of which there were perhaps
no more than two) were clearly more
used to writing shorter charters or
documents.

Notes
1 Sweet 1871–2, vol. 1, pp. 2–8.
2 Keynes and Lapidge 1983, pp. 126–7.

✝ ÐEOS BOC SCEAL TO WIOGORA CEASTRE

ÆLFred kyning hateð gretan Wærferð biscep his wordum luf
lice ⁊ freondlice · ⁊ ðe cyðan hate ðæt me com swiðe oft onge
mynd · hwelce wiotan iu wæron giond angel cynn · ægðer ge godcundra
hada ge woruldcundra · ⁊ hu gesæliglica tida ða wæron giond angel
cynn · ⁊ hu ða kyningas ðe ðone onwald hæfdon ðæs folces gode ⁊ his
ærend wrecum hyr sumedon · ⁊ hie ægðer ge hiora sibbe ge hiora
siodo ge hiora onweald innan bordes gehioldon · ⁊ eac ut hiora
eðel gerymdon · ⁊ hu him ða speow ægðer ge mid wige ge mid wisdome ·
⁊ eac ða godcundan hadas hu giorne hie wæron ægðer ge ymb lare
ge ymb liornunga · ge ymb ealle ða ðiowotdomas · ðe hie gode scol
don · ⁊ hu man utan bordes wisdom ⁊ lare hieder on lond sohte · ⁊
hu we hy nu sceoldon ute begietan gif we hie habban sceoldon · Swa
clæne hio wæs oðfeallenu on angel cynne · ðæt swiðe feawa wæron
be hionan humbre ðe hiora ðeninga cuðen understondan on en
glisc · oððe furðum an ærend gewrit of ledene on englisc areccean ·
⁊ ic wene ðæt noht monige begiondan humbre næren · swa
feawa hiora wæron ðæt ic furðum anne anlepne ne mæg
geðencean besuðan temese · ða ða ic to rice feng · gode ælmih
tegum sie ðonc ðæt we nu ænigne on stal habbað lareowa · ⁊ forðon
ic ðe bebiode ðæt ðu do swa ic geliefe ðæt ðu wille · ðæt ðu ðe ðissa
woruld ðinga to ðæm gemetige swa ðu oftost mæge · ðæt ðu ðone
wisdom ðe ðe god sealde ðær ðær ðu hiene befæstan mæge ·

Hatton . 88 .

49

ʿABD AL-RAḤMĀN AL-ṢŪFĪ (d. 986)

Kitāb Ṣuwar al-kawākib al-thābitah
(*The Book of the Constellations of the Fixed Stars*)

Twelfth century (?)

The colophon states that this manuscript was written out and illustrated by the author's son, al-Ḥusayn ibn ʿAbd al-Raḥmān ibn ʿUmar ibn Muḥammad, in 400 AH (AD 1009); it may in fact date up to a century and a half later, with parts supplied in about the fourteenth century and in the sixteenth century
In Arabic; 424 pages, 268 × 182 mm
Later eastern-style binding with fore edge flap: goatskin

Provenance: Inscription: Christian Ravius, 1641; Jacob Golius sale, Leiden, 1696: purchased by Narcissus Marsh (1638–1713), who bequeathed it to the Bodleian

Exhibition: Oxford 1981, no. 41

Literature: Wellesz 1959; Sezgin 1986 (facsimile)

MS. Marsh 144 [pp. 81–82 illustrated]

The Alexandrine Greek mathematician, geographer and astronomer Ptolemy (*c.* 90 – *c.* 168) synthesized and corrected the work of earlier astronomers, and added observations of his own, recording them in his *Mathematike syntaxis* (*Mathematical Synthesis*). This presented an exceedingly intricate model of the universe, with the earth at the centre, and the sun, moon and five planets radiating from it. Beyond them were the 'fixed stars'. Ptolemy provided tables for predicting planetary motions and a catalogue of 1,028 stars in forty-eight constellations.

In the eighth and ninth centuries the Ptolemaic tradition was absorbed and developed by Islamic scholars. In around AD 800 the *Mathematike syntaxis* was translated into Arabic and assumed the name by which it is still known today, the *Almagest*.

This is a very early manuscript of the most important guide to the constellations in the Islamic world, *The Book of the Constellations of the Fixed Stars* by al-Ṣūfī, a court astronomer in Isfahan, Iran. al-Ṣūfī describes each constellation in turn, and follows his descriptions with a catalogue of its stars according to Ptolemy. But al-Ṣūfī builds on Ptolemy by making amendments and revisions according to his own detailed observations. He also describes the pre-Islamic constellations (the *Anwa*) and relates them to their Greek counterparts.

Each constellation is illustrated twice, in mirror-image. Both the classical Greek and the early Islamic astronomers constructed globes on which they mapped the heavens; this was the earliest way of physically representing the positions of the stars. The convex form of the globe, however, meant that the stars were shown from a position above the sphere, and anyone looking up at the stars from the earth would therefore be seeing them in reverse formation. It is for this reason that al-Ṣūfī gives two illustrations for each constellation: one as represented on a celestial globe, and one as seen from the ground, 'for otherwise the beholder might be confused if he saw the figure on the globe differing from what he sees in the sky. If we want to see the constellations in their true state we must raise the page over our head and look at the second figure from underneath. We shall then see it conforming to what is found in the sky.'[1] The stars in a constellation are drawn in red, the stars outside it in black. The most important stars have their names added.

Drawn around each star pattern is the appropriate figure of the zodiac. These, of course, have nothing to do with the science; they are imaginary formulations to act as an aide-memoire when finding and identifying stars and star groups. al-Ṣūfī and other Islamic astronomers, because they were building on classical astronomy, inevitably took over the classical constellations such as Cassiopeia, Perseus, Virgo, Andromeda, Sagittarius and Orion. Usually al-Ṣūfī gives the Arabic transcription of the Greek names and, sometimes, a translation; he then gives the names which had been assigned to them by the Arabs. In this manuscript the artist has made the mythological figures recognizably Islamic in their hairstyle, costume and pose.

Shown here is the constellation of Heracles, called 'the kneeling man' or 'the dancer', the former being the correct translation of Engonasin, the original name given to this figure in antiquity. But whereas in Western tradition the figure would be clothed in a lion's skin and given a weapon such as a club, here he is in Eastern-style robes and holding a scimitar, an Oriental weapon.

Note
1 Wellesz 1959, p. 5.

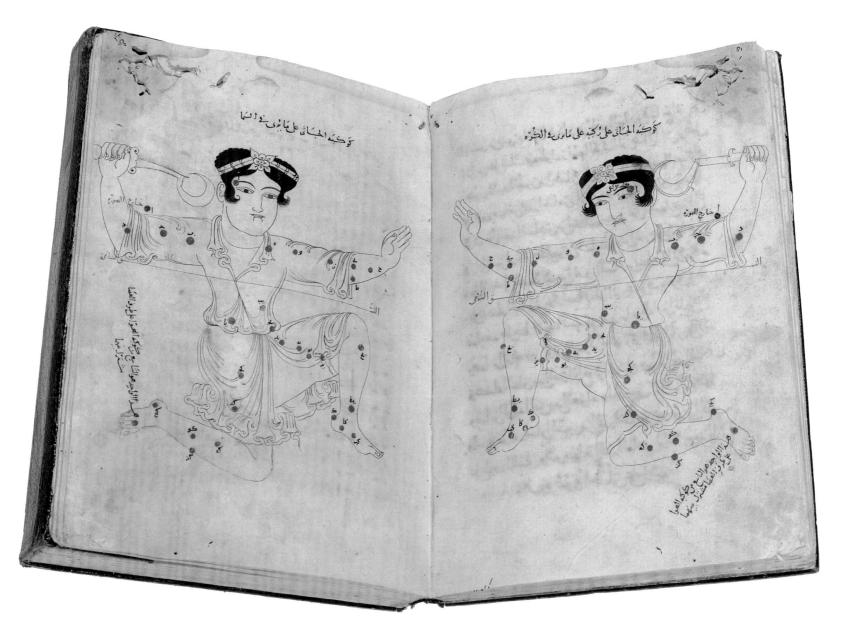

AL-IDRĪSĪ (*c.* 1100–1166)

Nuzhat al-mushtāq fī ikhtirāq al-āfāq (*Entertainment for he who Longs to Travel the World*)

Provincial Ottoman, 1553

In the hand of ʿAlī ibn Ḥasan al-Hūnī al-Qāʾimī (?)
Seventy maps (one folding, currently detached)
In Arabic; 325 leaves, 300 × 218 mm
Contemporary Ottoman blind-stamped corner and
centrepiece binding: brown goatskin with replacement
fore edge flap for the Bodleian, nineteenth century

Provenance: Edward Pococke (1604–1691); purchased
by the Bodleian in 1692 from his widow

Exhibition: Oxford 2002b, no. 51

Literature: Rogers 1991, p. 164

MS. Pococke 375 [fols. 3v–4r illustrated]

Ptolemy's *Almagest* provided a coherent model of the heavens. His subsequent *Geography* mapped the *oikoumené*, or known world, by assembling a vast amount of geographical data and drawing – he says – on the work of earlier scholars such as Marinus of Tyre (about whom nothing else is known). In the first book Ptolemy defined the subject of geography and proposed ways in which the spherical earth could be projected onto a flat surface. In books 2–7, the core of the work, he provided latitudes and longitudes for more than eight thousand cities and locations, from Ireland in the west to India in the east. In book 8 he divided the world into twenty-six regional areas: ten of Europe, four of Africa and twelve of Asia. It is uncertain whether Ptolemy included any maps in the *Geography*, but they can be constructed from the data he provides.

In a Ptolemaic world map the lands of the Roman Empire are relatively accurate and immediately recognizable, but inevitably the distortions and inaccuracies increase as one moves outwards. The Americas, Australasia and the polar regions are of course missing, as is the Far East and much of the African continent. Instead, Africa curls round and joins up with China, thereby turning the Indian Ocean into an immense lake. Ptolemy divided this world into seven longitudinal *klimata*, or climatic regions.

Ptolemy's *Geography*, like his *Almagest*, was forgotten by the West for centuries, while it was assimilated and improved by Islamic scholars further east. The Arab geographer al-Idrīsī drew on his knowledge of Ptolemy when compiling his geographical compendium *Entertainment for he who Longs to Travel the World* (otherwise known as *The Book of Roger*) for Roger II of Sicily in 1154. al-Idrīsī created seventy regional maps by dividing each of Ptolemy's seven climes into ten sections.

Some manuscripts of the *Entertainment* also include the circular world map shown here. It was thought to be by al-Idrīsī himself until an almost identical map was identified in a manuscript which, present evidence suggests, was originally designed in

1020–50.[1] It is uncertain why versions of this world map should later have formed part of the *Entertainment*, but as al-Idrīsī makes no mention of the map in his text it was perhaps inserted into the later manuscripts by copyists because it was thought (or considered by tradition) to be an appropriate accompaniment to his regional maps.

In contrast to the Christian maps with which it is broadly contemporary, this map is an intellectual rather than a religious representation of the world, the product of a culture in which classical and Islamic scholarship were combined and developed. Oriented, as customary with Islamic maps, with south at the top, it shows Africa extending eastwards so that it covers virtually all of the Southern Hemisphere. A series of red concentric circles marks the seven climes. The eastward curve of Africa, and the source of the Nile in East Africa, are Ptolemaic; but Africa no longer joins up with India, making the Indian Ocean an open sea rather than a gigantic lake, suggesting additional knowledge derived from more recent scholarship.

Note

1 Bodleian MS. Arab c. 90; see Edson and Savage-Smith 2004, pp. 75–81.

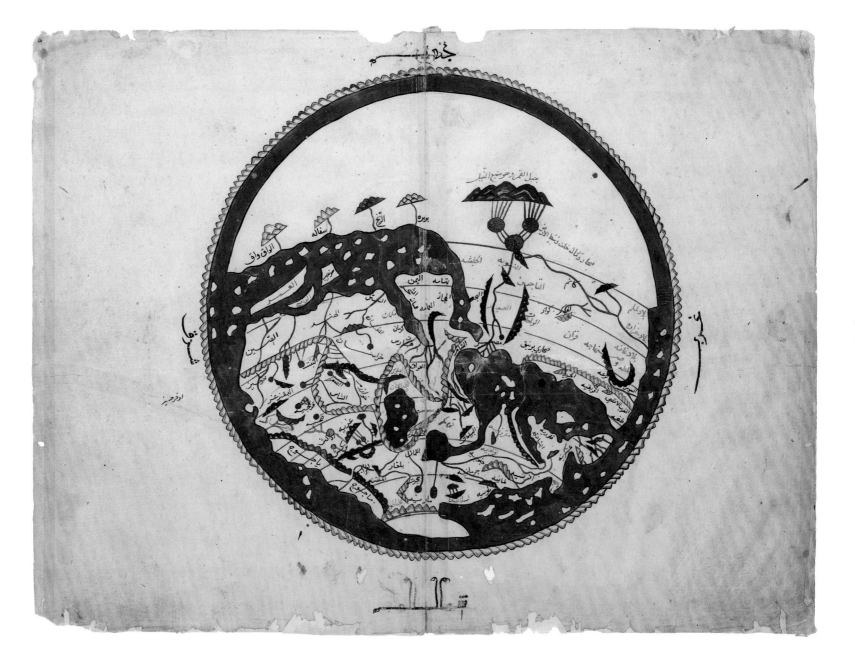

51

PTOLEMY (*c.* 90 – *c.* 168)

Geographia (*Geography*)

Ulm: Johann Reger, for Justus de Albano, 1486

Translated from the Greek by Jacobus Angelus
In Latin; 194 leaves, with thirty-two hand-coloured maps from the edition of *Cosmographia* published by Lienhart Holl in Ulm, 1492; 420 × 285 mm
Fifteenth-century wooden-boarded binding: re-covered with brown sheepskin with blind and gold tooling, and provided with new endleaves, in England, early nineteenth century

Provenance: Given to Francesco Capello (1460–1513), Venetian Ambassador to Spain, in Burgos on 25 August 1492 by Ferdinand and Isabella, King and Queen of Spain (inscription on front pastedown, below arms of Ferdinand and Isabella: 'Regum insignia: oratoribus tradita Burgis xxv augustij 1495'); inscription: '1613 / Donatomi in Venetia con molti altri da una gentildonna I.L. / M.M.D²'; Francis Douce (1757–1834), who bequeathed it to the Bodleian

Exhibition: Oxford 1994, no. 3

Literature: Bod-inc. P-529

Arch. B b.19 [fols. 131v–132r illustrated]

Ptolemy's *Geography* was reintroduced to the West by a Byzantine scholar, Maximus Planudes (*c.* 1255–1305), who examined and collated a number of manuscripts and in about 1300 produced a recension of the Greek text. By the early fifteenth century numerous manuscripts of the *Geography* were in circulation, some of which included sets of maps. By 1410 the Tuscan scholar Jacopo d'Angelo had translated the text into Latin. The maps were redrawn and given Latin inscriptions, and were later revised by Nicolaus Germanus. In the fifteenth century the *Geography* was one of the first classical texts to be printed: first in Vicenza in 1475, in an edition without maps, and subsequently in Bologna, Rome and Florence, all with maps. The first German edition was published in Ulm in 1482, with woodcut maps. Exhibited here is the second German edition, which was published without maps in 1486; in this copy, however, the maps from the earlier Ulm edition, richly hand coloured, have been inserted.

The restoration of Ptolemaic geography in the West was thanks to the endeavours of humanist scholars who revered classical authority, but it came at a time when that geography was being superseded. The sea voyages of the Spanish and Portuguese, for instance, discovered the tip of southern Africa and revealed that the Indian Ocean was not a gigantic lake. The curious overlap of classical knowledge and contemporary discovery is illustrated in this atlas. True to Ptolemy, it has twenty-six regional maps: ten of Europe, four of Africa and twelve of Asia; but it also includes modern maps of Italy, Spain, France (each of which comes straight after its Ptolemaic counterpart; see the two maps of Spain illustrated overleaf) and Palestine. The world map, illustrated opposite, still shows Africa joined to China, but it also incorporates recently acquired knowledge of the geography of Scandinavia and Africa.

Just as the Ptolemaic geocentric model of the universe, reassuringly familiar and intellectually coherent, remained in place for some time after the publication of Copernicus's heliocentric model of the solar system, so a similar cultural attachment to Ptolemy's mapping of the earth's surface obscured the most recent geographical discoveries. At the same time, however, the revival of Ptolemy inspired the exploration that made these discoveries possible, and Ptolemy's scientific methods, particularly his techniques of projection, led to the cartographic advances of the fifteenth and sixteenth centuries.

The front leaf of this copy of the *Geography* bears the coat of arms of Ferdinand and Isabella of Castile, who six years later would be the patrons of Christopher Columbus's Atlantic voyage of 1492. The *Geography* may well have contributed to Columbus's explorations by encouraging his belief that Asia was much closer to Europe than it was. The subsequent discovery by Columbus of the American continent rendered obsolete much of Ptolemy's geographical model of the earth, and yet editions of the *Geography* continued to be published after 1492 without any reference to this discovery.[1]

Note

1 Brotton 2012, p. 162.

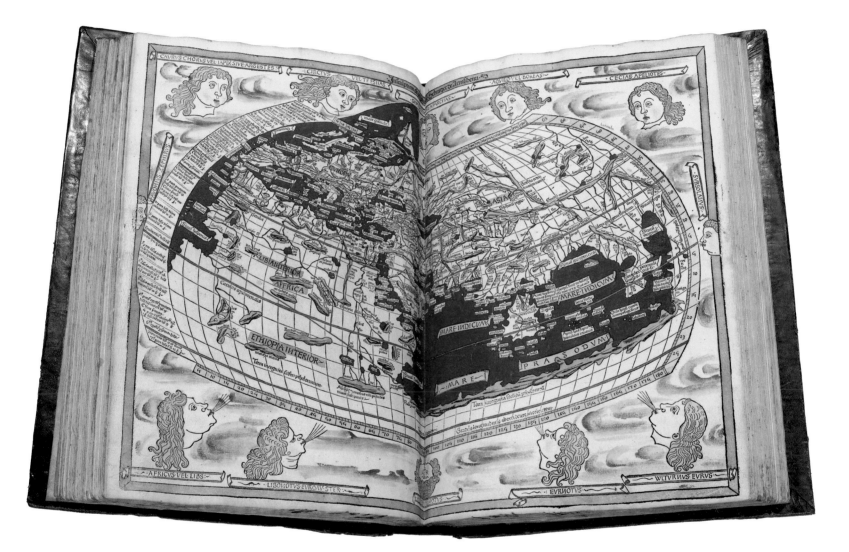

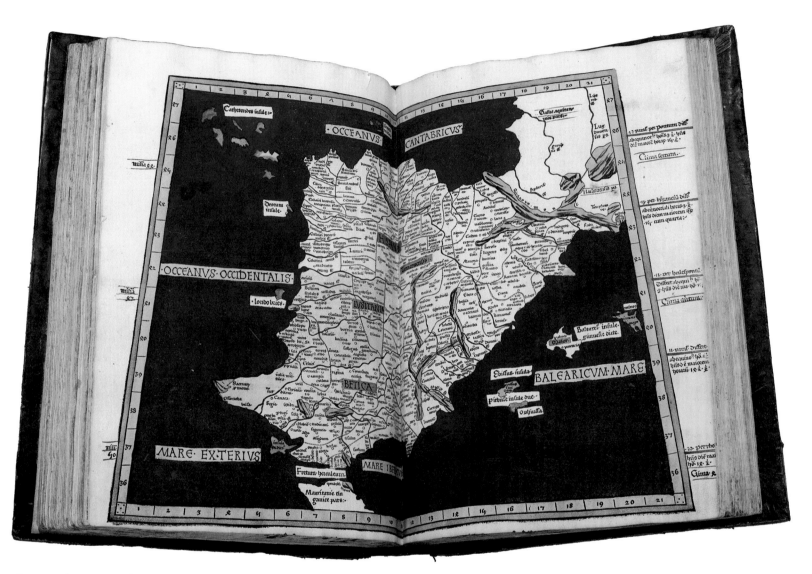

Cat. 51 Ptolemaic map of Spain

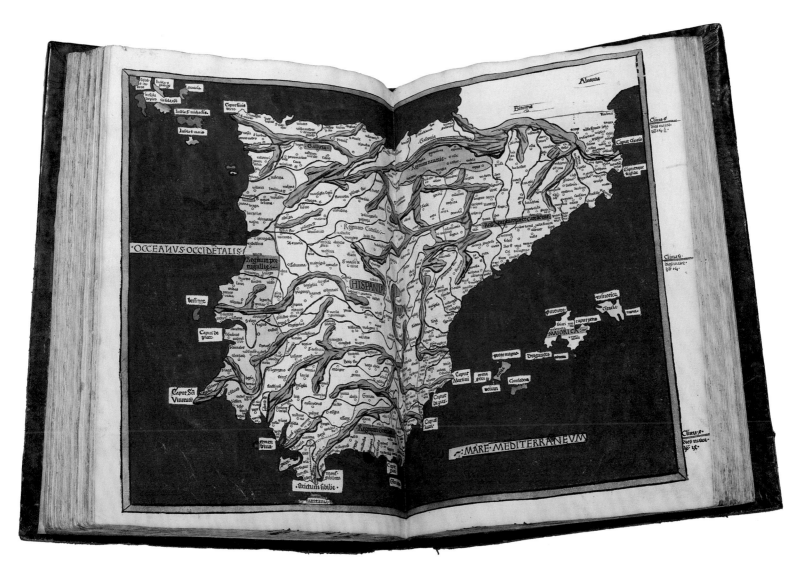

Cat. 51 Ptolemaic map of Spain with amendments and additions

Deferit, ac Nautis fufpectas nudat arenas;
Alternis vicibus fuprema ad littora pulfans.
Quæ toties animos veterum torfere Sophorum,
Quæque Scholas fruftra rauco certamine vexant
Obvia confpicimus nubem pellente Mathefi.
Jam dubios nulla caligine prægravat error
Queis Superum penetrare domos atque ardua Cœli
Scandere fublimis Genii conceffit acumen.
 Surgite Mortales, terrenas mittite curas
Atque hinc cœligenæ vires dignofcite Mentis
A pecudum vita longe lateque remotæ.
Qui fcriptis juffit Tabulis compefcere Cædes
Furta & Adulteria, & perjuræ crimina Fraudis;
Quive vagis populis circumdare mœnibus Urbes
Autor erat; Cererifve beavit munere gentes;
Vel qui curarum lenimen preffit ab Uva;
Vel qui Niliaca monftravit arundine pictos
Confociare fonos, oculifque exponere Voces;
Humanam fortem minus extulit; utpote pauca
Refpiciens miferæ folummodo commoda vitæ.
Jam vero Superis convivæ admittimur, alti
Jura poli tractare licet, jamque abdita cœcæ
Clauftra patent Terræ, rerumque immobilis ordo,
Et quæ præteriti latuerunt fæcula mundi.
 Talia monftrantem mecum celebrate Camænis,
Vos qui cœlefti gaudetis nectare vefci,
NEWTONUM claufi referantem fcrinia Veri,
NEWTONUM Mufis charum, cui pectore puro
Phœbus adeft, totoque inceffit Numine mentem:
Nec fas eft propius Mortali attingere Divos.

 EDM. HALLEY.

PHILO-

[1]

PHILOSOPHIÆ
NATURALIS
Principia
MATHEMATICA.

Definitiones.

Def. I.

*Quantitas Materiæ eft menfura ejufdem orta ex illius Denfitate &
Magnitudine conjunctim.*

AEr duplo denfior in duplo fpatio quadruplus eft. Idem
intellige de Nive et Pulveribus per compreffionem vel lique-
factionem condenfatis. Et par eft ratio corporum omnium, quæ
per caufas quafcunq; diverfimode condenfantur. Medii interea,
fi quod fuerit, interftitia partium libere pervadentis, hic nullam ra-
tionem habeo. Hanc autem quantitatem fub nomine corporis vel
Maffæ in fequentibus paffim intelligo. Innotefcit ea per corporis cu-
jufq; pondus. Nam ponderi proportionalem effe reperi per expe-
rimenta pendulorum accuratiffime inftituta, uti pofthac docebi-
tur. Def.

 B

52

SIR ISAAC NEWTON (1642–1727)

Philosophiae naturalis principia mathematica (*Mathematical Principles of Natural Philosophy*)

London: the Royal Society, 1687

In Latin; 518 pages, 237 × 188 mm
English binding, before 1690: brown calfskin with blind tooling

Provenance: Given to Nicolas Fatio de Duillier (1664–1753) in 1687 by Edmond Halley (1656–1742); acquired by the Bodleian in 1755

Arch. A d.37 [pp. x–1 illustrated]

A handful of scientific publications are especially celebrated. Charles Darwin's *On the Origin of Species* (1859) is one example, the series of papers Albert Einstein published in 1905 another. So too is Isaac Newton's *Principia mathematica*, which provided the basis for modern physics, from the inverse square law of gravity to the three universal laws of motion. Its publication by the notoriously secretive Newton was in large measure thanks to the efforts of his fellow scientist Edmond Halley. It was Halley who prompted Newton to think about articulating his discoveries by asking him a question about the shape of planetary orbits which neither he (Halley) nor anyone else could answer. When, more than two years later, Newton finally completed the text of the *Principia*, it was Halley who persuaded him to publish it.

Halley also supervised the complicated process of putting the book together. He edited the lengthy Latin text, oversaw the making of the many mathematical diagrams that accompanied the text, and read the proofs. The publication was initially sponsored by the Royal Society, but Halley was eventually obliged to underwrite the book himself, at a time when he could barely afford the risk. Finally, Halley wrote a poem to preface Newton's text, in which he portrays Newton as a man of genius ('Scandere sublimis Genii concessit acumen') who towers above his fellow human beings and has enabled them to see 'the patterns of the heavens, and the balances of the divine structure':

O you who rejoice in feeding on the
 nectar of the god in heaven,
Join me in singing the praises of
 NEWTON, who reveals all this,
Who opens the treasure chest of hidden
 truth,
Newton, dear to the Muses,
The one in whose pure heart Phoebus
 Apollo dwells and whose mind he has
 filled with all his divine power;
No closer to the gods can any mortal rise.[1]

Such poems are always hyperbolic in their praise, but the *Principia* bestowed on Newton a pre-eminence that perhaps only Einstein among physicists has since equalled. What Newton would have made of this may be guessed from a passage he wrote in a letter to Robert Hooke, eleven years before the publication of the *Principia*: 'What Des-Cartes did was a good step. You have added much several ways, & especially in taking ye colours of thin plates into philosophical consideration. If I have seen further it is by standing on ye shoulders of Giants.'[2]

Among the new friends Newton made following the publication of the *Principia* was a brilliant young Swiss mathematician, Nicolas Fatio de Duillier. This copy of the first edition of the *Principia* was given to Fatio by Halley. At one stage Fatio contemplated a revised edition of the *Principia*, and he has made various annotations in this copy, introducing running headers and correcting a number of errors.[3]

Notes
1 Cohen and Whitman 1999, pp. 379–80.
2 Turnbull et al. 1959–77, vol. 1, p. 416.
3 Rigaud 1838, pp. 89–95.

53

Sir Isaac Newton (1642–1727)

Undated

Marble, height 495 mm

Provenance: Possibly acquired by the University of Oxford in 1762

Literature: Lane Poole, vol. 1, no. 227; Garlick, p. 235; Keynes 2005, p. 60 (A.32)

LP 227

Newton was an introverted man, habitually silent and reserved in company. He was small in stature and in later life appeared somewhat wizened. In the many portraits that were made of him, however, he is an imposing and masterful figure, as befitted his standing as the greatest scientist of the day and, latterly, a senior public servant (he was appointed Keeper of the Royal Mint). The leading court painter Sir Godfrey Kneller painted him at least four times, on the first occasion soon after the publication of *Principia mathematica* (cat. 52) and for the last time when Newton was over 80.

After Newton's death busts and statues proliferated as he duly took his place in the premises of learned societies, in libraries and in the 'temples of worthies' that adorned the grottoes and private gardens of the wealthy. Alexander Pope owned a bust of Newton made by Giovanni Battista Guelfi in about 1731, presumably for his Twickenham grotto. Another Guelfi bust was made in 1732 for Queen Caroline's grotto at Richmond, and is now in Kensington Palace. A stone bust by Michael Rysbrack of *c.* 1727 is in the Temple of Worthies at Stowe, where he occupies a place between John Locke and Francis Bacon. At the Royal Society there is a marble bust made by Louis François Roubiliac in 1738; another Roubiliac bust is in the Wren Library of Trinity College, Cambridge, and a full-length statue by Roubiliac stands in the ante-chapel at Trinity. Newton is memorialized in Westminster Abbey by a monument designed by Rysbrack and William Kent.

In his 1766 portrait of Benjamin Franklin, David Martin depicted the great American polymath working at his desk, on which sits a large bust of Newton; the portrait now hangs in the White House, Washington, DC. Following his experiments with electricity and lightning Franklin had been hailed by his contemporaries as the 'new Newton'. In 1767 Joseph Priestly called one of Franklin's demonstrations 'the greatest, perhaps, that has been made in the whole compass of philosophy, since the time of Sir Isaac Newton.' In his autobiography Franklin recalled that when he was a young man in London he had been intorduced to 'Dr Pemberton, at Batson's Coffee House, who promis'd to give me an Opportunity some time or other of seeing Sir Isaac Newton, of which I was extremely desirous; but this never happened.'

Evidence for the date and manner of the Bodleian's acquisition of this bust is lacking. It is not signed or dated (*pace* Keynes). It was thought to be by the English sculptor Joseph Wilton, a friend of Roubiliac, but this attribution has recently been questioned.

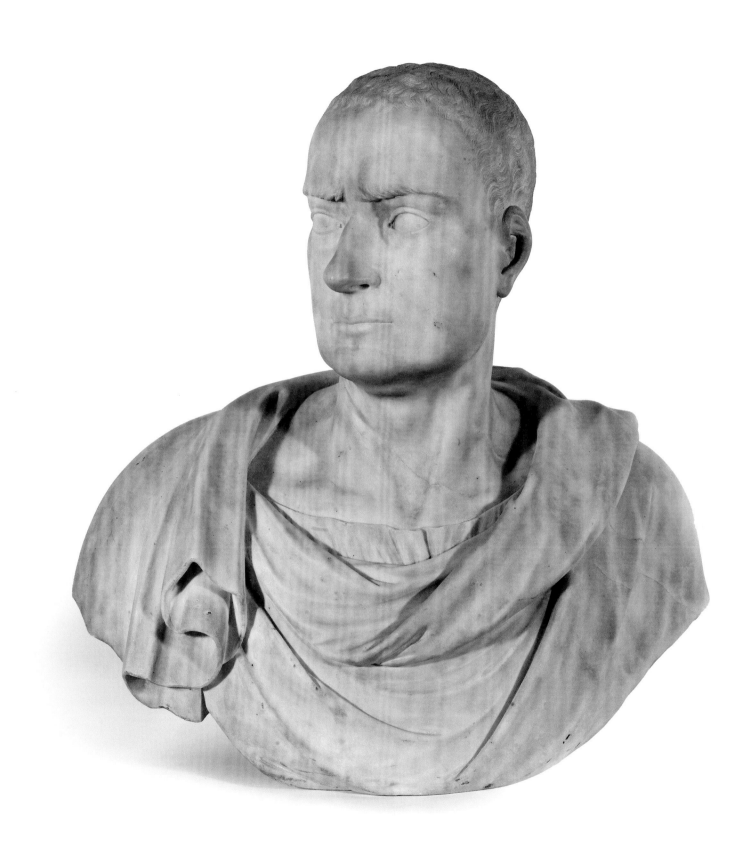

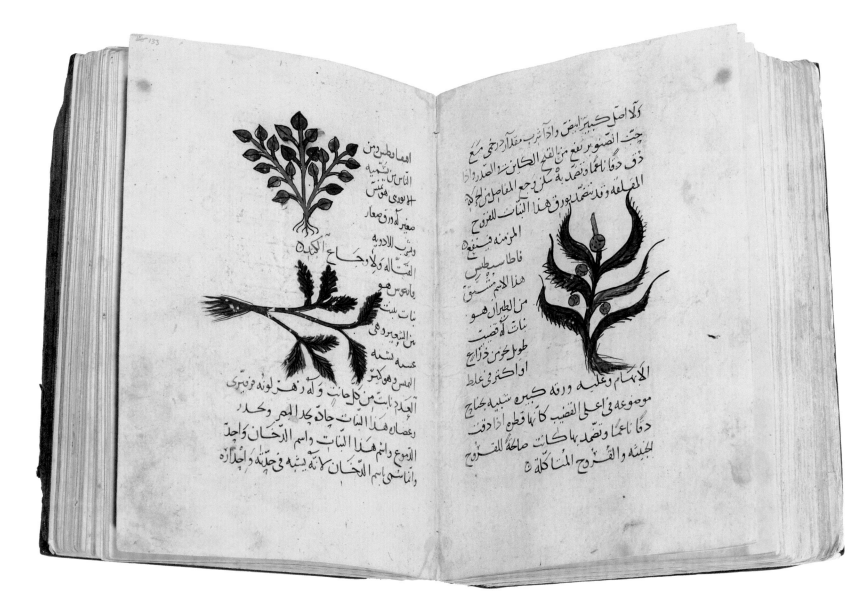

ولا أصل كبير أبيض وإذا شرب مقدار درخمي مع
جبن انصو يرفع من القلح الكائن الصدر وإذا
دق دقا ناعما وتضمد به سكن وجع المفاصل الحارة
المقلقة وقد ينصّف ورق هذا النبات للفروح
الرمنه فينفع
فاطاسطس
هذا الاسم مشتق
من الطيران هو
نبات لا ينقض
طول نحو ذراع
أو اكثر في غلط
الأبهام وعليه ورقة كبيرة شبيه بحاج
موضوعه في اعلى القضيب كانها قطن إذا دق
دقا ناعما وتضمد بها كانت صالحة للفروح
الجنبه والفروح المأكلة ه

اهما يطرون ومن
الناس من يسميه
الح بوبى فونس
معبره له ورق صغار
ويطيب الادويه
القتاله وللادجاع الكبد
باسوس هو
نبات نبت
من الشجر وهى
عسبه نشه
الهس وهو كثير
العدد نبات من الاعشاب وله زهر لونه وبرى
وبعضان هذا النبات جاده جدا المر وحده
الدموع واسم هذا النبات واسم الرخان واحد
وانما سمى باسم الدخان لانه بينه في حلته دراراه

54

DIOSCORIDES OF ANAZARBUS (d. *c*. AD 90)

Materia medica (*Materials of Medicine*)

Baghdad (?), completed 1240

Translated from the Greek by Iṣṭafān ibn Bāsil, revised by Ḥunayn ibn Isḥāq al-ʿIbādī (d. 873 or 877)
Miniatures
In Arabic; 209 leaves, 246 × 166 mm
Nineteenth-century European rebinding incorporating earlier boards: dark red goatskin with blind-stamped centrepiece, blind and gold tooling; remains of original fore edge flap

Provenance: Purchased by Sir William Osler (d. 1919) through the agency of J.H. Bill, British consul in Shiraz; bequeathed by him to the Bodleian (received 1926)

Exhibition: Oxford 1981, no. 19

Literature: NCAM-1, no. 14A

MS. Arab. d. 138 [fols. 132b–133a illustrated]

The ancient Greek physician Dioscorides has been called the father of pharmacology. His *Materia medica* describes around seven hundred plants and a thousand drugs, and arranges them according to their medicinal properties and physiological effects. Dioscorides explained his methods: he began by researching the existing authorities and then improved on them by directly and precisely observing plants in their natural habitats.

The *Materia medica* was translated several times into Arabic. The standard version was made by Iṣṭafān ibn Bāsil in Baghdad in the middle of the ninth century and lightly revised by Ḥunayn ibn Isḥāq. Further translations and revisions were undertaken in Spain, Iran and Diyarbakr. Not only did the translators have to identify plants from their Greek names, they had to provide an Arabic equivalent – and they would often simply transcribe the Greek characters into Arabic rather than devise a completely new name. The results of this can sometimes be puzzling.

This thirteenth-century manuscript is a copy of the Iṣṭafān/Ḥunayn translation. It contains only the last three books (*maqālah*s) of the treatise: the third book, on roots and extracts; the fourth, on herbs and roots; and the fifth, on vines and wines. Like many manuscripts of the *Materia medica* it is richly illustrated, suggesting that Dioscorides' original text had been accompanied by images. The difficulties of identification are demonstrated in the opening illustrated opposite. On the right-hand page is an unidentified illustration: the Greek text is generally interpreted as describing coltsfoot, but the Arabic commentators appear to describe a form of arum; the illustration corresponds with neither. The upper illustration on the left-hand page is another unidentified picture; the plant described is usually identified as rupture wort or a variety of orchid, but the illustration is of neither. The lower illustration is of fumitory.

As an authority on Mediterranean flora Dioscorides had a remarkably durable afterlife. In the 1930s, centuries after the *Materia medica* had been superseded as a medical manual, Arthur Hill, director of the Royal Botanical Gardens at Kew, saw an elderly monk with his treasured copy of it on Mount Athos:

He was a remarkable old Monk with an extensive knowledge of plants and their properties. Though fully gowned in a long black cassock he travelled very quickly, usually on foot and sometimes on a mule, carrying his 'Flora' with him in a large, black, bulky bag. Such a bag was necessary since his 'Flora' was nothing less than four manuscript folio volumes of Dioscorides, which apparently he had himself copied out. This flora he invariably used for determining any plant which he could not name at sight, and he could find his way in his books and identify his plants – to his own satisfaction – with remarkable rapidity.[1]

Note
1 Harris 2007, p. 42.

55

FERDINAND BAUER (1760–1826)

Arum dioscorides

c. 1789

Pencil and watercolour with gum arabic on paper; 489 × 292 mm

Provenance: Commissioned by John Sibthorpe (1758–1796), who bequeathed it to the University of Oxford

Exhibition: Oxford 1999, no. 25

MS. Sherard 245, fol. 56

In the sixteenth century Dioscorides' *Materia medica* was closely studied as an authoritative classical text which, it was believed, could improve medical practice. Early manuscripts, however, presented certain problems. The language was frequently obscure, and repeated copying had progressively altered the accompanying illustrations and rendered many of them unrecognizable. Identifying the plants could thus be extremely difficult. In the seventeenth and eighteenth centuries botanists began to compare Dioscorides' descriptions with actual plants in an effort both to identify what was in the *Materia medica* and to learn about the many species which, it was realized, had been left out. To this end they travelled to the Mediterranean, either individually or as part of sponsored expeditions.

One such traveller was a wealthy young botanist called John Sibthorpe, the son of Humphrey Sibthorpe, an undistinguished Sherardian Professor of Botany at Oxford. Sibthorpe succeeded his father as Sherardian Professor in 1784. The following year he went to Vienna, where he saw an early manuscript copy of the *Materia medica*, and soon afterwards

he conceived an ambition to identify as many of Dioscorides' plants as he could and to build on the work of the great physician. From March 1786 he travelled extensively around the Mediterranean. He employed an Austrian artist, Ferdinand Bauer, to accompany him and make drawings of all the plants they encountered.

Sibthorpe and Bauer returned to England in September 1787, Sibthorpe with diaries, notes and some two thousand plant specimens, Bauer with portfolios full of field drawings, made in pencil but colour coded according to a comprehensive numbering system of his own devising. In Oxford Bauer developed these pencil drawings into life-sized watercolours. He painted quickly, by one estimate producing a watercolour every one and a half days,[1] but the quality of his work is superb. He successfully combines rigorous scientific accuracy with artistic beauty.

Note

1 Harris 2007, p. 107.

Fig. 21. Detail of Ferdinand Bauer's field sketch of *Arum dioscorides*, showing his system of numerical colour-coding. PLS MS. 247, fol. 112r

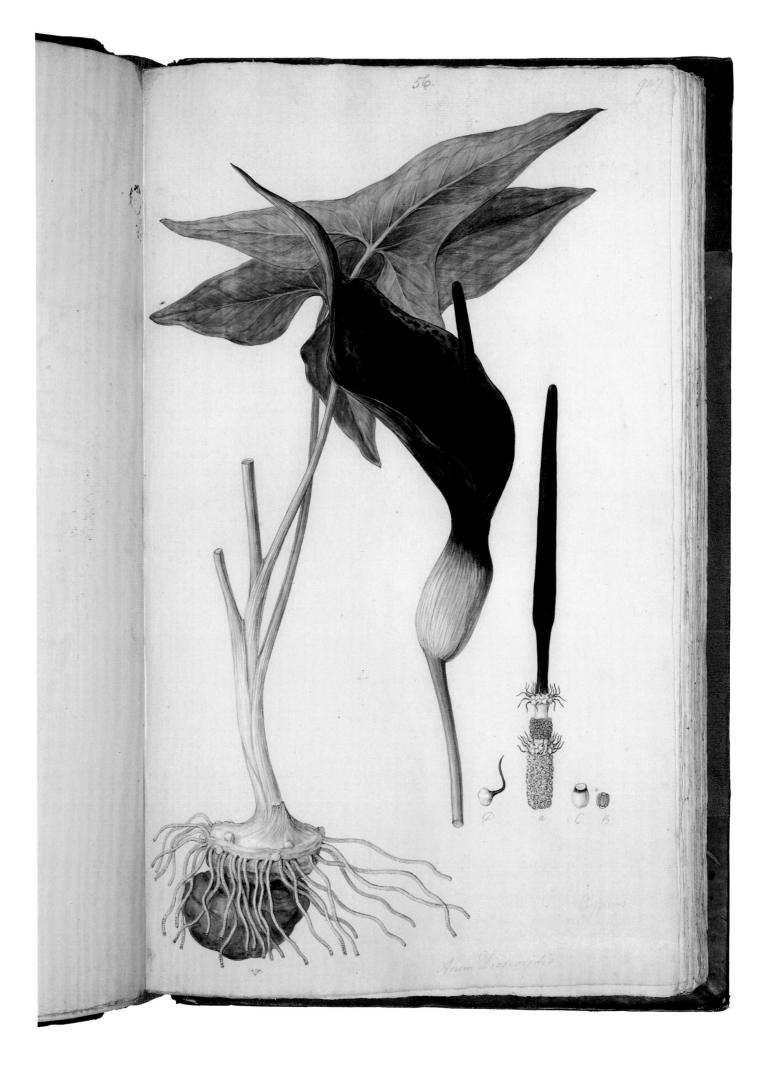

Arum Dracontium

Cyprus

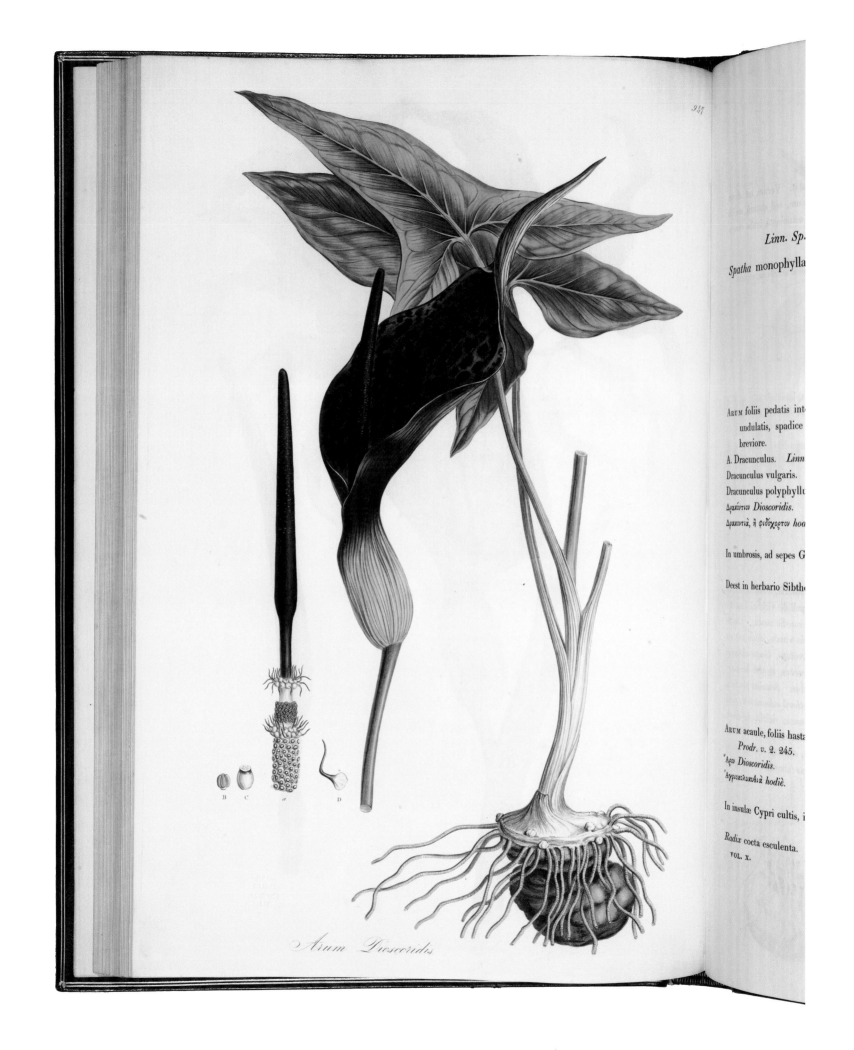

Arum Dioscoridis.

B C *a* D

Linn. Sp.

Spatha monophylla

ARUM foliis pedatis inte-
 undulatis, spadice
 breviore.
A. Dracunculus. *Linn*
Dracunculus vulgaris.
Dracunculus polyphyllu
Δρακόντιον *Dioscoridis.*
Δρακοντιὰ, ἡ φιδόχορτον hod

In umbrosis, ad sepes G

Deest in herbario Sibth

ARUM acaule, foliis hasta
 Prodr. v. 2. 245.
Ἄρον *Dioscoridis.*
Ἀγριοκολοκυθιὰ hodiè.

In insulæ Cypri cultis, i

Radix cocta esculenta.
VOL. X.

56

JOHN SIBTHORPE (1758–1796), JAMES EDWARD SMITH (1759–1828) and JOHN LINDLEY (1799–1865)

Flora Graeca (The Flora of Greece)

London: Richard Taylor et al., 1806–40

In Latin; 896 pages and 966 plates in ten volumes,
470 × 325 mm
Mid-nineteenth-century English binding (after 1840):
green goatskin with gold tooling

Provenance: Thomas Platt (1760–1842); purchased
in 1928 by George Claridge Druce (1850–1932);
bequeathed by him to the Department of Botany,
University of Oxford, and transferred to the Bodleian

Exhibition: Oxford 1999, no. 71

RR. y. 143 [plate 947 illustrated]

In 1794 John Sibthorpe left for a second
field trip to the Mediterranean, this
time without Ferdinand Bauer (see
cat. 55), who resented being treated
like a servant. When he returned
the following year he was ill with
tuberculosis. He died in 1796, but his
ambitions were realized posthumously.
His will directed that the proceeds from
one of his estates be used to publish
his botanical fieldwork in a most
magnificent form:

*the Profits or Rents of such Estate to be
applied in the following manner first the
Publication of a Work for which I have
collected the Materials to be entitled
Flora Graeciae which is to consist of ten
Folio Volumes each Volume to consist of
one Hundred Plates … I do request of my
Executors to find out & nominate some
Person well skilled in Botany & Natural
History for that Purpose & under whose
direction the Plates may be engraved &*

*coloured from the Drawings & MS Notes
which may be found in my Journals or
loose Papers & have before him all my
collections of dried Plants & Natural
History …*[1]

It was estimated that this enormous task
would take eleven years to complete.
In the end it took forty. Sibthorpe's
executors chose James Edward Smith,
president of the Linnean Society, to
make sense of Sibthorpe's extensive
but chaotic materials and put them
into a lucid and intellectually coherent
form. Meanwhile, Bauer's watercolours
were transferred on to copper plates
by experienced botanical engravers,
James Sowerby and his family, printed
and then meticulously hand-coloured.
Smith laboured on *Flora Graeca* for
twenty-nine years until his death in
1828. He was replaced by another fine
botanist, John Lindley, who saw the
project through to completion.

Just twenty-five sets of *Flora Graeca*
were published, containing 966
plates in Sibthorpe's stipulated ten
folio volumes. Each set cost £620 to
produce – an enormous sum – and
was sold to subscribers for £254. The
resulting substantial loss was covered
by Sibthorpe's estate, but the finances
of such an expensive project were
nevertheless tight. A demand from the

British Museum for a free copy under
the terms of the Copyright Act had to
be fended off in the courts.

This perfect copy of *Flora Graeca*
probably belonged to Thomas Platt,
one of the executors of Sibthorpe's will.
It was bequeathed to the University
of Oxford by George Claridge Druce,
Mayor of Oxford 1900–1901. Both
the Bodleian and the Botanic Garden
had been presented with copies by
the executors of Sibthorpe's will, but
because those copies were deemed
inferior to the Druce copy they were
sold for the benefit of the Druce Fund,
and the Druce copy was transferred
to the Bodleian Curators. It was kept
in the Rare Book collection at the
Radcliffe Science Library.[2] Shown here
is the engraving of *Arum dioscorides*,
a distinctive Mediterranean species
which Smith described as new to
science, and which was named after
the ancient Greek authority who had
first inspired the project more than half
a century earlier. For Bauer's original
watercolour and pencil drawing see
cat. 55.

Notes

1 Harris 2007, p. 151.
2 *Bodleian Library Record*, vol. 2 (1949),
 pp. 75–6.

57

JULIA MARGARET CAMERON (1815–1879)

The Henry Taylor Album

1864–5 and 1867

112 albumen prints of varying sizes, bound in blue cloth-covered boards, 385 × 335 mm

Provenance: Given by the photographer to Sir Henry Taylor (1800–1886); given to the Bodleian in 1930 by the Taylor family

Literature: Cox and Ford 2003, p. 505

Arch. K b.12 [*fol. 53r illustrated*]

The great photographer Julia Margaret Cameron did most of her photographic work in the 1860s and 1870s, while she was living on the Isle of Wight as the neighbour of the Poet Laureate, Alfred Tennyson. Writers, artists, academics, scientists and politicians all came to the Isle of Wight, and there Cameron created a body of work which is an incomparable visual record of eminent Victorians. 'It was a splendid exclusive society which circled more or less around Tennyson', wrote Sir Edmund Gosse. 'They lived in a radiance of mutual admiration.' 'Everybody is either a genius or a painter or peculiar in some way', wrote Caroline Stephen, 'is there *nobody* commonplace?' The Irish writer and theologian Wilfred Ward compared Tennyson's house, Freshwater, to the French *salons* of Paris which congregated around Madame Récamier and Chateaubriand: 'The essential work of gathering together the interesting people who were to form the Tennyson society, the enthusiasm for the hero as for genius in general, was Mrs Cameron's part, as it was for Madame Récamier.'

Cameron was certainly a hero-worshipper, but through her photography she brought her own genius to bear on these distinguished gatherings. Indeed, Frederick Pollock called her 'the presiding genius of the place'.[1]

In her portraits Cameron sought not so much to record the sitter's features, as to reveal the genius within. Referring to her photographs of Thomas Carlyle, she wrote in her memoir, *Annals of my Glass House* (1874): 'When I have such men before my camera, my whole soul has endeavoured to do its duty towards them in recording faithfully the greatness of the inner as well as the features of the outer man.'[2] Her portraits of this type, almost all of men, are mostly close-ups of the head and shoulders, thus eliminating the costumes and contrived backgrounds which give photographs a period flavour. Her exposures were famously long, and in many instances her subjects look steadfastly at the camera with a peculiarly intense gaze.

Sir John Herschel, the subject of the portrait illustrated here, was an illustrious scientist with an equally illustrious father – the astronomer William Herschel, who identified the planet Uranus and is buried next to Newton in Westminster Abbey. It was Sir John Herschel, a pioneer in the chemistry of photography, who first told Cameron about the new science when they met in Cape Town in 1836, and who later encouraged her photographic pursuits.

The portrait is one of 112 photographs in an album once belonging to the writer Henry Taylor. Other portraits in the album, mostly dating from 1864–5, are of Taylor himself, Tennyson, Robert Browning, Benjamin Jowett (the Master of Balliol College, Oxford), Ellen Terry, William Michael Rossetti, William Holman Hunt and George Frederic Watts.

Note
1 Cox and Ford 2003, pp. 23–4.
2 Ibid., p. 24.

THE CHILD OF PATRONAGE

On 17 July 1830, *The Spectator* published a letter from 'an old dilettante', who was responding to a recent suggestion in the *Westminster Review* that 'genius was the child of patronage'. 'Now who but a weak man would ever assert such nonsense?' asked the old dilettante. 'Genius is the gift of God, in poetry, painting, or music; but the degree to which that genius can develop itself, I maintain, depends on the opportunity given it by patronage, that is by employment.'

Books and manuscripts can be objects of great elaboration and unusual beauty. More often than not they are collaborative, and as such offer a corrective to what is sometimes dismissed as 'the myth of solitary genius'. The scholar, the scribe, the artist, the printer and the binder may all have a hand in their creation. Some are created at the behest of a wealthy patron; others are made in the hope of patronage or royal favour. The powerful figures behind the works of art in this section include a Frankish emperor (cat. 58), a duke of Mantua (cat. 61), a prominent Florentine merchant (cat. 63), a Holy Roman Emperor (cats 64 and 65), Mughal rulers (cats 67 and 68), an English queen (cat. 69) and unknown rich aristocrats in Japan and Asia (cats 71 and 74). They all either commissioned the finest craftsmen and artists available to them, or inspired someone to produce his or her best work.

As commissioned objects, these books and manuscripts were occasioned and shaped by the personal preferences and, sometimes, the political purposes of the patron. The patron's wishes were in turn influenced by the prevailing tastes of the time. The calligraphy and adornment of religious texts (cats 62 and 66) were also executed according to established traditions. Maps are also determined by the circumstances of and reasons for their making. Sometimes, as for example in a map of new colonial territory (cat. 72), these contexts and intentions are clear; on occasions when they are not, the map can remain something of a mystery (cat. 60).

Although embedded in the tastes, traditions and politics of their time, these books and manuscripts are not predetermined and lifeless followers of fashion, let alone the dreary products of some committee. On the contrary, their beauty comes from the character and artistry – the genius – of the individuals who conspired, often anonymously, to make them.

58

The Douce Ivory

Plaque: Aachen (?), *c.* 800
Manuscript: Chelles, near Paris (?), *c.* 800

Plaque: ivory, 210 × 125 mm
Manuscript: in Latin, on parchment; 129 leaves,
290 × 195 mm
Late eighteenth-century French binding: red leather
with gold tooling, with recess for ivory

Provenance: Inscription: 'Ce livre, avant la Révolution,
appartenoit à l'abbaye de St. Faron, située près de
Meaux. Gosselin.'; Abel Remusat's sale, 27 May 1833:
purchased by Payne, the London bookseller; acquired
in 1833 by Francis Douce (1757–1834), who bequeathed
it to the Bodleian

Exhibitions: Oxford 1984, no. 39; Paderborn 1999,
no. X.7; Oxford 2002b, no. 19; Washington 2006, no. 73

Literature: SC 21750; P & A, vol. 1, no. 412

MS. Douce 176

This ivory panel was made in Aachen,
at the court of Charlemagne, where
intellectual and artistic life thrived.
Carolingian scholars copied classical
Latin texts; court artists engaged with
classical art, particularly that of the Late
Antique period.

In the fifth and sixth centuries AD the
Romans used ivory for diptychs – works
of art consisting of two facing pieces,
often joined by a hinge. 'Consular
diptychs' were ceremonial writing
tablets; the inner surfaces were wax and
the outer surfaces were adorned with
relief ivory carvings. They marked the
appointment of a new consul and were
distributed to his relatives and friends.
Carolingian artists imitated the style
of these diptychs in the form of single
plaques, and six of the individual scenes
in the present plaque may be traced to
fifth-century fragments now preserved
in Paris and Berlin. In classical ivories
the middle panel would normally have
been occupied by a conquering ruler;

here, Christ in Majesty is the central
figure. Otherwise, however, the style
and composition of the plaque is
consciously Late Antique.

Christ, a beardless young man,
holds his cross-staff over his shoulder
as an emblem of victory and carries an
open book inscribed 'IHS XPS' ('Jesus
Christus') and 'SVP[er] ASP[idem]'
('super aspidem' from Psalm 91:13).
He is shown standing on a lion and a
serpent, according to the prophecy in
the psalm: 'Thou shalt tread upon the
lion and adder: the young lion and the
dragon shalt thou trample under feet.'
The smaller scenes begin, top left, with
the figure of Isaiah holding a scroll
bearing the first word of his prophecy
on the coming of Christ: 'Ecco virgo
conc[ipiet]' ('Behold, a virgin shall
conceive' – Isaiah 7:14). They continue
clockwise: the Annunciation, the
Nativity, the Adoration of the Magi,
the Massacre of the Innocents, the
Baptism, the Wedding at Cana, the
Stilling of the Storm on the Sea
of Galilee, the Raising of Jairus's
Daughter, the Healing of the Gerasene
Demoniac, the Healing of the Paralytic
and the Healing of the Woman with
an Issue of Blood.

From the reign of Constantine,
Christian texts were given precious
bindings as an expression of the
pre-eminent status of the official
Roman religion. This plaque was
made for a liturgical book. It is now
set in an eighteenth-century French
binding, but the manuscript within

the covers – a gospel lectionary – is
written in a script that has been linked
to a nunnery at Chelles, near Paris, and
to a period when the abbess of that
monastery was Gisla, Charlemagne's
sister. It is impossible to determine
whether the ivory and manuscript have
always been joined, but it is not unlikely
that they have been so from an early
date.

A note in the manuscript states that
before the French Revolution it had
belonged to the nunnery of St Faro at
Meaux, also near Paris.

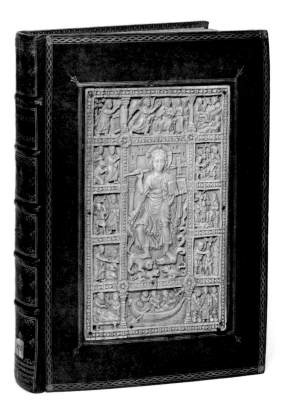

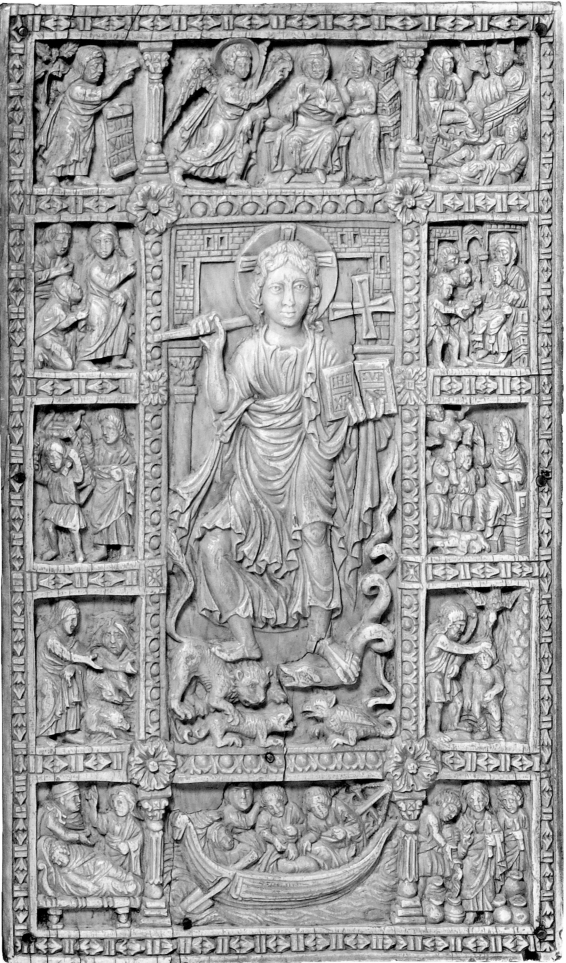

59

Bestiary

Salisbury (?), mid-thirteenth century

Miniatures, initials
In Latin, on parchment; 140 leaves, 294 × 195 mm
Seventeenth-century English binding: brown calfskin
with blind tooling

Provenance: Inscription (fifteenth century): 'Gaunte';
probably reached the Bodleian in the first decade of
the seventeenth century (it may be the *Bestiarium*
listed in the first Bodleian catalogue, 1605)

Exhibition: Tokyo 1990, no. 37

Literature: SC 2544; P & A, vol. 3, no. 372; Barber 1992
(facsimile); Barber and de Hamel 2008 (facsimile);
Morgan 1982–8, vol. 2, no. 98

MS. Bodl. 764 [fols. 11v–12r illustrated]

Of the approximately one hundred
medieval bestiaries that survive, most
were made in England, and most date
from between the mid-twelfth and
late thirteenth centuries. The creatures
they describe range from the familiar
(dogs, cows, owls, bees) to the exotic
(lions, crocodiles, elephants, whales)
and the fabulous (phoenixes, basilisks,
dragons, unicorns). The monks who
composed the bestiaries read about
these marvellous beasts in classical
encyclopedias: chiefly the *Natural
History* of Pliny the Elder (AD 23/4–79),
the *Etymologiae* of Isidore (Bishop
of Seville, *c.* 600–636), and the
Physiologus, an anonymous work dating
from sometime between the second
and third centuries AD that describes
around fifty creatures, plants and
stones.

Bestiaries were not scientific
catalogues; they were religious books.
All beasts, from the cattle in the nearby
pasture to the dragons of remote
Ethiopia and India, exhibited certain

characteristics, and those characteristics
were not accidental, but had been
created by God to instruct and guide
mankind. As Thomas Cobham
(d. *c.* 1236) wrote in his *Summa de arte
praedicandi,*

*The Lord created the various creatures
with different natures, not only for
the sustenance of men but for their
instruction – characteristics in animals
lead us to imitate the Lord or avoid the
devil. The whole world is full of different
animals, like a book filled with written
words and sentences in which we can
read what we should imitate or avoid.*[1]

The splendid accompanying
illustrations animated and intensified
the verbal descriptions.

To begin with, most bestiaries were
made for monasteries, the medieval
centres of literacy and religious
contemplation. Later, however, they
were commissioned by royalty and the
upper ranks of society. There are clues
to the ownership of this manuscript.
The 135 illustrations depict creatures
in a domestic or agricultural context
but also as part of such knightly
pursuits as hunting, hawking and
physical combat. The depiction of the
elephant (illustrated opposite) shows
knights defending a tower, and their
coats of arms have been linked to
the families of Berkeley, Mohaut and
Clare, all of which had connections
with the Welsh Marches. Further, the
inscription 'gaunte' on the original

pastedown may be a reference to John
of Gaunt (1340–1399), the fourth son of
Edward III.[2] Such a provenance, though
not provable, suits a manuscript that
few people could have afforded. The
colouring, with extensive use of red,
orange and blue, and the lavish gold
burnishing, are particularly elaborate.

The elephant and his wife are the
symbols of Adam and Eve. They have
no desire to mate, but if 'they want to
have offspring, they go to the east, near
the earthly Paradise, where a tree called
mandragora grows. The elephant and
his mate go there, and she picks a fruit
from the tree and gives it to him. And
she seduces him into eating it; after
they have both eaten it, they mate and
the female at once conceives.' In such a
manner were Adam and Eve seduced by
the dragon (the enemy of the elephant).
But the elephant is also the greatest
of beasts, and a source of strength.
Following their banishment from the
earthly paradise, Adam and Eve were
helped by the great elephant, 'namely
the law', and the twelve elephants
('that is, all the prophets'). But only
the cunning elephant ('that is our Lord
Jesus Christ') could truly change their
fate, by making himself very small ('in
that He humbled Himself before death,
in order to raise mankind up').[3]

Notes

1 Barber and de Hamel 2008, p. 22.
2 Ibid., pp. 32–4.
3 Quotations from Barber and de Hamel 2008,
 pp. 65–7.

12

Inter dicta quia inluppozum genere nu-
meratur bestia maculis tergo distin-
cta ut pardus. sz similis lupo. huius urina
coniti induriciam preciosi lapidis dr: quod
ligurius appellat. Quod et ipsas uncos feru-
hoc documento pbatur. Nam egestam li-
quorem arenis ipse contum pertenere con-
gunt inuidia qdam nature ne talis li-
quor transeat in usum humanum. Lt
dicitur plinius extra unum n adiunitur-
ista bestia typum tenet inuidoz
hominum atqz dolosoz qui magis cupiunt
nocere qin pdesse. & hiis cupidi dzanibz: m
ct: ea que sibi supflua sunt. & ceteris pesse:
teratur inutaliter seruant.

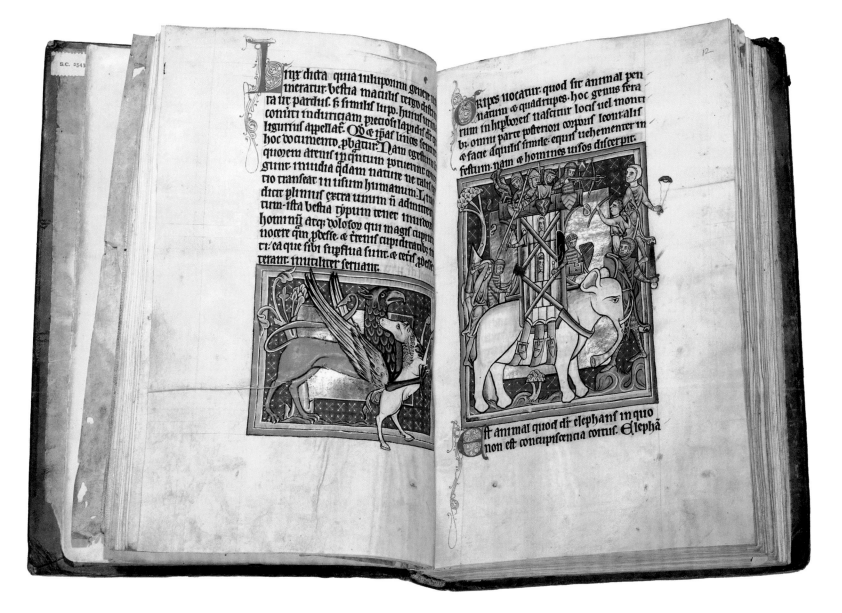

Oripes uocatur: quod sit animal pen-
natum & quadrupes. hoc genus fera-
rum in hiperboreis nascitur locis uel monti-
bz. omni parte posterion corpus leoni: alis
& facie aquilis simile: equis uehementer in-
festum. nam & homines uisos discerpit.

Est animal quod dz elephans in quo
non est concupiscencia coitus. Elephâ

60

The Gough Map

Thirteenth/fourteenth century (?)

Pen, ink and washes on parchment (two membranes joined together); 1150 × 560 mm

Provenance: Purchased at a sale in 1774 by Richard Gough (1735–1809), who bequeathed it to the Bodleian

Exhibition: Oxford 2002b, no. 43

Literature: Millea 2007; Lilley et al. 2009; Smallwood 2009; Solopova 2012; Smallwood 2012

MS. Gough Gen. Top. 16

When this map is turned 90 degrees in a clockwise direction its shape immediately becomes familiar: it is the earliest surviving map to show the coastline of Britain in a recognizable form. When the map was made, this shape would have been quite new and would certainly not have existed in anyone's mind's eye, educated or otherwise. If people travelled at all, they did so not with the aid of maps, but by following itineraries – lists of places and the distances between them. As an example of cartography the Gough Map is a remarkable achievement; it served as the blueprint for similar maps for over two centuries, and was well known both at home and abroad.

The map is named after a former owner, the antiquary Richard Gough (1735–1809), who described it as 'a curious and ancient map of Britain'. It is oriented with east at the top, and is drawn on two pieces of vellum. It portrays the whole of England and, with considerably less detail and accuracy, Wales and Scotland. The Orkneys and the Channel Islands are included; on the edges are parts of the coastlines of Ireland and, rather vaguely, an amalgam of Scandinavia and Continental Europe. A number of rivers and a few lakes are depicted with great prominence; over 650 towns and settlements are included (with London and York the most prominent), and the names of eight counties are given. Hadrian's Wall is clearly shown, and three forests: the New Forest, Sherwood Forest and an unnamed forest on the Isle of Bute. The map itself is drawn with care, and with a skilful awareness of scale that was well ahead of its time, although the degree of accuracy varies considerably; Scotland is particularly rough compared to parts of England. It is highly unusual for a map of a single country to have been made at this date.

The Gough Map is a rich source of historical information, but because the circumstances of its making are so obscure, it raises as many questions as it answers. When was the map made? Cogent arguments have been given for a date anywhere between the mid-fourteenth century and the early decades of the fifteenth century. Is it an original map, or was it derived from a lost earlier map? If the latter, were several maps made from a single prototype, of which this is the only survivor? Large-scale single documents of this kind are, after all, highly vulnerable to the ravages of time. Does the map show signs of revision? Many of the settlements identified on it are linked by a series of straight red lines, which provide information on the distances between them and appear to be associated with particular itineraries, but what is their exact purpose? The fact that a number of the key settlements of the time are not linked in this way adds to the mystery. What, indeed, was the overall purpose of the map itself?

An obvious ambition to make the map as accurate and as informative as possible suggests that it had a practical function. The financial and administrative resources necessary would have required a very well-placed, possibly royal, patron. Field surveys would have had to be commissioned; and large amounts of data would have had to be gathered, processed and interpreted, and then translated into visual form.

Suggestions have been made that the map was intended as a symbol. On the one hand it has been argued that it shows the whole of Britain in order to reveal the disunity of the kingdom, and, on the other hand, that it shows the whole country in order to convey the message that the isles were under the sovereignty of a single monarch. It has been argued that it was based on a much earlier prototype conceived in the reign of Edward I (1272–1307) in order to aid and symbolize his territorial expansion into Wales and Scotland. References to King Arthur and to Brutus – 'hic Brutus applicuit cum Troianis' ('Here Brutus landed with the Trojans') – have been put forward as evidence of this imperial intent.

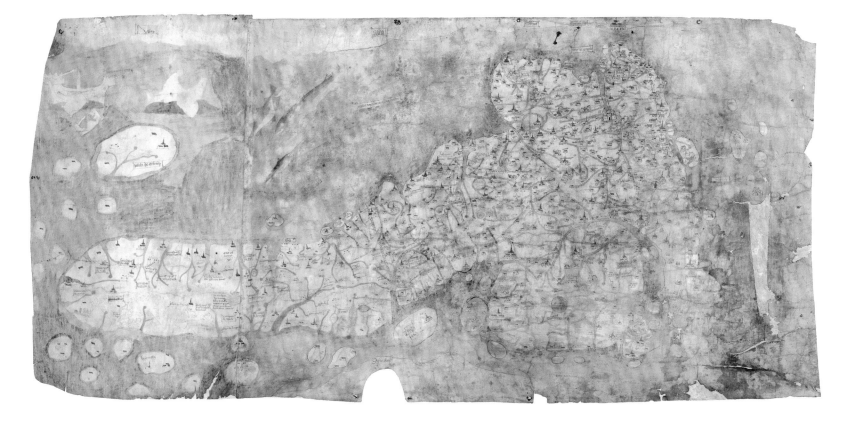

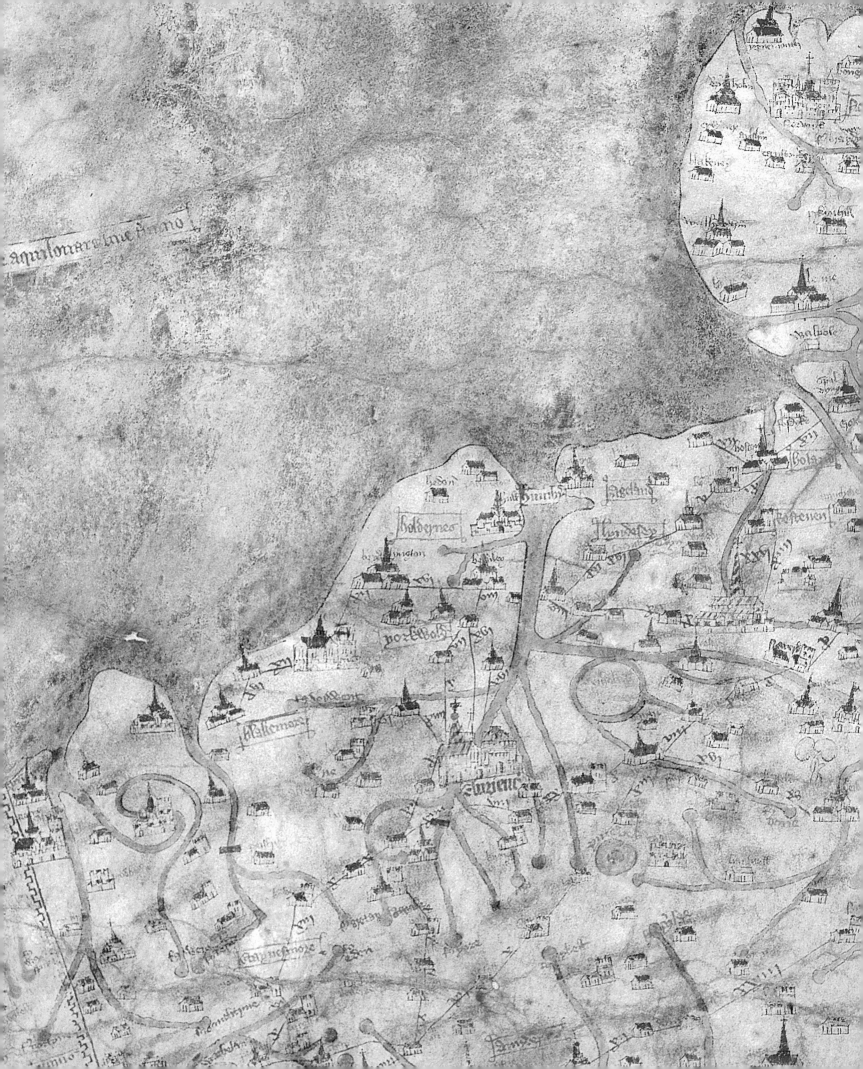

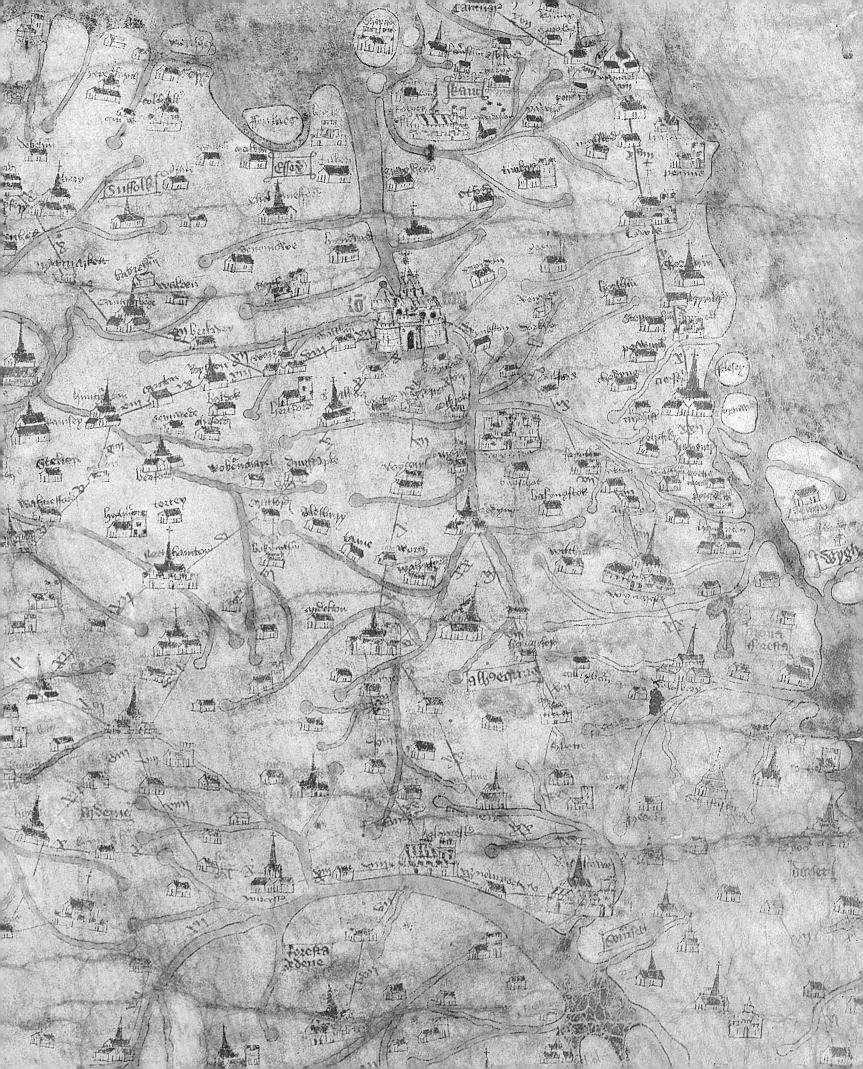

61

GIOVANNI BOCCACCIO (1313–1375)

Il Filocolo ('Love's Labour')

Mantua or Ferrara (?), *c.* 1463–4

In the hand of Andrea da Lodi; miniatures perhaps by Pietro Guindaleri (*fl.* 1464–1506), borders, initials
In Italian, on parchment; 242 leaves, 364 × 242 mm
Seventeenth-century Italian binding: red goatskin with gold tooling

Provenance: Made for Ludovico III Gonzaga of Mantua (1412–1478); Matteo Luigi Canonici (1727–1805); purchased by the Bodleian in 1817 from his heirs

Exhibitions: London 1981b, no. 20; London and New York 1995, no. 22

Literature: P & A, vol. 2, no. 393; de la Mare and Reynolds 1991–2

MS. Canon. Ital. 85 [fol. 25r illustrated]

Giovanni Boccaccio was the first great master of Italian prose. *Il Filocolo*, composed between 1336 and 1338, is one of his earliest works. It is a version of a medieval courtly romance, *Floire et Blancheflor*, in which the two lovers of the title (called by Boccaccio Florio and Biancifiore) are thwarted by Florio's father, the king of Spain. He sends Florio off to his uncle and sells Biancifiore to merchants, who in turn sell her to an Egyptian sultan. Taking the name of Filocolo ('Love's Labour'), Florio goes in search of Biancifiore, and after many adventures eventually succeeds his father as king and takes Biancifiore as his queen.

This manuscript of *Il Filocolo* is a product of the court of Ludovico III Gonzaga, the marchese, or duke, of Mantua from 1444 to 1478. The scribe was Andrea da Lodi, who specialized in vernacular texts and also made, probably for the Gonzagas, a manuscript of Dante's *Divine Comedy*. Each of the five books is headed by an exquisitely painted miniature. They have been attributed to the illuminator Pietro Guindaleri of Cremona, who worked for the Gonzagas from 1464 to 1506. The miniatures are set within superbly drawn interlace borders on a gold ground and a decorated initial, probably the work of another court artist. There are also smaller initials within the text, marking chapter openings or major speeches.

Ludovico Gonzaga was not the wealthiest of the great Renaissance Italian patrons – on 30 January 1464 Andrea da Lodi wrote to him requesting that his wages be paid for 'uno philocolo che ho principiato' – but he was one of the best educated. He was tutored by the great teacher Vittorino da Feltre at the Casa Giocosa, the school in Mantua set up by his father, Gianfrancesco. There he learned the essential disciplines of humanism: Roman poetry, history, rhetoric and ethics, as well as mathematics, astronomy and music. As a humanist prince Ludovico turned from the French courtly traditions to the classical past, replacing the late Gothic world of his predecessors with a Roman-based art. Among those Ludovico attracted to the Mantuan court were the great Florentine architect and polymath Leon Battista Alberti (1404–1472) and (after three years of persuasion) the finest artist in Northern Italy, Andrea Mantegna (*c.* 1431–1506).

Mantegna's humanist-inspired art dominated the Gonzaga court and his influence may be seen in this manuscript. The miniatures do not elucidate (or even show much knowledge of) Boccaccio's text, but give a courtly romance a classical flavour. In the miniature shown here a statuesque Cupid tempers his arrows in the stream running through the foreground. From a cloud his mother, Venus, gives him instructions while his altar burns behind him. The figure of Venus is derived from the so-called *Tarrochi del Mantegna*, which are no longer considered to be by Mantegna himself. Integrated into the border design are the Gonzaga arms.

The manuscript probably stayed in the Gonzaga family until the library was sold in Venice in 1707 by the last duke of Mantua, Ferdinando Carlo. It belonged to the collector Matteo Luigi Canonici, who purchased much of his collection in Venice.

DVNQVE CO
MIN CARNO
CON DILECEV
LE STVDIO LI

giouani ancora ne pri
mi anni puerili ad im
prendere gliamorosi
uersi. Nelle quali i
uoci sentendosi. La
sancta dea madre del
uolante fanciullo no
minare con tanto effe
cto non poco neglialtri
regni con glialtri dei se ne gloriaua. Ma non sofferse longame
te che niuano fossero da giouani poeti sapute cosi altre cose come
come ilaudeuoli uersi narrauano. Ma a muolti icandidi membri

אַשְׁרֵי הָאִישׁ אֲשֶׁר לֹא הָלַךְ בַּעֲצַת רְשָׁעִים וּבְדֶרֶךְ חַטָּאִים לֹא עָמָד וּבְמוֹשַׁב לֵצִים לֹא יָשָׁב
כִּי אִם בְּתוֹרַת יְהוָה חֶפְצוֹ וּבְתוֹרָתוֹ יֶהְגֶּה יוֹמָם וָלָיְלָה
וְהָיָה כְּעֵץ שָׁתוּל עַל פַּלְגֵי מָיִם אֲשֶׁר פִּרְיוֹ יִתֵּן בְּעִתּוֹ וְעָלֵהוּ לֹא יִבּוֹל וְכֹל אֲשֶׁר יַעֲשֶׂה יַצְלִיחַ
לֹא כֵן הָרְשָׁעִים כִּי אִם כַּמֹּץ אֲשֶׁר תִּדְּפֶנּוּ רוּחַ
עַל כֵּן לֹא יָקֻמוּ רְשָׁעִים בַּמִּשְׁפָּט וְחַטָּאִים בַּעֲדַת צַדִּיקִים
כִּי יוֹדֵעַ יְהוָה דֶּרֶךְ צַדִּיקִים וְדֶרֶךְ רְשָׁעִים תֹּאבֵד
לָמָּה רָגְשׁוּ גוֹיִם וּלְאֻמִּים יֶהְגּוּ רִיק
יִתְיַצְּבוּ מַלְכֵי אֶרֶץ וְרוֹזְנִים נוֹסְדוּ יָחַד עַל יְהוָה וְעַל מְשִׁיחוֹ
נְנַתְּקָה אֶת מוֹסְרוֹתֵימוֹ וְנַשְׁלִיכָה מִמֶּנּוּ עֲבֹתֵימוֹ
יוֹשֵׁב בַּשָּׁמַיִם יִשְׂחָק אֲדֹנָי יִלְעַג לָמוֹ
אָז יְדַבֵּר אֵלֵימוֹ בְאַפּוֹ וּבַחֲרוֹנוֹ יְבַהֲלֵמוֹ
וַאֲנִי נָסַכְתִּי מַלְכִּי עַל צִיּוֹן הַר קָדְשִׁי
אֲסַפְּרָה אֶל חֹק יְהוָה אָמַר אֵלַי בְּנִי אַתָּה אֲנִי הַיּוֹם יְלִדְתִּיךָ
שְׁאַל מִמֶּנִּי וְאֶתְּנָה גוֹיִם נַחֲלָתֶךָ וַאֲחֻזָּתְךָ אַפְסֵי אָרֶץ
תְּרֹעֵם בְּשֵׁבֶט בַּרְזֶל כִּכְלִי יוֹצֵר תְּנַפְּצֵם וְעַתָּה מְלָכִים הַשְׂכִּילוּ הִוָּסְרוּ שֹׁפְטֵי אָרֶץ
עִבְדוּ אֶת יְהוָה בְּיִרְאָה וְגִילוּ בִּרְעָדָה נַשְּׁקוּ בַר פֶּן יֶאֱנַף וְתֹאבְדוּ דֶרֶךְ כִּי יִבְעַר כִּמְעַט אַפּוֹ
אַשְׁרֵי כָּל חוֹסֵי בוֹ
מִזְמוֹר לְדָוִד בְּבָרְחוֹ מִפְּנֵי אַבְשָׁלוֹם בְּנוֹ יְהוָה מָה רַבּוּ צָרָי רַבִּים קָמִים עָלָי
רַבִּים אֹמְרִים לְנַפְשִׁי אֵין יְשׁוּעָתָה לּוֹ בֵאלֹהִים סֶלָה וְאַתָּה יְהוָה מָגֵן בַּעֲדִי כְּבוֹדִי וּמֵרִים רֹאשִׁי
קוֹלִי אֶל יְהוָה אֶקְרָא וַיַּעֲנֵנִי מֵהַר קָדְשׁוֹ סֶלָה אֲנִי שָׁכַבְתִּי וָאִישָׁנָה הֱקִיצוֹתִי כִּי יְהוָה יִסְמְכֵנִי
לֹא אִירָא מֵרִבְבוֹת עָם אֲשֶׁר סָבִיב שָׁתוּ עָלָי קוּמָה יְהוָה הוֹשִׁיעֵנִי אֱלֹהַי כִּי הִכִּיתָ אֶת
כָּל אֹיְבַי לֶחִי שִׁנֵּי רְשָׁעִים שִׁבַּרְתָּ לַיהוָה הַיְשׁוּעָה עַל עַמְּךָ בִרְכָתֶךָ סֶּלָה
לַמְנַצֵּחַ בִּנְגִינוֹת מִזְמוֹר לְדָוִד
בְּקָרְאִי עֲנֵנִי אֱלֹהֵי צִדְקִי בַּצָּר הִרְחַבְתָּ לִּי חָנֵּנִי וּשְׁמַע תְּפִלָּתִי
בְּנֵי אִישׁ עַד מֶה כְבוֹדִי לִכְלִמָּה תֶּאֱהָבוּן רִיק תְּבַקְשׁוּ כָזָב סֶלָה וּדְעוּ כִּי הִפְלָה יְהוָה חָסִיד לוֹ
יְהוָה יִשְׁמַע בְּקָרְאִי אֵלָיו רִגְזוּ וְאַל תֶּחֱטָאוּ אִמְרוּ בִלְבַבְכֶם עַל מִשְׁכַּבְכֶם וְדֹמּוּ סֶלָה
זִבְחוּ זִבְחֵי צֶדֶק וּבִטְחוּ אֶל יְהוָה רַבִּים אֹמְרִים מִי יַרְאֵנוּ טוֹב נְסָה עָלֵינוּ אוֹר פָּנֶיךָ יְהוָה
נָתַתָּה שִׂמְחָה בְלִבִּי מֵעֵת דְּגָנָם וְתִירוֹשָׁם רָבּוּ בְּשָׁלוֹם יַחְדָּו אֶשְׁכְּבָה וְאִישָׁן כִּי אַתָּה
יְהוָה לְבָדָד לָבֶטַח תּוֹשִׁיבֵנִי
לַמְנַצֵּחַ אֶל הַנְּחִילוֹת מִזְמוֹר לְדָוִד אֲמָרַי הַאֲזִינָה יְהוָה בִּינָה הֲגִיגִי
הַקְשִׁיבָה לְקוֹל שַׁוְעִי מַלְכִּי וֵאלֹהָי כִּי אֵלֶיךָ אֶתְפַּלָּל יְהוָה בֹּקֶר תִּשְׁמַע קוֹלִי בֹּקֶר אֶעֱרָךְ לְךָ וַאֲצַפֶּה
כִּי לֹא אֵל חָפֵץ רֶשַׁע אָתָּה לֹא יְגֻרְךָ רָע לֹא יִתְיַצְּבוּ הוֹלְלִים לְנֶגֶד עֵינֶיךָ שָׂנֵאתָ כָּל פֹּעֲלֵי אָוֶן
תְּאַבֵּד דֹּבְרֵי כָזָב אִישׁ דָּמִים וּמִרְמָה יְתָעֵב יְהוָה וַאֲנִי בְּרֹב חַסְדְּךָ אָבוֹא בֵיתֶךָ
אֶשְׁתַּחֲוֶה אֶל הֵיכַל קָדְשְׁךָ בְּיִרְאָתֶךָ יְהוָה נְחֵנִי בְצִדְקָתֶךָ לְמַעַן שׁוֹרְרָי הוֹשַׁר לְפָנַי דַּרְכֶּךָ

62

The Kennicott Bible

Corunna, Spain, 1476

In the hand of Moses Ibn Zabarah; miniatures by
Joseph Ibn Hayyim
Biblical text preceded and followed by a grammatical
treatise, *Sefer Mikhlol*, by Rabbi David Qimhi
(1160–1225)
In Hebrew, on parchment; 461 leaves, 300 × 235 mm

Binding: A contemporary Spanish box binding of
wooden boards covered in reddish-brown goatskin
blind tooled with interlacing geometric designs;
parchment doublures with geometric interlaces

Provenance: Purchased by the Radcliffe Library,
University of Oxford, on 5 April 1771 from Patrick
Chalmers, at the suggestion of Benjamin Kennicott
(1712–1783), the Radcliffe Librarian; transferred to the
Bodleian in 1872

Literature: Narkiss and Cohen-Mushlin 1985
(facsimile)

MS. Kennicott 1 [binding, fols. 5v–6r, 353r illustrated]

At the foot of the final book of this
magnificent Bible the scribe, one Moses
Ibn Zabarah, recorded that he finished
the work in La Coruña (Corunna)
in northern Spain, in the 5236th year
since the Creation – that is, AD 1476;
that he was responsible for copying,
checking and correcting the entire text;
and that it was made for his patron, the
'admirable youth, Isaac, son of the late
honourable and beloved Don Solomon
di Braga':

*The blessed Lord grant that he study it,
he and his children and his children's
children throughout all generations …
And God enable him to produce many
books, in order to fulfil the saying 'and
moreover take care, my son, to produce
many books, books without end'. Amen,
God grant that it be so.*[1]

On the last page of the manuscript the
artist identified himself as Joseph Ibn
Hayyim. The manuscript had been a
close collaboration between the two
men, and had probably taken them
around ten months to complete.

They may have worked at the home
of their patron. Nothing is known
about the young Don Isaac, except
that his family was of Portuguese
origin and that he was evidently very
wealthy, but the Bible is the product
of rich artistic and scribal traditions.
Moses Ibn Zabarah wrote the text in
a square Sephardi script, adopting
a standard two-column format and
when necessary elongating letters to
justify the lines. Vocalization marks
were then added to elucidate the
meaning of the Hebrew script, which,
like Arabic, has no vowels. For Psalms,
Proverbs, Job and the Songs of Songs
an older tradition is adopted, whereby
combinations of long and short lines,
centred and right-justified lines are
arranged in single columns. Each
psalm, for example, is set apart from the
previous one by the central placing of
the first line (see illustration opposite).

The biblical text was accompanied in
the margins by a body of textual notes
called the *masorah*, which correlated
and clarified the different usages of a
phrase, word or declension. This was
in two parts: the *magna*, the major
lexical treatise, was written above and
below the main text, in minute script
or micrography, and often, as here,

in such a way that the words formed
geometric shapes; the *parva*, the minor
textual notes, were written in the side
margins, also in micrography. Both the
biblical text and the *masorah* had been
established by a group of scholars from
the sixth to the tenth centuries. A newly
copied Bible was checked against a
precious authoritative copy of these
established texts, known as a *keter*, or
crown.

Working, like the scribe, within the
Sephardic tradition, the artist, Joseph
Ibn Hayyim, adorned the text in a
number of ways: carpet pages were
added at the main divisions of the Bible
(between Pentateuch and Prophets, and
Prophets and Hagiographa, and before
Psalms); decorated panels and frames
were added at the end of most books
and at the main divisions of the Psalms;
decorative motifs were added to the
parashah signs (indicating the weekly
readings) in the Pentateuch, and to the
numbering of the Psalms; the geometric
shapes formed by the *massorah magna*
were enhanced with colours and
gold; and large display letters, with
accompanying decorations, were added
to parts of the text.

The Kennicott Bible used an earlier
manuscript, the Cevera Bible of
1300, as a model, but is by no means
a leaden copy. Nor were the scribe
and artist constrained by traditions
they observed. Their work is, on the
contrary, highly distinctive and full of
character. Moses Ibn Zabarah's text is

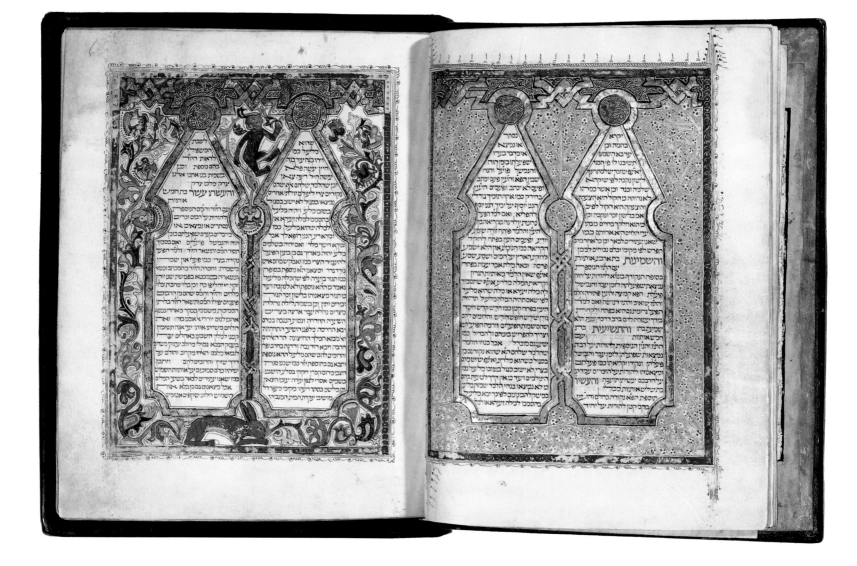

beautifully balanced and clear, finding a consistency and evenness over a long text that is achieved by only the finest professional scribes. As well as the Cevera Bible, the artist drew from a number of sources (from Castilian and Portuguese illumination to contemporary sources such as playing cards). A treatise, the *Sefer Mikhlol* by Rabbi David Qimhi, was added before and after the biblical text, and here Joseph Ibn Hayyim gave free reign to his lively and fertile imagination (illustrated opposite).

The Bible is in its original box binding (illustrated right), made from wood covered in goatskin, which is blind tooled with interlacing geometric designs on all six sides. It is not possible to say precisely where and when this was made, but it is probably of a type peculiar to Jewish binding of the period, as all six surviving examples encase Hebrew texts (five manuscript, one printed), and all date from the late fifteenth century and share the same technique. The bound Bible was in turn housed in a protective slip-case of wood lined with calfskin and bearing Isaac de Braga's name in Hebrew.[2]

Notes

1 Narkiss and Cohen-Mushlin 1985, p. 15.
2 Bodleian MS. Kennicott 1*.

PLINY THE ELDER (23–79)

Historia Naturale (*Natural History*)

Venice: Nicolaus Jenson, 1476

Translated from the Latin by Cristoforo Landino (1424–1498); miniatures by Gherardo (*c.* 1444–1497) or Monte (1448–1529) di Giovanni di Miniato (del Fora), Florence, *c.* 1479–83; historiated borders and initials In Italian, on parchment; 414 leaves, 415 × 280 mm Florentine binding, completed in 1483: dark olive-green goatskin over thick wooden boards, with bosses and blind and gold tooling

Provenance: Filippo Strozzi (1428–1491); Giulio d'Antonio di Nobili (1537–1612); Francis Douce (1757–1834), who bequeathed it to the Bodleian

Exhibitions: Oxford 1984, no. 129; London and New York 1995, no. 85; Oxford 2002b, no. 25

Literature: Bod-inc. P-372; P & A, vol. 3, Pr. 48; McHam 2013, pp. 10, 149–50

Arch. G b.6 [fols. 1r, 6r illustrated]

Pliny the Elder's *Natural History* was described by his nephew as 'Learned, comprehensive, as full of variety as nature itself'. It was an intellectual marvel in its day, and indispensable to later generations as an encyclopedia of antique knowledge of the natural world. In the Renaissance humanist scholars, starting with Petrarch, edited the difficult text, and it became a rich source of inspiration for artists and indeed anyone interested in ancient culture. It was also one of the first books to appear in print: an edition was published in 1469 by Johannes de Spira of Venice.

The first translation of the *Natural History* into the vernacular was published by the Strozzi family of Florence in 1476. It was commissioned, for fifty large gold coins, from another prominent Florentine, Cristoforo Landino, who had already undertaken the work for King Ferdinand I of

Naples. An edition of 1,025 copies was printed by Nicolaus Jenson, the great Venetian printer. Most of these copies were on paper, and they were distributed for sale around Italy and parts of Europe, including London. As was customary for large-scale books, several extra copies were printed on parchment for the financial underwriter (in this case Filippo Strozzi) and a few others.

Filippo Strozzi's copy, shown here, is truly magnificent. He commissioned a miniaturist, either Gherardo di

Giovanni di Miniato or his brother Monte, to adorn the type, and this work took four years. As well as an elaborate title page there are exquisite historiated initials and borders at the start of each of the thirty-seven books, as well as hundreds of decorated initials within the text. The finished product was then finely bound in dark olive-green goatskin. It was designed with a political as well as an artistic purpose. In 1434 Filippo's father, Matteo Strozzi, had unsuccessfully opposed Cosimo de' Medici, the *de facto* ruler of Florence,

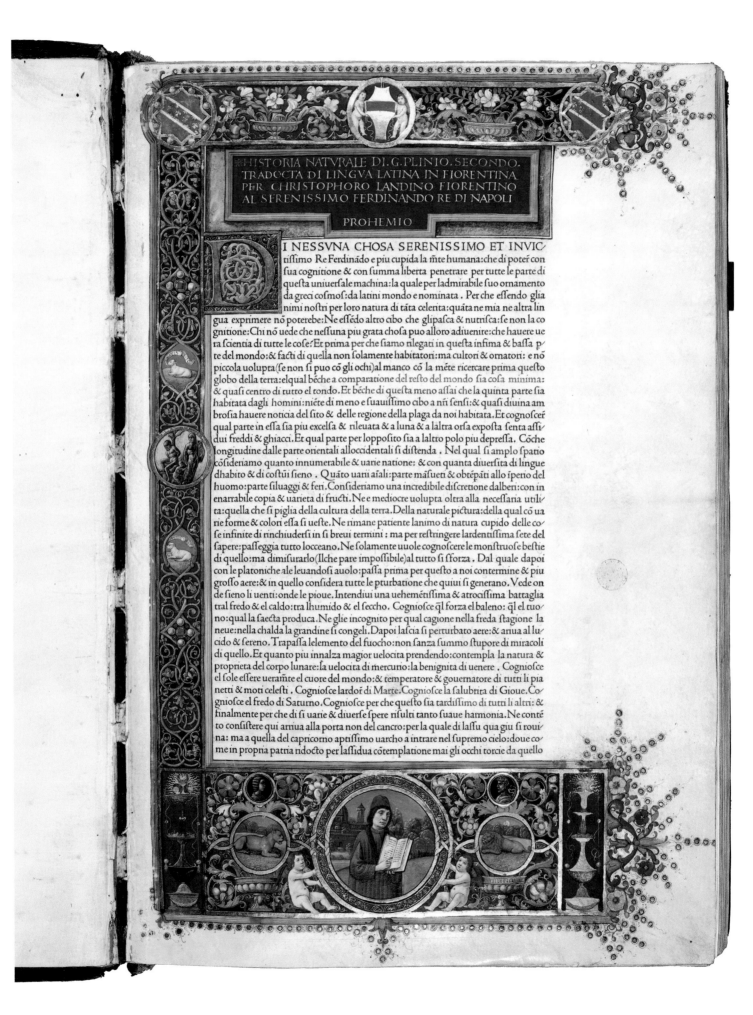

HISTORIA NATVRALE DI. G. PLINIO. SECONDO. TRADOCTA DI LINGVA LATINA IN FIORENTINA PER CHRISTOPHORO LANDINO FIORENTINO AL SERENISSIMO FERDINANDO RE DI NAPOLI

PROHEMIO

DI NESSVNA CHOSA SERENISSIMO ET INVIC
tissimo Re Ferdinãdo e piu cupida la mẽte humana:che di poteř con
sua cognitione & con summa liberta penetrare per tutte le parte di
questa uniuersale machina:la quale per ladmirabile suo ornamento
da greci cosmos:da latini mondo e nominata . Per che essendo glia
nimi nostri per loro natura di tãta celerita:quãta ne mia ne altra lin
gua exprimere nõ poterebe:Ne essẽdo altro cibo che glipasca & nutrisca:se non la co
gnitione:Chi nõ uede che nessuna piu grata chosa puo alloro adiuenire:che hauere ue
ra scientia di tutte le cose:Et prima per che siamo rilegati in questa infima & bassa p̃
te del mondo:& facti di quella non solamente habitatori:ma cultori & ornatori: e nõ
piccola uolupta (se non si puo cõ gli ochi)al manco cõ la mẽte ricercare prima questo
globo della terra:elqual bẽche a comparatione del resto del mondo sia cosa minima:
& quasi centro di tutto el rondo. Et bẽche di questa meno assai che la quinta parte sia
habitata dagli homini:niẽte di meno e suauissimo cibo a nří sensi:& quasi diuina am
brosia hauere noticia del sito & delle regione della plaga da noi habitata.Et cognosceř
qual parte in essa sia piu excelsa & rileuata & a luna & laltra orsa exposta senta assi
dui freddi & ghiacci.Et qual parte per lopposito sia a laltro polo piu depressa. Cõche
longitudine dalle parte orientali alloccidentali si distenda . Nel qual si amplo spatio
cõsideriamo quanto innumerabile & uarie natione: & con quanta diuersita di lingue
dhabito & di costũi sieno . Quãto uarii aĩali:parte mãsueti & obtẽpãti allo ĩperio del
huomo:parte siluaggi & feri.Consideriamo una incredibile discretione dalberi:con in
enarrabile copia & uarieta di fructi.Ne e mediocre uolupta oltra alla necessaria utili
ta:quella che si piglia della cultura della terra.Della naturale pictura:della qual cõ ua
rie forme & colori essa si ueste.Ne rimane patiente lanimo di natura cupido delle co
se infinite di rinchiudersi in si breui termini : ma per restringere lardentissima sete del
sapere:passeggia tutto locceano.Ne solamente uuole cognoscere le monstruose bestie
di quello:ma dimisurarlo (Ilche pare impossibile)al tutto si sforza . Dal quale dapoi
con le platoniche ale leuandosi auolo:passa prima per questo a noi contermine & piu
grosso aere:& in quello considera tutte le pturbatione che quiui si generano.Vede on
de sieno li uenti:onde le pioue.Intendiui una uehemẽtissima & atrocissima battaglia
tral fredo & el caldo:tra lhumido & el seccho. Cognosce q̃l forza el baleno: q̃l el tuo
no:qual la saecta produca.Ne glie incognito per qual cagione nella freda stagione la
neue:nella chalda la grandine si congeli.Dapoi lascia si perturbato aere:& ariua al lu
cido & sereno. Trapassa lelemento del fuocho:non sanza summo stupore di miracoli
di quello.Et quanto piu innalza magior uelocita prendendo:contempla la natura &
ptoprieta del corpo lunare:sa uelocita di mercurio:la benignita di uenere . Cognosce
el sole essere ueramẽte el cuore del mondo:& temperato & gouernatore di tutti li pia
netti & moti celesti. Cognosce lardoř di Marte.Cognosce la salubrita di Gioue.Co
gniosce el fredo di Saturno.Cognosce per che questo sia tardissimo di tutti li altri: &
finalmente per che di si uarie & diuerse spere risulti tanto suaue harmonia. Ne contẽ
to consistere qui ariua alla porta non del cancro:per la quale di lassu qua giu si roui
na: ma a quella del capricorno aptissimo uarcho a intrare nel supremo cielo:doue co
me in propria patria ridocto per lassidua cõtemplatione mai gli occhi torcie da quello

and as a result he and his family had been exiled from the city. In their exile they were welcomed by King Ferdinand of Naples, who supported Filippo and his brother Lorenzo until the exile was lifted by Piero de' Medici in 1466. Filippo's copy of the *Natural History* celebrates the return of the Strozzi family to their native city and the restoration of their fortunes; expresses his gratitude to Ferdinand, to whom the edition was dedicated; and affirms the new political accord between the King of Naples and the Medici of Florence which Filippo had brokered.

All this is articulated on the page illustrated opposite. Within the opening initial is a traditional author-portrait of Pliny, at his lectern and pointing to an armillary sphere. Halfway down the page, in the left and right borders, are copies of two jewels that were among the prizes of the Medici art collection. In the lower left corner is a portrait of Ferdinand. Facing the king, in the lower right corner, is a portrait of Filippo Strozzi himself, based on a marble bust he had commissioned from Benedetto da Maiano in 1475.[1] Behind him is his young son Alfonso, who had been named after Ferdinand's father, Alfonso the Magnanimous, and his brother, the Duke of Calabria (who was also the boy's godfather). The roundel between the two portraits shows the Strozzi coat of arms: three silver crescents on a red band in a gold field. The bird perched on the shield, a falcon, is a play on the family name – *strozziere* is Italian for falcon. The flowers and the cherubs, and the fact that the falcon is shedding its old feathers, all signify renewal. On either side of the roundel are images of the Strozzi emblem, a lamb lying in a field with the motto 'Mitis Esto' ('Be gentle'). On the first page of the manuscript (illustrated on p. 189) there is a miniature showing the translator, Cristoforo Landino, in front of the *Duomo* of Florence.

The Strozzi edition of Pliny's *Natural History* sold well, and Landino's translation was reprinted six times between 1481 and 1543. Filippo Strozzi's own copy illustrates how the intricate political manoeuvres of a patron can lead to the creation of a superb work of art. 'Il mio Pliny', Strozzi called it – 'my Pliny'.

Note

1 Paris, Musée du Louvre; see Berlin and New York 2011, nos 23–5.

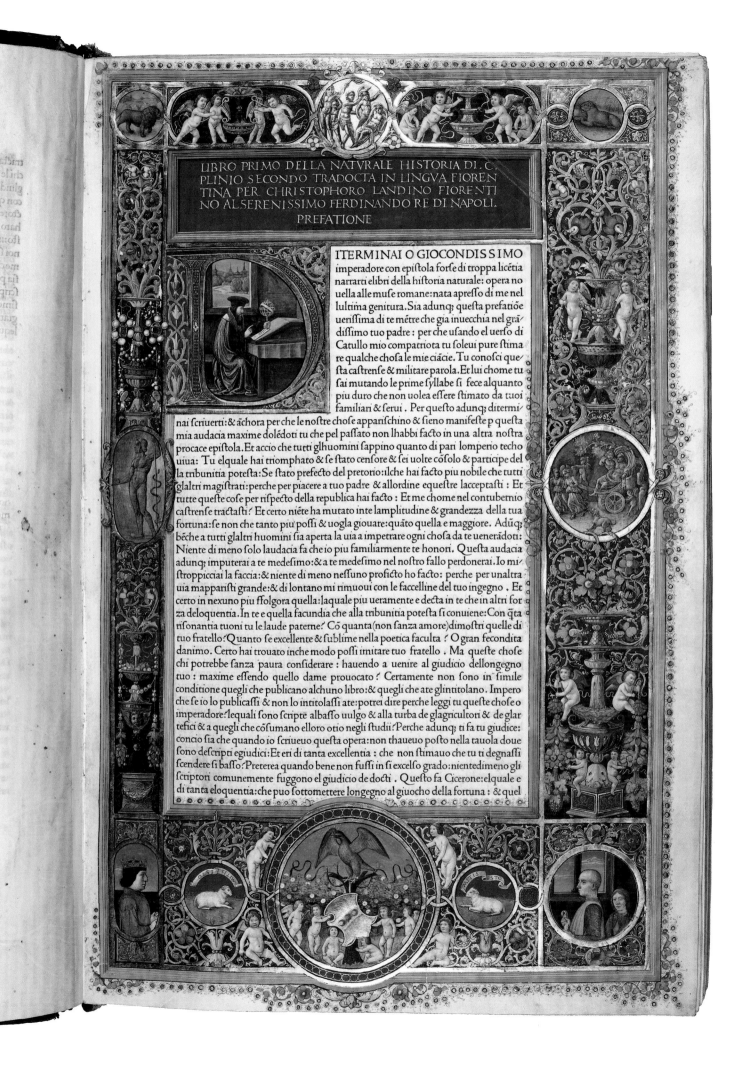

LIBRO PRIMO DELLA NATVRALE HISTORIA DI. C.
PLINIO SECONDO TRADOCTA IN LINGVA FIOREN
TINA PER CHRISTOPHORO LANDINO FIORENTI
NO AL SERENISSIMO FERDINANDO RE DI NAPOLI.
PREFATIONE

ITERMINAI O GIOCONDISSIMO
imperadore con epistola forse di troppa licétia
narrarti elibri della historia naturale: opera no
uella alle muse romane: nata apresso di me nel
lultima genitura. Sia adunq; questa prefatióe
uerissima di te métre che gia inuecchia nel grá
dissimo tuo padre: per che usando el uerso di
Catullo mio compatriota tu soleui pure stima
re qualche chosa le mie ciácie. Tu conosci que
sta castrense & militare parola. Et lui chome tu
sai mutando le prime syllabe si fece alquanto
piu duro che non uolea essere stimato da tuoi
familiari & serui. Per questo adunq; determi
nai scriuerti: & áchora per che le nostre chose apparischino & sieno manifeste p questa
mia audacia maxime dolédoti tu che pel passato non lhabbi facto in una altra nostra
procace epistola. Et accio che tutti glhuomini sappino quanto di pari lomperio techo
uiua: Tu elquale hai triomphato & se stato censore & sei uolte cósolo & participe del
la tribunitia potesta: Se stato prefecto del pretorio: ilche hai facto piu nobile che tutti
glaltri magistrati: perche per piacere a tuo padre & allordine equestre lacceptasti: Et
tutte queste cose per rispecto della republica hai facto: Et me chome nel contubernio
castrense tractasti: Et certo niéte ha mutato inte lamplitudine & grandezza della tua
fortuna: se non che tanto piu possi & uogla giouare: quáto quella e maggiore. Adúq;
béche a tutti glaltri huomini sia aperta la uia a impetrare ogni chosa da te uerádoti:
Niente di meno solo laudacia fa che io piu familiarmente te honori. Questa audacia
adunq; imputerai a te medesimo: & a te medesimo nel nostro fallo perdonerai. Io mi
stroppicciai la faccia: & niente di meno nessuno proficto ho facto: perche per unaltra
uia mapparisti grande: & di lontano mi rimuoui con le faccelline del tuo ingegno. Et
certo in nexuno piu sfolgora quella: laquale piu ueramente e decta in te che in altri for
za deloquentia. In te e quella facundia che alla tribunitia potesta si conuiene: Con q̃ta
risonantia tuoni tu le laude paterne? Có quanta (non sanza amore) dimostri quelle di
tuo fratello? Quanto se excellente & sublime nella poetica faculta? O gran fecondita
danimo. Certo hai trouato inche modo possi imitare tuo fratello. Ma queste chose
chi potrebbe sanza paura considerare: hauendo a uenire al giudicio dellongegno
tuo: maxime essendo quello dame prouocato? Certamente non sono in simile
conditione quegli che publicano alchuno libro: & quegli che ate glintitolano. Impero
che se io lo publicassi & non lo intitolassi ate: potrei dire perche leggi tu queste chose o
imperadore? lequali sono scripté albasso uulgo & alla turba de glagricultori & de glar
tefici & a quegli che cósumano elloro otio negli studii? Perche adunq; ti fa tu giudice?
concio sia che quando io scriueuo questa opera: non thaueuo posto nella tauola doue
sono descripti egiudici: Et eri di tanta excellentia; che non stimauo che tu ti degnassi
scendere si basso? Preterea quando bene non fussi in si excelso grado: nientedimeno gli
scriptori comunemente fuggono el giudicio de docti. Questo fa Cicerone: elquale e
di tanta eloquentia: che puo sottomettere longegno al giuocho della fortuna: & quel

64

PETER APIAN (PETRUS APIANUS) (1495–1552)

Astronomicum Caesareum (*Astronomy of the Caesars*)

Ingolstadt: Georg and Peter Apian, 1540

Woodcuts, many of them volvelles (movable discs)
In Latin; sixty leaves, 465 × 315 mm
Mid-nineteenth-century English binding: brown
calfskin with blind tooling

Provenance: Inscription: 'Du Burseon'; acquired by the
Bodleian probably in 1842

Exhibition: Oxford 1994, no. 55

Literature: Gingerich 1971

Arch. B b.7 [fols. 27v–38r illustrated]

Peter Apian (or Petrus Apianus) was born Peter Bienewitz in Saxony. From 1527 to his death in 1552 he was Professor of Mathematics at Ingolstadt. He published several scientific and geographical works, many of them out of his own printing shop in Ingolstadt, which he ran with his brother Georg, an esteemed woodcutter. His many achievements in planetary and stellar observation and calculation were all made according to the geocentric system of Ptolemy, of which he was one of the last great proponents. He worked at a time when the lines between astronomy and astrology were blurred, and the astrological aspects of his work – that is, the ways in which the planets and stars directly influenced human life – naturally attracted him to the rulers of the day, who, preoccupied with prophecies and portents, were interested in the positions of the planets and the way they affected their political fortunes. Apianus's most important and powerful patron was the Holy Roman Emperor, Charles V (1500–1588).

The *Astronomicum Caesareum* was Apian's finest work, remarkable both as a masterpiece of printing and as the realization of one of his chief preoccupations: how the Ptolemaic system could be represented graphically, and in a clearer manner than the customary mathematical tables. Apian aimed to overcome the arithmetical complexities inherent in the geocentric representation of planetary movements (with its cycles and epicycles) by 'a complete solution, as far as is possible, of the problem of predicting the positions of the heavenly bodies by mechanical means'. With the aid of simple tools, he thought, it should be possible to plot the paths of planets and the movements of the stars, and calculate the occurrence of eclipses and comets. The *Astronomicum* endeavoured to supply these tools in the form of highly intricate moving discs, or volvelles, from which information could be obtained through combinations of circles and angles.

Two things are immediately apparent about the *Astronomicum*. First, Apian is firmly embedded in the Ptolemaic system; the signs of the zodiac are his system of reference for the movements of the planets. Secondly, the book was carefully tailored for Charles V, to whom it was dedicated. Time and again in the first forty chapters, the examples Apian gives to demonstrate the workings of the volvelles use the birth dates of Charles V and his brother, Ferdinand I, so that sometimes the book reads almost like their personal horoscope. Illustrated overleaf are two of the most elaborate volvelles, which are concerned with predicting eclipses of the sun and moon. The disc on the left shows a many-headed dragon and a partial eclipse of the sun. In this section, special attention is given to those eclipses that have a connection to the years of birth of Charles and Ferdinand; there is also a detailed description of a total lunar eclipse on 6 October 1530, the year of Charles V's coronation. *Astronomicum Caesareum* duly brought Apian many honours. Not only did Charles V pay for the printing, but on its publication he presented the author with 3,000 gold coins. The following year, in 1541, Apian was appointed Imperial Mathematician and was raised to the nobility with a hereditary title.

It is an irony that the much-fêted *Astronomicum* appeared just three years before Copernicus's *De revolutionibus orbium coelestium* (*On the Revolutions of the Celestial Spheres*), which revolutionized our view of the universe and which replaced Apian's marvellously elaborate volvelles with a simple woodcut showing earth and the other planets orbiting around the sun (see cat. 103). Apian was an instrument-maker. He constructed a celestial sphere for Charles V and a large sundial for the Castle Trausnik near Landshut; he also wrote a number of treatises on observational instruments such as the quadrant, the torquetum and

the cross-staff. The *Astronomicum* belongs to the world of skilfully constructed and marvellously elaborate mechanical instruments. This is what Johannes Kepler, a key figure of the new astronomy, complained of in his *Astronomia nova* (cat. 105):

Who will provide me with a source of tears to bewail the misdirected efforts of Apianus, who in his Opus Caesareum, as faithful a servant of Ptolemy, has wasted so many fine hours and so many highly ingenious arguments on constructing a most complicated maze of spirals, loops, lines and whirls which represent nothing more than what exists in the imagination of man, and is wholly divorced from nature's true image. His work demonstrates one thing only, namely, that this man, with God's gift for a profound and penetrating intellect, could have mastered nature. Instead he was satisfied and even pleased that he had invented those artificial constructions (in competition with nature herself) and that he had succeeded in making those mechanical models. Thereby he may have earned the prize of perpetual fame, but let us not forget the damage he has caused through the success of his works; and what shall we say about the empty art of the producers of automatons, who used 600 or even 1200 wheels in order to reproduce the figments of the human imagination, and who were gloating in triumph about their achievements and were claiming prizes because of them.[1]

Some thirty-five copies of the *Astronomicum Caesareum* are known today. Fabulously expensive to produce and prohibitively expensive to buy, it was always a rare book. Nicholas Wotton reported in 1544 from the Diet of Speyer that Apian would give Henry VIII a copy, for otherwise the king would not be able to get hold of it; Edmond Halley tried in vain to obtain a copy.

Note
1 Wattenberg 1967, p. 62.

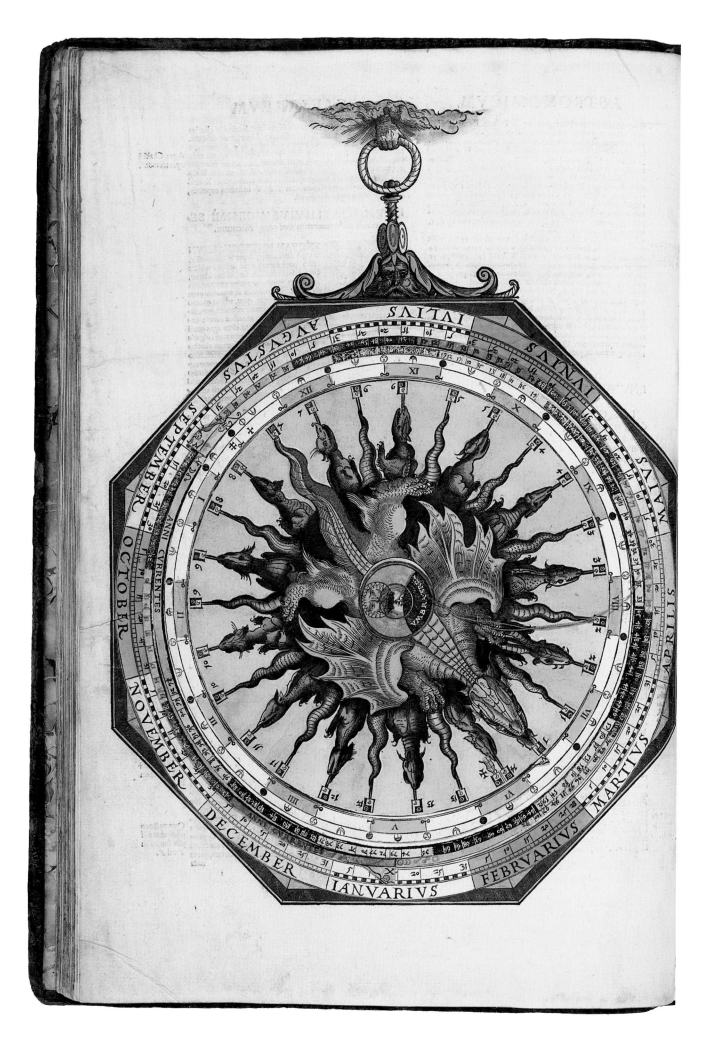

Cat. 64

¶ Cautela obseruanda in dispositione rotarum.

Operandi modus huius secundi instrumenti verus qdem & certus est, quoties annus currens siue propositus in arcu limbi inferioris rotæ ab indice X Y procedendo secundum dieꝝ ordinem, usꝗ ad 29 diem Ianuarii, horam 12, Mi.44 siue stellam lunæ sic depictam ✳☽ reperitur. Annus ille cum filo (vt prius dictū est) signatur, eidemꝗ denuo index X Y adducitur, qui inuariatus ad operationis finem sic perdurabit. Si uero post primam siue radicalem indicis locationem annus ꝓpositus à stella prædicta

(supputatione secundum dierū ordinem facta) usꝗ ad indicem X Y occurrat, iam dictæ stellæ centrum inspice, p huncꝗ filū tende, cui subducis indicem T. Mox deinceps filum ducatur per ꝓpositum siue currentem annum, ubi inꝄ tersectio fili cū circulo T diem tantū, aut diem horamꝗ dabit. Dies ille tandem in limbo Ianuarii requisitus, cum filo signatur, eidemꝗ denuo ostensor X Y subiungitur, ita autem rota illa ultimum sui locum sortita est. Atqui nunc mihi uideor satis superꝗ positionem rotæ X Y declarasse, admonens interim, ut similia de rota Z V intelligantur, qualia derota X Y prodita sunt, interesse tamen hoc vnum quod hic considerandus erit index Z V, & centrum stellæ iuxta 27 Ian: diem signatæ cū charactere draconis sic ✳☊

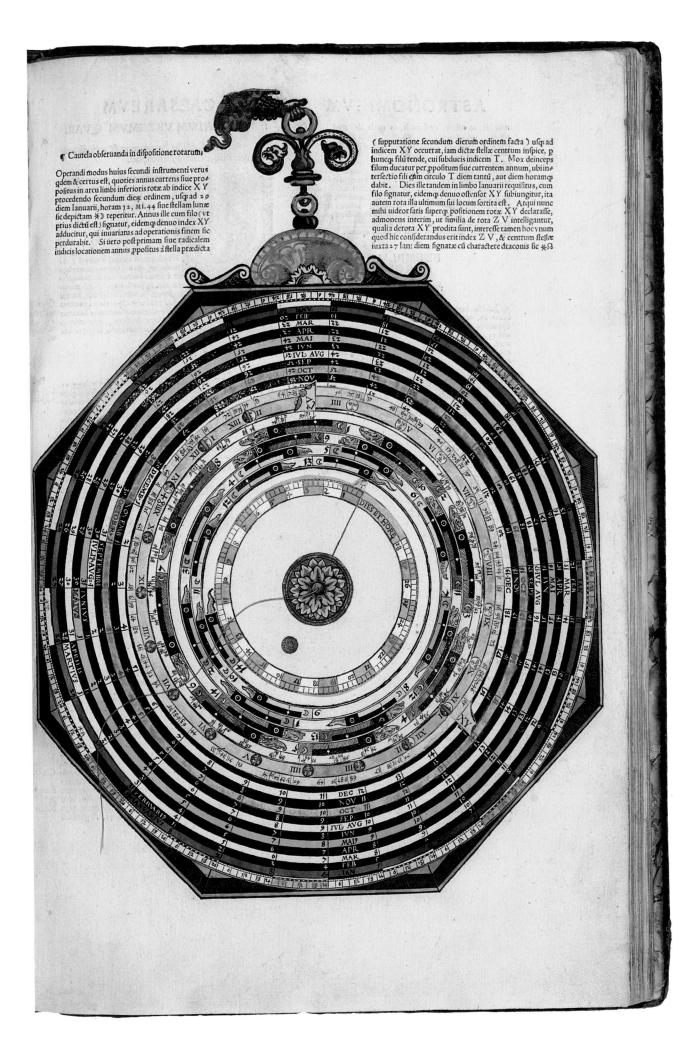

65
Codex Mendoza

c. 1541

Mexican pictograms annotated in Nahuatl and Spanish with facing commentary in Spanish, on Spanish paper; eighty-four leaves; 300–15 × 210–15 mm
Binding probably seventeenth-century English: parchment over plain boards

Provenance: In the possession of André Thevet (b. *c.* 1502–17, d. 1592) by 1553; acquired from Thevet by Richard Hakluyt (1552?–1616); acquired after Hakluyt's death by Samuel Purchas (bap. 1577, d. 1626); sometime before 1654 it was acquired by John Selden (1584–1654); in 1659 Selden's executors gave it to the Bodleian in accordance with the terms of Selden's will

Literature: SC 3134; Clark 1938 (facsimile); Berdan and Anawalt 1992 (facsimile)

MS. Arch. Selden. A. 1 [fols. 1v–2r, 70r illustrated]

This remarkable manuscript takes its name from Antonio de Mendoza, conde de Tendilla, who from 1535 to 1550 served as the first viceroy of Spanish Mexico. According to a subsequent owner, Samuel Purchas, it was commissioned by the 'Spanish Governour' for the overlord of 'New Spain', the Emperor Charles V, and its presentation of secular aspects of Aztec life certainly suggests that it was intended to inform and delight the emperor with interesting details about a huge addition to his far-flung empire.

The manuscript is made up of three distinct parts. The first section is a historical document chronicling the Aztec rulers from the mythical foundation of Tenochtitlan (modern-day Mexico City) through the military victories of successive rulers to the Aztec domination of the entire area. The second section describes very fully the complex system of annual tributes paid by four hundred towns to the last native emperor, Montezuma II. The third section is a unique account of the lives led by certain classes of Aztec.

In its construction and physical form the Codex Mendoza is a complicated hybrid of two cultures – one indigenous, the other colonial. Native pictograms, and the glyphs which constituted the Aztecs' pictorial writing system, are combined with annotations written by a Western hand in Spanish. The pictures were probably drawn by a single artist, and the annotations then added by a Spaniard who knew the native language, Nahuatl, but who, it seems, had to work in a hurry. He wrote at the end of the manuscript:

The interpreter was given this history ten days prior to the departure of the fleet, and he interpreted it carelessly because the Indians came to agreement late; and so it was done in haste and he did not improve the style suitable for an interpretation, nor did he take time to polish the words and grammar or make a clean copy. And although the interpretations are crude, one should only take into account the substance of the explanations that explain the drawings; these are correctly presented, because the interpreter is well versed in the Mexican language.

Each page of the manuscript is clearly structured round the pictograms, rather than the words, but to what extent was the choice of subject matter dictated by the patron? How far was the artist, working in the unfamiliar format of the western codex, guided by pre-Conquest native traditions, and how far by newly acquired Western techniques? For the first two sections of the work there were prototypes to work from, but the third part is wholly original. Here the artist represents Aztec warriors, and members of the class of skilled urban artisans to which he belonged. The images are arranged in the strip form that would have been familiar to the artist, depict the various professional paths an individual might take from birth to death, and describe such fundamental aspects of Aztec life as education, crime and punishment, and marriage. The page shown overleaf illustrates a number of trades – including carpentry, painting and metalwork – and didactically contrasts an idle life with a constructive one.

The manuscript came to the Bodleian by a circuitous route. If it was indeed intended for Charles V then it never reached him, for the ship on which it left America was captured at sea by French men-at-war and it was carried off to France. Somehow it came into the hands of the French Royal Geographer, André Thevet. It was purchased from Thevet by Richard Hakluyt, author of *Divers Voyages touching the Discovery of America* (1582), for twenty gold crowns. Hakluyt bequeathed the manuscript to a London clergyman, Samuel Purchas, in 1616. It was acquired sometime after the death of Purchas by John Selden, who bequeathed it to the Bodleian.

tenayncom. e onsi mismo parece doze demostracion por lo figuradot
lo qual paso enel discurso del senorio de tenuch. e figurado.
on cinquenta, y un años, y al remate dellos, murio, e fueron

los figurado de azul enlos margenes desta storia, e cada una ca
sita, o apartado dignifica un año, es enel numero de años que
e tuuieron los señores de mex. y para que abiertamente y clara se entien
da lo figurado y la cuenta, e los nombres delos años que en los pintos
cadaun apartado contauan por el apunto primero numerando hasta
llegar a treze pintos, y de alli, adelante toznabã aun pt primero
en su cuenta, y buen discuriendo
ta llegar los treze pintos, e buen discuriendo los
estan diversas figuras, pero la prime pal cuenta es la delos
pintos, y aun e doze, poco al caso alguno que cada un apartado
casita los nobres delos años, e nombrauan en lo de
numero del primer apunto hasta los treze pintos, y ã se entien
de aqui por si señal y demostracion delos nombres con sus
interpretaciones que esta de nota de letra

en la orden y regla delos apartados o casitas numeradas
en la casita donde pende un señor conserie y otra
nera de flor, significa un año figurado por una
ternian memoria, diziendo que sus passados los mexicanos
memorial les avian dexado aviso de tiempo en tiempo
dian de cincuenta, dos en cincuenta, delos tales años que eran
fortuytos y aziagos por causa delos años eran peligrosos hasta
dilunio de aguas general, o entales años, avia peligroso
eclipse del sol, o terremoto universal. y ansi mismo la tenebrosidad
hazian grandes sacrificios, y ansi enel tal año
con a hazer penitencia, y se abstenian de todos los vicios, e a
quando llegase el propio dia dia del tal año
dia generalmente apagauan todas las lumbres y fuegos y a
pasase el dia, y pasado con cencion lumbre nueva todos
de una sierra sacada por en hazer se

come, yei, nahui, macuili, chiqcen, chicome, chicna, matlac. x.oce. x.omo. x.omey, x.ona
ce tuchtli acatl tecpatl cali tuchtli acatl tecpatl hui cali ti tuchtli x.acatl me.tecpa cali huitli

| vnconejo | doscañas | tres pe dernales | quatro casas | cinco conejos | seis cañas | siete pe dernales | ocho casas | nueue conejos | Diez cañas | onze pe dernales | doze casas | haze conejos |

lo de suso que esta escrito de colorado son los nombres que ponian a los años
que es cada un apartado, y la interpretacion de los tales nombres son
los de abaxo el con apartado, y enlo de colorado donde esta nume
rado una x. que son diez, nombron. matlactli.

A. Thevet cosmographe du roy — numero de años L.j.

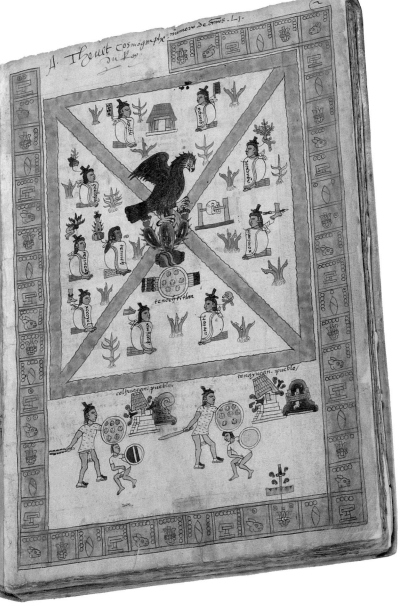

colhuacan pueblo. tenayucan pueblo.
tenochtitlan.

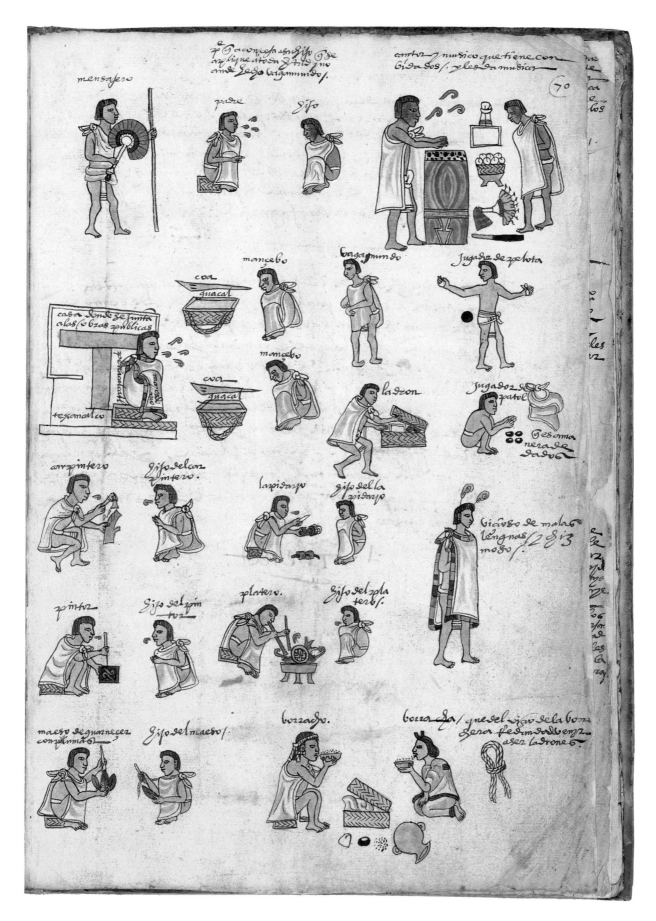

mensajero

⁊ q̃ a con qʼsa aʃ̃ hijo q̃ de
aʃligue a tod⁊ d̃tro i n̄o
am̃ꝺ q̃go tragamundo⁊

cantor ⁊ muſico que tiene con
bidados / ⁊ les da muſica

padre · hijo

70

casa donde se junta
a las obras publicas

texomatico

coa
guacal

mancebo

tragamundo

Jugador de pelota

coa
guacal

mancebo

ladron

Jugador de
patol

⁊ es manera de dados

carpintero

hijo del car
pintero

lapidario

hijo de la
pidario

bicioso de malas
lenguas / ⁊ es
moço /

pintor

hijo del pin
tor

platero

hijo del pla
tero /

maestro de guarnecer
con pluma ⁊

hijo del maestro /

borracho ·

borracho / que del hijo de la bo
rrachera ʃe siguen a venir
a ſer ladrones

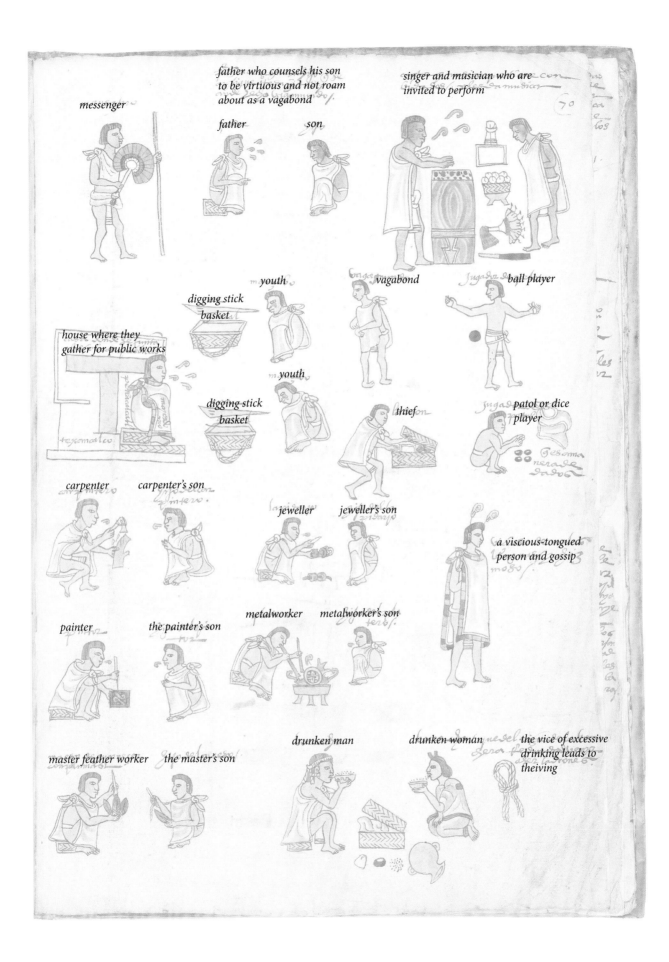

messenger

father who counsels his son to be virtuous and not roam about as a vagabond

father

son

singer and musician who are invited to perform

70

youth

digging stick

basket

house where they gather for public works

vagabond

ball player

youth

digging stick

basket

thief

patol or dice player

carpenter

carpenter's son

jeweller

jeweller's son

a viscious-tongued person and gossip

painter

the painter's son

metalworker

metalworker's son

master feather worker

the master's son

drunken man

drunken woman

the vice of excessive drinking leads to theiving

66

A copy of the Qur'an

Safavid Shiraz, 1550

Miniatures, borders
In Arabic; 344 leaves, 390 × 240 mm
Mid-sixteenth-century Persian binding: black goatskin over paper pasteboards, decorated with gilt-blocked panels, some of which are sunk into the boards; the doublures are of red, green, orange and blue paper filigree, combined with gilt tooling

Provenance: Tipu Sultan (1750–1799), ruler of Mysore; taken with Tipu's other books by the East India Company following his defeat by the British in 1799, and given to the Bodleian on 15 August 1806 by the directors of the Company

Literature: SC 28031

MS. Bodl. Or. 793 [fols. 9v–10r illustrated]

The words of the Qur'an were revealed to the Prophet Muḥammad, in Arabic, by the archangel Gabriel between 610 and the Prophet's death in 632. In the middle of the seventh century the text was fixed, and formally arranged into 114 *surah*s or chapters. The first manuscripts date from about this period, and by the tenth century they had become elaborate and beautiful objects. Islamic religious texts are not accompanied by representations of the human form; the beauty of early copies of the Qur'an is therefore to be found in a rich calligraphic tradition and ever more elaborate ornamentation.

Copies of the Qur'an are adorned according to established patterns. Ornaments mark chapter headings, the end of verses and the beginning of sections; they also emphasize key words and headings. Highly decorative carpet pages head the book, and often incorporate in their complex abstract patterns the first chapter of the Qur'an, the *surat al-fātiḥah*, which is recited during the five daily prayers. The scribes and artists who worked on these productions were educated traditionally: having served an apprenticeship they entered a workshop which observed particular styles. And yet the finest of them could imbue a book with a character all their own.

The most lavish Qur'ans required rich patrons, usually a ruling sultan or an influential member of his court. This beautifully decorated manuscript belonged to Tipu Sultan, the eighteenth-century ruler of the Islamic Kingdom of Mysore. He did not commission it; instead he probably acquired it from a defeated enemy. He in turn lost it to the East India Company, who took his library of around two thousand books when he was defeated by the British in 1799.

Except for a few books which the Company gave the Bodleian, Cambridge University Library and the Royal Asiatic Society, Tipu's library went to the East India Company College in Hertfordshire. It was listed in 1809 by Charles Stewart, a professor of Oriental languages at the college; his list included seventeen copies of the Qur'an (single and multi-volume).

Stewart described Tipu as 'the inveterate enemy of the British nation', but he thought it was an act of great foresight to keep his magnificent library intact, and hoped his catalogue of Tipu's books would

serve as a guide to the sources of information and his choice of authors; whilst it cannot but be generally interesting to observe, from the dates of the greater number of the volumes, that in Asia, at a period when Europe was overcast with ignorance and barbarism, Literature was ardently cultivated, and Science flourished. If our progress in the arts enables us to look with contempt on the attainments of the Mohammedan schools, we should reflect, that they were our precursors in knowledge, and that for much of our information we are indebted to them.[1]

The carpet page of this manuscript (illustrated overleaf) is typical of the decoration found in Shirazi manuscripts of the sixteenth century. The two central roundels contain the first chapter of the Qur'an, which is skilfully interwoven into the background design. Above them are two chapter headings, reading: 'This is the opening chapter of the Book which was revealed at both Mecca and Medina. It consists of seven verses.' The pages are symmetrical, but not perfectly so as only God is perfect.

Note
1 Stewart 1809, pp. i–v.

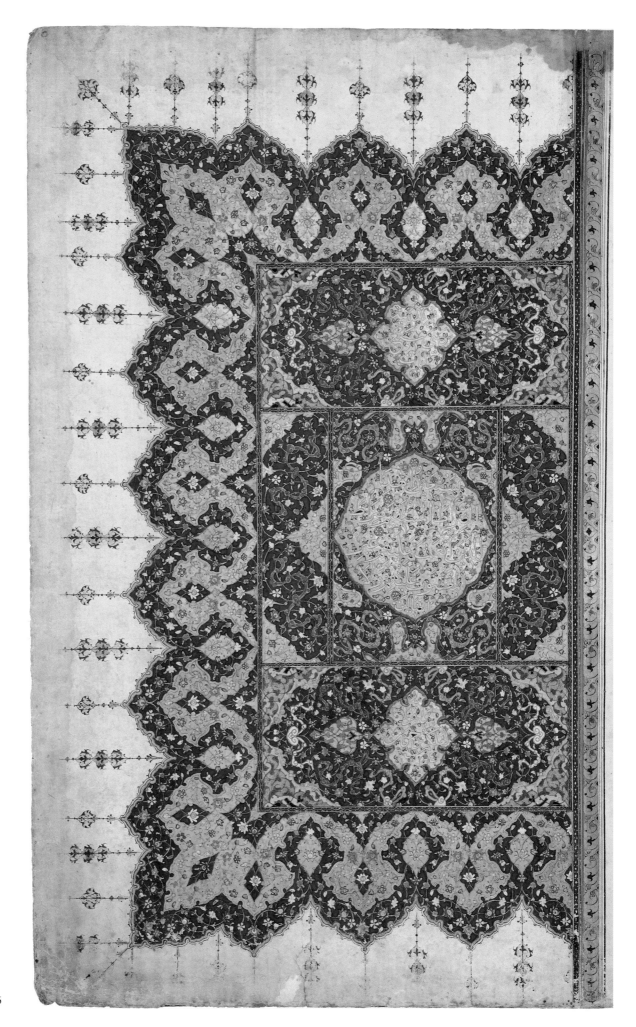

Cat. 66

67

JĀMĪ (1414–1492)

Bahāristān (*The Garden of Spring*)

Lahore, 1595

In the hand of Muḥammad Ḥusayn; miniatures by Basawan, Kesu Das, Madhu, Miskin, Mukund, La'l and decorative borders by other artists
In Persian; sixty-seven leaves, 290 × 195 mm
Now disbound, but kept with its nineteenth-century binding: red velvet over cardboard with brass centrepiece and corner pieces on upper and lower covers

Provenance: Commissioned by the Emperor Akbar (1542–1605); entered the library of his grandson Shāh Jahān (1592–1666) in 1611; acquired by Sir Gore Ouseley (1770–1844) in 1800; given to the Bodleian in 1859, through John Bardoe Elliott

Literature: Ethé et al., vol. 1, no. 963

MS. Elliott 254 [fols. 2a, 41b–42a illustrated]

Under the patronage of the Emperor Akbar, miniature painting in Mughal India, and the associated arts of decoration and calligraphy, reached a high point. Akbar was illiterate, but had received painting lessons as a child, and when he became emperor in 1556 at the age of just thirteen he recruited a number of Indian artists for his court. They worked in the Persian tradition, but invested it with their own energetic Mughal style, and illustrated a wide range of subject matter from the great Persian and Hindu epics to chronicles of Akbar and his ancestors.

Among the finest products of Akbar's patronage is this superb manuscript of *Bahāristān* (*The Garden of Spring*), a fifteenth-century classic by the great Persian poet Jāmī. Akbar called upon the finest scribes and most accomplished artists and illuminators of his workshop. The text was written in a beautiful *nastaʿlīq* script by the great scribe Muḥammad Ḥusayn, who held

the title of *Zarīn Qalam*, or Pen of Gold. Specialist artists drew marginal figures, animals, birds and arabesques in gold outline on coloured paper. Illustrating scenes from the poem are six miniatures by the finest artists of the time. Distinctly Mughal in their sensitive feeling for nature, they also show European influences in their naturalistic detail.

Shown overleaf is an illustration of an episode from *Bahāristān* by the painter Miskin, in which the nocturnal atmosphere is beautifully evoked by the deep blues, greens and reds. Two lovers, Ashtar and Jayida, are from different tribes. One night they meet secretly while a friend of Ashtar dresses in Jayida's clothes and takes her place in her husband's tent. The husband arrives with some milk for Jayida, but Ashtar's friend, overplaying the part, acts coquettishly and spills it. The enraged husband proceeds to beat him savagely until Jayida's mother and sister intervene. The friend, who has somehow managed to keep his real identity secret, has the consolation of the sister's company for the remainder of the night.

Miskin skilfully combines the two scenes of this story in a single composition. In the far right corner we see Ashtar approaching Jayida's tent before a receding landscape of lawn, trees and distant hills. Below and to the left we see the two lovers consorting under a palm tree and beneath the moon – a haven of peace compared to the drama

of the foreground scene. Jayida's raging husband is being restrained by his mother and sister while Ashtar's friend, in his disguise, peeps out from inside the tent. The landscape of hills, trees, lawns and jagged rocks (which contain concealed faces in the Persian manner) is populated by sensitively drawn animals. The quiet camels and sleeping sheep form a contrast to the leaping horses in the background.

On Akbar's death the manuscript passed to his grandson, Shāh Jahān (see cat. 68); it subsequently came into the hands of the diplomat and collector Sir Frederick Gore Ouseley, and both owners left their mark on the title page (illustrated opposite). It is inscribed along the left edge: 'In the Name of God the Universally Merciful the Particularly Merciful. On the 25th of the month of Bahman, corresponding to the 8th of the month of Jumādá II in the year 1020 of the Ḥijrah, which was the day of the auspicious accession, this Baharistan entered the library of this supplicant at The Court. Signed Shihāb al-Dīn Muḥammad Shāh-i Jahān Pādishāh son of Jahāngīr Pādishāh son of Akbar Pādishāh-i Ghāzī.' In the panel at the top of the page Ouseley has scratched out the inscription of a former owner and written over it in Persian: 'On the 4th [of the month of] Muḥarram in the year 1215 of the Ḥijrah [28th May 1800], this Baháristan entered the library of this servant of God. Signed Gore Ouseley.' An owner's inscription in the lower panel has also been removed.

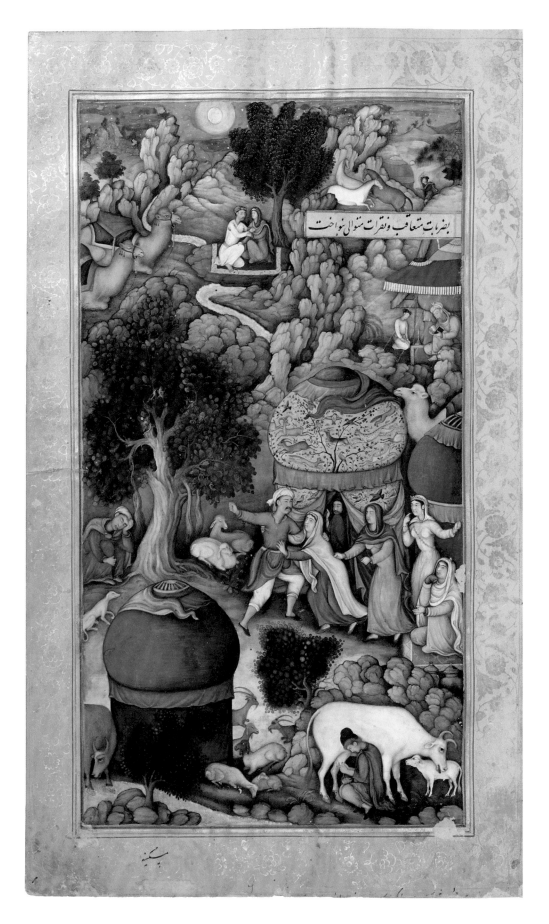

این را بپوشش و جامهای خود را بمن ده پس گفت برخیز و نیمه

من درآی و در پس پرده بنشین شوهرمن خواهد آمد و قدحی

شیرخواهد آورد و خواهد گفت این شام تیت بستان تو در گرفتن

آن تعجیل مکن و اندکی تعلل پیش کیمه ازرا بدست تو خواهد

وبا بر زمین خواهد نهاد و برفت و تا با مداد و یکبر نخواهد آمد هرچه

کفت پنهان کردم شوهروی قدحی شیر آورد من ناز در از

در پیش کی فهم وی خواست که بر زمین نهد و من خواستم که از تست

من وی بستانم دیست من رقدح خورد و پیژگون شد و شیر ما لخت

درغضب آمد و گفت این ما بمن ستیزه می کند دیست دراز کرد و از خانه

تا زیانه از جمه کو و کو زن از پس کردن تا پشت دم ریده و به

بزروی پیر نجه شدت و جلاوت بر جم جیده و قطعه

برداشت و پست مراجون شکم طبل بر بنه بپاخت و چون طبال روز حبک

68

Album of Mughal paintings and calligraphy

Assembled in India in the Shāh Jahān period (1628–58)

Calligraphy in the hand of Mīr ʿAlī
In Persian; sixty leaves, 385 × 255 mm
Lacquer binding, with floral portraits on upper and
lower boards and doublures

Provenance: Charles Chauncy (1709–1777); Francis
Douce (1757–1834), who bequeathed it to the Bodleian

Literature: Ethé et al., vol. 2, no. 2381; Topsfield 2008

MS. Douce Or. a. 1 [fol. 55b illustrated]

This album was assembled for a member of the imperial Mughal family, Shāh Shujāʿ, the second son of the Emperor Shāh Jahān (1592–1666). A variety of paintings were mounted on to large sheets, and the margins filled with highly decorative floral borders. The pages were then bound with extracts from Jāmī's *Tuḥfat al-aḥrār* (*The Gift to the Nobles*), written in the finest calligraphy, and placed between ornamental lacquer covers.

The forty-one paintings include scenes from the great Persian epic the *Shāhnāma*: Rustam slaying a dragon, Shīrīn discovering the dead Farhād, and Layla visiting Majnūn in the desert. Others show the interests and activities of the Mughal court, from falconry and hunting to jewellery, music and contemplation. Portraits of hermits and dervishes reflect the emperors' interest in Sufi mysticism and reverence for holy men. Their fascination with Western art is expressed in portraits of Christ, the Virgin Mary and St Matthew the Evangelist derived from European prints.

Taken as a whole, the album is a glorification of the Mughal dynasty from Tīmūr (1336–1405) to Akbar (1542–1605), Jahāngīr (1569–1627) and Shāh Jahān. One painting depicts Akbar and Jahāngīr in apotheosis, but the tendency towards self-aggrandizement reached its peak in Shāh Jahān. His majestic figure, resplendent in fine clothes and jewellery, and his proud profile, shown within a gold nimbus, dominate a number of glittering pages. He is depicted as a world ruler, enthroned and holding an orb representing heaven and earth; as a connoisseur, examining jewellery by a lake; and in durbar, formally receiving visitors from his throne of state.

Illustrated opposite is a page portraying Shāh Jahān in his role as a patron of art and scholarship. The emperor is seated on a carpeted terrace by a lake, in the shade of a tree, while a servant with a yak-tail fan attends behind him. Artists or scholars sit round him, offering him their work in the form of illuminated pages and bound albums. Winged figures, resembling the putti of Western art, rain gold on his head. Among the many birds painted in the margins (a reflection of the Mughal interest in the natural world) may be seen birds of paradise, hoopoes, kingfishers, bee-eaters, shrikes, parakeets, partridges, grouse and pheasants.[1]

Note
1 Topsfield 2008, pp. 80–81.

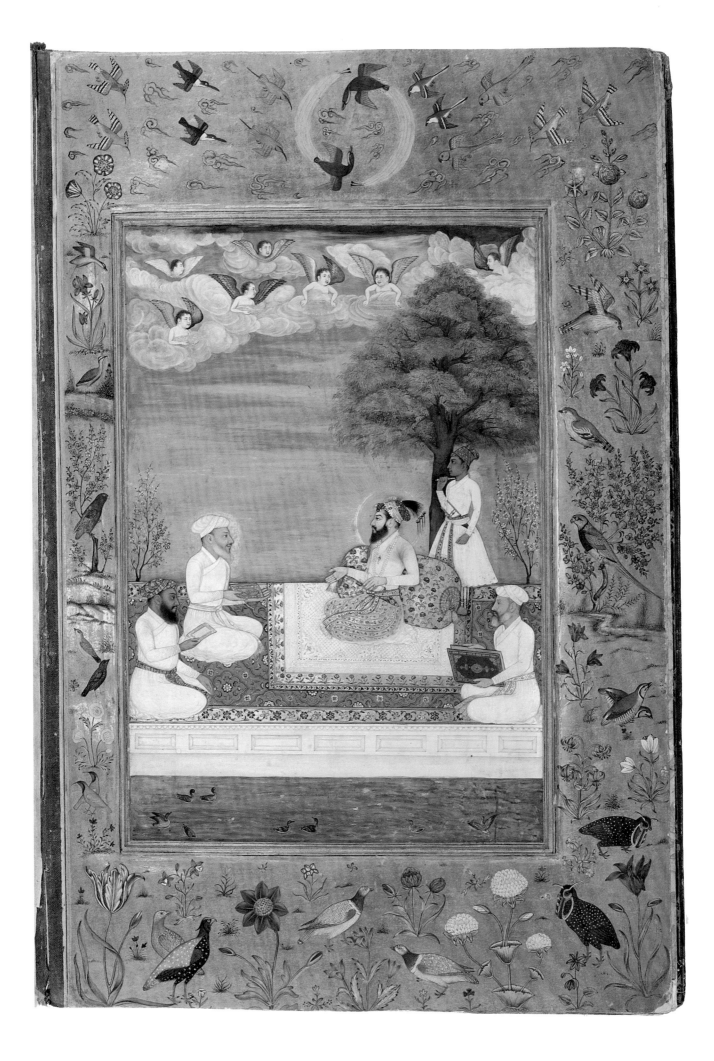

A Geneva Bible

London: Christopher Barker, 1583

689 leaves, 427 × 287 mm
Sixteenth-century English binding (for Elizabeth I): gold, silver and silk threads on crimson velvet; fore edge gilt, coloured and gauffered

Provenance: Francis Douce (1757–1834), who bequeathed it to the Bodleian

Exhibitions: Oxford 1968, no. 163; Oxford 1984, no. 62

Literature: Barber 1971, pl. 8

Douce Bib. Eng. 1583 b.1 [title page illustrated]

This embroidered Geneva Bible was presented to Elizabeth I by the printer Christopher Barker (1528/9–1599) on New Year's Day 1584. Textile bindings were popular in England in the late sixteenth and early seventeenth centuries, a popularity that may have been partly due to Elizabeth I, who favoured textile over leather covers, and may even have made embroidered bindings herself at a young age (see cat. 24). She received frequent gifts of finely bound books from those who knew her preferences. A visitor to the Royal Library at Whitehall in 1598, Paul Hentzner of Brandenburg, noted that its books were 'all … bound in velvet of different colours, though chiefly red, with clasps of gold and silver; some have pearls, and precious stones, set in their bindings'.[1]

Embroidered bindings provided much-needed employment for needleworkers. In 1638 the Archbishop of Canterbury, William Laud, was petitioned by 'those … being Milliners & keeping shopp in the Royall Exchange in London', protesting against a decree that limited the sale of Bibles, Testaments and Psalm Books to members of the Stationers' Company:

That the petitioners do set on worke many Imbroiderers and other poore freemen of London, who among other wares and workes, which they make for the petitioners have for many yeares past as well as of their own accord as by the petitioners bespeaking been accustomed to bring to the petitioners shopps rare and curious covers of imbroithery and needle works, wherein the petitioners have used to cause Bibles Testaments & Psalms Books of the best sort and neatest print to be richly bound up for the nobility and gentry of this kingdome, for whom and not for common persons they are indeed most fitt, which bookes they allways bought of the company of Stationers because they would be sure to have none but such as should be lawfull and warrantable. May it please your Grace there is upon some just grounds a case drawne in Starr chamber for suppressing the selling of any bookes but by the stationers and the petitioners not selling any other, but the Bible, Testament and Psalms soe bound as aforesaid are pretended to

be so included therein and are warned by one Mr Spencer one of your Grace's officers to answere the matter in the high Commission Court.

Now that many poore are set on worke by the petitioned and do get a good part of their living by making the said covers and in regard of the constant and dayley recourse of the nobility and gentry thither from all parts of this kingdome and of strangers and also from forraigne partes, & that the booksellers have never used to selle any of the sayd bookes so bound, And that the petitioners doe not know or can perceive wherein and how they have heretofore offended, or for the time to come can be prejudiciall by continuing theyre accustomed sale of the said Bookes so bound being ready to enter bonds as your Grace shall order not to vent any other.

Therefore the petitioners most humbly pray that by your Grace's means and favours they may continue theyre trading in the said rich bound books … [2]

Christopher Barker received 11⅛ ounces of gilt plate in return for his gift, which was described as 'couered wt crymson vellat alouer embradered whythe venys golde and seade perle'.[3] He was adept at courting favour in order to pursue his publishing and printing career, especially in connection with royal printing patents. In 1575 the Stationers' Company ended a monopoly on printing bibles held by the queen's printer, Richard Jugge. Barker shrewdly went to the Privy Council and obtained a patent for the Geneva Bible, the most popular English version of the Bible until the King James Bible. He published an edition of the Geneva New Testament later that year, and in 1576 a complete Bible. When Jugge died in 1577 the office of queen's printer went to Sir Thomas Wilkes, but the following month Barker paid Wilkes a 'great somme' for the office, and was granted a patent which gave him exclusive rights to all English Bibles. In all these machinations he had a powerful ally (and probable patron) in Sir Francis Walsingham, Elizabeth's secretary of state. He became a wealthy man, and in 1583 bought a country house in Buckinghamshire, conveniently close to the court at Windsor Castle.

Notes
1 Nixon and Foot 1992, pp. 41–2.
2 Bodleian MS. Hatton 67, fol. 33.
3 London, British Museum, Egerton MS. 3052.

70

Les Proverbes de Salomon

Edinburgh, 1599

In the hand of Esther Inglis (1570/71–1624)
In French and Latin; seventy pages, 178 × 120 mm
Late-seventeenth or early eighteenth-century Oxford
binding for the Bodleian; dark red sheepskin with gold
tooling

Provenance: Robert Devereux, 2nd Earl of Essex
(1566–1601), dedicatee; Sir Thomas Neville (d. *c.* 1628),
who gave it to the Bodleian in 1620

Literature: SC 3082; P & A, vol. 1, no. 864; Scott-Elliot
and Yeo 1990, no. 9

MS. Bodl. 990 [pp. xiv–xv illustrated]

This is one of more than fifty surviving books of religious and secular texts which the calligrapher Esther Inglis sent to persons of status, influence and wealth. She herself was not from a rich background: her parents were French Huguenots who had fled France for England in about 1569 and settled in Edinburgh; her husband, Bartholomew Kello, was a clerk in holy orders who seems to have done clandestine work for King James both in Scotland and on the Continent. Her calligraphy, at which she laboured for most of her life, was therefore done in the hope of financial reward.

Inglis's dedicatees include two monarchs (Elizabeth I, James VI and I), a future monarch (Charles I), several princes, a duke, eight earls and a French count. This manuscript is one of four she sent out within a few days of each other in early 1599. The first, a book of the Psalms, was dedicated to Elizabeth I on 27 March;[1] the second, another copy of the Psalms, to Prince Maurice of Nassau on 2 April;[2] the third, the present manuscript, was dedicated to the 2nd Earl of Essex on 13 April; and the fourth, 'Le Livre de l'Ecclesiasté', was dedicated the following day to Anthony Bacon, who was in Essex's service.[3]

Inglis heaps praise on Essex in her dedication to this volume, a French text of the Proverbs of Solomon. The Proverbs, she tells Essex, suited a man so renowned for his wisdom, truly the Solomon of the age: 'vous la presente ornee des traces de ma plume'. Her dedication is followed by poems in praise of the 'tresnoble et tresillvstre' Essex by Andrew Melville and Robert Rollock, the principals of, respectively, Glasgow and Edinburgh universities, and John Johnston, a cosmopolitan scholar, poet and man of letters.

Inglis includes, as she often does in her manuscripts, a miniature self-portrait. Her left hand rests on an open book, while her right hand holds a quill; to the left of the book are a lute and a sheet of music. It is an exercise in self-promotion, but Inglis's mastery of the pen speaks for itself in the pages that follow. The thirty-one chapters of Proverbs are written in an extraordinary variety of scripts, from conventional romans and italics to elaborate *lettres de fantaisie*, including Pierre Hamon's *lettre pattée* with its triangular serifs; the trembling hand known as *lettera rognosa*; *lettera tagliata*, in which a horizontal white line runs through the letters; and *lettre entrelacée*, in which the letters are pierced and joined by a cord. Inglis's dexterity is especially apparent in the miniature scripts, some of which are barely a millimetre high. Each chapter has a headpiece and decorated initial, and a stippled border has been painstakingly drawn round every page.

Esther Inglis's work is derivative: many of these scripts and ornaments may be traced to specific writing manuals and specimen books,[4] but the precision and evenness of her calligraphy, maintained page after page, is remarkable. Her work also has an intensity and a concentration that evince the ever-present need for patronage.

Notes

1 Oxford, Christ Church 180.
2 Washington, Folger Shakespeare Library, V a.93.
3 London, British Library, Add. MS. 27927.
4 See Barker 2012.

Ad Illvstris=
simum Comitem
Essexivm. &c.

Herculeam gestas dextram Comes inclyte, avitam
 Incolis antiqua nobilitate domum.
Diceris egregius divæ virtutis amator
 Et pacta observans fœdera, largus ope.
Pro patriaq, pati durissima quæq, paratus,
 Promptus' Et Hesperios subdere marte feros.
Nullus qui eximiæ superet te munere formæ
 Prædicat ingenium et Anglica gens animum.
Macte Heros, tibi partus honos, tibi gloria surget,
 Major marte tuo laude perennis eris.
Parcius inde tuum jactes mihi Roma, Camillum
 Protulit huic similem. terra Britana virum.

 Robertvs Rollocvs.

IN PROVERBIA SALOMONIS
Esteræ Inglis (cuius effigiem hic
vides) manu descripta.

Si mihi mens, tibi quæ manus est, ego pingere tentem
 Mente mea, manus hoc quod tua pinxit opus.
Si mihi, quæ tibi mens, manus esset, pingere tentem
 Ipse manu, mens hoc quod tua pinxit opus.
Sed mihi nec manus hæc, nec mens, Tua pingere sola
 Et mentem manus, et mens queat vna manum.
 AD EANDEM.
Quod natura, quod ars, quod nec natura nec vlla ars
 Pinxerit hoc tua mens, pinxerit ista manus.
 Andreæ Melvlni.

UNKNOWN ARTIST

The tale of Urashima

Japan, early Edo period (mid-seventeenth century)

Ten paintings, alternating with texts in decorative panels
In Japanese; scroll measuring 332 × 9159 mm

Provenance: Received by the Bodleian in 1901

Literature: SC 33030

MS. Jap. c. 4 (R) [painting 5 illustrated]

Fig. 22. Urashima returning home. *Manjū* netsuke by Suzuki Kōsai, mid to late nineteenth century. Ashmolean Museum, Oxford (EA 2001.139)

This is a fine and late example of a Japanese picture scroll, or *emaki*. The definition of *emaki* (or *emakimono*) varies, but broadly speaking they were popular from the tenth to the nineteenth century. The *emakimono* is particularly suited to narratives: using a low table, the reader scrolls from one calligraphic panel or image to the next, moving at his or her own pace.[1]

The scroll narrates one of the oldest and best-known Japanese folk tales. The tale exists in several versions, but the essential elements of the story are as follows. Urashima, a young fisherman, rescues a turtle and releases it back into the sea. Some days later the turtle returns, thanks Urashima, and takes him away – in some versions to an underwater palace, the home of Ryūjin, the Dragon King of the Sea, but here to a mountain palace on an island. The turtle is revealed as a princess, and Urashima stays in the palace as her guest for what seems to him a few days. After a while he begins to miss his home and asks if he may leave. The princess consents and gives him a sealed box which he is not to open. When Urashima arrives back at his village he finds everything very different. His parents are not there,

and he does not recognize any of the villagers, nor they him. Without thinking, he opens the box given to him by the princess. As a thin column of smoke rises from the box he is transformed into an old man; a great period of time has passed since he left the village – in this version, seven thousand years.

From each of the four sides of the palace there was a magical view of one of the seasons: from the north side, winter; from the east, spring; from the south, summer; and from the west, autumn, which is illustrated here. The painting displays many of the features of *emaki*. The artist has increased the depth by adopting a high viewpoint and basing the composition on strong diagonal lines. There is a subtle use of colour: the autumnal reds and browns of the leaves are repeated in the banisters and fabrics of the palace and the kimonos of the princess's

attendants, and provide the background for the adjacent lettering. The natural world is depicted with considerable sensitivity.

The tale of Urashima was often depicted by Japanese artists, and the celebrated fisherman cuts a lively figure on prints and netsuke (see fig. 22). The *emaki*, by contrast, was essentially a courtly medium which originated in the medieval Heian period. They were made for the wealthy and the leisured and share many of the characteristics of Heian literature, such as Murasaki Shikibu's *Tale of Genji*. The figures are stylized and the faces inscrutable; emotions are expressed through subtle and mannered gestures, and the atmosphere is dreamlike and remote. In this example, a popular folk tale becomes distinctly aristocratic in tone.

Note
1 Okudaira 1973.

72

JOHN SMITH (bap. 1580, d. 1631)

A Map of Virginia

Oxford: J. Barnes, 1612

48 leaves + fold-out map; 183 × 139 mm
Bound with other titles in mid-seventeenth-century Oxford centrepiece binding for the Bodleian: brown calfskin with blind tooling

Provenance: Robert Burton (1577–1640), who bequeathed it to the Bodleian

Arch. G e.41(5) [not illustrated]*

73

WILLIAM STRACHEY (1572–1621)

The Historie of Travell into Virginia Britania

Probably completed 1612

104 leaves, including pages from Theodore De Bry's 1590 edition of Thomas Hariot's *A Briefe and True Report of the New Found Land of Virginia* and John Smith's *Map of Virginia* of 1612; 340 × 220 mm
Contemporary English centrepiece binding: brown calfskin with blind and gold tooling

Provenance: Possibly among the books inherited from Captain John Smith (bap. 1580, d. 1631) by John Tradescant the Elder (d. 1638); John Tradescant the Younger (bap. 1608, d. 1662); acquired after his death by Elias Ashmole (1617–1692); bequeathed by him to the University of Oxford; transferred to the Bodleian from the Ashmolean Museum in 1860

Literature: Black, cols 1480–81; Verner 1968; MacGregor 1983, no. 446 (p. 357); Rogers 1991, pp. 160–61

MS. Ashmole 1758 [fols. 13v–14r illustrated]

The first accurate map of Chesapeake Bay in North America was made by an English soldier, Captain John Smith, who in 1608–9 served as president of the governing council of the English settlement in Virginia. It was engraved by William Holl, and included in Smith's 1612 pamphlet *A Map of Virginia. With a Description of the Countrey, the Commodities, People, Government, and Religion.* The pamphlet was printed in Oxford, and this copy (cat. 72) was owned by the writer Robert Burton, a student of Christ Church.

Smith's map served as the prototype for subsequent maps of the area for more than fifty years, and today is particularly valued for the unique information it provides about the locations of Native American tribes (it identifies ten tribes and some 166 native villages). It was constructed from Smith's own surveys, and from information he obtained from tribal members. He explained: 'as far as you see the little Crosses on rivers, mountains or other places, have been discovered. The rest was had by information of the savages and are set down according to their instructions.' The image of the standing Indian was taken from a drawing by John White, which had been engraved by Theodore de Bry and published in the 1590 edition of Thomas Hariot's *A Briefe and True Report of the New Found Land of Virginia.* Smith's depiction of Powhatan, the local tribal chief, interestingly shows that women were members of Powhatan's court. Smith had been taken prisoner by Powhatan's tribe, and according to legend had been been released thanks to the intervention of the chief's daughter, Pocahontas.

A coloured copy of Smith's map (illustrated opposite) was included in a manuscript volume put together by the historian William Strachey (cat. 73). Strachey was a member of the Virginian colony in 1609–11, and *The Historie of Travell into Virginia Britania* is partly an eyewitness account. It is also a distillation of the work of others, including John Smith; as well as the copy of Smith's map of Chesapeake Bay, the volume includes illustrated pages from Hariot's *Briefe and True Report.*

Smith's map and Strachey's text express the colonial instincts of seventeenth-century England. Both men were vocal proponents of colonization. 'The gaining Provinces addeth to the King's Crown', Smith wrote in the preface to his *Generalle Historie of Virginia* (1624), 'but the reducing Heathen people to civilitie and true Religion, bringeth honour to the King of Heaven.' Similarly Strachey maintained that it was his country's duty to convert the 'natives' to the true religion and become subjects of King James: once the 'seducers', their priests, were disposed of, they inevitably would see the truth of the Christian religion, and the benefits of English civility and the rule of law.

Strachey's work was originally intended for publication, but because of its critical tone it was turned down by the Virginia Company. He therefore employed a scribe to make copies. This is one of three such copies, and was presented to Sir Allen Apsley, Purveyor to the King's Navy. The other copies are in the British Library (presented to Sir Francis Bacon) and Princeton University (presented to Henry Percy, 9th Earl of Northumberland). The text was first published in 1849, by the Hakluyt Society.

Cat. 73

74

Miniature copies of the *Bhagavadgītā*

India, eighteenth century

Miniatures, borders
In Sanskrit; scroll, width 50 mm

Provenance: James Fraser (d. 1754); purchased from his widow in 1758 by the Radcliffe Trustees for the Radcliffe Library; transferred to the Bodleian in 1872

Exhibition: Oxford 2002b, no. 60

MS. Fraser Sansk. *41 a, b*

The *Bhagavadgītā* was composed around two thousand years ago. The Sanskrit text forms part of the huge Hindu epic the *Mahābhārata*, although it may originally have been a separate work. It does not advance the action of the *Mahābhārata*; instead, it is a meditation on action itself, in the form of a dialogue between the warrior Arjuna and the god Krishna.

The *Bhagavadgītā* is set just before a great battle between the armies of the Pāṇḍavas and Kauravas, who are related. Seeing his kinsmen arrayed against him, Arjuna hesitates. 'I see evil omens,' he tells Krishna, 'nothing good can come from slaughtering one's own family in battle – I foresee it!'[1] To encourage him to fight, Krishna then teaches Arjuna about correct and incorrect action, and about renunciation, sacrifice and, finally – after a life of correct action – freedom from selfish human desires. Arjuna is encouraged, and the narrative of the *Mahābhārata* resumes with a great battle, which lasts eighteen days.

The *Bhagavadgītā* is one of the central texts of Hinduism. Its meanings are not always clear and a large body of commentary and interpretation has built up round it. Readers have typically approached the text according to various traditions. These two rolls contain the eighteen chapters of the *Bhagavadgītā* in minute script, but have no commentary. They are part of a fashion for copying certain Hindu sacred texts (most commonly the *Bhāgavata Purāṇa, Bhagavadgītā* and *Devīmāhātmya*) onto thin, burnished strips of paper – not to be read, but to be carried on one's person as an amulet. They date from the eighteenth century and the centres of production were in North India (Alwar, Jaipur, Benares). The fashion may have started in imitation of the long strips of birch bark that were not infrequently made into rolled manuscripts as amulets. Another possible source is a Middle Eastern tradition by which tiny copies of the Qur'an were kept as amulets within cases, either as rolls or shaped as squares, rectangles and octagons.[2]

One of the manuscripts is shown here in its original container. The other is unrolled to show the illustrations which head the text, and the richness of the decoration suggests that it was commissioned by a wealthy patron. There are six eight-lobed cartouches

in a floral border showing the major Hindu deities. From the top, they are Gaṇeśa, the elephant-headed, four-armed God of wisdom; Brahmā, God the creator, with his four heads and four hands; Viṣṇu, the preserver, with his wife Lakṣmī, Goddess of happiness and prosperity; Śiva worshipped by a devotee; Durgā, riding a tiger, symbolizing her warlike nature and invincibility; and Krishna, depicted as Arjuna's charioteer. After a portion of text comes another image of Durgā.

Krishna is Arjuna's traditional comrade and teacher, but in the *Bhagavadgītā* he is more – the omnipotent deity to whom Arjuna should direct all his devotion:

Fix your mind on me, devote yourself to me, sacrifice to me, do homage to me, and so you shall in reality come to me. I promise you: you are dear to me.
 Abandoning all duties, vow yourself to me alone. Don't agonize, I shall release you from all evils.[3]

Notes
1 Johnson 2004, p. 5.
2 London 1982, no. 130.
3 Johnson 2004, p. 80. I am grateful to John Brockington for his assistance with this entry.

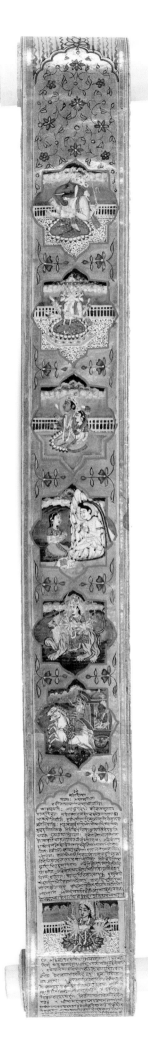

PART TWO

GENIUS AND LEARNING

Genius is from Heaven, Learning from Man

'Genius leaves but second place, among men of letters, to the Learned', wrote Edward Young in 1759. 'It is their Merit and Ambition, to fling light on the works of Genius, and point out its charms.… Genius is from Heaven, Learning from man.'[1] Providing one accepts that genius cannot be taught, it becomes the humble responsibility of a university to recognize and nurture genius, to elucidate its works and, in time, to honour its achievements. These tasks have not always been straightforward, however, for the stellar genius and the university are not necessarily a comfortable fit – as Max Beerbohm comically illustrates in his image of Dante in Oxford (cat. 75).

Incipient genius may be difficult to spot. In the early eighteenth century Percy Bysshe Shelley did not impress Oxford University with his precocious literary productions, he outraged it. Only at the end of the century would his college honour his peculiar greatness (cat. 76). A careers adviser, interviewing an uncertain young author, may hardly be expected to foresee the great works which lie ahead, and is concerned instead with the student's immediate need to earn a living (cat. 77).

Honorary degrees, by contrast, have brought people of proven distinction to the university. Some have been accustomed to the academic environment (cat. 78), but others have lived and worked in very different conditions, and so found the experience bemusing and even difficult (cats 79 and 80).

Equally, a person of rare talent may, against the odds, find a sustainable place in a university, and because of their unconventional style and uncertain status bring it honours and success (cats 81–5).

Note
1 Young 1759, p. 21.

DANTE IN OXFORD
PROCTOR : "YOUR NAME AND COLLEGE?"

75

SIR HENRY MAXIMILIAN (MAX) BEERBOHM (1872–1956)

'Dante in Oxford'

From *The Poets' Corner*, London: William Heinemann, 1904

374 × 275 mm

Provenance: Given to the Bodleian in 1981 by Emma Dunston (1886–1983)

Dunston B 9

Oxford University has a long tradition of Dante scholarship. At the beginning of the seventeenth century, when the poet was little read in Britain, the Bodleian had two copies of the *Divine Comedy*; by 1620 it had five.[1] When Britain rediscovered Dante in the nineteenth century the University played a leading role: founded in 1876, the Oxford Dante Society is one of the oldest Dante societies in the world.

In his *Life of Dante* (*c.* 1350) Boccaccio mentioned that the poet had studied in Paris. This is very unlikely, but around half a century later a Dante commentator, Giovanni Bertoldi da Serravalle, went further and maintained that Dante had studied at Oxford too: 'He loved sacred theology, a subject he studied for a long time both in Oxford in England, and in Paris in France.' The breadth of Dante's learning is certainly extraordinary, but in all likelihood he never left his native Italy. Serravalle had met two English bishops, Nicholas Bubwith and Robert Hallum (or Hallam), at the Council of Constance (1414–17) and dedicated his Latin translation of the *Divine Comedy* to them. Hallum had been Chancellor of Oxford University in 1403–5, and Bubwith was probably an Oxford man as well, so perhaps Serravalle was merely engaging in a bit of flattery.[2]

No one has taken the possibility of Dante visiting Oxford very seriously, with one curious exception. In June 1892 William Gladstone published a long article in *Nineteenth Century* entitled 'Did Dante Study at Oxford?' Gladstone had been an undergraduate at Christ Church, and the University's Member of Parliament. The *Divine Comedy*, which he read constantly, had often been his guide and solace. In his article, written towards the end of his life, he brought his favourite poet to his favourite city. Perhaps he did so only half-seriously and for his own amusement, but his central premise was that Dante only ever described places where he had been, and that descriptions of England in his poetry could only mean that he had experienced the country at first hand. He also considered it plausible that Dante had been one of the numerous itinerant scholars who had travelled to Oxford from Paris in the thirteenth century.[3]

In 1894 an Italian scholar, Agostino Bartolino, demonstrated that there was no historical basis to Gladstone's arguments – but he could appreciate why other countries would wish to have a part of Italy's foremost literary genius, whose greatness made him truly an international figure:

it is very gratifying, this rivalry among foreigners to share in the glory of our poet … The cult of Dante in Oxford, and Gladstone's fine article, flatter our amour propre; we feel sincerely grateful towards all students of our great man. In honouring him, they do us great honour as well. But this is not about poetry and affection, but about historical fact…. Ingenious efforts to show Dante travelled to England and attended the University of Oxford, only serve to increase … our gratitude to all those outside our borders … who by showing their appreciation of our poet and by their longing to make him their own … do us a great honour as well.[4]

In his wonderfully absurd picture Max Beerbohm drops Dante into Victorian Oxford after curfew and confronts him with the University authorities. The poet's patrician figure towers over the rotund, officious little proctor. Beerbohm had been a student at Oxford, 'this little city of learning and laughter', from 1890 to 1893, and had not been preoccupied with thoughts of genius. 'Undergraduates', he wrote, 'owe their happiness chiefly to the consciousness that they are no longer at school. The nonsense which was knocked out of them at school is all put gently back at Oxford or Cambridge.'[5]

Notes
1. Toynbee 1909, vol. 1, pp. 103–4.
2. Kay et al. 2010, p. [ix].
3. The earliest royal document in the University Archives (WP Beta/E/4) is a letter of 1229 in which Henry III offers Parisian scholars an academic haven.
4. Isba 2006, p. 125.
5. Beerbohm 1899, p. 156.

MARY WOLLSTONECRAFT SHELLEY (1797–1851)

Pages from the draft of *Frankenstein*

December 1816 (?) – April 1817

Autograph
Two leaves from 'Draft Notebook B', 310 × 200 mm

Provenance: Purchased before 7 June 1887 by Sir Percy Shelley (1819–1889) and Jane, Lady Shelley (1820–1899); bequeathed to their adopted daughter Bessie Scarlett (1852–1934); by descent to James Scarlett, 9th Baron Abinger (b. 1959), from whom purchased by the Bodleian in 2004[1]

Literature: Robinson 1996 (facsimile)

MS. Abinger c. 57, fols. 47–48 [fols. 47v–48r illustrated]

Mary Shelley had the idea for *Frankenstein*, her remarkable novel about a student and the monster he creates, while she, her husband Percy Bysshe Shelley, and step-sister Claire Clairmont were staying in Geneva as the holiday neighbours of Lord Byron. Incessant rain confined them indoors, and at Byron's suggestion they each tried their hands at a ghost story. As Mary later recalled, *Frankenstein* came to her in a dream:

I saw – with shut eyes, but acute mental vision – I saw the pale student of unhallowed arts kneeling beside the thing he had put together. I saw the hideous phantasm of a man stretched out, and then, on the working of some powerful engine, show signs of life, and stir with an uneasy, half-vital motion. … He sleeps; but he is awakened; he opens his eyes; behold, the horrid thing stands at his bedside, opening his curtains, and looking on him with yellow, watery, but speculative eyes.[2]

Mary drafted the novel in two notebooks. The first she purchased in Geneva; the second she obtained in England. Her text is accompanied throughout by Shelley's corrections, revisions and additions. He amends awkward words and loose constructions (particularly in the early chapters), suggests word changes, and adds short passages.

The leaves illustrated overleaf are taken from the second notebook, which – like the first – is now disbound. In a passage which Mary Shelley did not include in the finished novel, Victor Frankenstein and his friend Clerval look round Oxford. They are charmed by the University and amused by its strange rules, 'which although they might excite the laughter of a stranger were looked upon in the world of the university as matters of the utmost consequence'. Two students, they learn, are obstinately wearing 'light coloured pantaloons when it was the rule of the colledge to wear dark', and are in danger of being expelled for the offence.

Was Mary Shelley, when she wrote this passage, thinking of another two Oxford students who had defied their college? Six years earlier her husband, Percy Bysshe Shelley, and his friend T.J. Hogg had been undergraduates at University College. Unimpressed by the religious orthodoxies that prevailed in Oxford, and full of youthful self-confidence, in 1810 they had written and published a pamphlet entitled *The Necessity of Atheism*. When asked to explain themselves by the college authorities, they had refused to cooperate, and as a consequence had been expelled. Their Oxford career had lasted less than two terms.

According to one very unreliable biographer, Thomas Medwin, Shelley had visited the Bodleian 'after [he] had been matriculated' and had asked the librarian, vaguely, 'whether he had the Wandering Jew'. There is no evidence that he made any further visits during his brief undergraduate career, and as a junior member of the University he would not have been eligible to study there.[3] Two days after his expulsion, on 9 March 1811, an Assistant at the Library, Philip Bliss, noted Shelley's expulsion and listed four of his publications: *St Irvyne* (a gothic romance), *Posthumous Fragments of Margaret Nicholson* (a collection of juvenile poems), *The Necessity of Atheism* and *A Poetical Essay on the Existing State of Things*.[4] That Bliss should know of these obscure publications is interesting, but there was little in them to suggest unusual talent.

Shelley returned to Oxford in the summer of 1815 with Mary, his friend Thomas Love Peacock and Mary's stepbrother Charles Clairmont. While on a boating trip up the Thames, Clairmont described the day to his half-sister Claire:

We spent the next morning in a more intimate investigation of the beauties of the Architecture, & the shape & situation of the Town; we saw the Bodleian Library, the Clarendon Press,

& walked through Quadrangles of the different Colleges; we visited the very rooms where the two noted infidels Shelley & Hogg (now happily excluded the society of the present residents, those virtuous devotees of voluptuo[u]sness & ease, and extortion and deceit and blindness), poured with the incessant & unwearied application of an Alchemyst over the artificial & natural boundaries of human knowledge; brooded over the perceptions which were the offspring of their villainous & impudent penetration & even dared to threaten the World with the horrid & diabolical project of telling mankind to open its eye. I am sure you will duely apreciate the sagacity & rigid justice of the directors, whose anxiety for the commonweal led them to excommunicate such impious monsters.[5]

As an expelled former student, Shelley would not have enjoyed any special privileges. He would, for instance, have entered the Bodleian as a tourist, paying his shilling to the janitor for a brief look at the Library and a stroll around the Picture Gallery (see cats 94–7). But he was evidently happy to show his companions his former haunts, and Charles Clairmont's gently satirical tone suggests that the poet, while retaining his contempt for the University's moribund conservatism, could now laugh at the earnestness of his younger self.

Shelley never visited Oxford again, but the antipathy between the poet and the University was resolved posthumously. In 1893 his daughter-in-law, Lady Shelley, gave a third of the family archive to the Bodleian, and at her request a number of items from it were put on public display. The following day she opened a Shelley memorial at University College. 'Men of great genius could not always be reduced to rule', she reminded the assembled University dignitaries. 'They erred sometimes, but they were not therefore to be deprived of the love and admiration of their countrymen.' In his reply the Master, James Bright, did not condemn the college for its treatment of the poet – 'there was hardly any place in Oxford which would not have acted in the same way'. Shelley, he said, was a prophet, a great man ahead of his time, and 'the very greatness of the man had rendered him open to that sort of treatment … being a rebel, he was treated as a rebel. But the rebel of 80 years ago was the hero of the present century.'[6]

Notes

1 For earlier provenance see Oxford 1992a, no. 59.
2 From the preface to the third edition of *Frankenstein* published in 1831
3 Barker-Benfield 1989.
4 Bodleian MS. Top. Oxon., e. 51, pp. 160–61; see Oxford 1992a, no. 26.
5 Stocking 1995, vol. 1, pp. 14–15.
6 As reported in *The Times*, 15 June 1893, p. 11.

We had arrived in England at the beginning of october and it was now february; we accordingly determined to commence our journey towards the north at the expiration of another month. In this expedition we did not intend to follow the great road to Edinburgh But to visit Windsor, Oxford, Matlock & the Cumberland lakes resolving to arrive at the completion of this tour about the end of July. I packed my chemical instruments & the materials which I had collected resolving to finish my labours in some obscure nook in the country.

We quitted London on the 27 of March and remained a few days at Windsor rambling in its beautiful forest. This was a new scene to us mountaineers; the majestic oaks the quantity of game & the flocks of lovely deer were all novelties to us. From thence we proceeded to Oxford. We were charmed with the appearance of the town. The colleges are antient and picturesque, the streets board & the landscape rendered perfect by the lovely Isis which near spreads into broad placid expanse of water & runs south of the town. We had letters to several of the professors who received us with great politeness & cordiality. We found that the regulations of this university were much improved since the days of Gibbon; But there is still in fashion a great deal of bigotry & devotion to established rules that constrains the mind of the students & leads to slavish & narrow principles of action

many enormities are also practised which 111 48
although they might excite the laughter
of a stranger were looked upon in the
world of the University as matters of the ut most
consequence. Some of the gentlemen obsti-
nately wore light coloured pantaloons
when it was the rule of the college to
wear dark — the masters were angry
& their resolves resolute so that while
during our stage there two of the students were
on the point of being expelled on this
very question. The threatened severity
caused a considerable change in the
costume of the gentlemen for seve-
ral days

Such to our infinite astonishment
we found to be the principal topic
of conversation when we arrived in
the town — our minds had been filled
with the remembrance of the events that
had been transacted here above
a century before. It was here that Charles
I had collected his forces, this town had
been faithful to him when the whole
nation had forsaken him to join the
standard of parliament & liberty.
It was strange to us on entering the town
full of the our thoughts were occupied
by the memory that unfortunate king,
the amiable Falkland and the insolent
Gower and finding it filled with
gownsmen & students who think
of nothing else than these events. Yet
there are some relics to remind you
of antient times; among others we regard

Reference cards compiled by the Oxford University Careers Service

1920s–1940s

Three index cards, 96 × 150 mm

Provenance: Kept in Oxford University Archives

University Archives

The Oxford University Careers Service was founded in 1892 as the Appointments Committee. These cards reveal its procedures in the first half of the twentieth century. The secretary interviewed a student, or former student, in search of a job and jotted down his impressions, which today seem startlingly frank. To these were added the opinions of college tutors, a record of the interviewee's educational history, and notes on their first steps towards a professional life. Anyone with literary ambitions had, of course, to find additional ways to earn a living, and shown here are the early choices of three young authors: W.H. Auden (Christ Church, 1925–8), William Golding (Brasenose, 1930–34) and Philip Larkin (St John's, 1940–43).

Auden (English literature, third class) was interviewed in 1927 and 1928. He is described as 'Tall fair rather pale' and 'youthful'. His prospects as a teacher are considered. He is the 'P.S. [public school] type', but though 'nicely turned out', is 'not an all-round strong candidate' for there are doubts about his ability to keep discipline in class. In the second interview, however, he gives a better impression, and is advised to keep an eye on *The Times Educational Supplement* for a job in a

London day school. His young tutor, Neville Coghill, recognizes him as a 'Man of great brilliance, with general culture and personal charm' – Auden had been writing poetry for some time, and had co-edited the 1926 edition of *Oxford Poetry*. He went on to teach at Larchfield School, Dunbartonshire, and then at Down School, Herefordshire. He was an unconventional but popular teacher and enjoyed the experience. His first volume, *Poems*, was published by T.S. Eliot at Faber in 1930.

Golding (English literature, second class) is bluntly described in February 1934 as 'A stout fellow – fat faced … cheerful'. As a teacher he is 'fit only for day schools', for he is 'N.T.S.' – 'not top shelf'. In May that year things looked a bit more hopeful: 'A bit dull & heavy – but a nice enough fellow. Attracted by the Egyptian Educ. Service – & might apply. A decent sincere man, with a lot of the free lance spirit about him.' In the opinion of his tutors he had no bent for science but was keen on the literary and the artistic and had a wide range of interests. A journal entry Golding wrote many years later throws an intimate and revealing light on these matter-of-fact impressions. 'No wonder I was unhappy at Oxford', he recalled on 21 March 1977. 'As a callow youth from a Grammar School, with nothing to offer the Dons in the way of youth, beauty, wit, brains, it's not surprising I was lost. The whole thing was a mistake.' It can take time for genius to find its voice: Golding

published a collection of poems in 1934, but his first novel, *Lord of the Flies*, did not appear until 1954.

Larkin (English literature, first class), is described in May 1943 as 'A tall man – quiet day school & black coat worker type. Speech & appearance good … Rather the literary type – his aspiration being mainly in that way. Wears specs, and eyesight sound with these.' He found his first job in 1943, a district librarianship in Wellington, Shropshire, 'which he could leave at a moment's notice. But not satisfied with it. And wld like to hear of other jobs of a literary type. Advised him to stick to librarianship'. In an interview with the *Observer* in 1979 Larkin, then the librarian of the Brynmore Jones Library in Hull, recalled this early career, and admitted that librarianship suited him:

In any case, I could never have made a living from writing. If I'd tried in the Forties and Fifties I'd have been a heap of whitened bones long ago. Nowadays you can live by being a poet. A lot of people do it: it means a blend of giving readings and lecturing and spending a year at a university as poet in residence or something. But I couldn't bear that: it would embarrass me very much. I don't want to go around pretending to be me.[1]

Note
1 Larkin 1983, p. 51.

AUDEN W. H. (Oxon.) Gresham's Sch. (Sch.)

Born 21.2.1907 Regd. 8.11.27 ✗ Educ. Ch.Ch. (Sci. Exhib.) '25

PAID

Wants { Prep School. }

Oxford Course Zool. June '25 Eng. Lit. III 1928.
 Chem. " '26
 Bot. " '27

Mod. Lang. Fr (3) Ger (3)

Athletics

Experience 1925-29 Abroad
 February 1930 Larchfield School, Scotland

S + 1¼

 Opinions
Secretary (4.11.17) Tall fair rather pale : born 8 year : youthful : R.S.
type : neat an all-round strong candidate : nicely turned out : [...]
am a bit doubtful about his power of keeping discipline : nothing [...]
induce him to go out of this century. (6.3.28) Rather improved impression :
advised him to keep his eyes on the times Educ. Suppt. for London day school
posts.

College R F Harrod Conduct exemplary M K Coghill Man of
great brilliance, wide general culture and personal charm

HM recommends

Last heard of 24 5 32

Permanent Address 42 Lordswood Rd. Harborne, B'ham.

GOLDING, W.G. [Sch master] — (M EL) Marlborough G.S.

Born		Regd. 22.2.34	Educ. B.N.C.

Wants

Oxford Course

Mod. Lang.

Athletics

Experience
1934–35. Dramatic Experience. Special Training.
1935–37. Michael Hall. Streatham.

Sc. Prelim — 32 —
Biology Physics Chem.

French 3 —

English
Biology
Chem:
Physics

Exhib. 32 II
Oxford Educ Dip 37–38

Music
Dramatics

but would change field. good

22.2.34

Opinions

Secretary 22/2.34.

College

Taylor —

H.M.

Last heard of 22 2 34

LARKIN. P. A. City Treasurer (MEC) C.D.J.K. K. Henry VIII School,
Born 9-8-22 Coventry Regd. 11.5.43 Educ. S* Johns. Coventry

PAID

Wants Literary B6/47 B178/46
3.9.43 ꝺ Publishing B169. C172.
 Motor Gove admin bookish. Librarianship C182
Oxford Course Librarianships B7/44
 English School. E.L. full 57/44
1940~43. all passed one June 43. I 54/44
 with distinction 108/45
 B145/c.
Mod. Lang. Fr. G11/46
 B188/46
Athletics - Treasurer O.U. English Club.

Experience Prefect. Grad iv (eyesight?) - wh. is not bad.
 Dec 43 Librarianship at Wellington. Salop.
 15.8.46 Off NA to circular. Educ. books only
 7.1.47 Off NA k Bus. Circ. 20.12.46.

Opinions

Secretary 11.5.43. A tall man - quiet day school + black
coat worker type. Speech + appearance fair,
able reminiscences. Rather the literary type
- his aspiration being mainly that way. Wears
specs, and eyesight sound with these. 27.11.43. Has a job
as shown on the reverse which he could leave at a moment's notice.
But not satisfied with it, and wld like to hear of other jobs of a
literary type. Advised him to stick to librarianship. Gave him the
requisite information.

(Costin) Should do quite well as an temp. A.P. or at
publishing work. Intelligent and wide-awake. Worked well
and steadily - believes he will get a 2nd. in English.
Personally does not find him one of the more attractive
xxCollege men in College - but he has parts and a curious
touch of distinction. He is, he believes, quite morally
sound and trustworthy.
3/12/45. Tall, pleasant fellow. interviews quite well: now finds himself
in a dead end: was turned down for an I/P job in temp HCS; advised
him to apply again under reconstruction scheme: difficult to see where he'd
fit in: & the longer he stays in his present job, the more difficult it.
will be! Last heard of doesn't want to teach: has a slight stammer.
 3.12.45.

Cat. 77

ALBERT EINSTEIN (1879–1955)

Letter to the University Registry, Oxford

12 May 1931

Autograph
In German; single leaf, 260 × 215 mm

Provenance: Kept in Oxford University Archives

University Archives, UR6/HD/2B, file 1

Albert Einstein was awarded honorary doctorates by the universities of Harvard, Madrid, Oxford, Princeton and Rostock, and the Swiss Federal Institute of Technology in Zurich. Here he accepts the offer from Oxford:

Esteemed Colleague,
 Many thanks for your kind message regarding the honorary doctorate. I am most thankful for the offer of bestowing such an honour on me. Naturally, I will accept. May I also confirm that the arranged date suits me very well.
 Most respectfully yours [1]

Einstein received the doctorate on 23 May 1931. While in Oxford the great physicist gave three lectures to packed audiences at Rhodes House: 'The Theory of Relativity', 'The Cosmological Problem' and 'The Latest Developments of the Theory of Relativity'. After the second lecture a blackboard on which Einstein had chalked a few equations concerning the expansion and age of the universe was taken straight to the Museum of the History of Science, where it remains to this day. The chalk has proved remarkably durable, and it is one of the museum's most popular exhibits.

Note

1 Translation by Julia Wagner.

Fig. 23. Blackboard used by Einstein on his visit to Oxford in 1931. Museum of the History of Science, Oxford

University Registry, Oxford.

Hochgeehrter Herr Kollege!

Ich danke Ihnen für Ihre freundliche Mitteilung betreffend die Verleihung des Ehrendoktor-Titels. Ich nehme die mir angebotene hohe Würde selbstverständlich dankbar an und erkläre mich mit der hiefür vorgeschlagenen Zeit einverstanden.

Mit ausgezeichneter Hochachtung

A. Einstein.

79

DMITRI SHOSTAKOVICH (1906–1975)

Telegram to 'University Board Oxford'

Moscow, 25 March 1958

Single leaf, 121 × 186 mm

Provenance: Kept in Oxford University Archives

University Archives, UR6/HD/6, file 8

In 1958 the University honoured eight men: the Prime Minister, Harold Macmillan; the author and Member of Parliament for the University, Sir Alan Herbert; the politician and Labour Party leader, Hugh Gaitskell; the economist Lord Beveridge; the Australian judge Sir Owen Dixon; the chemist and Nobel Laureate, Arne Tiselius; and two composers, François Poulenc and Dmitri Shostakovich. Photographs of the occasion (see

fig. 24) show Shostakovich half-hidden at the back of the procession looking rather bemused, and Macmillan at the front looking cheerful and thoroughly at home (three years later he would become Chancellor of the University).

Shostakovich was nominated, along with Pablo Picasso, by the historian Alan Bullock. Initially he was reluctant to make the journey from Moscow, as he thought he was in a competition which he might not win, but as soon as the nature of the honour was explained to him he accepted warmly by telegram. His host in Oxford was the distinguished philosopher and fellow of All Souls College, Sir Isaiah Berlin.

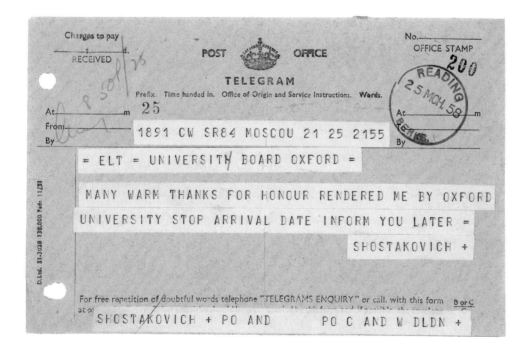

80

SIR ISAIAH BERLIN (1909–1997)

Letter to Rowland Burdon-Muller (1891–1980)

Oxford, 28 June 1958

Typed letter, corrected and signed
Two leaves, 255 × 204 mm

Provenance: Given to the Bodleian Library in 1999 by the Isaiah Berlin Literary Trust

Literature: Hardy and Holmes 2009, pp. 637–41

MS. Berlin 269, fols. 111–112 [fols. 111r–112v illustrated]

'Goodness, but it was a business', Berlin begins his compelling account of Shostakovich's visit to Oxford. The composer arrived by car accompanied by two 'diplomats' – 'small, shy, like a chemist from Canada (Western States), terribly nervous, with a twitch playing in his face almost perpetually'. Once free of his minders, who went off with 'some unfortunate Fellow at New College', Shostakovich became more relaxed, but at a party given by the historian Hugh Trevor-Roper he made straight for the nearest corner 'and sat there, contracted like a hedgehog'. There was music: a cello sonata by Shostakovich, songs by Poulenc, and one of Shostakovich's preludes and fugues played on the piano by the composer himself. His two guardians, meanwhile, 'went to an undergraduate party at New College, then to the Exeter Ball, had a tremendous time, exchanged insults and pleasantries with undergraduates and dons, and obviously enjoyed themselves'.

The following day, 'the nervous tic began in S. again', and 'he went through the horrors of the degree ceremony'. There were embarrassing moments: guests attempted to speak Russian to the composer at the All Souls luncheon; Lord Beveridge tried to present him with a bunch of flowers 'which he had been charged to give him by some dim Welsh composer'; several enthusiastic White Russians tried to engage him in conversation. 'Finally we took him home, dressed him in a white tie and sent him to dine at Christ Church with the other recipients of honorary degrees, such as the Prime Minister, Gaitskell, etc., he came home more dead than alive'.

Ceremonial Oxford was not an easy place for an artist who had worked under the shadow of Stalin, and although the upper echelons of the University are wonderfully depicted in Berlin's lively, gossipy pages, it is his portrayal of Shostakovich as a haunted man of genius baffled by his surroundings that stays in the mind.

Fig. 24. Encaenia procession, June 1958. Shostakovich is second from the left

HEADINGTON HOUSE.

OLD HIGH STREET, HEADINGTON,

OXFORD. 28th June,1958.

TEL. OXFORD 61005.

Dearest Roland,

Your humidor arrived to-day and is obviously a most delightful
object and just what I need, for my cigars are perpetually being eroded
by dryness. I have repacked all my cigars into it at once, and contem-
plate the object with great pleasure and pride, it was very good indeed
of you to send it.

Alas, no Chinese gong has yet materialised; but Aline is thinking
vaguely about buying that chandelier - you were with us when we looked at
it? - as well as other objects upon which she has set her heart both
"above doors" and a hunt table to be put in a semi-circular,semi-bay win-
dow in the dining-room.

Meanwhile Poulenc and Shostakovich have come and gone. Goodness,
but it was a business. First a great fuss about the British Council which
had arranged elaborately for a musical party for S. on Monday night (we
were to entertain him on Tuesday and he was to get his honorary degree
with Macmillan and Gaitskill on Wednesday), but the Soviet Embassy app-
ears to be engaged in some kind of warfare with the British Council and
more or less forbade him to have anything to do with them. The result was
that the party was held without him, much bad blood, general indignation,
telegrams, anger, tears. He finally materialised on Tuesday, and it was a
wonderful business. First there arrived in our drawingroom a very stiff
and upright, rather handsome young Soviet official, who said:"I wish to
introduce myself. My name is Loginov. The composer,D.D.Shostakovich is in
the car outside. We were told you were expecting him at 7-0. It is now
3-0. Do you wish him to remain in the car, or what? And for how
now We explained that we were expecting him at 3-0, and it would be
perfectly permissible for him to enter straightaway. Whereupon the car
was ceremonially driven in, another Soviet official leapt out, and final-
ly the composer himself appeared, small, shy, like a chemist from Canada
(Western States), terribly nervous, with a twitch playing in his face al-
most perpetually - I have never seen anyone so frightened and crushed in
all my life - he reintroduced the two Soviet officials as "my friends,my
great friends", but after he had been with us for a bit, and the Soviet
officials were got out of the way, he never referred to them as that ag-
ain, but only as "the diplomats". Every time he mentioned them a curious
expression of "angst" appeared on his face, rather like the expression
which sometimes enters Aline's face - indeed on the last morning of all
when he was waiting for the two officials to appear and was in a state of
utter panic and despair,I said in English (which he does not understand)
to Aline, who was also looking rather distraught, that the expression of
their faces was identical. Anyway the problem was how to get Shostakovich
to stay to dinner and go on the musical party given in the Trevor-Roper's
house for him and Poulenc, and how to get rid of the two Soviet officials,
who would cast a terrible frost on the occasion. In the end,I announced
firmly to them that the University had a strict set of rules which it
obeyed: under these a University official would appear in half an hour,

Cat. 80

and take them off to dinner in New College, after which they would be
allowed to see a play (by David Pryce-Jones), while for Mr.Shostakovich
an entirely different ~~programme~was~arranged~~ arrangement had been made.
This they took calmly - after glancing at one another to see if it was
all right - and bowed their heads submissively. The University official
duly called, some unfortunate Fellow at New College was suborned to
look after the two "diplomats", and Shostakovich was left with us. His
manner brightened. But throughout the visit he looked like a man who
had passed most of his life in some dark forbidding place under the su-
pervision of jailers of some sort, and whenever the slightest reference
was made to contemporary events or contemporary personalities, the old
painful spasm would pass over his face, and his face would assume a
haunted, even persecuted expression and he would fall into a kind of
terrified silence. It was depressing and very harrowing, and made one
like him and pity him a great deal. In due course the other guests ap-
peared, Poulenc, Cecile, the Cecils, the Trevor-Ropers etc., Poulenc
was charming to S.,and he visibly thawed under the benign influence.
We dined, and went on to the Trevor-Ropers' drawingroom. There S.imme-
diately made for the nearest corner and sat there, contracted like a
hedgehog, occasionally smiling wanly if I made a particularly bold
boutade. His cello sonato was played by a young and very handsome cell-
ist from Ceylon, he listened to it calmly, said to me that the cellist
was good, and the pianist very bad (which was perfectly true), and com-
plained to the cellist that he had played two passages incorrectly.The
cellist flushed, produced the score, and S.saw that the score bore out
the cellist. He could not think how this could be, suddenly realised
that it had been edited Piatigorsky, who had of course altered the
score arbitrarily to please himself, this was the moment at which he
came nearest to real rage, took out a pencil and violently crossed out
Piatigorsky's forgeries, and substituted his own original version.After
that his brow cleared,and he returned to his little corner. Songs by
Poulenc were then sung by Miss Margaret Ritchie, absurdly, in the ludi-
crous Victorian English fashion, Shostakovich writhed a little, but
Poulenc, very polite, very mondain, contragulated her and made grimaces
to others behind her back. After this a movement of Poulenc's cello
sonata was played, to placate him, and then there was a silence, and I
said to S.that everyone would be delighted if he too played a little.
Without a word he went to the piano and played a prelude and fugue -
one of the twenty-four he has composed like Bach, with such magnific-
ence, such depth and passion, the work itself was so marvellous, so
serious and so original and unforgettable, that everything by Poulenc
flew through the window and could not be recaptured. Poulenc did play
something from "Les Biches", and something else, but his music could
not be listened to any more, the decadence of the Western world had alas
become all too apparent. While playing S.'s face really had become trans
formed, the shyness and the terror had gone, and a look of tremendous
intensity and indeed inspiration appeared,I imagine that is how 19th
century composers may have looked like when they played. But I do not
think it has been seen much in the Western world in the 20th. After
that he ceased playing and various people wished to be presented. He
shewed the first violin of the Philharmonia Orchestra how to play the
2nd and 3rd movements of his concerto; he told Desmond Shaw-Taylor ab-
out his future plans - he gave autographs, he ate and drank. Poulenc,
although looked after nicely, felt somewhat relegated, rather like
Cocteau when Picasso is about. Everyone felt that this was a remarkable

-3-

occasion, unique and moving, and although he spoke no English, everyone except the thickest-skinned and most philistine,(like for example Mr. Hodson, the Editor of The Sunday Times,superfluously invited by the Ropers) felt moved, and said so in various ways afterwards. It really was an occasion and an experience. After this, at home, he did talk a little, complained about no piano, discoursed on his musical taste, and went to bed almost happy I think. Meanwhile his two guardians went to an undergraduate party at New College, then to the Exeter Ball, had a tremendous time, exchanged insults and pleasantries with undergraduates and dons, and obviously enjoyed themselves. Very nice they turned out to be - they may have had their hands dripping with Hungarian blood,but personally they were innocent, rather wooden peasants, who obviously at an order from above would have had no compunction in shooting one dead, but at the same time had a certain charm.

On the next day the nervous tic began in S.again, he went through the horrors of the degree ceremony, was terribly embarrassed at meeting various people who spoke Russian at the All Souls luncheon, was always taking cover with me, who after all was an accredited representative of the University registered by the Soviet Embassy as such. People asked him intolerable questions such as "What has happened to your 2nd,3rd and 4th symphonies ?" Admirable works condemned by the regime. He would answer lamely,"They were not a very great success", which was literally true, but he suffered as he spoke. An absurd incident occurred when Lord Beveridge, aged 84,tried to present him with a bunch of flowers - too large for a buttonhole, too small for a proper bouquet, which he had been charged to give him by some dim Welsh composer, and chose the middle of lunch to do so. Poor S.got up, mumbled, Beveridge, who was out of his mind, also mumbled, and they were taken apart with difficulty. Various White Russians tried to engage him in conversation,naturally enough,and he managed to disengage himself with enormous effort and agony. Finally we took him home, dressed him in a white tie and sent him to dine at Christ Church with the other recipients of honorary degrees, such as the Prime Minister,Gaitskell etc.,he came home more dead than alive, but got up early the next morning and presented us with scores of three works with suitable inscriptions, and even talked a little about his wife and children. At 10-0 a.m.the guardians were to call for him, but they were late. He got into a state of appalling nervous panic, made me ring the Mitre Hotel three times, began to wring his hands, wondered what would happen if he arrived late at the Embassy, how he would explain it, wondered whether his guardians had somehow abandoned him, or some mistake had been made for which he would be blamed, and got into an appalling neurotic state. However they appeared, explained they were late because they had been buying Guides to Oxfordshire at Blackwells, and took him off. I was invited to lunch with him in the Soviet Embassy next day, but refused. S.had seen enough of me, and knew enough about me to realise that I understood his position too well, and that I thought that it would be better for him to meet all the British musicians etc., whom he would meet in London through interpreters, and without being self-conscious about an observer understanding his reactions a little too well. So out of a kind of delicacy - I think you will agree it was not inappropriate - I refused, and that was that.

The whole thing has left me with a curious sensation of what it is to live in an artificial 19th century - for that is what Shostakovich does - and what an extraordinary effect censorship and prison has on creative genius. It limits it, but deepens it.

I must stop and go down to lunch with Peter and his school-friends assembled round the table, but S.'s face will always haunt me somewhat, it is terrible to see a man of genius victimised by a regime, crushed by it into accepting his fate as something normal, terrified almost of being plunged into some other life, with all powers of indig-nation, resistance, protest removed like a sting from a bee, thinking that unhappiness is happiness and torture is normal life. On this sombre note I must stop and go down to lunch.

Dear Stuart is coming in ~~immediately~~. Please give my love to Brian, and anyone you would like to in Boston. I shall write you next from Monte Carlo, and thank you again for your gifts, and how delightful your visit was - really I have seldom enjoyed anything more. Do come again as soon as possible.

Yours ever,

with much love
Isaiah

P.S. I have had no time to write to you about Callas - really like a 19th century prima donna of a sinister kind, pale face, huge eyes, dom-inating, nasty, hypnotic, romantic, like Turgeniev's mistress.

81

Laboratory of DOROTHY HODGKIN (1910–1994)

Hand-drawn insulin map

January 1968

Red and black ink; single leaf, 390 × 348 mm

Provenance: Part of a donation received at various dates between October 1991 and February 1994 from Dorothy Hodgkin and from the Chemical Crystallography Laboratory at Oxford University

MS. Eng. b. 2056 (B.281)

Dorothy Crowfoot Hodgkin is celebrated for her exceptional achievements in chemistry and crystallography (the study of the atomic structures of solids). She began her long association with Oxford as an undergraduate at Somerville College from 1928 to 1932. After working on her doctorate at Cambridge she returned to Somerville in 1934 as a temporary fellow. In 1946, after wartime work in Oxford on the structure of penicillin, she was appointed University Demonstrator. In 1955 she was given a readership, and the following year she was awarded the Royal Medal by the Royal Society, who in 1959 chose her as their first Wolfson Research Professor, a post she could hold at any university.

Hodgkin established a laboratory in Oxford which was remarkable both for the quality of its work and for its collaborative, non-hierarchical working methods. She drew her researchers from Somerville chemistry students, but also appointed post-doctoral students from overseas, including Western and Eastern Europe, the United States, Africa, Australasia, South-East Asia and the Far East. Considerable practical difficulties had to be overcome to staff the laboratory in this fashion, and external funding had to be secured for an interdisciplinary science which, as such, could not be placed in a conventional university department. This uncertain, changeable and creative set-up was held together by Hodgkin's unobtrusive but pervasive brilliance.

Throughout her life Hodgkin actively engaged in domestic and international politics, but her scientific work was based on the belief that science cut through ideological and national boundaries. Thus she visited and worked fruitfully with colleagues in the Soviet Union and communist China. When she went to Stockholm in 1964 to receive the Nobel Prize in Chemistry, she welcomed the internationalism of the occasion. 'We knew,' she said in a speech, 'when we came here, as laureates from our own different countries, that we should enjoy meeting one another and talking together in our international language'.[1]

Perhaps the crowning achievement of the Oxford laboratory was its analysis of the structure of insulin, a protein she had worked on since 1934. Using electron density maps Hodgkin and her colleagues built the first model of the insulin molecule in the summer of 1968.

Note

1 See cat. 84.

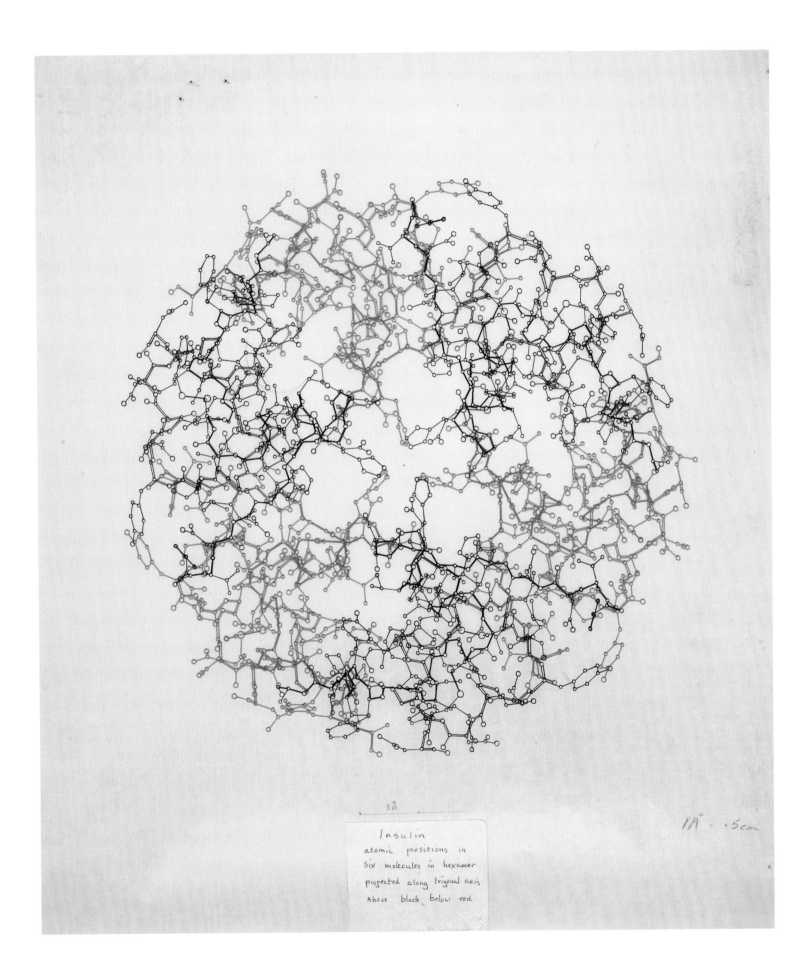

5Å

1Å = .5cm

Insulin
atomic positions in
six molecules in hexamer
projected along trigonal axis
Above black, below red

POST ⚜ OFFICE

TELEGRAM

Prefix. Time handed in. Office of Origin and Service Instructions. Words.

316 GN L1615 STOCKHOLM 43 29 1505 NORTHERN =

PROFESSOR DOROTHY HODGKIN 94 WOODSTOCKROAD

OXFORD =

ROYAL ACADEMY OF SCIENCE TODAY AWARDED

YOU THE 1964 NOBEL PRIZE FOR CHEMISTRY IN

RECOGNITION OF YOUR STRUCTURE DETERMINATIONS BY

POST ⚜ OFFICE

TELEGRAM

Prefix. Time handed in. Office of Origin and Service Instructions. Words.

XRAY METHODS FOR BIOCHEMICALLY IMPORTANT

SUBSTANCES OUR WARM CONGRATULATION LETTER WILL

FOLLOW = ERIK RUDBERG THE PERMANENT SECRETARY +

COL 94 1964 TS 784

82

ERIC RUDBERG (1903–1980)

Telegram to Dorothy Hodgkin

29 October 1964

Two leaves, 121 × 186 mm

Provenance: As cat. 81

MS. Eng. c. 5577/3, 7–8

83

ERIK LINDBERG (1873–1966)

Dorothy Hodgkin's Nobel Medal

Minted in Sweden, 1964

23-carat gold, diam. 66 mm

Provenance: As cat. 81

Somerville College, Oxford

When, in 1964, it was announced that Dorothy Hodgkin had won the Nobel Prize in Chemistry, she was in Ghana, where her husband Thomas worked as director of the Institute of African Studies. His students celebrated by performing traditional court dances of the Ashanti and the Twi. The official telegram of notification from the Permanent Secretary of the Nobel Committee for Physics (cat. 82) did not arrive until three months later: Hodgkin's frugal niece had bundled it up with letters of congratulation from all over the world and sent the package from Oxford to Africa by sea.

At the Nobel ceremonies in Stockholm Dorothy Hodgkin spoke before an audience on three occasions. First she delivered her formal Nobel lecture, entitled 'The X-ray Analysis of Complicated Molecules'. The following day, at the formal Nobel banquet, she gave two brief after-dinner speeches which typify her internationalism, her instinctive egalitarianism and her unforced modesty. The first was a short speech of thanks: 'my heart a little fails me, thinking of all the great names between us, and of all those on whom my work has depended, whose encouragement has brought me here today, on whose hands and on whose brains I have relied'.[1] The second speech was addressed on behalf of all that year's laureates to the Students of Stockholm (see cat. 84).

Note

1 Bodleian MS. Eng. misc. c. 5577.

Your majesties, your Royal Highness, students of Stockholm.

I am very happy indeed to hear your speech today as you do. We knew, when we came here as laureates from our different countries that we should enjoy meeting one another and talking together of scientific problems in our international language. I do not think any of us had realised how much more this festival might mean both to you in Sweden and to the whole world.

I was chosen to reply to you as the one a woman of the our group — a position which I hope very much will not be so very uncommon in the future that it will require any comment or special treatment — as more use is made of the many gifts which women share share equally with men. But as it turns out I might have been chosen for quite another reason since I come from the same country — East Anglia England as Tom Paine who wrote Rights of Man — a book from which you may say is derived the Declaration of Human rights that you also celebrate today.

84

DOROTHY HODGKIN (1910–1994)

Draft of a speech given at the Nobel Banquet

December 1964

Autograph
Two leaves, 255 × 202 mm

Provenance: As cat. 81

MS. Eng. c. 5577/8, 2–3

85

20th Century Women of Achievement: Portraits of Genius

First-day cover issued on 8 August 1996

Provenance: Given to the Bodleian in 2013

John Johnson: Postal History adds. Modern First Day Covers, 1

In her speech to the students of Stockholm Hodgkin revealed why she, out of that year's Nobel laureates, had been asked to address them: 'I was chosen to reply to you as the one woman of our group; the situation in which I find myself will, I very much hope, not be so uncommon in the future that it will require any comment or special treatment – as more use is made of the many gifts which women share equally with men.' When drafting the speech Hodgkin had replaced 'uncommon' with 'remarkable', then changed her mind. She never claimed that being a woman had impeded her progress as a scientist, but it is nevertheless an aspect of her distinctive achievements. When she was an undergraduate men outnumbered women twelve to one in the chemistry honours course; her own laboratory, by contrast, had an equal number of men and women. She was the first woman to win the Royal Society Copley Medal (in 1976), and only the third woman (after Marie Curie and her daughter Irène Joliot-Curie) to win the Nobel Prize in Chemistry. Two years after her death she took her place as one of five 'women of achievement' in a group of stamps issued in 1996 under the title 'Portraits of Genius'.

```
The Rt Hon Lord Mason of Barnsley PC
The House of Lords
LONDON
SW1A OPW
```

Gathering in Books

In 1600 Thomas Bodley announced his intention to 'busy my selfe and my friends about gathering in Books'. At that time Oxford University owned no books. The colleges had their libraries, but the University itself had nothing but an empty reading room (cat. 86). A comprehensive collection of books and manuscripts therefore had to be assembled from scratch, and this *tabula rasa* was filled according to contemporary – and more accurately Sir Thomas Bodley's – ideas about what was suitable for a university library.

With funds donated by a number of wealthy benefactors, Thomas Bodley (cats 88 and 92) embarked on an energetic and comprehensive programme of book buying. His outlook was international and he took advice from leading London booksellers. His purchasing was guided by his preferences, and he disdained what he termed 'idle books and riff raffs'. Occasionally, however, something which is valued today, but which would not necessarily have been appreciated by Bodley, slipped through (cat. 89).

As the Bodleian's reputation grew, authors and publishers began to see it as a prestigious home for their books. Francis Bacon presented the newly formed Library with copies of his works, thereby including it in his scheme to advance learning (cats 90 and 91). In 1610 the Stationers of London echoed Bacon's public-spirited ambitions when it agreed to supply the Library with free books 'out of their zeale to the advancement of good learning' (cat. 92). Johannes Hevelius sent the Library many of his books on publication (cat. 93). Portraits of the great were given to adorn the Bodleian's walls, conferring fame and honour on those portrayed (cats 94–7).

Purchases and gifts have since continued, and gaps filled (cats 98–101), according to the constantly changing ideas of what genius is and how it should be represented in a library's collections.

86

DAVID LOGGAN (bap. 1634, d. 1692)

Engravings from *Oxonia illustrata* (*Oxford Illustrated*)

First published Oxford: the University Press, 1675

(a) 'Bibliotheca Publica Bodleiana'
(b) 'Bibliothecæ Bodleianæ Oxoniæ'

Plate size of (a) 294 × 404 mm; trimmed sheet size of (b) 320 × 450 mm

Provenance: From the collection formed by John Johnson (1882–1956); housed at Oxford University Press until transferred to the Bodleian in 1968

John Johnson: Oxford folder IV, 1, and 7a

David Loggan's *Oxonia illustrata*, from which these two loose engravings are taken, was the first comprehensive visual record of the University. The city's fine architecture is shown off to the full in the magnificent views of the colleges, gardens and university buildings, and when distinguished visitors came to Oxford they were presented with a copy of *Oxonia illustrata* together with its companion volume, Anthony Wood's *Historia et Antiquitates Universitatis Oxoniensis* (1674).

Loggan's bird's-eye view of the Bodleian Library and the University Schools is characteristically detailed and accurate. Looking north, it shows how closely integrated the Library was with the central teaching area of the University. Forming the cross-stroke of the distinctive 'H' to the west is the oldest of the buildings, completed in 1488. On the ground floor is the Divinity School, and above it the medieval University Library of Duke Humfrey, which by the end of the sixteenth century had been denuded of furniture and books, prompting

Thomas Bodley's decision to refound the Library. To its right is the later extension of Arts End (1610–12) and to its left a second extension, Selden End (1634–40).

To the east of the Library is a large quadrangle (1613–19). The first two floors contained the University Schools, where lectures and examinations took place. The upper storey was part of the Library. It was built with funds left by Thomas Bodley, who envisaged it as a space for future book storage, but by the time this engraving was made it was serving as a public picture gallery (see cats 94–7). The main entrance to the quadrangle was in the eastern wall. The archway is concealed in this view, but rising above it may be seen the Tower of the Five Orders, so called because its façade reproduces the five orders of classical architecture: Tuscan, Ionic, Doric, Corinthian and Composite.

As well as providing a topographical record of the University, Loggan's views convey a pleasing, and no doubt idealized, impression of life within its precincts. Gowned academics and fashionable visitors parade the streets, quadrangles and gardens. They are also to be seen in an engraving of the Bodleian's interior, which shows Duke Humfrey's Library from both Arts End and Selden End. When Bodley established the new Library he was determined to turn what had a become 'a great desolate roome' into a noble space that would give readers all they required and would also 'stirre vp other

mens benevolence, to helpe to furnishe it with bookes'.[1] The timber, supplied by Merton College, was carefully seasoned for twelve months; then Bodley brought in the carpenters, joiners, carvers and glaziers and directed the furnishing. Once the shelves and cupboards were ready the books started to arrive, but Bodley would not open the Library until the shelves were sufficiently full to make a good impression on potential benefactors.

The books were divided by subject into theology, law, medicine and the arts. The larger volumes were chained to the shelves and were available to readers to take down for consultation. The smaller books were kept locked in the 'closets' and to see them a request had to be made to the Librarian. A few items of special rarity were kept in the archives, or 'grates'. In Arts End, which was also built and furnished under Bodley's close supervision, bookcases were placed against the walls from floor to ceiling, with a gallery at mid-height. This was the first time such a system had been used on a large scale in England, and it allowed the Library to accommodate the numerous books that came from the Stationers' Company (see cat. 92). It was also employed in Selden End, which Bodley had imagined before his death as 'some bewtifull enlargment at the west end'.[2]

Notes
1 Wheeler 1926, pp. xi–xii.
2 Ibid., p. xl.

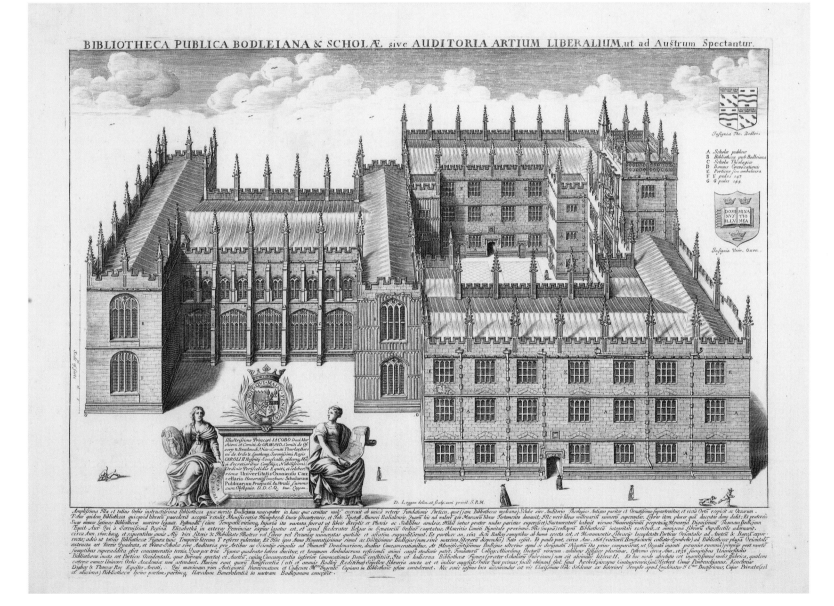

BIBLIOTHECA PUBLICA BODLEIANA & SCHOLÆ sive AUDITORIA ARTIUM LIBERALIUM, ut ad Austrum Spectantur.

Cat. 86(a)

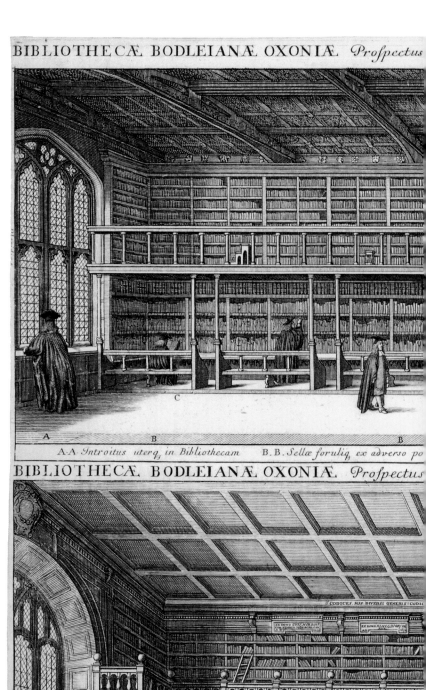

A · A · *Introitus uterq̃ in Bibliothecam* B · B · *Sellæ foruliq̃ ex adverso po*

Viro admodum Reverendo vitæ integritate morum candore, spec
Academiæ ornamento; pro Dᶯᵃ Margareta Comitissa Richmondiæ
ANÆ Typum, Cui (dum IPSE præfuit) AVCTARIVM SELDE

Cat. 86(b)

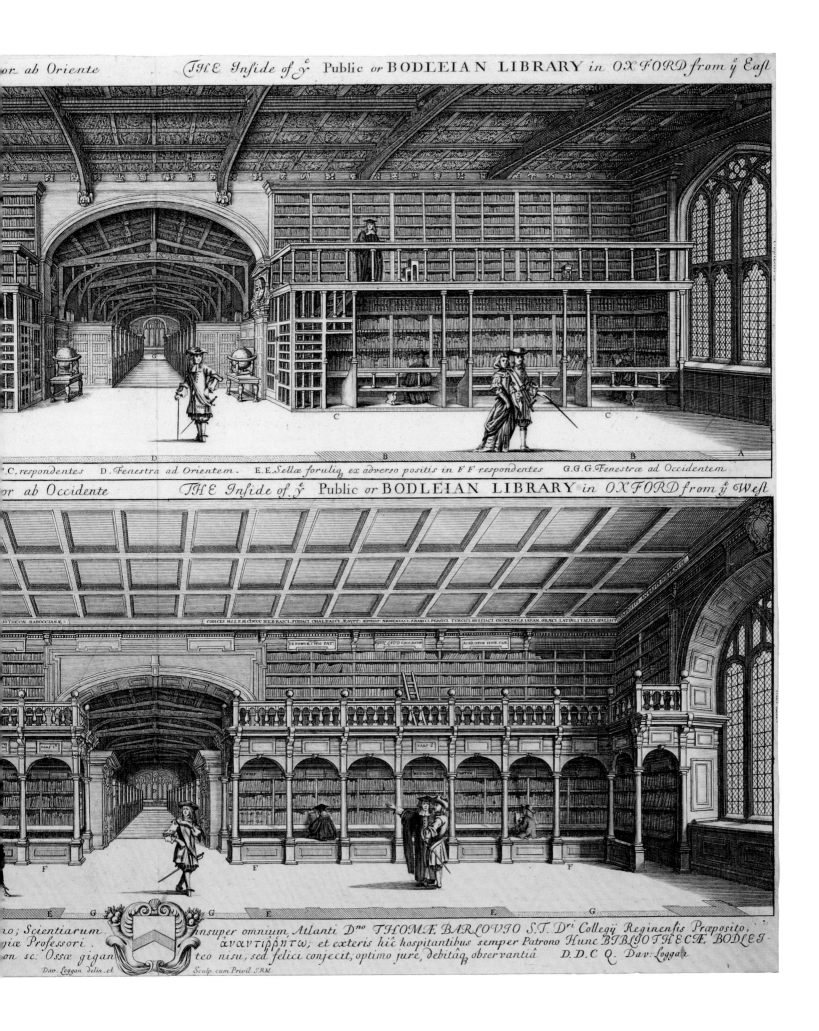

...C. respondentes D. Fenestra ad Orientem. E.E. Sellæ foruliq ex adverso positis in F F respondentes G.G.G. Fenestræ ad Occidentem

or ab Occidente *THE Inside of* y *Public or* BODLEIAN LIBRARY *in* OXFORD *from* y West

...o; Scientiarum Insuper omnium Atlanti Dno THOMÆ BARLOVIO S.T. Dri Collegij Reginensis Præposito,
...giæ Professori . ἀναντιῤῥῆτω; et exteris hîc hospitantibus semper Patrono Hunc BIBLIOTHECÆ BODLEI
...on sc: Ossæ gigan teo nisu, sed felici conjecit, optimo jure, debitâq observantiâ D.D.C.Q. Dav: Loggan

Dav. Loggan delin. et Sculp. cum Privil. SRM.

87

NICHOLAS HILLIARD (1547?–1619)

Sir Thomas Bodley (1545–1613)

1598

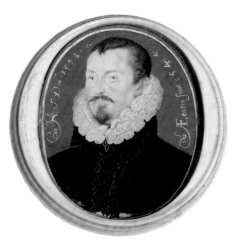

Watercolour and gouache on parchment laid on board, 51 × 38 mm; in a turned ivory case

Provenance: Duke of Buckingham sale, 1849; R.R. Ellacombe, Roehampton; given to Oxford University in 1897 by Canon H.N. Ellacombe

Exhibitions: London 1983, no. 50; Oxford 1998, no. 7; Oxford 2002a, no. 2

Literature: Lane Poole, vol. 1, no. 73; Garlick, p. 35; Rogers 1991, p. 22

LP 73

Nicholas Hilliard's miniature portrait of Thomas Bodley was painted in 1598. Aged fifty-four, he had retired from public service the previous year, and for the remainder of his life he would concentrate on the foundation and furnishing of the Library that bears his name: 'I concluded at the last to set up my Staffe at the Library doore in *Oxford*; being throughly perswaded, that in my solitude and surcease from the Common-wealth affaires, I could not busy my selfe to better purpose, then by reducing that place (which then in every part lay ruined and wast) to the publique use of Students.'[1]

Nicholas Hilliard had known Bodley in childhood. Their fathers were leading citizens of Exeter, and devout Protestants. With the accession of the Roman Catholic Mary I in 1553 Bodley's father, John (*c.* 1520–1591), like many English Protestants, fled to the Continent to escape persecution. He eventually settled in Geneva with his wife and children. The 10-year-old Nicholas Hilliard was part of his

household, and he probably remained with the Bodley family on their return to England in 1559, when they settled in London. Hilliard made his first portraits the following year and before long would become the leading miniaturist in the country. He was made a member of the royal household and painted portraits of both Elizabeth I and James I.

Bodley's career was more international, but no less illustrious, than Hilliard's. After studying at Magdalen College in Oxford he became a fellow of Merton College. In 1576 he left Oxford and spent four years exploring Europe: 'I waxed desirous to travell beyond the Seas, for attaining to the knowledge of some speciall moderne tongues, and for the encrease of my experience in the managing of affaires.'[2] Bodley journeyed through France, Germany and Italy; already proficient in Latin, Greek and Hebrew, he learned French, German and Spanish. On his return to England he became increasingly involved in state foreign affairs, and in 1588, after various diplomatic missions, he became Elizabeth I's ambassador to Holland. He remained there until his retirement in 1597. In 1604 he was knighted by James I.

Notes

1 Bodley 1913, p. 24.
2 Ibid., p. 7.

88

Probably CLAUDE VARIN or WARIN

The Bodley Medal

c. 1646

Obverse: profile of Thomas Bodley (1545–1613), around which is inscribed 'TH · BODLY · EQ · AVR · PVBL · BIBLIOTH · OXON · FVNDATOR' ('Sir Thomas Bodley, founder of the public library at Oxford')
Reverse: a classical female figure holding busts of the sun and moon, around which is inscribed 'AETERNITAS · RP · LITERARIAE' ('the eternity of the republic of letters')
Gilt-bronze; diam. 50 mm

Provenance: Commissioned by the Bodleian in 1646

Exhibition: Tokyo 1990, no. 8

Literature: Rogers 1991, pp. 106–7

Cons. Res. objects no. 61

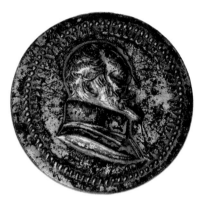

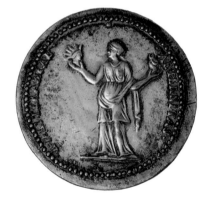

The manufacture of this medal is recorded in the Library accounts for 1646, which note a payment of two shillings to a 'Mr Warren' 'that made his [i.e. Sir Thomas Bodley's] medale'. The reasons for its making, however, are obscure. Oxford had been serving as Charles I's headquarters during the Civil War, but in June 1646 the city surrendered to the Parliamentary army, so perhaps the recent violence and political upheavals prompted the Library to reassert the internationalism and durability of learning, 'the eternity of the republic of letters'. Sir Thomas Fairfax, who led the Parliamentary forces into Oxford, would have concurred, for he immediately placed a guard around the Library.

Today copper replicas of the medal are awarded to individuals who have made outstanding contributions to the fields of literature, culture, science and communication.

89

MIGUEL DE CERVANTES SAAVEDRA (1547–1616)

El Ingenioso Hidalgo Don Quixote de la Mancha (*The Ingenious Hidalgo Don Quixote of la Mancha*)

Madrid: for Juan de la Cuesta, 1605

In Spanish; 332 leaves, 210 × 140 mm
Early seventeenth-century English laced-case binding for the Bodleian: calf parchment

Provenance: Probably acquired by the Bodleian soon after publication, as the result of a visit to Seville by Thomas Bodley's bookseller, John Bill

Exhibition: Oxford 1994, no. 44

Literature: Ungerer 1997; Michael 2001

Arch. B e.53 [pp. viii–1 illustrated]

This very rare original edition of the first part of Cervantes's great satirical novel was acquired by the Bodleian from Spain shortly after its publication. Using the funds donated by a number of early benefactors, Bodley purchased books in great numbers and from all over Western Europe – including the major centres of the book trade, Paris and Frankfurt. He relied on the expertise and energy of two booksellers, John Norton (1556/7–1612) and Norton's former apprentice John Bill (1576–1630). Norton was among the most successful booksellers and publishers of the day. His acquaintance with the international trade in books began in the late 1580s when he imported volumes into Scotland, and he regularly bought and sold works at the twice-yearly Frankfurt Book Fair. In 1597 Norton printed an edition of John Gerard's *Herball*, and in 1601 he presented a de-luxe copy to the Bodleian.[1] He was elected to the Stationers' Company in 1598 and served as its Master in 1607–8 and 1611–12.[2]

While Norton acted as Bodley's principal adviser in the years of his most concentrated book buying, John Bill, who was made a freeman of the Stationers' Company in 1601, did the travelling. Still only in his twenties, he moved tirelessly round Europe on Bodley's behalf, buying as he went. As Bodley remarked to his first Librarian, Thomas James, Bill had all the time, energy and resources that he could want, and he duly acquired thousands of books. In August 1602 he was in Paris, and by December he was in Venice, where he would remain until Easter – 'and vntill then will be alwaies buieng, and inquiring after bookes', Bodley told James with satisfaction. By February the following year Bill had been to Venice, Ferrara, Padua, Verona, Brescia, Mantua, Pavia, Milan, Florence, Pisa and Rome, and – reported Bodley – 'hath bought as many bookes as he knewe I had not, amounting to the summe, of at the lest, 400[li]. besides those that he may haue bought, sins his last vnto me, which was in December'. The shipments from this sustained shopping trip began to arrive in London in March 1603, and Bodley noted with approval that 'Io. Bille hath gotten euery where, what the place would affourd'.[3]

In November 1604 Bodley wrote to James to inform him that Bill had just returned to London from Spain, and that he was expecting the harvest from this trip in the next couple of days. Bill had bought 'a goodly stoare of bookes' from Seville, but unfortunately he had been thwarted in his intention to book-hunt in other Spanish cities and universities. The effects of the long enmity between the two countries were still apparent, and 'the peoples vsage towardes all of our nation is so cruel and malicious, as he was vtterly discouraged for this time'. Bill hoped, however, to make another voyage soon.[4]

The assumption that Bill acquired this copy of *Don Quixote* while he was in Spain has recently been questioned.[5] It has been pointed out that he was back in England in November 1604, and *Don Quixote* was almost certainly not for sale until January 1605. Books could be bought in advance of their going on the press, so perhaps a final instalment of Bill's purchases left Spain in early 1605, and the novel was added to it. Whatever the case, it is unlikely that Bill would have recognized *Don Quixote* as a work of genius, or that Bodley would have countenanced the purchase of a work of vernacular literature, so the book's presence in the Library is the result of good fortune rather than foresight. It took its place on the Library's shelves, but its pristine condition suggests it was little read.

Notes
1 Bodleian L 1.5 Med.
2 Barnard 2002.
3 Wheeler 1926, pp. 65, 76, 90.
4 Ibid., p. 118.
5 Ungerer 1997; Michael 2001.

aunque desnudo de aquel precioso ornamento de elegancia, y erudicion, de que suelen andar vestidas las obras que se componen en las casas de los hombres que saben, o se parecer segura-mente en el juyzio de algunos, que continien-dose en los limites de su ignorancia, suelen co-denar con mas rigor, y menos justicia, los tra-bajos agenos, que poniendo los ojos la prudencia de vuestra Excelencia en mi buen desseo, fio, que no desdeñara la cortedad de tan humilde seruicio.

Miguel de Ceruantes Saauedra.

DESOCY-

PRIMERA PARTE
DEL INGENIOSO
hidalgo don Quixote de la Mancha.

Capitulo Primero. Que trata de la condi-cion, y exercicio del famoso hidalgo don Quixote de la Mancha.

EN Vn lugar de la Mancha, de cuyo nombre no quiero acor-darme, no ha mucho tiempo que viuia vn hidalgo de los de lança en astillero, adarga anti-gua, rozin flaco, y galgo corre-dor. Vna olla de algo mas vaca que carnero, salpicon las mas noches, duelos y quebrátos los Sabados, lantejas los Viernes, algun palomino de aña-didura los Domingos: consumian las tres partes de su hazienda. El resto della concluian, sayo de velarte, calças de velludo para las fiestas, con sus pantuflos de

A lo

FRANCIS BACON, VISCOUNT ST ALBAN (1561–1626)

Novum organum
(New Instrument)

London: John Bill, 1620

In Latin; 410 pages, 334 × 205 mm
Seventeenth-century English binding: purple velvet with gold tooling
Provenance: Presented to the Bodleian by the author in 1620
Exhibition: Oxford 1968, no. 170

Arch. A c.5

FRANCIS BACON, VISCOUNT ST ALBAN (1561–1626)

De dignitate et augmentis scientiarum
(The Dignity and Advancement of Science)

London: John Haviland, 1623

Edited by William Rawley (*c.* 1588–1667)
In Latin; 514 pages, 330 × 225 mm
Seventeenth-century English binding: silver thread on light blue velvet
Provenance: Presented to the Bodleian by the author in 1623
Exhibition: Oxford 1968, no. 172
Literature: Rogers 1991, pp. 76–7

Arch. A c.6

In 1605, two years after James VI of Scotland's accession to the English throne as James I, Francis Bacon published *The Advancement of Learning*, in which he presented to the king his proposals for a reformation of knowledge and the establishment of new methods of scientific progress. The implementation of these proposals depended upon institutions, and, in a speech written for the Gray's Inn Revels in 1594, Bacon identified four: the garden, the museum, the laboratory and the library. Of the last he wrote: 'the collecting of a most perfect and general library, wherein whatsoever the wit of man hath heretofore committed to books of worth, be they ancient or modern, printed or manuscript, European or of other parts, of one or other language, may be made contributory to your wisdom'.[1]

Bacon sent a copy of *The Advancement of Learning* to Thomas Bodley with an accompanying letter:

My labours (if I may so term that which was the comfort of my other labours) I have dedicated to the King; desirous, if there be any good in them, it may be as

fat of a sacrifice, incensed to his honour: and the second copy I have sent unto you, not only in good affection, but as a kind of congruity, in regard of your great and rare desert of learning. For books are the shrines where the Saint is, or is believed to be: and you having built an Ark to save learning from deluge, deserve propriety in any new instrument or engine, whereby learning should be improved or advanced.[2]

Bacon was congratulating Bodley on his achievements but also presenting him with a challenge. The preservation of knowledge was one thing, but it was also the responsibility of his library to play a role in the new learning.[3]

In *The Advancement of Learning* Bacon urged the king to initiate a reform of scholarly institutions which would lead to 'the further endowment of the world with sound and fruitful knowledge'. Intellectual progress was, he wrote, currently impeded by a reliance on tradition: 'why should a few received authors stand up like Hercules' columns, beyond which there should be no sailing or discovering, since we have so bright and benign a star as your

Majesty to conduct and prosper us?' This image found visual expression in the title page of Bacon's *Novum organum* (1620), a copy of which he also presented to the Bodleian (cat. 90).

Three years later Bacon sent the Library a greatly enlarged edition of *The Advancement of Learning* (cat. 91), written this time in Latin, thereby making the book 'a citizen of the world, as English books are not'. In a Latin inscription (illustrated overleaf) he urges Oxford University, as he also urged Cambridge, to continue to preserve the works of the past, but also to advance learning by a direct engagement with nature and experience. The volume was richly bound in velvet – as was the *Novum organum*, which had an old-fashioned version of the University's arms on its upper cover, and on its lower cover the author's own crest of a wild boar (illustrated on p. 260).

Notes
1 Vickers 2002, pp. 54, 581.
2 Spedding 1861–74, vol. 3, p. 253.
3 See Summit 2008, pp. 197ff.

FRANCISCI
DE VERULAMIO,
Summi Angliæ
CANCELARIJ,
Instauratio
magna.

Multi pertransibunt & augebitur scientia.

Anno

LONDINI
Apud Joannem Billium
Typographum
Regium.

1620.

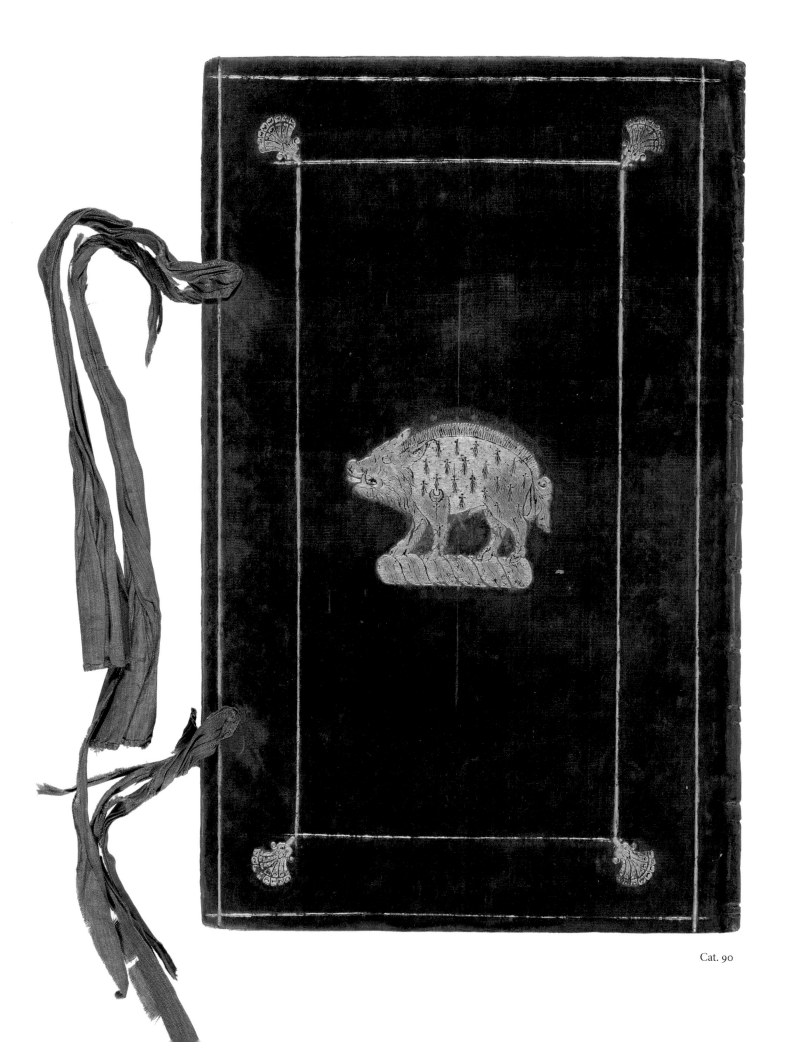

Cat. 90

Franciscus Baro de Verulamio, Vicecomes S^{ti} Albani.
Inclytæ Academiæ Oxoniensj. S.

Cum Almæ matri meæ, Incl. Academiæ Cantabrigiensj scripserim,
deessem sane officio, si simile amoris pignus Sororj ejus non deferrem.
Sicut autem eos hortatus sum, ità & vos hortor; ut Scientiarum
Augmentis strenue incumbatis, & veterum labores, neque nihil, neque
omnia esse putetis; sed vires etiam proprias molestè perpendentes, subinde
tamen experiamini. Omnia cedent quam optimè, si Arma non alij
in alios vertatis, sed junctis Copijs in Naturam rerum impressionem
faciatis. Sufficiet· quippe illa honori & victoriæ. Valete.

Agreement between the Bodleian and the Stationers' Company

28 January 1612

Reaffirmation of an original agreement of 1610
On parchment, 540 × 440 mm

Provenance: Kept in Oxford University Archives

Exhibition: Oxford 2002a, no. 48

University Archives, SEP 9/6

Today six libraries in the United Kingdom are entitled by law to a copy of all printed works when they are published: the British Library, the Bodleian Library, Cambridge University Library, the National Library of Scotland, the National Library of Wales and the Library of Trinity College, Dublin. When the Bodleian was founded, the book trade was tightly controlled by the Stationers' Company of London and no law of this kind existed. Yet only a few years later, on 12 December 1610, an agreement was reached with the Stationers whereby, 'out of their zeale to the advancement of good learning, and at the special request of the right worshipful Thomas Bodley', the Library was entitled to receive one unbound copy of every new book published by their members. The first book was duly received the following year: Thomas Cartwright's *Christian Religion: substantially, methodicallie, plainlie, and profitablie treatised.*[1]

This unprecedented agreement was possibly Thomas James's idea. 'For the stationers gifte, I am of your opinion, that it is to be accounted, a gifte of good moment', Bodley wrote to his Librarian in February 1611, '& I thinke I had hardly thought vpon it, if yow had

not moued the mater at first'. But, he added, 'for the effecting whereof, I haue found notwithstanding many rubbes & delaies'.[2] Since 1602 all books destined for the Bodleian had first been delivered to Bodley's house in Fulham, where he looked through them and discussed any gaps or duplications with his bookseller, John Norton, before sending them on to Oxford by barge. He was therefore well placed to recognize that books were not coming from the Stationers' Company as steadily as they should have been. Evidently, members of the company were not keen on giving their publications away for nothing.

At the beginning of 1612 the agreement of 1610 was reaffirmed, probably at the instigation of Norton, who was then Master of the Stationers' Company.[3] To give the document further weight nineteen members of the Court of High Commission added their signatures to it, including the Archbishop of Canterbury ('G. Cant'). Furthermore, any stationer who did not comply with the agreement would from then on be fined.

Despite this reaffirmation, new books continued to arrive in a very fitful fashion. The annual intake of books recorded in the Library in 1613–14 represents only about 20 per cent of the printed material registered in that period. This drops to a mere 8 per cent in 1622.[4] A series of subsequent agreements, culminating in the Copyright Act of 1710, attempted to ensure that newly published books

would be received by qualifying libraries, but it would be some time before the legal deposit of books became an ordered and well-observed system.

Bodley had another complaint. A good number of the books he received in London were, in his opinion, unsuitable for a noble library. 'I wish yow had foreborne, to catalogue our London bookes, till I had bin privie to your purpose', he wrote to Thomas James in January 1612:

There are many idle bookes, & riffe raffes among them, which shall neuer com into the Librarie, & I feare me that litle, which yow haue done alreadie, will raise a scandal vpon it, when it shall be giuen out, by suche as would disgrace it, that I haue made vp a number, with Almanackes, plaies, & proclomacions: of which I will haue none, but suche as are singular.[5]

The strength of today's Legal Deposit Library Act is its comprehensiveness, the assurance it brings that, at least in theory, nothing will be missed. Thomas Bodley would not have agreed – a university library was no place for riff-raff.

Notes

1 Bodleian 4° R 34 Th.
2 Wheeler 1926, p. 206.
3 Barnard 2002.
4 Philip 1983, pp. 28–9.
5 Wheeler 1926, p. 219.

Vicesimo octavo Januarij 1611 Nono Regni Regis Jacobi

At Stationers Hall in Ave Mary Lane in London

Forasmuch as this Companye out of their zeale to the advancement of learninge, and at the request of the Right Hoble Sr Thomas Bodley knight ffounder of the newe publique Library of the Vniversitye of Oxford, beinge readye to manifeste their willinge desires to a work of so great pietye and benefitt to the generall state of the Realme, Did by their Indenture vnder their comon Seale dated the Twelveth daye of December in the Eight yeare of his Maties raigne of England ffraunce and Ireland and the fourt and fortith yere of his raigne of Scotland for them and their successors, graunte and confirme vnto the Chauncellor Maisters, and Schollers of the Vniversitie of Oxford and to their successors forever That of all bookes after that from tyme to tyme to be printed, in the said Company of Stationers, beinge newe bookes and Coppies never printed before or beinge formerly printed yet newly augmented or enlarged there should be freelie given one perfect Booke of every such booke in quyers of the first ympression thereof, towardes the furnishinge and increase of the said Library Nowe therefore to the intent the said graunte maie take due effect in the orderlie performance and execution thereof, And that so good and godlie a work and purpose maie not bee disappointed or defeated by any meanes It is ordayned by this Company That all and every Printer and Printers, that from tyme to tyme hereafter shall either for him or themselves or for any other, printe or cause to be printed any newe booke or Coppie never printed before or although formerly printed yet newly augmented or enlarged shall within Ten daies next after the finishinge of the first ympression thereof and the puttinge of the same to Sale, bringe and deliver to the yonger Warden of the said Company of Stationers for the tyme beinge one perfect booke thereof to be delivered over by the same Warden to the vnited vse to the handes of such person or persons as shalbe appointed by the said Chauncellor Maisters and Schollers for the tyme beinge to receive the same And It is alsoe ordayned That every Printer, that at any tyme or tymes hereafter shall make defaulte in performance hereof, shall for every such defaulte forfeite and paie to the vse of this Company Treble the value of every Booke that he shall leave vndelivered contrarie to this Ordenance Out of the which forfeiture, vpon the levyinge and paymt thereof There shalbe provided for the vse of the said Library, that Booke, for the not delivery whereof, the said forfeiture shalbe had and paid And to the intent all Printers and others, this Companye whome it shall concerne, maie take notice of this Ordenance, And that any of them shall not pretend Ignorance thereof It is ordeyned that once in every yere at some generall assemblie and meetinge of the said Company vpon some of their vsuall quarter daies or some other tyme in the yere at their discretion, this vnited Ordenance shalbe publiquely read in their Hall, as other of their Ordenance are accustomed to be read there.

John Norton Mr

Richard Field

Humfrey Lownes wardens

Robt Barker
Thomas Mann
Thomas Dawson

Edward Joyght
Humfrey Hooper
Symon Waterson
William Leake

John Standishe
Thomas Adames
John Harryson

Ri: Collins Clerk of the Company

Havinge latelye byn entreated, aswell by the said Sr Thomas Bodley knight, as by the Maister Wardens and Assistants of the foresaid Company of Stationers, to take some speciall notice of this their publique Acte and Graunte and in regard of our beinge of his Maiestyes highe Commission in ecclesiasticall causes to testifie vnder our handes what allowance and good likinge we have thought it meete to be receaved Wee doe not onlie as of merit comend it to posteritie for a singuler token of the fervent zeale of that Company, to the furtherance of good learninge and for an exemplarie guift and graunt to the Schollers and Students of the Vniversitye of Oxford But withall wee do promise by subscribinge vnto it That if at any tyme hereafter occasion shall require that we should help to maynteyne the due and perpetuall execution of the same Wee will as readilie represent our selves thoroughe our present authoritie or by any whatsoever our further endeavor it maie be fullye promised.

G. Cant:

Jo: London Blondell: Jo: Roffens
G: Bene: Jhon boys George Montaigne
Tho: Ridley Char: Fotherbye Ro[bt]
Tho: Edwardes Henr: Hickman
Jo: Newmane Martin Fotherby John Six
John Spenser John Layfield Willm Ferrand
Richard Moket

93

JOHANNES HEVELIUS (1611–1687)

Selenographia (*Atlas of the Moon*)

Danzig: Andreas Hünefeld, 1647

Engraved title page by J. Falck Polonus after Adolf Boy; copper engravings by the author
In Latin; 594 pages and eighty-nine leaves of plates (including one volvelle), 347 × 215 mm
Contemporary Danzig binding: brilliant red goatskin with gold tooling

Provenance: Given to the Bodleian on 18 November 1649 by the author

Exhibition: Oxford 1968, no. 190

Literature: Rogers 1991, pp. 110–13

Arch. H c.12 [plate following p. 222 illustrated]

From his private observatory in Danzig (now Gdansk) Johannes Hevelius made methical and precise observations of the moon, and in *Selenographia* – his first book – he published detailed maps, engraved by himself, of the moon's surface. Using variously spaced parallel lines he skilfully depicted the silvery textures of the lunar terrain. He also assigned familiar place names to the moon in a manner that Sir Thomas Browne, in *Pseudodoxia epidemica* (book VI, chapter 14) found fitting:

And therefore the learned Hevelius in his accurate Selenography, or description of the Moon, hath well translated the known appellations of Regions, Seas and Mountains, unto the parts of that Luminary: and rather then use invented names or humane denominations, with witty congruity hath placed Mount Sinai, Taurus, Mæotis Palus, the Mediterranean Sea, Mauritania, Sicily, and Asia Minor in the Moon.

This finely bound copy of *Selenographia* was presented to the Bodleian by the author in 1649. Hevelius was a wealthy man, and could afford to give his books away. Over the next forty years he presented the Bodleian with copies of most of his subsequent works, including a group of nine in 1688, for which he was thanked by the University's Vice-Chancellor, John Fell. In one regard Hevelius was an old-fashioned figure: he stubbornly refused to use a telescope for his observations, preferring the open-sighted instruments with which he was familiar. Edmond Halley famously went to Gdansk to persuade him otherwise, and had no success. But by presenting his books to libraries and his fellow astronomers (including Halley) Hevelius engaged in the international conversation of science. In a lengthy inscription in this copy of *Selenographia* he mentions that he has visited to the illustrious Bodleian Library, and expresses his hope that it will, replete as it is with treasures, accept such a humble gift.

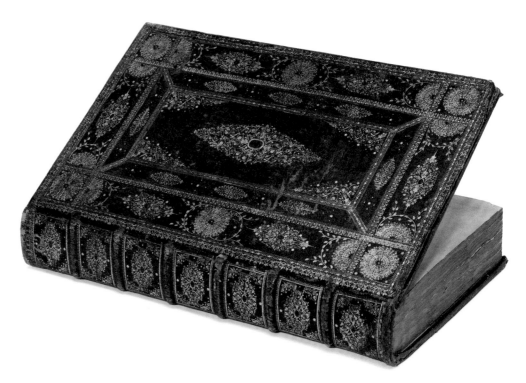

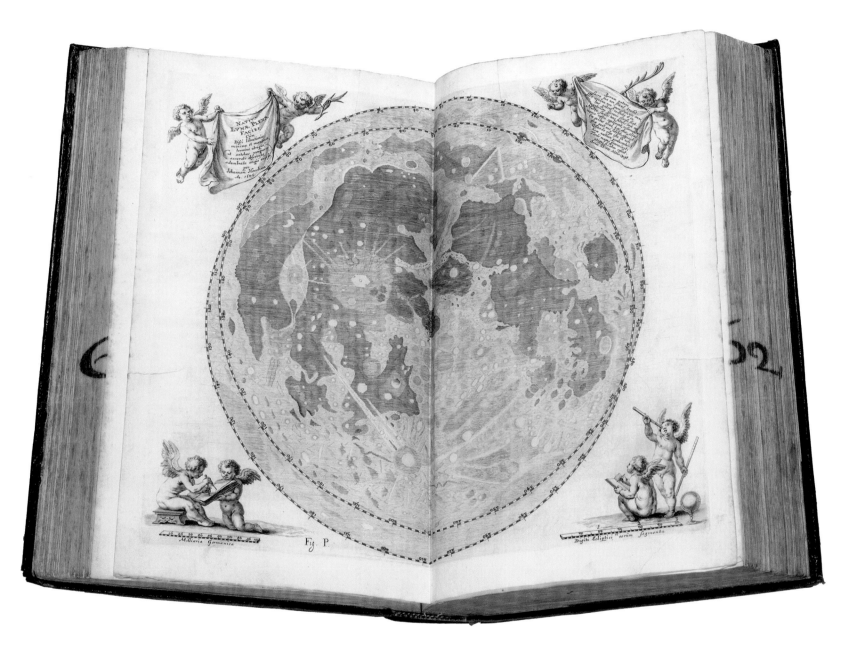

NATVS LVNÆ PLENÆ FACIES

Fig. P

Milliaria Germanica

Digiti Eclipsei eorum Segmenta

94

After JUSTUS SUSTERMANS (1597–1681)

Galileo Galilei (1564–1642)

Copy of original portrait of 1636

Oil on canvas; 740 × 610 mm

Provenance: Sent from Italy to the University of Oxford in April 1661 by Vincenzo Viviani (1622–1703)

Literature: Lane Poole, vol. 1, no. 99; Garlick, p. 145

LP 99

95

THOMAS MURRAY (1663–1735)

Edmond Halley (1656–1742)

Oil on canvas; 1270 × 1016 mm

Provenance: Given to the University of Oxford by the artist in 1713

Literature: Lane Poole, vol. 1, no. 241; Garlick, p. 163

LP 241

96

CHARLES JERVAS (1675–1739)

Alexander Pope (1688–1744)

c. 1714

Oil on canvas; 735 × 610 mm

Provenance: Probably acquired from the estate of Matthew Prior (1644–1721) by Edward Harley, 2nd Earl of Oxford and Mortimer (1689–1741), who gave it to the Bodleian in 1722

Literature: Lane Poole, vol. 1, no. 243; Garlick, p. 252; Wimsatt 1963

LP 243

97

THOMAS GIBSON (*c.* 1680–1751) after SIR GODFREY KNELLER (1646–1723)

John Locke (1632–1704)

Oil on canvas; 1245 × 1003 mm

Provenance: Given to the University of Oxford in 1733 by the artist

Literature: Lane Poole, vol. 1, no. 186; Garlick, p. 205

LP 186

Images of illustrious men and women have traditionally adorned places of learning. Pliny the Elder described how manuscripts were accompanied by bronze likenesses in Roman libraries. The frescoes with which Raphael adorned the Stanza della Segnatura in the Vatican, at the request of Pope Julius II who used it as his library, portray both the great classical philosophers (Plato, Socrates, Aristotle and others) and the Church Fathers. The walls of Renaissance libraries all over Italy were similarly decorated.

It was in this spirit that, during the seventeenth and eighteenth centuries particularly, the Bodleian was presented with a considerable number of portraits and busts. The first such presentation was, appropriately, a bust of Sir Thomas Bodley – the gift of the Chancellor of Oxford University, the Earl of Dorset, in 1605.

In 1618–19 the floor above the University Schools (see cat. 86) was decorated with a frieze depicting 201 men and one woman, Sappho.[1] This gallery of worthies included the greatest names of classical Greece and Rome, through the Doctors of the Church, to the writers and scientists of the Renaissance. It is uncertain whose idea this was, but the antiquary Thomas Hearne credited the existence of the frieze to the Library's presiding genius, Bodley himself: 'Quod eas in galeria depingendas jusserit ipse Thomas Bodleius Loci Genius' ('Because it was Thomas Bodley himself, the moving spirit of the place, who gave orders that [the heads] should be painted in the gallery').[2]

Hearne was writing in 1716, by which time the upper storey had been a public picture gallery for more than fifty years. Here many of the portraits acquired by the Bodleian since its foundation were hung. Further portraits would be added to the walls in the coming years to create a very miscellaneous group of poets, scholars, scientists, religious figures and statesmen. Many of the sitters had no connection to the University; their fame carried them there. A portrait usually arrived as a gift because its presence in the Library conferred honour on the sitter, and

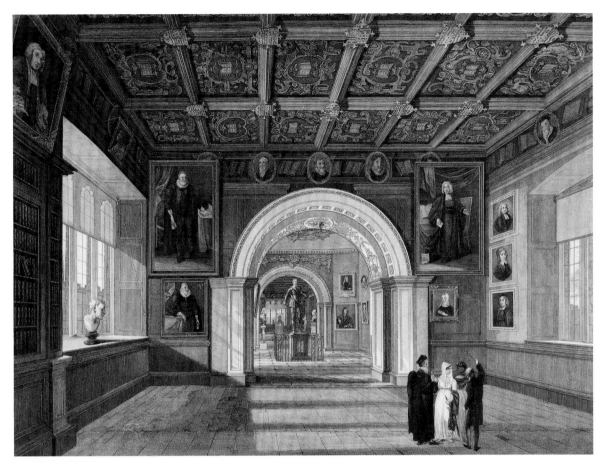

Fig. 25. I. Whessell, *View of the Interior of the Bodleian Picture Gallery, Oxford*, 1829. John Johnson Oxford Folders IV, 15

was a credit to the artist. In 1739, for instance, Jonathan Swift received a letter informing him that his portrait, painted by Charles Jervas, was to be presented to the Bodleian by his printer, John Barber:

Your friend Mr. Alderman Barber, whose veneration for you prompts him to do anything he can think of that can show his respect and affection, made a present to the University of Oxford of the original picture done for you by Jervas, to do honour to the University by your being placed in the Gallery among the most renowned and distinguished personages this island has produced, but first he had a copy taken, and then had the original set in a rich frame and sent it to Oxford

after concerting with Lord Bolinbroke, the Vice-Chancellor, and Mr Pope.[3]

The four portraits here were all gifts. The painting of the elderly Galileo was sent from Italy in April 1661 by Vincenzo Viviani (d. 1703), the great scientist's final pupil and amanuensis. The fine portrait of Alexander Pope by Charles Jervas was given by Edward Harley, later the 2nd Earl of Oxford and Mortimer, and the portraits of two distinguished Oxford men, Edmond Halley and John Locke, were presented by the artists.

For years the painted frieze suffered water damage owing to the poor design of the roof, and in 1831 it was plastered over. It was accidentally rediscovered in

1949 and restored. The upper storey of the Library is now a reading room, but portraits still line its walls.

Notes

1 Bullard 1994.
2 Ibid., p. 499, n. 28.
3 Lane Poole, p. 99.

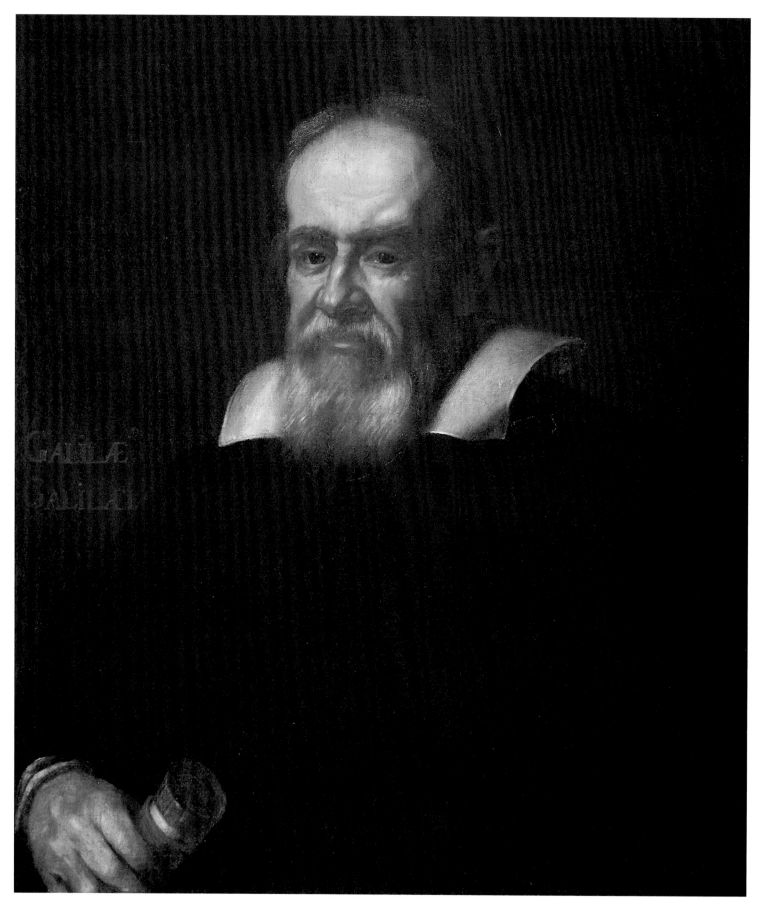

Cat. 94

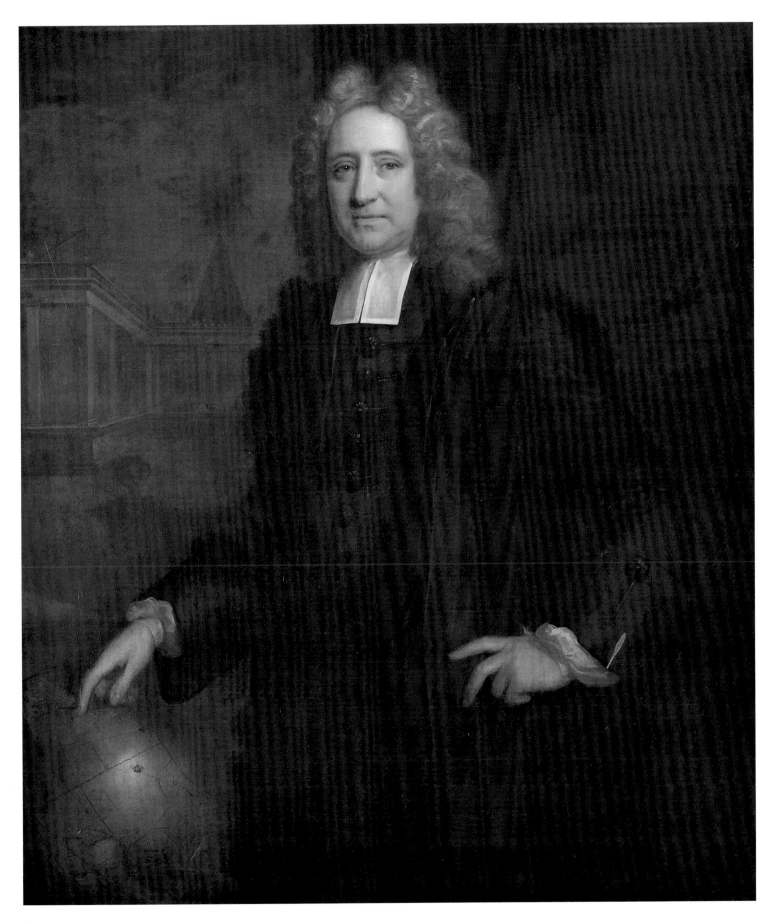

Cat. 95

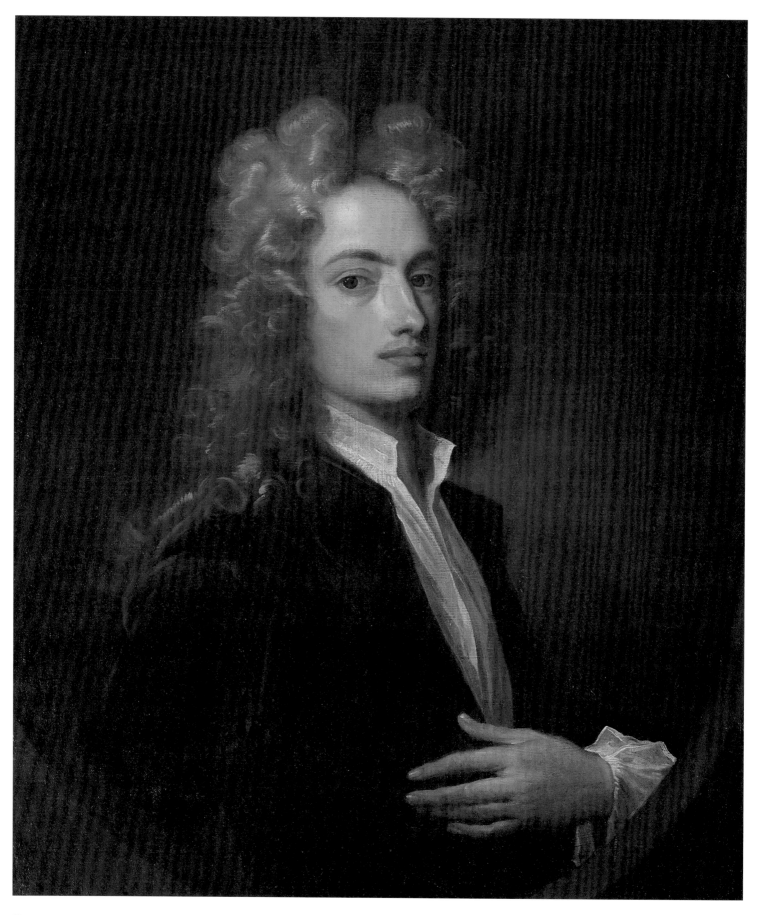

Cat. 96

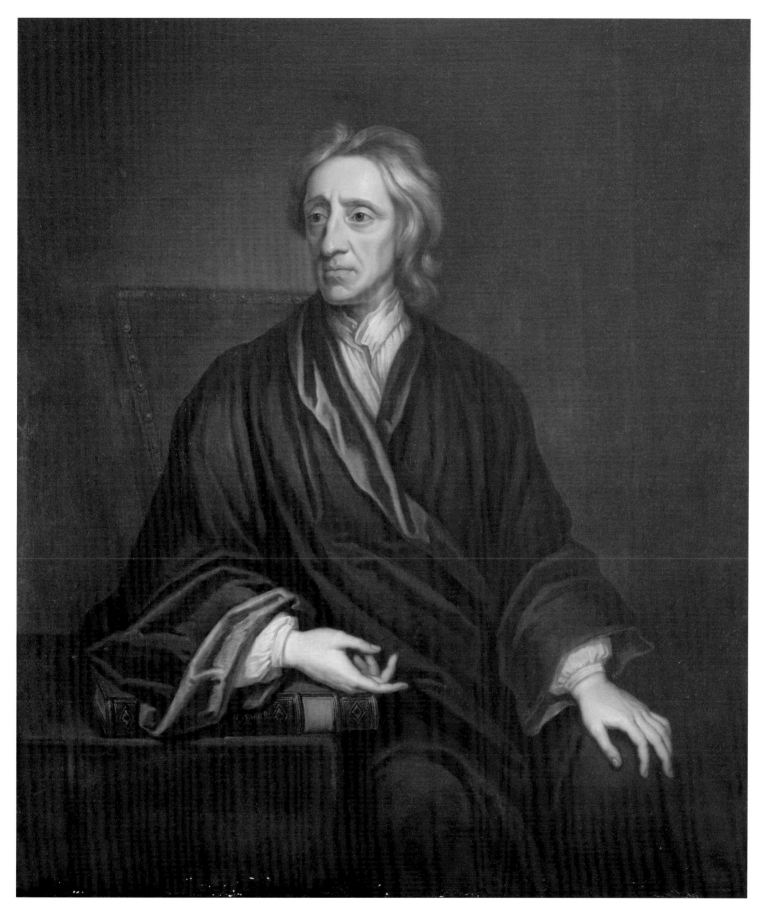

Cat. 97

TELEPHONE 0197.

The Fowey Hotel

FOWEY, CORNWALL, 7th June 1907.

My dearest Mouse

I hope you are having better weather than we are getting here. It is so wet & windy here that we cannot go out rowing in boats, or fly kites, or sail, or anything.

You may be wishing to hear what further things happened to Toad on his way home, after his escape from the policemen who were pursuing him to take him back to prison. Well, next morning the sun shone brightly into the hollow tree, & woke up Mr Toad, who was sleeping soundly after his fatiguing exertions of the previous day. He got up, shook himself, combed the dead leaves out of his hair with his fingers, & set off walking briskly, for he was

very cold & rather hungry. Well, he walked & he walked, till he came to a canal, & he thought that must lead to a town, so he walked along the tow-path, & presently he met a horse, with a long rope attached to it, towing a barge; & he waited for the barge to come up, & there was a man steering it, & he nodded, & said "Goodmorning, washerwoman! what are you doing here?" Then the toad made a pitifull face, & said "Please, kind Sir, I am going to pay a visit to my married daughter, who lives near a fine house called 'Toad Hall'; but I've lost my way, & spent all my money, & I'm very tired". Then the man said "Toad Hall? Why, I'm going that way myself. Jump in, & I'll give you a lift". So he steered the barge close to the bank, & the toad stepped on board & sat down, very pleased with himself. Presently the man said "I don't see why I should give you a lift for nothing, so you take that tub of water standing over there, & that bit of yellow soap, & here are some shirts, & you can be washing them as we go along". Then the toad was rather frightened, for he had never washed a shirt in his life; but he dabbed the shirt into the water, & he dabbed some soap on it, but it never seemed to get any cleaner, & his fingers got very cold & he began to get very cross. Presently the man came to see how he was getting on, & burst out laughing at him, & said "Call yourself a washerwoman? That's not the way to wash

a shirt, you very silly old woman!" Then the toad lost his temper, & quite forgot himself, & said "Don't you dare to speak to your betters like that! And don't call me a silly old woman! I'm no more an old woman than you are yourself, you common, low, vulgar bargee!" Then the bargee looked closely at him, & cried out "Why, no, I can see you're not really a washerwoman at all! You're nothing but an old toad!" Then he grabbed the toad by one hind-leg & one fore-leg, & swung him round & sent him flying through the air Like that — Splosh!! He found himself head-over-ears in the water!

When the toad came to the surface he wiped the water out of his eyes & struck out for the shore; but the woman's dress he was wearing got round his legs, & made it very hard work. When at last he was safely on the tow-path again, he saw the barge disappearing in the distance, & the man looking back & laughing at him. This made Mr Toad mad with rage. He tucked the wet skirt up well under his arms, & ran as hard as he could along the path,

& passed the barge, & ran on till he overtook the horse that was towing it, and unfastened the tow-rope, & jumped on the horse's back, & dug his heels into its sides, & off they went at a gallop! He took one look back as they went, & he saw that the barge had run into the opposite bank of the canal, & stuck, & the bargee was shaking his fist at him & calling out "Stop, stop, stop!!" But the toad never stopped, but only laughed & galloped on & on & on, across country, over fields & hedges, until he had left the canal, & the barge, & the bargee, miles & miles behind him.

I am afraid the Gipsy will have to wait till the next letter.

Your affectionate

Daddy

I am so glad to hear you have been out in a motor-boat

98

KENNETH GRAHAME (1859–1932)

Letters to his son, Alastair ('Mouse') Grahame (1900–1920)

Falmouth, 10 May 1907 – Kensington, September 1907

Autograph
Fifteen letters pasted on to forty-four leaves, approx. 200 × 130 mm
Bound for the Bodleian by O.V. Calder, Oxford, in 1943: blue goatskin with gold tooling

Provenance: Given to the Bodleian in 1943 by the poet's widow, Elspeth Grahame (1862–1946)

Literature: NSC 45278

MS. Eng. misc. 281 [fols. 9r–10v illustrated]

99

KENNETH GRAHAME (1859–1932)

The Wind in the Willows

1907

Autograph
369 leaves in two volumes; 162 × 203 mm
Bound for the Bodleian by O.V. Calder, Oxford, in 1943: blue goatskin with blind and gold tooling and leather onlays of various colours

Provenance: As cat. 98

Literature: NSC 45279–80

MS. Eng. misc. e. 247–248 [MS. Eng. misc. e. 247, fol. 9r illustrated]

In 1932 Kenneth Grahame bequeathed – subject to his wife's life interest – his residuary estate, including all the royalties from his works, to 'the Chancellor, Masters and Scholars of the University of Oxford to be applied by them for the benefit of the Bodleian Library in such manner as they may think desirable'. It was an expression of his great love of the city. To his lasting disappointment, he never studied at the University – his uncle had refused to pay for his entry – but he was a pupil, and eventually head boy, at St Edward's School in North Oxford, and the beautiful evocation of river life in *The Wind in the Willows* drew upon his memories of his childhood years close to the Thames. As an adult he lived for a time just outside Oxford in Blewbury, a village near Didcot. His troubled son, Alastair, nicknamed 'Mouse', was an undergraduate at Christ Church from 1918 until 1920, when he was killed by a train near Port Meadow in a probable suicide. Father and son are buried at Holywell Cemetery in Oxford. 'He loved Oxford and he loved books, so I should like to see that his

memory was enshrined in the Library he so greatly valued, and the city he so deeply cared for', wrote his wife Elspeth Grahame to Bodley's librarian on 10 May 1933, when giving her consent to Graham's name being added to the Library's tablet of benefactors. It was decided that the bequest be used to set up a publications fund, and a reserve fund for the purchase of rare books and manuscripts.

Mrs Grahame was greatly attached to the manuscript of *The Wind in the Willows*, and, until the Library waived any rights it may have had, feared that it would go to the Bodleian as part of the bequest. In April 1943, however, she wrote to Bodley's Librarian offering him the manuscript, 'now'. It was immediately followed by another letter offering 'the collection of letters written by Kenneth to his little son which constitute the fons et origo of "The Wind in the Willows" chapter by chapter'. On their arrival at the Library the letters and the manuscript of *The Wind in the Willows* were given fine bindings of blue morocco. The latter binding (illustrated overleaf) included

a large cockle shell, the crest of the Montrose branch of the Grahame family. Mrs Grahame provided the Library with samples of the precise shade of blue she was looking for, and expressed her concern that the shell be accurately rendered. She also took a close interest in how her gift would be publicized, and how the manuscripts would be displayed.[1]

Kenneth Grahame began the letters to his son in May 1907, when he and his wife were taking a long holiday in Cornwall. Alastair had agreed to stay behind with his nanny, Miss Stott, on condition that his father sent him regular bedtime stories by post. Over five months Grahame penned fifteen letters recounting the adventures of Rat, Mole, Badger and Toad, occasionally adding little sketches. From about halfway through the correspondence the letters are no longer addressed to 'My dearest Mouse' but to 'Dear Robinson', and are no longer signed 'your affectionate Daddy', but end simply 'to be continued'. For reasons of his own Alastair had changed his name, and his father mildly protested that he

could not possibly write in a familiar tone to someone he had never met.

The manuscript of *The Wind in the Willows* still has its early title, 'The Mole and the Water Rat', and is fluently written in Grahame's legible hand, with occasional neat corrections and revisions. He created the oblong pages by carefully tearing large sheets in half, and then punched them in the top left corner so they could be tagged. The result is a charming and accessible manuscript which may have been sent to potential publishers. Against a list of

chapter titles Grahame made notes of his progress: 'say 5,000 [words]'; '5,000 (nearly ready)'; 'more to come here'. He sent two chapters of *The Wind in the Willows* to an American publisher, who promptly rejected them. The novel eventually appeared in England in 1908, and after a slow start established itself as a lasting favourite among young and old alike, and a classic evocation of idle pleasures.

In the second chapter of *The Wind in the Willows*, 'The Open Road', the Mole asks his friend the Rat if he could

introduce him to Toad, supposing him to be 'a very nice animal':

'He is indeed the best of animals,' replied Rat. 'So simple, so good-natured, and so affectionate. Perhaps he's not very clever – we can't all be geniuses; and it may be that he is both boastful and conceited. But he has got some great qualities, has Toady.'

Note
1 Bodleian Library Records d. 1895.

Cat. 99

"Nice?" Its the only thing, said the Water Rat solemnly, as he leant forward for his stroke. "Believe me, my young friend, there is nothing — absolutely nothing — half so much worth doing, as simply messing about in boats. Simply messing, he went on dreamily: "messing — about — in — boats; messing —————"

"Look ahead, Rat!" cried the Mole, suddenly.

It was too late. The boat struck the bank full tilt. The dreamer, the joyous oarsman, lay on his back at the bottom of the boat, his heels in the air.

"— about in boats — or with boats," the Rat went on composedly, picking himself up with a pleasant laugh. "In or out of 'em, it doesn't matter. Nothing seems really to matter, that's the charm of it. Whether you get away off, or whether you don't; whether you arrive at your destination, or whether you reach somewhere else, or whether you never get anywhere at all. You're always busy, & you never

Five novels by Jane Austen (1775–1817)

1811–18

a) Given to the Bodleian in 1981 by Emma F.I. Dunston:

Sense and Sensibility
London: T. Egerton, 1811
Dunston B 124

Mansfield Park
London: T. Egerton, 1814
Dunston B 120

Emma
London: John Murray, 1816
Dunston B 119

Northanger Abbey: and Persuasion
London: John Murray, 1818
Dunston B 121

b) Purchased by the Bodleian in 1921:

Pride and Prejudice
London: T. Egerton, 1813
Arch. AA e.23

Four of Jane Austen's novels were published in her lifetime: *Sense and Sensibility* (1811), *Pride and Prejudice* (1813), *Mansfield Park* (1814) and *Emma* (1815). They each appeared in the three-volume format standard at the time, and following common practice Austen published them anonymously (although the title pages made clear that they were all by the same author). Austen's gravestone makes no mention of her writings, and it was not until the posthumous publication in 1818 of *Northanger Abbey* and *Persuasion* that her name was revealed to the reading public.

The first editions exhibited here did not reach the Bodleian until the early twentieth century. As a copyright library it was entitled to a copy of each title on publication, but its librarians did not, at that time, believe it necessary to collect mere novels.

When the Bodleian did, eventually, acquire copies of Austen's works, some, including a first edition of *Pride and Prejudice*, were purchased. Others came in 1981 as part of a large gift to the Bodleian by Emma Dunston.

Miss Dunston was the last surviving member of an extraordinary family of collectors and hoarders. Her father and brothers had been students at Oxford. On her death at the age of ninety-seven the rooms of her dilapidated house were stuffed with collections of every description. Among the stamps, franked envelopes, butterflies and moths, prints, photographs, dried flowers and old spectacles were approximately thirty thousand books. The collection was particularly strong in English writers of the nineteenth century, and included works by Robert Browning, Lord Byron, Alexander Pope and Alfred Tennyson, and a thousand volumes of Sir Walter Scott. Around eight thousand books came to the Bodleian, 'having undergone necessary cleaning and fumigation'.[1]

Several of the Dunston Austens are, as a bookseller would say, 'ex-library copies'. *Sense and Sensibility*, for example, was once the property of the Diss Book Society, and a label glued on to the front endpaper warns that 'Any Member who shall lend a Book belonging to the Society to a non-Subscriber shall forfeit two shillings and sixpence for every volume lent'. It was not a revered object: one unimpressed early reader wrote on the flyleaf of the first volume: 'More absolute Trash was never written than in the present work.'

Note
1 Hurst 1986, p. 177.

PRIDE & PREJUDICE.

CHAPTER I.

IT is a truth universally acknow-
ledged, that a single man in posses-
sion of a good fortune, must be in
want of a wife.

However little known the feelings
or views of such a man may be on
his first entering a neighbourhood,
this truth is so well fixed in the minds
of the surrounding families, that he
is considered as the rightful property
of some one or other of their daugh-
ters.

"My dear Mr. Bennet," said his
lady to him one day, "have you heard

VOL. I. B

101

JANE AUSTEN (1775–1817)

The Watsons

c. 1805

Thirty-eight leaves in ten gatherings; each leaf approx.
190 × 120 mm

Provenance: Bequeathed in 1817 to the author's sister
Cassandra Austen (1773–1845); on her death passed to
her niece Caroline Mary Craven Austen (1805–1880),
younger daughter of their eldest brother James (1765–
1819), and then to Caroline Austen's nephew, William
Austen-Leigh (1843–1921); this larger portion of the
manuscript in Austen-Leigh family ownership until
1978, when it was purchased at auction by the British
Rail Pension Fund; it was auctioned again in 1988 and
purchased by Sir Peter Michael, and again in July 2011,
when it was purchased by the Bodleian

Literature: <http://www.janeausten.ac.uk>

MS. Eng. e. 3764 [fols. 15v–16r illustrated]

The Bodleian may not have acquired
Jane Austen's novels until well after
their publication (see cat. 100), but
when a very rare example of Jane
Austen's literary manuscripts came
up for auction in 2011 there were no
doubts about the novelist's genius and
the importance of her working papers,
either on the part of the Library or on
those who supported its purchase. It is
a most revealing manuscript. Such is
the fluency and polish of Jane Austen's
prose that it is tempting to imagine it
flowing ready-formed from her pen.
Her original draft of *The Watsons* shows
that, on the contrary, it was the result
of considerable time and labour. The
writing is relatively rough and there are
numerous crossings-out and revisions,
as well as factual inconsistencies,
spelling errors and lapses in punctua-
tion. There are no chapter and few
paragraph breaks.[1]

Perhaps following her customary
practice, Austen created a book-like
manuscript by folding her paper into
small, numbered gatherings, or quires.
She worked on *The Watsons* some
time between 1804 and 1807, but for
unknown reasons never finished it.
The surviving fragment is about 17,500
words. The story largely concerns
the efforts of Emma Watson's three
sisters to get married. Its set-piece is
a brilliant description of a ball, and in
one passage – illustrated here – Emma,
to everyone's delight, impulsively offers
to dance with a young boy who has just
been jilted by his dancing partner:

*– Emma did not think, or reflect; – she
felt & acted –. I shall be very happy to
dance with you Sir, if you like it. said
she holding out her hand, with the most
unaffected good humour. – The Boy
was again all made of in one moment
restored to all his first delight – wanted
no farther solicitation; & with a Thank
you, as honest as his Smiles, held out
his hand in a hurry to looked joyfully at
his Mother but and instantly stepping
forward with an honest & simple Thank
you 'Maam' was instantly ready to attend
his new acquaintance.*

Note

1 Another portion of the manuscript is at the
 Morgan Library and Museum, New York
 (MA 1034).

engaged this week, cried the boy. We are to dance down every couple." — On the other side of Emma, Miss Osborne, Miss Carr, & a party of young Men were standing in very eager lively consultation — & soon afterwards she saw the smartest officer of the sett, walking off to the Orchestra to order the dance, while Miss Osborne passing before her, to her little expecting Partner hastily said — "Charles, I beg your pardon for not keeping my engagement, but I am going to dance these two dances with Col:n Beresford. I know you will excuse me, & I will certainly dance with you after Tea. And without staying for an answer, she turned again to Miss Carr, & in another minute was led by Col. Beresford to begin the Sett. If the poor little boy's face had been interesting in its happiness to Emma, it was infinitely more so under this sudden reverse; — he stood the picture of disappointment, with crimson'd cheeks, quivering lips, & eyes bent on the floor. His mother, stifling her own mortification, tried to soothe his, with the prospect of Miss Osborne's second promise;

but tho' he continued to utter with an effect of boyish Bravery "Oh! I do not mind it" it was very evident by the unceasing agitation of his features that he minded it as much as ever. — Emma did not think, or reflect; — she felt & acted — "I shall be very happy to dance with you Sir, if you like it," said she, holding out her hand with the most unaffected goodhumour. — The Boy in one moment restored to all his first delight — looked joyfully at his mother and stepping forwards with an honest & simple Thank you ma'am was instantly ready to attend his new acquaintance. The gratitude of Mrs Blake was more diffuse; — with a look most expressive of unexpected pleasure, & lively Gratitude, she turned to her neighbour with repeated & fervent acknowledgements of so great & condescending a kindness to her boy. — Emma with perfect truth could assure her that she could not be giving greater pleasure than she felt herself — & Charles being provided with his gloves & charged to keep them on, they joined the set which was now rapidly forming, with nearly equal complacency. — It was a Partnership which cd. not be noticed without surprise. It gained her a broad stare from Miss Osborne & Miss

Books of their owne stoare

Many of the earliest gifts to the Bodleian came in the form of money, which Thomas Bodley often used to buy books. His initial stocking of the Library was in many ways remarkably far sighted. At a time when the intellectual community conducted its affairs largely in Latin he collected books in Hebrew (a language in which he was proficient), Arabic and even Chinese. If benefactors wished to give not money but 'bookes of their owne stoare', Bodley asked for the titles first, so he could pick out the ones he wanted.[1] He was keen to avoid duplicate copies, and wanted to weed out anything he considered unsuitable. Parts of the Library's holdings, however, would only acquire true breadth and coherence when it acquired whole collections skilfully assembled by others.

Sometimes books were acquired and valued by their collectors for reasons that would not be recognized today, and their acquisition may have been prompted by simple curiosity (cats 107–8). More often, however, the collectors whose benevolence so enriched the Bodleian were highly learned. They both collected genius and had a genius for collecting, and with their specialist interests could assemble collections which comprised the finest achievements of a particular subject or culture.

Sir Henry Savile established a separate library in his own name (cats 102–6). Intended for the University professors of astronomy and geometry, this constantly developing scientific collection would in time become part of the Bodleian. The magnificence of the Arabic and Chinese collections formed by Edward Pococke (cat. 109) and Sir Edmund Backhouse (cats 110 and 111) owed much to linguistic skills, local knowledge, refined taste and sufficient quantities of time and money. The collection of printed ephemera formed by John Johnson (cat. 112) captures an overlooked and unexpected niche in the history of genius. Mendelssohn collected autographs of his great forebears (cat. 113) in albums passed down with his own papers through generations, and then reassembled and secured years later by a dedicated collector, Margaret Deneke. Marks of genius often owe their survival to the collector's single-minded expertise.

Notes
1 Wheeler 1926, p. 3.

102

JOHN SOMER (d. in or after 1409)

Kalendarium (Calendar)

England, after 1387

Miniatures, diagrams, initials
In Latin, on parchment; eleven leaves,
approx. 295 × 210 mm
Twentieth-century Bodleian binding

Provenance: Inscription (sixteenth century): 'Liber Willelmi Snawdun'; Sir Henry Savile (1549–1622); Savilian Library, University of Oxford; transferred to the Bodleian in 1884

Literature: SC 6585; P & A, vol. 3, no. 679; Mooney 1998

MS. Savile 39 [fol. 7r illustrated]

Thomas Bodley's closest adviser in the early years of the Bodleian Library was the imposing figure Sir Henry Savile (1549–1622), Warden of Merton College, Provost of Eton College, and one of the most distinguished scientists and classicists in the University. Having earlier developed the libraries at Merton and Eton, Savile played a large part in the building work, and in all likelihood the Tower of the Five Orders was his idea. He also donated a number of manuscripts to the Library, and promised more. Savile was the only person to whom Bodley was prepared, 'in the infancie of the Librarie', to lend books. 'You knowe very well', he told Thomas James around 1611, 'that Sir H. Sauile, for the raritie of those bookes, that he hath in part conferred already, & doth purpose heerafter, to conferre in greater measure, vpon the publike Librarie of the Vniuersitie, is like to proue, without exception, the greatest benefactour, of all that haue hitherto contributed to it.'[1]

Savile's great benefaction to the University came in 1620, when he founded two professorships – in geometry and astronomy. As a scientist he embraced the modern; he was, for instance, the first person in an English university to teach Copernican astronomy; but he approached the scientific disciplines as a classicist and a humanist, and his work was centred on the texts of the ancients: Euclid, Apollonius, Archimedes and Ptolemy (early in his career he had translated half of the *Almagest* into Latin). He therefore directed that the Savilian professors were to begin their courses with the classical authorities, and then move on to the work of the Arabs and recent astronomers such as Copernicus.

Over the years Savile built up a collection of scientific books and manuscripts, with which he established a library especially for the use of the Savilian professors. It was prominently situated in the first-floor room of the Tower of the Five Orders, with the schools of geometry and astronomy respectively in the adjoining rooms to the north and south. Savile had collected both at home and abroad – on a four-year tour of the Continent he had visited some of the finest libraries in Europe and copied many of their manuscripts. His collection covered the whole field of mathematics and included the allied subjects of optics, harmonics, mechanics and cosmography, and the applied sciences of surveying, navigation and fortification.

This manuscript contains the observational records of John Somer, a Franciscan friar associated with the Merton school of astronomy that flourished in fourteenth-century Oxford. His *Kalendarium* contains astronomical data covering the four Metonic (nineteen-year) cycles between 1387 and 1462. The data are presented in a series of tables and diagrams, and linked to saints' days. The inclusion of a traditional 'zodiac man' illustrates the inseparability, at that time, of astronomy, astrology and medical practice. The parts of the body were directly related to the heavenly spheres, and in the illustration the signs of the zodiac are superimposed on specific areas of the human figure. When the moon was in a particular sign, then blood should not be let from the corresponding part of the body. Using the turning disk (volvelle) above the zodiac man, a reader could calculate the longitude and phases of the moon at a particular time.

The Savilian professors were forbidden by Savile to make astrological predictions or construct horoscopes, but the presence of this manuscript in his library suggests that he saw historical value in the astronomical data it contained.

Note

1 Wheeler 1926, pp. 201–2.

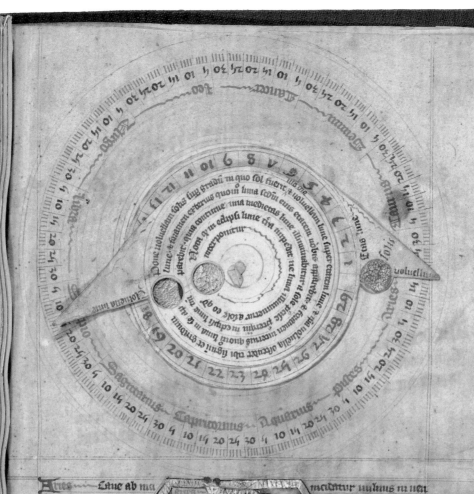

net, in quo terram cum orbe lunari tanquam epicyclo contineri
diximus. Quinto loco Venus nono mense reducitur. Sextum
deniq; locum Mercurius tenet, octuaginta dierum spacio circū
currens. In medio uero omnium residet Sol. Quis enim in hoc

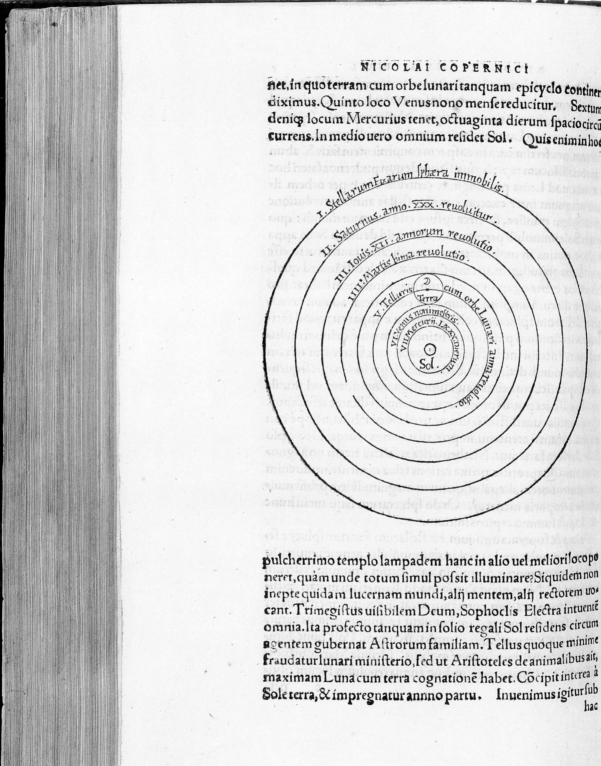

pulcherrimo templo lampadem hanc in alio uel meliori loco poneret, quàm unde totum simul possit illuminare? Siquidem non
inepte quidam lucernam mundi, alij mentem, alij rectorem uocant. Trimegistus uisibilem Deum, Sophoclis Electra intuentē
omnia. Ita profecto tanquam in solio regali Sol residens circum
agentem gubernat Astrorum familiam. Tellus quoque minime
fraudatur lunari ministerio, sed ut Aristoteles de animalibus ait,
maximam Luna cum terra cognationē habet. Cōcipit interea à
Sole terra, & impregnatur annno partu. Inuenimus igitur sub
hac

hac ordinatione admirand.
moniæ nexum motus & m
do reperiri non potest. Hic
ter contemplanti, cur maio
pareat, quàm in Saturno, &
ior in Venere quàm in Mer
in Saturno talis reciprocatio
te, & in Venere, quàm in M
piter, & Mars acronycti pr
eorū occultationem & appa
nox factus magnitudine lo
xat rutilo discretus: illic aut
stellas inuenitur, sedula obse
omnia ex eadem causa proce
autem nihil eorum apparen
celsitudinem, quæ faciat etia
ginem ab oculis euanescere .
nem distantiæ habet aliqua
tur, ut demonstratur in Op
um Saturno ad fixarum sp
tillantia illorum lumina de
scernūtur à planetis, quodq
oportebat esse differentiam
Opt. Max. fabrica.

De triplici mo

CVm igitur mobilit
derū consentiant te
ma exponemus, q
quam hypotesim demonst
tet admittere. Primum quen
ri, diei noctisq; circuitum p
su in ortum uergentem, pre
tur, æquinoctialem circulu
quidialem dicunt, imitante

103

NICOLAUS COPERNICUS (1473–1543)

De revolutionibus orbium coelestium
(*On the Revolutions of the Celestial Spheres*)

Basle: Officina Henricpetrina, 1566

In Latin; 220 leaves, 282 × 196 mm
Bound with other titles in late sixteenth-century Oxford (?) centrepiece binding: dark calfskin with blind tooling

Provenance: Savilian Library, University of Oxford; transferred to the Bodleian in 1884

Savile N 12 (3) [fols. 9v–10r illustrated]

104

GALILEO GALILEI (1564–1642)

Siderius nuncius (*The Starry Messenger*)

Pirated edition published in Frankfurt, 1610

Woodcuts
In Latin; fifty-six leaves, 170 × 95 mm
Bound with other titles in late seventeenth-century Oxford binding: quarter parchment over uncovered boards

Provenance: As cat. 103

Savile Cc 8 (5) [pp. 16–17 illustrated]

105

JOHANNES KEPLER (1571–1630)

Astronomia nova (*New Astronomy*)

Prague: 1609

In Latin; 378 pages, 370 × 235 mm
Early seventeenth-century English binding: brown calfskin with blind tooling

Provenance: As cat. 103

Savile Q 8 [p. 131 illustrated]

The books and manuscripts with which Sir Henry Savile formed the Savilian Library were listed on a miniature roll which he signed and approved.[1] The list is essentially classical: the most common authors are Euclid, Proclus, Archimedes, Apollonius, Ptolemy, Autolycus, Theodosius and Pappus. But the Library did not exclude the new.

Savile's attitude towards the heliocentric model of the universe put forward by Copernicus in *De revolutionibus orbium coelestium* (*On the Revolutions of the Celestial Spheres*) – 'All the spheres revolve about the Sun as their midpoint and therefore the Sun is the centre of the universe' – was not unusual for the time: he deeply respected Copernicus's achievements as an astronomer but did not necessarily agree with his conclusions. Thus he taught the Copernican and Ptolemaic systems side by side, and was not unduly troubled by the fact that they contradicted each other.

Another revolutionary publication, Galileo's *Siderius nuncius* (*The Starry Messenger*) is present in the Library in the form of a pirated edition printed in Frankfurt in 1610, copied from the first edition published that year in Venice. In this modest-looking pamphlet Galileo published the astounding observations he had made using the telescope: the uneven surface of the moon, sunspots, the moons of Jupiter. It is bound with a number of related works, including Johannes Kepler's *Dissertation* on *Siderius nuncius*, published the following year.

The Savile Library also contains a copy of Kepler's earlier, great work, *Astronomia nova* (*New Astronomy*), in which he described the elliptical orbits of the planets round the sun.

Note

1 Bodleian Library Records f. 58.

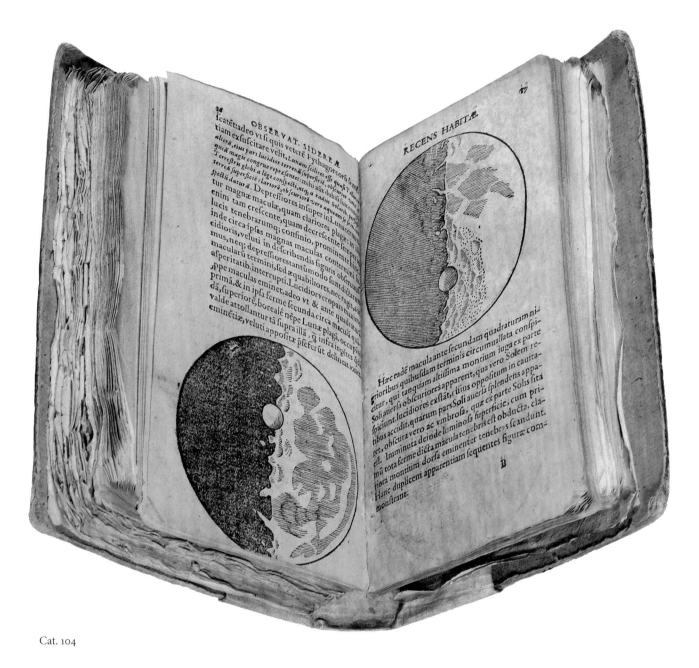

Cat. 104

ngentem & fecan-

Q cognita ad QS.

Et quia æquales

ne igitur QS: pro-

lo igitur D QB da-

ur & DB 62237.

ii ad eccentrici-

e 62237 ad 1143.

fic 1143 ad 1837.

fi præcessionem a-

vero loco aphe-

vel F (quod cen-

cilicet 1837, qua-

RAHE vero eccen-

ab A centro cor-

ti æquatorii mo-

AICA suppositio-

um ab 1837 diffi-

eccentricitatis in-

xx in eccentrico

on sunt adeo scru-

m diurni contro-

l definire possint:

tam in motu ec-

, simili plane ra-

co deferente sy-

schemate apsides

HONE loco justo

orpore peragrat,

cæteros diversum

plane nihil nostræ

eu orbem

ita-

onis, timida illa &

lis haberetur ex u-

Jam

Jam postquàm semel hujus rei periculum fecimus, audacia subvecti porro liberiores esse in hoc campo incipiemus. Nam conquiram tria vel quotcunque loca visa MARTIS, Planeta semper eodem eccentrici loco versante: & ex iis lege triangulorum inquiram totidem punctorum epicycli vel orbis annui distantias a puncto æqualitatis motus. Ac cum ex tribus punctis circulus describatur, ex trinis igitur hujusmodi observationibus situm circuli, ejusque augium, quod prius ex præsupposito usurpaveram, & eccentricitatem a puncto æqualitatis inquiram. Quod si quarta observatio accedet, ea erit loco probationis.

PRIMVM tempus esto anno MDXCX D. V Martii vesperi H. VII M. X eo quod tunc ♂ latitudine penè caruit, ne quis impertinenti suspicione ob hujus implicationem in percipienda demonstratione impediatur. Respondent momenta hæc, quibus ♂ ad idem fixarum punctum redit: A. MDXCII D. XXI Jan. H. VI M. XLI: A. MDXCIII D. VIII Dec. H. VI. M. XII: A. MDXCV D. XXVI Octob. H. V M. XLIV. Estq; longitudo Martis primo tempore ex TYCHONIS restitutione ⅕. 4̇. 38. 50″: sequentibus temporib. toties per 1. 36″ auctior. Hic enim est motus præcessionis congruens tempori periodico unius restitutionis MARTIS Cumq; TYCHO apogæum ponat in 23½♌, æquatio ejus erit 11. 14. 55: propterea lógitudo coæquata anno MDXC 1. 15. 53. 45.

Eodem vero tempore & commutatio seu differentia medii motus SOLIS a medio Martis colligitur 10. 18. 19. 56: coæquata seu differentia inter medium SOLIS & MARTIS coæquatum eccentricum 10. 7. 5. 1.

PRIMVM hæc in forma COPERNICANA ut simpliciori ad sensum proponemus.

Sit α punctum æqualitatis circuitus terræ, qui putetur esse circulus δ γ ex α descriptus: & sit Sol in partes β, ut α β linea apógæi

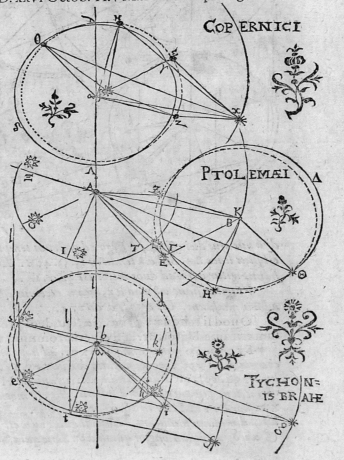

COPERNICI

PTOLEMÆI

TYCHONIS BRAHE

Books given to the Savilian Library by three Savilian professors

(a) John Wallis (1616–1703)
Savile B 3–6

(b) Sir Christopher Wren (1632–1723)
Savile K 5–8

(c) Seth Ward (1617–1689)
Savile M 8–11

The Savilian professors kept the Savilian Library alive in a number of ways. First, they used it: its resources proved indispensable when they came to make modern editions of the great works of classical science (see cat. 117). Secondly, and according to Savile's original stipulation, they deposited in the Library their extensive notes on the books and manuscripts therein. The Professor of Astronomy was also directed to make regular observations on the night sky and add his records of those observations to the Library. Thirdly, a number of professors donated their books to the Library on their retirement. Sir Christopher Wren left his astronomy and geometry books to the Library when he retired from the professorship of astronomy; John Wallis, holder of the Chair of Geometry, gave some of his books in his lifetime, and after his death many more were presented by his son. Their names and monograms may be seen on the spines of their books. Other books apparently bear the monogram of Wren's predecessor, Seth Ward. The Savilian Library is thus a very complete collection of mathematical works up to the end of the seventeenth century.

107

The Ashmole Bestiary

England, early thirteenth century

Miniatures, initials

In Latin, on parchment; 105 leaves, 275 × 180 mm
Twentieth-century English binding by Christopher
Clarkson: white tawed calfskin over wooden boards

Provenance: Inscription: 'Liber Willm Wryght vicarii
de Chepynge Wycombe et theologiæ professoris
anno salutis 1550°'; inscription: 'This booke was
gyven mee by my good freinde William Man esquire,
this thirde day of August 1609. Peter Manwood.'
(Sir Peter Manwood, d. 1625); in the possession of
John Tradescant (bap. 1608, d. 1662) by July 1638;
acquired after his death by Elias Ashmole (1617–1692);
bequeathed by him to the University of Oxford;
transferred to the Bodleian from the Ashmolean
Museum in 1860

Exhibitions: London 1987, no. 253; Oxford 2002b, no. 20

Literature: Black, cols 1413–14; P & A, vol. 3, no. 334;
Morgan 1982–8, vol. 1, no. 19; MacGregor 1983, no. 435
(p. 353); Muratova et al. 1984 (facsimile); Rogers 1991,
pp. 156–7

MS. Ashmole 1511 [fols. 67v–68r illustrated]

This exceptional English bestiary was
once part of the collection of Elias
Ashmole. He was left it by the eminent
gardener John Tradescant, who had
probably inherited it from his father,
John Tradescant the Elder (d. 1638), also
a gardener, and an extensive traveller
and compulsive collector.

The elder Tradescant was fascinated
by all things rare and strange. He
assembled a cabinet of curiosities,
then very much in fashion, and put
it on display in 'The Ark', his house
in Lambeth. It became a celebrated
spectacle and was especially popular
with tourists. The younger Tradescant
probably added little to his father's
collection, but maintained The Ark
and cooperated in the preparation of a
catalogue, *Musaeum Tradescantianum,
a Collection of Rarities.* From this we

learn that The Ark housed the remains
of numerous species of birds, fishes
and 'four-footed beasts', including an
'Alegator, or Crocodile, from Aegypt',
a 'Sebra's skin', a 'natural Dragon,
above two inches long', a dolphin, sea
horses and a 'Dodar, from the Island
Mauritius; it is not able to flie being so
big'. There were even 'Two feathers of
the Phoenix tayle', which John Evelyn
noted in his diary: 'Some habits also of
curiously colourd and wrought feathers:
particularly that of the Phoenix Wing,
as tradition gos'.[1]

A German tourist, Georg Christoph
Stirn, visited The Ark in July 1638 and
listed several of the items on show,

including 'the hand of a meermaid', 'the
hand of a mummy', and 'Isidor's MS of
de natura hominis'. The last item is the
present manuscript, now known as
the Ashmole Bestiary.[2] The miniatures
which adorn its pages manuscript are
among the finest of their kind, and
the depictions of fabulous beasts such
as the griffin, the dragon, the basilisk,
the unicorn and the phoenix, vividly
painted within burnished gold grounds,
have proved longer lasting than the
more ephemeral curiosities of The Ark.

Notes

1 MacGregor 1983, p. 22.
2 Ibid., p. 21.

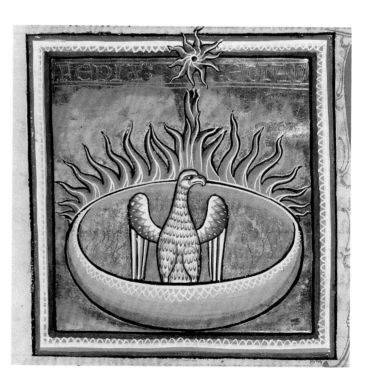

absoluto breuis tam paucorum dierum lit. Famam autem grām minuscula aut diuturnus indultam habet quos ratio mondas nocant. quibus nullus motus pcellose te pestant horrescat.

st uolatile filua sacra intelligibile, sumum animal, cadauit nd uestatur: ñ abunde puolat. siue oberrat: ñ uno loco commoratur: ipmanentiis infinem, ibi escam suam it frequetat. Sic ĝ. ñmus fidelis caute delectetur: ĝ tempe pdulsa oberrans cur in ecclia catholica. ñ dñi pabritare fac unanimes in domo ibiq; habeat conciliabum uitcum. moraliterquepotum ĝ pfosum sanguinem suum. panem in mel i fauum suauissimus eloquiis dñmi.

eiur arabie auis dicta quod coloren ta quod coloren habeat. uel quod sit intro orbe singulari i tunica hec quid dum se uiderit senuisse: collectis aromatum uir gutis: rogum instruit: incensa ad radium solis.

alarum plausu nolūtarium incendium nutrit. seq; it postea si die nona auis de cineribus surgit. huius figuram gerit dñmi nr ihs xpc. qui dic potestatem ha teo ponendi animam meam i iterum sumdi eam; Sig frui mortificandi atq; uiuificandi se potestatem ut eur stulti homines irascunt in uerbo dñi qui uerus dñi filius. ē. qui dic. ph. descendit namq; saluator nost de celo alas suas suauitatis odoribus noui i uetis testam li repleuit. i in ara crucis scipsum dño patri p nobis obtu lit. i tercia die resurrexit.

eur enā significa i resurrectio nem iustorum qui aromatibus uirtutum colle et restauratio nem post uigo ris: post mortem i pararē. feuit. ē arabie auis. ar rabia siuterp tatur campes tris. campus. ē hic mundus. Arrabia. ē secularis uita. Arabes: sedarē. arabes senicem appellant singularem, sin gularis. ē. quilibet auis inlocis arabie pibetur degere atq; eā frunx quoq; auis inlocis arabie pibetur degere atq; eā usq; ad annos quingentos longeua etate pcedere. Que cum finem uite. ē. aduenerit: facret e uerbam de turis murra. i cetris odoribus in qm impleto uite sue tempore.

皇曆未至本藩權依

大統曆法命官考訂刊行俾

中興臣子咸知

正朔用是為誰

大明永曆三十一年大統曆

108

Southern Ming calendar

1677

In Chinese; sixteen leaves, 295 × 170 mm

Provenance: Henry Coley (1633–1704), who gave it to Elias Ashmole (1617–1692) on 28 September 1680

Literature: <http://oldchinesebooks.wordpress. com/2012/01/>

Sinica 88

The Tradescant collection passed in its entirety to Elias Ashmole, who had worked on, and paid for, the catalogue. Ashmole absorbed it into his own large collection, which reflected his varied interests: heraldry, botany, coins, alchemy, medicine, astronomy and astrology. Ashmole collected systematically with an informed eye, but like the Tradescants he would also, acquire things merely for their curiosity value.

This calendar, and others like it, served an important imperial function in traditional China, for they were used to legitimize the prevailing power, in this case the Southern Ming. The calendars were probably brought to England by employees of the East India Company and collected by those who had an interest in astrology.

Ashmole could not read a word of Chinese, but the calendar would have interested him because he was aware of its astrological content. It was given to him by the Oxford mathematician and astrologer Henry Coley (1633–1704), who produced annual astrological forecasts, or almanacs. In 1669 Coley published *Clavis astrologiae, or, A Key to the Whole Art of Astrology*. A greatly enlarged second edition, published in

1679, was dedicated to Ashmole.

Ashmole offered to bequeath his entire collection to the University of Oxford on condition that a building was erected where it could be housed and displayed to the public. The

University agreed, and in 1683 the Ashmolean Museum was established. The books and manuscripts in Ashmole's collection were transferred to the Bodleian in 1860.

IBN AL-MUQAFFAᶜ (d. *c. 760*)

Kalīlah wa-Dimnah (*Kalilah and Dimnah*)

Syria (?), 1354

In the hand of Muḥammad ibn Aḥmad, known as Ibn al-Ghazūlī, and dated 25 Rabīᶜ II 755 (19 May 1354); miniatures
In Arabic; 148 leaves, 368 × 252 mm
Later Oriental-style centrepiece binding: black leather with blind and gold tooled red leather onlays

Provenance: Edward Pococke (1604–1691); purchased by the Bodleian in 1692 from his widow

Literature: Atıl 1981; Rogers 1991, p. 163; O'Kane 2003, p. 222

MS. Pococke 400 [fols. 98b–99a illustrated]

The Bodleian acquired a number of Arabic works in its early years, and when it opened in 1602 it already possessed a manuscript copy of the Qur'an. By the early eighteenth century the Library had more than 1,500 Arabic manuscripts, and this rapid increase was thanks to its acquisition of several fine collections. In 1692 it purchased over four hundred manuscripts belonging to Edward Pococke, the leading English Arabist of the day.

Pococke proved his scholarly gifts while still a student: he discovered two overlooked epistles of the Syrian New Testament in the Bodleian's collections, which he proceeded to publish. He then spent five years in Syria as Chaplain of the Levant Company at Aleppo, where he became fully proficient in Arabic and closely acquainted with its literature. Pococke also proved to be a skilful and discriminating collector. He was, commented one contemporary, the only Western collector who could not be tricked by local dealers. In 1631 the Chancellor of Oxford University, William Laud, asked him to collect

coins and manuscripts on his behalf. Five years later Pococke accepted Laud's invitation to become the first Laudian Professor of Arabic at Oxford. The following year he went to Constantinople with John Greaves, later the Savilian Professor of Geometry at Oxford, and remained there for the next three years. He studied Hebrew, and continued to collect. On his return he was elected Regius Professor of Hebrew. He was an influential Curator of the Bodleian for over forty years.

Among Pococke's collection is a fine fourteenth-century manuscript of *Kalilah and Dimnah*, a collection of fables with both animal and human protagonists, and for centuries one of the most popular books in the Islamic world. The five central tales are versions of the *Pañcatantra*, a work originally written in Sanskrit around the third century AD by an unknown author (or authors), then translated into Middle Persian in the sixth century by a physician called Burzūya. In the eighth century this Persian text was in turn translated into Arabic by a secretary of the Abbasid court, Ibn al-Muqaffaᶜ. Both Burzūya and Ibn al-Muqaffaᶜ added stories, but the core of *Kalilah and Dimnah* remained the five *Pañcatantra* tales. In a preface to his Arabic text Ibn al-Muqaffaᶜ wrote that the stories were intended for a wide audience: youths, princes, kings, commoners and philosophers.

This is one of only four manuscripts of *Kalilah and Dimnah* to survive from

the fourteenth century. Like all early manuscripts of the work, it is richly and charmingly illustrated. 'Images of the animals in varieties of paints and colours', writes Ibn al-Muqaffaᶜ, are intended 'to delight the hearts of princes, increase their pleasure, and also the degree of care which they bestow on the work.'[1]

The manuscript is open here at a story taken from the section of *Kalilah and Dimnah* called 'The Owl and Crows', which demonstrates how guile can overcome physical strength. In a time of drought, the elephants discover a pool called 'the moon' and regularly drink from it. In so doing they trample on the hares who live there. The most cunning of these hares, Pairuz, goes to the elephants, and from the safety of a small hill-top tells their king that he has a message from the moon: 'You have unjustly used your power against the weak, if you come back to the spring which bears my name you will be afflicted. Come now if you do not believe my message.' The elephant goes with Pairuz, who tells him to wash in the pool and bow down. When the elephant sees the reflection of the moon in the disturbed water he takes fright. He believes Pairuz when the hare claims that this is a sign of the moon's anger, and that he and the other elephants should not return.[2]

Notes

1 O'Kane 2003, p. 23.
2 Atıl 1981, pp. 38–40.

بعد القضاء قال طلق الأرنب وأتى الأفيلة حين طلع القمر
وكذب جرز من منهم وقال أنا خفي الشخص صغير وهزءوا عظام
فاخاف أن دخلت عنهن أنها في بعض فينفلكي وقد قيل إن من
مسح الحية فلم ينهشه فوجدي فوقه شئ يسيل عليه من لعابها فيقتله
ومن خدم الملوك وكان من اهل الخير فان الاشرار لحينهم بعلوزه
نصب الشوء له وأمانة اليه وكذلك ينبغي ان اصعد على مكان
مشرف عليهم فاكلمهم بالذي أريد فقعل ذلك وناداهم الأرنب
وقال يا ملك الفيلة إن القمر يعني اليك وقد علمنا ان الرسول
لا يقتل ولا يؤثر ولا يشتروا وان اغلظ في القول لانه إنما عليه البلاغ قال
ما لك الفيلة وما بعثك به القمر فقال الارنب ان القمر يقول لكل ذي
القوة الجرى المجرب مصاه وتشجاعته ليبترجح وان في حمله ذلك لغار
من هو اعز منه واحرب وانك عدت الى الانابيب اللاتي كرنهوا العين
وهزعيتها وهلما مكتى فعللهرق هدمت احجزون وكدر الماطين
ولا بد لي من ان اطمئن اصاركم وأوصرانفسكم فارشت في حلم في بالى من

صورة الفيل وهو عايض في العين وظل القمر في العين والأرنب مزعقة ينظر ويخاطب الفيل

康熙五十二年歲在
癸巳夏六月敬書

志不在虛詞而在至
理不在責人而在責
己求之天道而盡人
事存吾之順末吾之
寧未知何如也

110

ZHU XI (1130–1200)

Zhu zi quan shu (*Complete Works of Zhu Xi*)

An early printing of the 1713 Palace edition

In Chinese; 164 leaves, 280 × 175 mm

Provenance: Part of the collection of Chinese books given to the Bodleian by Sir Edmund Backhouse (1873–1944) between 1913 and 1922

Literature: Helliwell, vol. 1, p. 63

Backhouse 69

111

EMPEROR GAOZONG (the Qianlong Emperor) (1711–1799)

Twenty poems

China, *c.* 1750

In the hand of the scholar-official Liu Lun (1711–1773)
In Chinese; approx. size when opened out 97 × 600 mm
Zhezhuang fold binding, endpapers decorated in cloud patterns with gold dust, and boards of jade inscribed with the title and authorship details

Provenance: As no. 110

Literature: Helliwell, vol. 1, p. 64; <http://oldchinesebooks.wordpress.com/2012/01/17/the-jade-book>

MS. Backhouse 11

On 24 June 1607 Thomas Bodley wrote to Thomas James telling him to expect some Chinese books. He could not give him their titles, so he had written the name of the donors (that is, those who had provided the money for their purchase) on every volume. Bodley had already acquired a number of Chinese items, the earliest of them datable to 1604. He was fussy about what went into the Library, so it is remarkable that he should be collecting material that neither he nor anyone in Oxford for at least the next two centuries could understand. The Bodleian continued to acquire Chinese books in the seventeenth and eighteenth centuries, many of which are of great rarity and interest, but the Chinese collections did not achieve coherence until the nineteenth and twentieth centuries,

Cat. 111

and the acquisition of the libraries of knowledgeable collectors. First among these collectors was Sir Edmund Backhouse, the eldest son of a wealthy banker, who spent his adult life in and around Peking. Acquired in the early twentieth century, when China was in a state of political upheaval, his is one of the finest collections of old Chinese books in the West, particularly as the books have remained in their Eastern-style bindings. Backhouse was a curious and untrustworthy figure, much given to self-aggrandizement and even outright fabrication; but the quality of his collection is incontestable proof of his rare knowledge of Chinese printing in all its forms. The edition of the works of Zhu Xi, for example (cat. 110), beautifully illustrates the technical and artistic perfection of the official publishing of the Qing Dynasty.

A curiosity in the Backhouse collection, and an exquisite one, is a small book bound in jade. The text is unremarkable – twenty poems by the Emperor Gaozong (the Qianlong emperor, who reigned 1736–1796) – but the format is highly unusual. It is small enough to be kept in the sleeve of a gown, but the weight of the jade boards is so liable to tear the paper that it is completely impractical as a portable book. A possible clue to its provenance is contained in Backhouse's very unreliable (and highly pornographic) memoirs, which were not published until 2011. A passage in chapter 3 describes Backhouse's audience with the Grand Secretary Junglu (Ronglu):

The Grand Secretary had already hinted – and I did not wish to outstay my welcome – that it was time to take leave, and thanking Junglu for his exceeding kindness I was about to depart; but he stopped me to present a poem by Grand Secretary Liu Lun written for the Ch'ien Lung Emperor and bound in jade covers. It is now in a European library.[1]

Note
1 Sandhaus 2011, p. 58.

112

Items from the John Johnson Collection of Printed Ephemera

Eighteenth – twentieth century

Literature: Oxford 1971

Provenance: From the collection formed by John Johnson (1882–1956), and housed at Oxford University Press until transferred to the Bodleian in 1968

Various shelfmarks

John de Monins Johnson was Printer to the University of Oxford from 1925 to 1946. Before moving to the Press in 1915 he worked as a papyrologist with A.S. Hunt, and on the second of two expeditions to Egypt on behalf of the Egypt Exploration Society he discovered the earliest known manuscript of Theocritus which, like thousands of other papyri, had been consigned by its original owner to a rubbish heap. More than four decades later Johnson recalled: 'Often I used to look over those dark and crumbling sites and wonder what could be done to treat the background of our own English civilization with the same minute care with which we scholars were treating the ancient.'[1]

It was while at Oxford University Press that Johnson began to form his great collection of over a million items of printed ephemera – everything from large broadsides to calling cards, bus tickets, cigar bands and children's games. He collected with discrimination, and carefully classified 'the evidential data of tomorrow' under approximately seven hundred headings. He absorbed similar collections, and attracted benefactors at a time when libraries and museums showed no interest in printed ephemera. 'It is difficult to describe it', Johnson later wrote,

except by saying that it is everything which would ordinarily go into the waste paper basket after use, everything printed which is not actually a book. Another way of describing it is to say that we gather everything which a museum or library would not ordinarily accept if it were offered as a gift; so that these University collections fill a gap in the world which nothing else really fills.[2]

The collection was first housed at Oxford University Press, where it was referred to as 'the Sanctuary of Printing'. It was transferred to the Bodleian in 1968. It may be asked what 'the ephemera of our lives', as Johnson called it, has to do with genius – which is exceptional and rare, and stands apart from the ordinary concerns of daily life. Ever since the word acquired this meaning, however, salespeople have had no scruples about using it for their own ends, and have cheerfully called upon it when promoting something. An advertisement for a detailed model of Venice reminds potential buyers that this is 'the most interesting City in the world … from the halo that genius has thrown over it'. A new invention, the 'patent surgical gussets for trousers and drawers', is both simple and efficient, and 'Simple, combined with efficiency, is the triumph of human genius'. In 1830 audiences were invited to witness the 'almost superhuman genius' of an infant prodigy, the 7-year-old Master Joyce. It is a sign of the extent to which the word has woven its way into the language that it may be used to describe the highest reaches of creative achievement, what is set to stand the test of time, and equally find a place in the more ephemeral worlds of fashion and the market, supporting the hyperbole of the salesperson and the critic.

Notes

1 Oxford 1971, p. 7.
2 Ibid., p. 11.

PATENT.

A NEW INVENTION.

THE PATENT SURGICAL GUSSETS FOR TROUSERS AND DRAWERS;

(For Universal Wear.)

MR. A. THACKER, AGENT,

29, GREAT ST. HELENS, BISHOPSGATE STREET, LONDON.

RECOMMENDED ON PHYSIOLOGICAL AND SANITARY GROUNDS;

BY A LONDON SURGEON, M.R.C.S. ENG.

Of upwards of Twenty Years standing.

The cut of the European Trousers and Drawers is physically wrong, and the physical defect often involves serious consequences. It is known to every surgeon, that Hernia and numerous other complaints are in a great measure caused or aggravated by an accumulation of animal heat about the Urino-Genital Organs, &c.

The state of these organs operates by reflex action through the spinal chord, and other nervous *ridettes* upon the Brain; and as this is not merely the centre of sensation, but the seat of thought, any influence, direct or indirect, that affects its operations, ought to be carefully watched and attended to.

It is therefore for personal comfort, and for assisting to secure correct moral conduct, that cool air, should as much as possible, be in contact with these parts.

This may be effected to a greater degree than is generally imagined, and that too without the slightest infringement of the usuages of civilized society. The Surgical Gusset is invisible, and permanently effectual, *when properly inserted in the Fork of the Trousers and Drawers.*

It is stronger than most kinds of cloth, and it has the merit of being cheap. It only requires to be known to be hailed as a boon by "all sorts and conditions of men." From practical experience, it can be shewn that it is of great use in preventing or alleviating numerous complaints, such as Hernia (in all its forms), Prolapsus, Piles, Fissure, Fistula, Affections of the Bladder, Hydrocele, &c., and many other ills that "flesh is heir to." It is specially necessary for men and boys where they exist in masses, and for all those persons who are unfortunately obliged to wear Trusses, Belts, Bandages, and such like surgical devices. The use of this new invention will tend to promote moral health.*

The simplicity of the invention may dispose some to undervalue its importance, but this is an objection that no surgeon, and indeed no intelligent man, will countenance. Simplicity, combined with efficiency, is the triumph of human genius, and experience will show that the two properties are combined in an unusual degree in the invention, which has been patented under the name of the Surgical Gusset for Trousers and Drawers.

The utility of the invention has been abundantly proved, and it has already received the approbation of some of the most distinguished physicians and surgeons of the present day.

The Patent Surgical Gussets for Trousers and Drawers may be had wholesale, or in boxes containing three, six, and twelve dozen each, of the Patentee's Agent, Mr. A. THACKER, 29, Great St. Helens, Bishopsgate Street, London; and of all Woollen Drapers, Tailors, Trimming Sellers, Hosiers, and Haberdashers.

* For a full detail of the benefits that this Invention is calculated to confer, see the Pamphlet, published under the same Title as at the head of this notice, to be had of the Agent.

LONDON,
May, 1856.

WHAT covers Virtue shelters Vice,

Shields Beauty, and tempts Avarice:

Which suits the old, the young, grave, gay,

Tall, short, thick, thin,—which ALL display;

Alike they all *that* most desire

Which 'tis agreed they most admire:

What is it?—Perring's Cheap light Hat;

So low in price—but, *verbum sat.*

Since, who would not his head adorn

With what has proved the *best* e'er worn?

Ask the best Beaver'd man you meet,

In every fashionable street,

Who *made* his elegant *chapeau*?

He'll answer thus:—" To-Perring go:

" 'Twas made by *him* (by *Genius* plann'd),

" The cheapest trader in the Strand."

The best Beaver Hats that can be made,
From three to five ounces weight, in 100 different shapes 21s.
Second qualities............. ditto 16s.
Perring's Economical Hats,
Beaver, having the appearance of a hat at twice the price 12s.
Newly-invented Light Hats,
Three and a half ounces weight, Drab and Black 12s.
Best Beaver Livery Hats 16s.
Youths' Hats, Cloth Caps, Children's Hats, Gentlemen's Travelling, Military, and Naval Caps and Hats, Fishing and Shooting Hats and Caps, at prices that cannot fail to meet the wishes of the Ready-Money Purchaser.

85, STRAND, CECIL HOUSE,
CORNER OF CECIL STREET.

N.B. BEWARE OF IMITATIONS.

Wilks, Printer, 5, Bartlett's-buildings, Holborn,

VENICE!

This, the most interesting City in the world, from its magic position in the midst of the waters, from its history, its legends, and from the halo that genius has thrown over it,—this, the city of Shylock and Othello, is now represented as exactly as it is possible for human patience, ingenuity, and skill to represent reality. Four talented architects assisted by several artists have, by the assiduous labour of fourteen years, and at the expence of nearly two thousand pounds, produced the model of the entire City of Venice upon the scale of one 540th part of its real dimensions. In viewing this surprising work of art containing the faithful copy of every object, however minute, that Venice presents, the spectator may indeed exclaim with Childe Harold on the Bridge of Sighs;—

" I see from out the wave her structures rise
" As from the stroke of an enchanter's wand."

102 Churches	135 Large Palaces
122 Towers	927 Smaller Palaces
340 Bridges	471 Canals

And 18,479 Houses are represented in the Model.

JUST ARRIVED.

THE INFANT
PRODIGY,
MASTER JOYCE,

Only Seven Years Old !!

[*From the Pantheon, Liverpool,*]

RESPECTFULLY acquaints the Gentry of TRALEE and its vicinity, that he intends to perform

This Evening, (5th Nov.)

NEXT DOOR TO BENNER'S
HOTEL, *Tralee*

AT THE HOUSE LATELY OCCUPIED BY MR. O'RIELY.

THE AMUSEMENTS OF THE EVENING COMPRISES

1st part---*Comic Singing,*
BY MASTER JOYCE.

2d part---*A Comic Dance,*
BY MASTER JOYCE.

THIRD PART:
Speeches and Recitations,

On Select and popular Subjects.
TO CONCLUDE WITH

The Inebriated Gentleman and Paul Pry.

MASTER JOYCE has had the honor of displaying his wonderful and unprecedented abilities in the principal Cities and Towns of the United Kingdom, and hopes to meet from the Inhabitants of Tralee, that patronage which an extraordinary and almost supernatural genius gives him a claim to.

ADMISSION—{ Ladies and Gentlemen . 0s. 6d.
{ Children . . Half Price.

Doors open at 6 o'Clock---Performance to commence precisely at 7.

☞ *In consequence of an Engagement at the Cork Theatre, Master JOYCE must limit his stay here to a few days. He will perform again on Monday Evening next.* TICKETS to be had at the Hotel.

FOR THREE DAYS ONLY.

ARRIVAL
OF THE
INFANT LYRA
AND HER THREE SISTERS.

The Nobility and Gentry, are respectfully informed, that the INFANT and her SISTERS will have the honor of giving their unprecedented Performances at the

Green Man Assembly Rooms, Blackheath,
On Friday 9th, Monday 12th, and Tuesday the 13th Inst.

This singularly Talented INFANT, has already been visited, by upwards of 150,000 persons; and has had the honor of Performing at Kensington Palace and Gloucester House, before their Royal Highnesses the Duke and Duchess of Cambridge, the Duke and Duchess of Gloucester, Princess Sophia, and Princess Augusta, the Duchess of Kent, Princess Pheodore, and Prince George, the Princess Augusta Amelia, the Princess Victoria, and other members of the Royal Family.

For TWO o'Clock.

Medley Overture, consisting of a Grand March and Admired Airs, on the Piano Forte and Three Harps, by the Four Sisters.
Grand March, the Infant Lyra.—*Boscha.*
Three National Airs, the Infant Lyra.
National Anthem, with Variations, MS. on the Piano Forte, the Infant's Eldest Sister.—*Infant's Eldest Sister.*
The Performance *which excited so much as-* tonishment and admiration at the late Concerts on the Harp and Piano Forte AT THE SAME TIME!!! by the Infant's Eldest Sister.—*Infant's Eldest Sister.*
Harp Duet, the Infant and Sister.—*Clementi.*
Solo on the Harp, Infant's Eldest Sister.—*Infant's Eldest Sister.*
TO CONCLUDE WITH
The National Anthem on the Piano Forte and Three Harps.

For Half-past THREE o'Clock.

National Airs, on the Piano Forte and Three Harps, by the Four Sisters.
Three National Airs, the Infant Lyra.
Air, with Variations, on the Piano Forte, by the Infant's Eldest Sister.—*Infant's Eldest Sister.*
Grand Introduction and Variation to the Scotch Air of "*Roy's Wife.*" by the Infant Lyra,—*Infant's Eldest Sister.*
The Performance on the Harp and Piano Forte together, by the Infant's Eldest Sister.—*Infant's Eldest Sister.*
"*Rule Britannia,*" with Variations, MS. on the Harp, by the Infant's Eldest Sister.—*Infant's Eldest Sister.*
Harp Duet Infant Lyra & Sister.—*Clementi.*
To CONCLUDE WITH the National Anthem on the Grand Piano Forte and Three Harps.

For SEVEN o'Clock.

Medley Overture, consisting of a Grand March and favourite Airs, Piano Forte and three Harps, the Four Sisters.
French Air, with Variations, the Infant Lyra.—*Cardon.*
Three Favourite Airs, the Infant Lyra.
Air, with Variations, Piano Forte, Infant's Eldest Sister.—*Infant's Eldest Sister.*
The Performance which excited so much as- tonishment and applause at the late Concerts, Infant's Eldest Sister. — *Infant's Eldest Sister.*
Harp Duet, Infant Lyra and Sister.
Solo on the Harp, Infant's Eldest Sister.—*Infant's Eldest Sister.*
To CONCLUDE WITH the National Anthem on the Grand Piano Forte and Three Harps, by the Four Sisters.

The Parents of the INFANT LYRA, grateful for past patronage, beg to say, that the Child continues to attend, as last season, at the Routs and Parties of the Nobility and Gentry, and for the same terms, viz. Two Guineas Morning Visits, before two o'clock, and Four Guineas Evening Visits; and that on occasions where an addition of Musical Entertainment may be wished for, the vocal and instrumental talents of the Infant's Mother and her Four Daughters, with a Grand Piano Forte and Four Harps, may be commanded; terms Ten Guineas, *or in proportion for a less number of the family.*

The Parents of the Child, in thus calling forth into public view the united talents of their Children, trust that they may, without presumption, hope for a share of favour. Their eldest daughter's singular powers have already been honoured by the distinguished patronage of the ever-lamented PRINCESS CHARLOTTE OF WALES, and the greater part of her Juvenile Musical Works, composed between her eighth and twelfth years, and consisting of near 300 pages, having been published under the immediate patronage and by the express wishes of her Royal Highness, it is respectfully hoped, that such evidence of singular genius may now entitle her to support and patronage from the Nobility and Gentry of this kingdom.

ADMISSION, 2s. 6d.; Family Tickets, to admit Four, 8s.—Children under 12 years, and School Establishments, 1s. each member.

G. Maddick, Printer, 119, Fleet Street.

Cat. 112 (all images)

Admirable Production of Native Genius.

NOW

EXHIBITING,

At Mr. BURT's, Fore-Street-Hill,

(ADMITTANCE ONE SHILLING,)

A most Extraordinary and Magnificent

PIECE OF

Machinery

INVENTED BY A NATIVE OF EXETER,

OF THE NAME OF LOVELACE, UPWARDS OF 100 YEARS SINCE,

CONTAINING THE FOLLOWING MOVEMENTS:

A TIME PIECE, striking the Hours, Quarters, &c.

A PERPETUAL ALMANACK, which has an exclusive Movement for the Leap Year, requiring to be regulated once only in 100 Years—the Principal Wheel in which revolves but once in Four Years.

On a Plate, in the Centre of the Face, is seen the SUN in his Course through the Heavens, as he appears to us. The Circle which he makes is beautifully described in the Changes of the Seasons, by the Horizon receding or advancing as the Days lengthen or shorten.

Under the above is seen the MOON, shewing her Age and Wane, as she appears to us in her different Stages.

An ORGAN, playing a Variety of Pieces, that produce a most delightful Harmony, the Figures of which are brilliant beyond any thing of modern Composition.

A BELFRY, in which are Six Figures ringing the Changes on Six Bells.

A Variety of other Figures are shewn, in Motion, playing Instruments, beating Time, &c.

The whole is contained in one splendid PILE of CABINET WORK, Ten Feet high, Five Feet wide, and weighs upwards of Half a Ton. The Sculpture, Paintings, and Embellishments of which, though executed more than 100 Years since, are not surpassed for Workmanship or Beauty in the present Day, and strike the Beholder with Admiration; but, at the same Time, with regret, that an Individual, whose powerful Intellect and refined Mind could execute so extraordinary a Machine, should have died in a Workhouse!

Mr. B. has on Sale a choice Collection of Paintings by the first Masters; which, with some fine Specimens of China, Cabinets, and other Curiosities, he conceives are not to be equalled out of London.

CULLUM, GENERAL PRINTING-OFFICE, EXETER.

113

CARL JOSEPH BEGAS (1794–1854)

Felix Mendelssohn (1809–1847)

1821

Oil on canvas, 182 × 140 mm

Provenance: Given by the artist to Dr Johann Ludwig Caspar; given by the daughters of Dr Caspar to Lili Wach (1845–1910), the composer's daughter, in 1896; her daughter, Maria Wach (1877–1964), from whom purchased by the Bodleian as part of her family papers and memorabilia (purchase completed in 1970)

Exhibition: Oxford 1997, no. 5

Literature: Crum and Ward Jones, vol. 2, p. 57

MS. M. Deneke Mendelssohn e. 5

114

Album compiled by Felix Mendelssohn

1836–48

88 items on 189 leaves, in album measuring 220 × 290 mm
Contemporary French blind-embossed binding: dark red sheepskin with gold tooling and colour leather onlays

Provenance: Cécile Mendelssohn; her daughter, Lili Wach (1845–1910); her daughter, Maria Wach (1877–1964), from whom purchased by the Bodleian as part of her family papers and memorabilia (purchase completed in 1970)

Exhibitions: Oxford 1997, no. 53

Literature: Crum and Ward Jones, vol. 2, pp. 78–85

MS. M. Deneke Mendelssohn, c. 21 [fols. 8r + 19r illustrated]

115

Conducting batons belonging to Felix Mendelssohn

a) Working baton
 Whalebone covered with white leather, length 336 mm

b) Presentation baton
 Inscribed 'F.M.B.'; ebony, with ivory handle and silver tip; length 345 mm
 In red goatskin presentation box

Provenance: As cat. 114

Exhibitions: Tokyo 1990, no. 58; Oxford 1997, no. 58

Literature: Crum and Ward Jones, vol. 2, p. 115

MS. M. Deneke Mendelssohn c. 89–90

The extensive papers of Felix Mendelssohn are a testament to his remarkable creativity and energy, and also to his collector's instincts. A methodical man, he made neat lists of his books and manuscripts, and was a great compiler of albums – which he would fill with his correspondence, with the watercolours he made on his travels and with manuscripts written by writers and composers he particularly admired. Some albums were made for his own amusement, while others served as gifts. He began to assemble the so-called 'Wedding Album' (cat. 114) for his future wife Cécile Jeanrenaud, and continued it after their marriage. It is a treasure trove containing manuscripts by Goethe, Schiller, Klopstock and Lessing among writers; and autograph scores by Haydn, Mozart (the Allegro in G minor for piano, K. 312; illustrated on p. 306) and Beethoven (an Eccosais and Trio in D for military band, 1810). They are accompanied by contributions from Cécile's family, drawings and watercolours by friends, and some pieces by Mendelssohn himself. Another album, a Christmas present from Mendelssohn to Cécile in 1844, contains fair copies of a ballade and mazurka by Chopin.[1]

In this warm culture of giving and receiving, Mendelssohn was presented with a number of gifts. They include a conducting baton (cat. 115) of unknown provenance, finely carved in ebony with an ivory handle and a silver tip. It is kept with a working baton made from

Cat. 113

Cat. 114

whalebone covered in white leather. Mendelssohn was one of the first conductors to use a baton in England, and it was of great use to him when he directed English orchestras such as the Philharmonic Society.

After Mendelssohn's death his papers were carefully preserved by Cécile, who on occasion would bring out her albums and show them to special friends. Most of the archive then passed to the Mendelssohn's daughters, Marie Benecke (1839–1897) and Lili Wach (1845–1910). Their collections were enriched by occasional gifts from the composer's surviving friends and their descendants. They include a small oil sketch of Mendelssohn (cat. 113), made when he was a 12-year-old boy and already a celebrated musical prodigy. The artist Carl Joseph Begas used it as a study for a full-size portrait which was destroyed by fire early in the twentieth century. He reluctantly gave it to Dr Johann Ludwig Caspar, who had written the libretti for the operas Mendelssohn had composed when he was just eleven and twelve. After Caspar's death his daughters gave the portrait to Lili Wach.

The principal keepers of the family papers in the next generation were Marie Benecke's son Paul (1868–1944) and Lili Wach's daughter Maria (1877–1964). Paul Benecke lived in Oxford, where his neighbours included two sisters, Margaret and Helena Deneke, who held convivial musical evenings at their home. Margaret was an accomplished piano player and a collector, purchasing a number of Mendelssohn manuscripts which she

kept in her attic, or 'Mendelssohn room'. She gradually earned the friendship of Paul Benecke, a reserved man, who over time gave her his family papers. She recalled: 'bit by bit he added his own even more valuable collection to my Mendelssohn room.… one by one he handed me his valued possessions, telling me the history of each, which he had written on a slip of paper'.[2] After Paul Benecke's death the collection was moved to the Bodleian for safe-keeping, and in 1959 it was decided that the Library would in time be its permanent home. Margaret's aim had been to put together as large a Mendelssohn collection as she could, and with this in mind in 1959 she visited Maria Wach at her home in Switzerland, and arranged for the purchase by the Bodleian of part of her collection. The purchase was completed in 1970. On Margaret Deneke's death all her manuscripts, including the Mendelssohn papers, were left to her sister Helena, a fellow of Lady Margaret Hall. In 1973 Helena bequeathed them, as intended, to the Bodleian. She requested that Margaret's initial be added to the shelfmark 'Deneke Mendelssohn', so that she would not take undue credit for her sister's remarkable efforts.

Notes

1 MS. M. Deneke Mendelssohn b. 2, fols. 52–3, 93.
2 Crum 1987, p. 303.

FOR THE USE AND EASE OF STUDENTS

In letters he wrote to the Vice-Chancellor in early 1598 Thomas Bodley expressed his desire that the restored Library would be 'an excellent benefit for the vse and ease of studentes'. His desks and chairs were designed 'for capacitie and strength and commoditie of Students'.[1] And the Library was to be not only comfortable, but accessible. He wrote to Thomas James in February 1603: 'For mine owne part I doe not dislike, that a gentleman stranger, vpon request first made vnto the Congregation, should haue, as all others, free accesse into the Libr. so that he take the same othe.'[2]

A few of the readers who came to the Bodleian from Oxford and beyond noted their experiences of working in the Library,[3] but mostly the record is limited to the usual concerns regarding the rules of entry, conditions of use, availability of books and opening hours. Research is by and large a silent activity, and the vital process whereby books and manuscripts are read and absorbed, and new books produced, is from an outsider's perspective complex. The path by which one work of genius leads, in time, to another, is particularly obscure. Occasionally, however, the influence of certain exceptional manuscripts on notable works may be traced.

Edmond Halley, in his great edition of the *Conics* of Apollonius of Perga (cats 116 and 117), made use of books and manuscripts in both the Bodleian and Savilian libraries, to such an extent that it is difficult to imagine its being produced anywhere else. Edward FitzGerald's version of the *Rubáiyát of Omar Khayyám*, one of the most popular poems of the Victorian and Edwardian Britain, began with a copy of a manuscript discovered in the Bodleian in the mid-nineteenth century (cats 118 and 119). William Morris saw a number of remarkable medieval manuscripts while an undergraduate (presumably by obtaining special privileges), which he could recall so vividly that their presence may be felt in his later books and calligraphy, and in his articulate belief in craftsmanship and the sanctity of labour (cats 120–23).

Notes
1 *Bodleian Quarterly Record*, vol. 5, pp. 48, 50.
2 Wheeler 1926, letter 70.
3 See Clapinson 2006.

APOLLONIUS OF PERGA (*c.* 262 – *c.* 190)

Conics

Maraghah, western Iran, 1070

In the version of Hilāl ibn Abī Hilāl al-Ḥimṣī (books 1–4) and Thābit ibn Qurrah al-Ḥarrānī (d. AD 901; books 5–7), revised by the Banū Mūsá, and with the marginal glosses of Naṣīr al-Dīn al-Ṭūsī (1201–74)
In Arabic; 170 leaves (+ later inserts), 310 × 212 mm
Late nineteenth-century English binding for the Bodleian: brown calfskin with blind and gold tooling

Provenance: Jacob Golius (1596–1667) (his inscription (?): 'Halebi XIX Sept. Ann. MDCXXVII'); purchased at the Golius sale, Leiden, 1696, by Narcissus Marsh (1638–1713), who bequeathed it to the Bodleian

Exhibition: Oxford 1981, no. 36

Literature: Beeston 1952; Toomer 1990

MS. Marsh 667 [fols. 83(b)v–83(c)r illustrated]

APOLLONIUS OF PERGA (*c.* 260 – *c.* 190 BC) /
SERENUS OF ANTINOUPLIS (AD *c.* 300 – *c.* 360)

Conicorum (Conics) / De sectione cylindri & coni (On the Sections of Cylinders and Cones)

Oxford: The University Press, 1710

Edited by Edmond Halley (1656–1742)
Copper engravings by Michael Burghers (1647/8–1727); woodcuts
In Latin and Greek (with a few lines of Arabic); 536 pages, 390 × 253 mm
Contemporary English binding (probably Oxford): brown calfskin with blind tooling

Provenance: Given to the Savilian Library by Edmond Halley; the Savilian Library was transferred to the Bodleian in 1884

Savile P 9 [frontispiece and title page illustrated]

In 1704 the astronomer Edmond Halley was appointed Savilian Professor of Geometry at Oxford. He was immediately asked to contribute to a project that had been instigated some three decades previously: the publication of the works of the ancient Greek and Latin mathematicians, the texts 'perfected from the Arabick versions, when the originals are lost, with their Scholia & comments; & all illustrated with Annotations'.[1] Editions of Euclid, Ptolemy and Archimedes, among others, had already been published. Halley's predecessor, John Wallis, had begun to edit Apollonius shortly before his death in 1703, and Halley agreed to take on this work in collaboration with David Gregory, the Savilian Professor of Astronomy.

Apollonius of Perga, 'the Great Geometer', was born in Asia Minor in the third century BC. His major work, the *Conics*, dates from around 200 BC when he was living in Alexandria, and describes the geometry of the cone. Halley first edited another Apollonius

treatise, *De sectione rationis* (*The Cutting-off of a Ratio*), which existed only in an Arabic version. The Oxford mathematician and Arabist Edward Bernard (1638–1697) had started a translation of this text into Latin but had only completed about a tenth of it on his death, so Halley was obliged to acquire some knowledge of Arabic. He did this, he said, by comparing Bernard's translation with the original text, and referring to a summary of the work by Pappus of Alexandria (*fl.* AD *c.* 320). This was an amazing achievement, and not everyone believed it. The Oxford antiquary Thomas Hearne, who always knew the gossip, commented: 'my Ld Pembroke was inform'd that Mr. Halley did not translate Apollonius out of Arabick himself, but got one Jones to do it, which Mr. Halley cannot but resent as a great Indignity'.[2]

Halley published *De sectione rationis* in 1706, together with his restoration of another work by Apollonius, *De sectione spatii* (*The Cutting-off of an*

Area). He and Gregory then embarked on the *Conics*, but when Gregory died in 1708 Halley continued alone and the edition is essentially his. In editing the text he drew on a number of sources available to him in the Bodleian and Savilian libraries. Apollonius's text for the *Conics* consisted of eight books. The first four books survived in a Greek edition made by Eutocius in the sixth century AD. A Latin version of this text, by Fredericus Commandinus, had been published in 1566 and a copy was in the Savilian Library.[3] Also in the Savilian were two manuscripts of books 1–4 in Greek, one or both of which served as printer's copy for Halley's edition.[4] There was a copy of Eutocius's commentary on books 1–4 in the Bodleian.[5]

There is no surviving Greek version of books 5–8 of the *Conics*. The text of the eighth book is lost, but an Arabic translation from the Greek of books 1–7 had been made in the ninth century. This text was unknown in the West until the seventeenth century, when

ductam secet in puncto I. Quoniam igitur BA.AH bifariam secta sint in
2.VI. C et D, æquidistantes erunt lineæ CD.BH: et quia etiam æquidistant
FI, duc lineæ IG et HD, idest, DA erunt æquales. quare etiam æquidistant
1.II. FI duobus GF.AD simul sumptis erit æqualis. rectangulo quod continetur
rectangulo quod continetur EF et duobus FG.AD simul sumptis quadratum
+ per 13 et 14 primi ordinata applicata EF æquale est rectangulo AFI
Conicorum continebitur AF et duobus FG.AD. sed rectangulum hoc est æquale
AFG. ergo quadratum EF duplo trapezii FADG æquale erit.

THEOREMA II·PROPOSITIO II.

Iisdem positis, si in ellipsi recta ordinatim applicata incidat
C sectionis centrum: poterit ordinata EC duplum trianguli CA

Quoniam enim CG.HD sint æquales, rectangula CAD.ACG æquali
rectangulo CAD æquali sit duplum trianguli. DAC: rectangula autem GCA
quadratum EC. Ergo idem hoc quadratum EC etiam æquale sit duplo trianguli

THEOREMA III·PROPOSITIO II.

Iisdem positis, si in ellipsi ordinatim applicata EF fuerit ab
4.VI. centri parte: quadratum eius erit duplum differentiæ qua
lum DAC excedit triangulum CFG.

Ab altero diametri extremo B recta ducatur lateri recto æquidistans BH, et
Ax lineæ DC occurrat in puncto H. Quadratum igitur ordinatim applicatæ
le est duplo trapezii FBHG. sed hoc trapezium triangulum HBC superat
CGF. eidem autem triangulo HBC æquale est triangulum CAD. propterea quod
CB, et anguli utriusque trianguli sunt æquales. Ergo quadratum EF æquali
plo differentiæ, qua triangulum ADC excedit triangulum CGF.

THEOREMA IV·PROPOSITIO IV.

Si in axe parabolæ sumatur punctum, cuius à vertice distantia
dio lateris recti sit æqualis: rectarum omnium, quæ ab illo pu
in sectionem cadunt, minima est quæ pertangit ad vertice
rum vero quæ propior minimæ minor est remotiore: earum
tem singula quadrata superat quadratum minimæ quadrati
ti axis, quod inter cuiusque perpendicularem et verticem

Sit parabola, cuius axis AB, et in eo sumatur punctum C. ita ut CA
recti æqualis, et à puncto C in sectionem cadant rectæ lineæ CD. CE. CF. CX
carum gemino ducantur in axem perpendiculares DH. EI. FG. GX
axe adventum signent HA. AI. CA. AK.

Aristippus Philosophus Socraticus, naufragio cum ejectus ad Rhodiensium litus animadvertisset Geometrica schemata descripta, exclamavisse ad comites ita dicitur, Bene speremus, Hominum enim vestigia video.
Vitruv. Architect. lib. 6. Præf.

APOLLONII PERGÆI
CONICORUM
LIBRI OCTO,
ET
SERENI ANTISSENSIS
DE SECTIONE
CYLINDRI & CONI
LIBRI DUO.

OXONIÆ,

E THEATRO SHELDONIANO, An. Dom. MDCCX.

Cat. 117

manuscripts of it began to appear. The German scholar Christian Ravius had brought one back from Constantinople in about 1640 and published a Latin translation (without diagrams) in 1669. Ravius's translation was in the Savilian Library, and his manuscript was in the Bodleian by 1706.[6] Another manuscript of the Arabic text (cat. 116) had been acquired in about 1627 by Jacob Golius, who lent it to the University of Leiden. It was seen there in 1668 by Edward Bernard, who commissioned or acquired a transcript of it and translated parts of it into Latin.[7] In 1696 Bernard returned to Leiden and at the Golius sale purchased the manuscript, along with many others, on behalf of Narcissus Marsh, Archbishop of Armagh. Marsh made it available to Edmond Halley for his edition of Apollonius (a page of Halley's Latin text has at some point been inserted into the manuscript), and in 1713 bequeathed it to the Bodleian.

Halley collated the various Greek and Arabic texts and revised the existing Latin translations. For books 1–4 he printed the Latin and Greek texts together, and for books 5–7 the Latin text alone. He also made a conjectural reconstruction of book 8 in Latin, based on references made to it by Pappus and an Islamic commentator, ʿAbd al-Malik al-Shīrāzī. The *Conics* was published in a fine quarto edition of 550 copies, together with a related work, *On the Sections of Cylinders and Cones*, by Serenus. The copy here was presented by Halley to the Savilian Library.

So much lay behind this work in addition to Halley's industry and brilliance: the emphasis the Savilian professorships placed on classical texts; the work of previous Oxford mathematicians and orientalists; the presence in the Bodleian of rare Greek, Latin and Arabic manuscripts which had been transcribed and purchased abroad; and, not least, the skill of the University Press compositors, who could set Greek and Latin texts in parallel and then combine them with complicated woodcut diagrams to create clear and balanced pages. The title page shows Athena in front of the Sheldonian Theatre surrounded by books, wreaths and geometrical instruments. It is a proud image, and certainly there were few other places at that time where such a book could have been produced.

Notes
1 Carter 1975, p. 240.
2 Hearne 1885–1921, vol. 2, p. 167.
3 Bodleian Savile X 9 (2).
4 Bodleian MS. Savile 7 and 59. See Cook 1998, pp. 489–90, n.49.
5 MS. Barrocci 169.
6 Bodleian Savile Y 35; MS. Thurston 3.
7 Bodleian MS. Thurston 1; MS. Lat. class. e. 2.

ای اول و ای آخر خلقانِ تو

خواجه تو مرا بسوز و خواجه نواز

و ایضاله

نا بتوانی طعنه زن پستانِ زا

از دست بهل تو حیله و پستانِ زا

کز انک زعمِ خویش خواجهٔ آسود

یک لطفِ من ز دست مرِ پستانِ زا

و ایضاله

نا بتوانی زنجبه کمردانِ کس را

بر آتش خشمِ خویش نشانِ کس را

کرکو سرِ طلعت نشستم برکز

کردکه از چهره نرفتم برکز

با این همه نومیدیم نیم از کرست

زان روکه یکی را و نگفتم برکز

و ایضاله

با تو نخرابات اگر گویم راز

بهزان که محراب کنم زی تو نماز

118

ʿUMAR KHAYYĀM (1048–1131)

Rubāʿiyāt (Quatrains)

Shiraz, Iran, 1460

In the hand of Shaykh Muḥammad Pīrbūdāqī; miniatures, borders
In Persian; forty-two leaves, 160 × 76 mm
Late eighteenth- or early nineteenth-century English binding: quarter brown calfskin with gold tooling over marbled boards with green parchment tips

Provenance: Sir William Ouseley (1767–1842); purchased by the Bodleian in 1844 from his estate

Exhibition: Oxford 2002b, no. 48

Literature: Ethé et al., vol. 1, no. 525

MS. Ouseley 140 [fols. 2b–3a illustrated]

119

ʿUMAR KHAYYĀM (1048–1131)

Rubāʿiyāt (Quatrains)

c. 1856 (watermark) – c. 1861

Transcript by Edward FitzGerald (1809–1883)
In Persian and English; twenty-two leaves, 220 × 140 mm
Late nineteenth-, early twentieth-century English binding: dark red pebble-grained leather with gold tooling

Provenance: Sir Edward Whinfield (1836–1922); bequeathed to the Indian Institute Library in 1922 and later transferred to the Bodleian

Literature: Ethé et al., vol. 3, no. 2548

MS. Whinfield 33 [fols. 2v–3r illustrated]

ʿUmar Khayyām was a Persian mathematician, astronomer and philosopher. He is also credited with several hundred *rubāʿīs* or quatrains which centuries later formed the basis of one of the most popular poems in English literature, Edward FitzGerald's *Rubáiyát of Omar Khayyám*.

FitzGerald began to learn Persian in Oxford, from his friend Edward Byles Cowell (1826–1903), who was studying at Magdalen Hall. After graduating with first-class honours in 1854 Cowell spent two years cataloguing Oriental manuscripts, mostly Persian, at the Bodleian. In 1856 he left for India, to work as Professor of English History at Presidency College, Calcutta – 'Compared with a post of usefulness in India, a quiet and idle Librarianship in the Bodleian were but poor employment', he told his mother.[1]

FitzGerald had not wanted Cowell to leave Oxford – 'You have as much Coaching as you want at Oxford … Some Professorship will one day relieve you from Coaching and then you can work at things you ought'[2] – but he continued with his Persian studies in the form of a translation of ʿUmar

Khayyām's quatrains. For this he had two Persian texts, both supplied to him by Cowell. One was a copy of a manuscript (cat. 118) containing 158 quatrains which Cowell had discovered in the Bodleian; the other was Cowell's copy of a manuscript he had found in the library of the Asiatic Society in Calcutta, and which had 516 quatrains.

FitzGerald transcribed Cowell's copy of the Bodleian manuscript into a notebook, remarking that although the Calcutta text contained more quatrains, it was of inferior quality. His interests were not, however, scholarly. Rather than attempt a literal translation of the Persian text, he improvised on it, altering quatrains, blending others, adding quatrains of his own and then reordering them to create a narrative progress from morning to night.

The first edition of 1859, published as an anonymous pamphlet, attracted little attention, but further, revised versions proved increasingly popular. Its melancholy wit, gentle nostalgia and oriental exoticism struck a chord with Victorian readers, and thanks to its epigrammatic nature it was probably quoted as often as any poem of the day:

A Book of Verses underneath the Bough,
A Jug of Wine, a Loaf of Bread – and Thou
 Beside me singing in the Wilderness –
Oh, Wilderness were Paradise enow!

Some for the glories of this world; and some
Sigh for the Prophet's Paradise to come;
 Ah! take the Cash, and let the Credit go,
Nor heed the rumble of a distant Drum!

Look to the blowing rose about us – "Lo,
Laughing," she says, "into the world I blow,
 At once the silken tassel of my purse
Tear, and its treasure on the garden throw."

Among the many admirers of FitzGerald's *Rubaiyat* was his friend Alfred Tennyson, who praised it in his affectionate verse epistle 'To E. FitzGerald':

 your golden Eastern lay,
Than which I know no version done
 In English more divinely well;
A planet equal to the sun
 Which cast it, that large infidel
Your Omar, and your Omar drew
 Full-handed plaudits from our best
In modern letters …

Cat. 119

While working on his translation
FitzGerald never saw the original
Bodleian manuscript – an exquisite
production with intricate illuminations
and a flowing *nastaliq* script bordered
with gold; his primary interest,
however, was in the spirit of the words,
and how he could shape them into
something original and his own. 'But
at all Cost, a Thing must *live*', he wrote,

'with a transfusion of one's own worse
Life if one can't retain the Original's
better. Better a live Sparrow than a
stuffed Eagle.'[3]

Notes

1 Cowell 1904, p. 120.
2 Ibid., p. 121.
3 Terhune and Terhune 1980, vol. 2, p. 335.

120

GEOFFREY CHAUCER (*c.* 1340–1400)

Works

Hammersmith: Kelmscott Press, 1896

Decoration, lettering and type designed by William Morris (1834–1896); woodcuts by William Harcourt Hooper (1834–1912) after Sir Edward Burne-Jones (1833–1898); text edited by F.S. Ellis (1830–1901)
558 pages, 425 × 290 mm
Bound in 1899 by the Doves Bindery: white pigskin with blind tooling

Provenance: C.S. Ascherson (d. 1945); Albert Ehrman (1890–1969); given to the Bodleian in 1978 by his son John Ehrman

Literature: Peterson 2011; Robinson 1982

Broxb. 67.7 [title page illustrated]

William Morris, poet, designer and socialist, haunted the Bodleian when he was an undergraduate at Exeter College in the 1850s. He was already irresistibly drawn to anything medieval, and among his favourite Bodleian manuscripts were the thirteenth-century Douce Apocalypse (cat. 122) and the fourteenth-century *Romance of Alexander* (cat. 121). He later became a keen and knowledgeable collector of manuscripts and early printed books and, according to one witness, he impressed everyone with his expertise on a visit to the Bodleian in about 1882 by confidently and correctly identifying the date and place of origin of 'a great pile of old illuminated missals'.[1]

Morris rejected the mass production he saw all round him. At a time when the art of printing was at a low point and publishers were releasing one dismal-looking volume after another, he extolled the virtues of the craftsman and the hand-made book:

The Clerk of Oxenford if he took up one of his 'Twentie bookes clad in black and red'; the fellow of the college, when with careful ceremony he took the volume from the chest of books which held the common stock of literature; the Scholar of the early Renaissance when he sold his best coat to buy the beworshipped classic new-printed by Vindelin or Jenson, each of these was dealing with a palpable work of art, a comely body fit for the habitation of the dead man who was speaking to them: the craftsman, scribe, limner, printer who had produced it had worked on it directly as an artist, not turned it out as the machine of a tradesman …[2]

It is a romantic image, certainly, but when in the last years of his life Morris made books himself, he did so in emulation of the exceptional medieval and Renaissance works he knew from the Bodleian and elsewhere. In a world where so much was quickly and carelessly produced, he laboured to create artefacts of integrity and beauty.

Morris conceived the idea of the Kelmscott Press after attending a lantern-slide lecture on letterpress printing by Emery Walker at the Arts and Crafts Exhibition in London in 1888. Between 1891, when the first printing began, and 1898 the Kelmscott Press produced 18,234 copies of fifty-three books. Many of them are very fine, but its crowning achievement is

undoubtedly *The Works of Geoffrey Chaucer*. Printed on the finest paper in a deep black ink, it is an astonishing feat. There are eighty-seven woodcut illustrations by Sir Edward Burne-Jones, and Morris designed an ornamental title page, fourteen large ornamental borders, eighteen different frames round the illustrations, twenty-six large initial words, and numerous ornamental initial letters. He also designed the type and the white pigskin binding. Every opening is a feat of invention, and always observes principles of page layout that would become standard practice in the fine press books of the twentieth century: the text is tightly set, avoiding 'those ugly rivers of lines running about the page which are such a blemish to decent printing'; the type, images and ornaments are carefully balanced and integrated; the left- and right-hand pages are considered together, with the inner margin narrow, the top margin wider, the outer margin wider still, and the bottom margin the widest – 'This rule is never departed from in mediæval books, written or printed', said Morris, 'the unit of a book is not one page, but a pair of pages.'[3]

Notes
1 Hyndman 1911, p. 355.
2 Peterson 1982, p. 2.
3 Ibid., p. 78.

Cat. 120

Cat. 120

MS. Bodley 264

Flemish and English, fourteenth and fifteenth centuries

a) *The Romance of Alexander*

> Flemish, script finished in 1338
> Miniatures, borders, initials by Jehan de Grise and assistants, finished in 1344, presumably executed 1338–44
> In French, on parchment; 206 leaves, 420 × 295 mm

b) Alexander's communication with the Brahmins

> England, early fifteenth century
> Same scribe as (c); miniatures
> In Middle English, on parchment; eight leaves, 420 × 295 mm

c) MARCO POLO (c. 1254–1324)
Li Livres du Graunt Caam

> England, early fifteenth century
> Same scribe as (b); miniatures, borders, initials by Johannes and assistants
> In French, on parchment; fifty-four leaves, 420 × 295 mm

Early eighteenth century Oxford binding for the Bodleian, retaining the manuscript's medieval sewing: brown calfskin with blind tooling

Provenance: 'Richart de Wideuille seigneur de Riuieres' (Richard Woodville, 1st Earl Rivers (d. 1469), who purchased the manuscript in London in 1466); subsequent inscriptions (sixteenth century): 'Thomas Smythe', 'Jaspere Fylolle', 'Gyles Strangwayes'; acquired by the Bodleian in *c.* 1603–4 from an unrecorded source (perhaps Thomas Bodley)

Exhibitions: Oxford 1994, no. 48; Paris and New York 2007, no. 15

Literature: SC 2464; P & A, vol. 1, no. 297 & vol 3, nos 792–3; James 1933 (facsimiles of [a] and [b]); Watson 1984, no. 74; Scott 1996, vol. 2, no. 13 (for [b] and [c]); Cruse 2011

MS. Bodl. 264 [fols. 54v–55r, 81v–82r (detail) illustrated]

Travel to distant and exotic lands is the subject of the three manuscripts that make up this lavish volume, which is typically referred to by its Bodleian shelfmark. *The Romance of Alexander* recounts, in French, the adventures of Alexander the Great, whose heroic exploits and encounters with marvellous creatures at the margins of the known world fascinated medieval audiences. It is supplemented with an English account of Alexander's encounters with the Brahmins of India, which are not described in the French romance. The third manuscript is a copy of Marco Polo's *Travels*.

According to the Bodleian entry books, William Morris saw this manuscript on 27 April 1857 when he was an undergraduate at Exeter College (presumably after he had obtained special permission to do so – as an undergraduate he would not normally have been able to see manuscripts). Some months later he and his fellow Pre-Raphaelites decorated the walls of the Oxford Union library with Arthurian themes, and he would surely have recalled the superb miniatures that illustrate the *Romance*: against glittering backgrounds Alexander's knights fight battles, confront strange dangers, perform chivalric deeds and engage in courtly rituals. Gothic arches, pillars and turrets frame their exploits.

Morris delighted in marginal decoration, and the margins of this manuscript depict life in myriad forms and with marvellous energy. Faces of all descriptions peep out of the initials, birds perch on the leaves of the floral borders and hares clamber about the branches. In the lower margins animated figures joust, hunt, dance, chase butterflies, watch puppet shows and play board games; they practise their trades and tend their animals. Grotesque creatures move easily among them, and monkeys cavort about like people. For Morris the bizarre, upside-down world depicted in manuscripts such as this was proof not only of the richness of the medieval imagination, but of the independence and creative freedom of the medieval craftsman:

I must ask the reader … to accept my position that the mediaeval workman was a free workman or artist; that he made his work beautiful almost unconsciously; that consciously and of intent he represented in the most direct and sincere manner scenes of life in which he believed, and that even if he were an ecclesiastic himself (as doubtless he often was, especially in the early Middle Ages), he was first of all a man, and thought it no impiety to draw a jest, his quaint and simple expression of how he personally felt the strangeness of life, and even on the page of a service book.[1]

As he saw it, the scribes' or illuminators' relationship to their work was personal, not mechanical. They were free to indulge their love of ornament, unhampered by the demands of the market.

Note
1 Peterson 1982, p. 5.

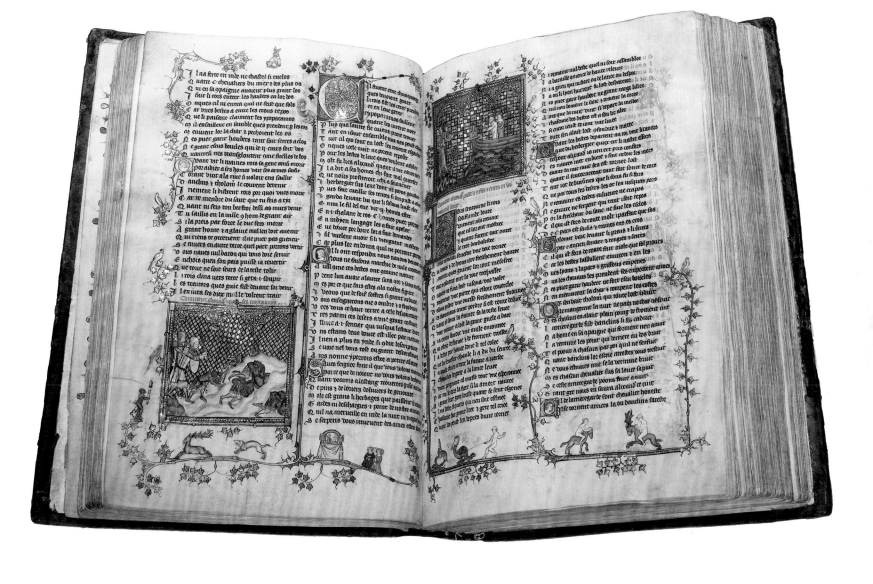

Que .i. cheual neust demie lieue alee
Les .iiij. vens trespassent a icele alenee
Lors truuent tel chalor qui est desatempree
Plus vont gtremont plus est desmesuree
A poi nart alixands tant fort la apressee
Li airs dela chambrete esprist ala bzullee
Li rois sest porpenses sil perdent la uolee
Il cherra ala terre siert sa uie finee
Z sa gent en sera dolente z esgaree
Car toute gent le heent qui terre il a gastee
Il rabaisse sa lance uers terre la esmee
Li oisel sameilleus retoznent loz uolee
Jus uiennent ala terre en mi leu de la pree
Li rois est la dedens sauue ot bone iornee

Comment alixandre z ses gens combatoient
ouec le griffons

Quant li rois saperchut
quil estoit allegies
Puis des oisiaus
a les loyens trenchies
Chastun sen fuit molt tost
quant se sent desloyes

Li assaus fu molt fors ne pot estre laissies
Li rois trenche les cordes z donques ueissies
Corre sus les barons molt les ont angoissies
Li uns sen est fuis les .iij. ont detrenchies
Des cheualiers de lost ia molt damagies
De langoisse est li rois molt mues z changies
Car lasses est du chaut z molt afebloies
Li roi maiment a lost si prince z si chase
Quant il le uirent sain grant ioie en ot mene
Seignors dist alixand dirai uous uerite
Ju ai ueu as ieus que molt ai desire
Car tout ai assaie z tout ai mesure
Le mont si q il est et de lonc z dele
Si q ie lai ueu lai ie tout conqueste
Fors seule babilone ou a grant fermete
Se ie cele ne ai petit pris mon barne
Z respondent si home ce est tout afine
Quant uous aues les nues z le uent sozmonte
Dont poes uous par force bien prendre la cite
Le matin par sous laube serons tuit apreste
Jus babilone irons si q me est deuise
Ia ne ert tant fermee de mur ne de fosse
Que nous ne la preignon a .i. seul ioz teste
Alixand respont bien uous ai alscoute
Ce que uous aues dit ert bien a creante
Z mourrons le matin ni aura demore
Quant li solaus leua z li ioz esclarchi
Se leuerent par lost macedonois z gri
Z li rois alixand se caucha z uesti
Quant apareillies fu nel nel mist pas en oubli
Sozoison fist a dieu quil li faiche merchi
Par lost chargent somiers si se sont bien garni
Car il en ont este autrefois escharni
Quant il furent en bastre en la terre pori
En babilone uont z mueuent amidi
Quant il furent montes z des loges parti
Li escuier de lost ont tout ars z bru
A grant ioie cheuauchent les puis de ual garni

e eſt qui iiij. lieues en teuoit ꝛ plaigne
Q ui a itel gent donne ſon bien le gaigne
Q uil ne trueue cite ne chaſtel quil ne ſtraigne
N e nul home tant ſoit pararmes ne deſtraigne
M aluais orgueil ne priſe li rois vne chaſtaigne
A honte fait morir qui ſeruir nel daigne

A liſant diſcuſſan que pas neu onlie
l amirant li vuet faire vne tele enuaie
Q uil ni vauroient eſtre por tout lor de pauie
il aprime ſa gent ꝛ ſa grant baronnie
a nen porrai i prendre que ſempres ne loeie
l rois maine ſa gent ꝛ ſeruee ꝛ ſerie

Comment Alixand ſes ala deſaler ouer
les greus pour combatir ouer lamirant

Comment Alixand cheuacha deuant
ſonoſt pour combatir ouer ſes euemes

S i com il adiournoit
et laube eſt eſclarchie
tout droit a lamirant
eſt venus vne eſpie
Qui li diſt que loſt eſt
a iornee et demie
C ment fait lamiral ne me mentir tu mie
D i moi la uerite ſe loſt eſt bien garnie
O il fait li meſſages de tous biens raemplie
C ar du uoſtre meiſmes prendent la manantie
I l ne trueuent nul home qui la lor otredie
A lixand cheuauce deuant ſa compaignie
N icanor ꝛ filote ont ſenſaigne en baillie
D andins ꝛ tholom ſi les chaſdele ꝛ guie
C e ſont iiij. barons ou li rois molt ſe fie
P ar foi diſt lamiral ce tieng a grant folie
D e quoi cuident il uiure cele gent eſbahie

A lixandres cheuauce
par fiere contenance
li xij per o lui
ou il a grant fiance
Et ſiſt ſus i deſtrier
de diuerſe ſamblance
L a teſte ot plus vermeille que neſt tait de garãce
L e col ꝛ les coſtes ot blans par demoſtrance
L a croupe ot pumelee por autre diferance
L es iiij. pies ot noirs ce fu ſeneſiance
O nques plus hardis rois de lui ne porta lance
P or ſa proeſce ot il par tout le mont puiſſance
O nques tels rois ne fu ſen dieu euſt creance
T rop ſet daſtronomie ꝛ plus de nigromance
A ſſes ſot de phiſique quapris lot de ſenfance
T holom fait langarde par itel guenance
Q ue nus ni coure a pie par nulle meſeſtance

The Douce Apocalypse

London, *c.* 1265 – *c.* 1270

a) An Apocalypse with an anonymous commentary
Borders, historiated initials
In Anglo-Norman, on parchment; twelve leaves;
312 × 212 mm

b) An Apocalypse, with extracts from the commentary of Berengaudus
Miniatures in varying states of completion
In Latin, on parchment; 109 pages, 312 × 212 mm

English (Cambridge?) centrepiece binding, probably 1580s: brown calfskin with gold tooling

Provenance: Arms of England with a label: Prince Edward, later King Edward I (1272–1307) and Eleanor of Castile (d. 1290); William Wilson, FSA; his sale, 1 February 1833: purchased afterwards from the bookseller Thomas Thorpe (1791–1851) by Francis Douce (1757–1834), who bequeathed it to the Bodleian

Exhibitions: Oxford 1984, no. 65; London 1987, no. 351

Literature: SC 21754 (+ addenda, vol. 5, p. xx); P & A, vol. 3, no. 469; Morgan 1982–8, vol. 2, no. 153; Morgan 2006; Klein 1983 (facsimile)

MS. Douce 180 [pp. 24–25, 71 illustrated]

According to Emery Walker, the Douce Apocalypse was a special favourite with William Morris and Edward Burne-Jones when they were at Oxford. It is one of several richly illustrated manuscripts of the Apocalypse made in England in the thirteenth century that Morris considered 'examples of serious Gothic design at its best … [they] seem to show us what wall-pictures of the period might have been in the north of Europe'.[1] The Douce Apocalypse is a masterpiece of medieval art, and in 1894 Morris even considered making a facsimile of it. 'The photo of the Apo; seems to me pretty well', he wrote to Walker on 30 October, 'but the dark draperies, which I believe are red, are too dark.'[2] There is a record of his seeing the manuscript on 28 November that year, along with another Apocalypse,[3] *The Romance of Alexander* manuscript (cat. 121) and the Ormesby Psalter.[4]

The author of the Apocalypse, or Book of Revelation, tells us that his name is John, and that he is writing on the island of Patmos in the Aegean. When the Douce Apocalypse was made he was thought to be the author of the Gospel of John, but this is now considered highly unlikely. The ecstatic, prophetic vision he describes is deeply enigmatic. 'The Revelation of St John contains as many mysteries as words', said St Jerome. It is evidently allegorical, and numbers play an important role: when, for example, the number of the beast, 666, is converted into Hebrew letters, it spells 'Nero'. Commentaries have attempted to resolve its difficulties, and extracts of a commentary written by one Berengaudus sometime between the ninth and eleventh centuries are included in this manuscript. In general, however, its hidden meanings have stayed hidden.

If the text of the Apocalypse remains obscure, its wild imagery is nonetheless remarkably powerful. It ends with a radiant vision of the triumph of good over evil, but it is the horror of all that precedes it that has frightened and fascinated readers for centuries, particularly at times when there was a general expectation of the imminent end of the world. A lamb with seven horns and seven eyes takes a scroll with seven seals which, when opened, brings terrible horsemen and a great earthquake. Seven angels sounding seven trumpets herald hail and fire storms, locusts and plagues; the sun, moon and stars are darkened. There are sea beasts, a seven-headed dragon, and a great whore of Babylon. It is no wonder that the Apocalypse is one of the most frequently illustrated book of the Bible, for it offers a wealth of possibilities for artists. Furthermore, in manuscripts such as the Douce Apocalypse – made not for a learned monastic audience but for the lay court of Prince Edward, son of Henry III – the illustrations help the reader to visualize the difficult text and render the narrative more immediate and accessible. Indeed, in this case priority is given to the illustrations, for when the scribe runs out of space he simply writes 'et cetera'.

Shown here are the second and third angels sounding their trumpets and bringing disaster with them (Revelation 8:8–11). After the first angel's trumpet has caused hail, fire and blood to fall from heaven onto the earth, the following six angels cause further devastation:

And the second angel sounded, and as it were a great mountain burning with fire was cast into the sea: and the third part of the sea became blood;

And the third part of the creatures which were in the sea, and had life,

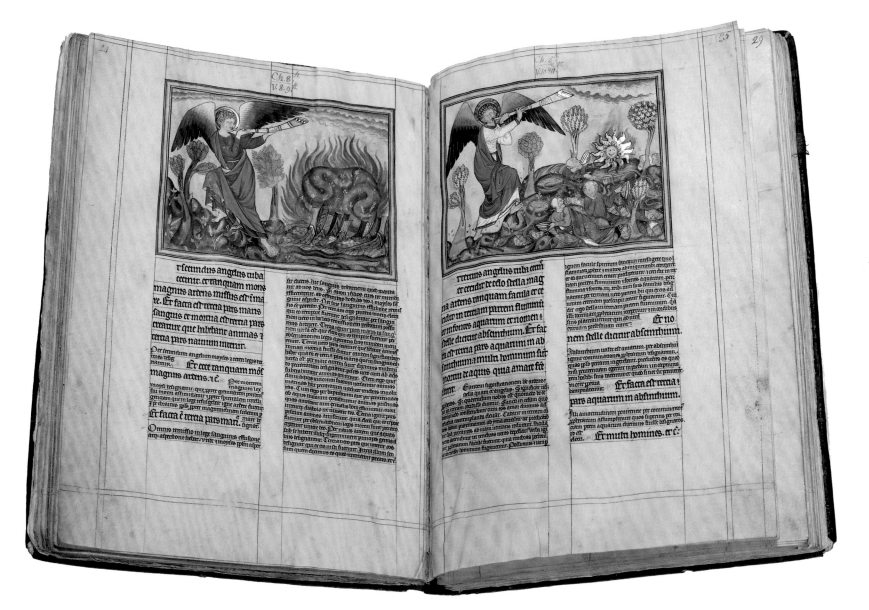

died; and the third part of the ships were destroyed.

And the third angel sounded, and there fell a great star from heaven, burning as it were a lamp, and it fell upon the third part of the rivers, and upon the fountains of waters;

And the name of the star is called Wormwood: and the third part of the waters became wormwood; and many men died of the waters, because they were made bitter.

The vital, muscular poses of the figures in these illustrations, the gesticulating hands and the wonderfully expressive faces (particularly the grinning Wormwood) are characteristic of the Douce Apocalypse artist, whose idiosyncrasies invigorate the courtly French style on which his work is based.

The Douce Apocalypse was never finished, and the illustrations are in various states of completion. Some, like the example illustrated below, survive as exceedingly sensitive line drawings; others have their gold leaf added, while others are partly coloured.

Notes

1 Peterson 1978, p. 12.
2 Kelvin 1996, vol. 4, p. 224.
3 Bodleian MS. Auct. D. 4. 17.
4 Bodleian MS. Douce 366.

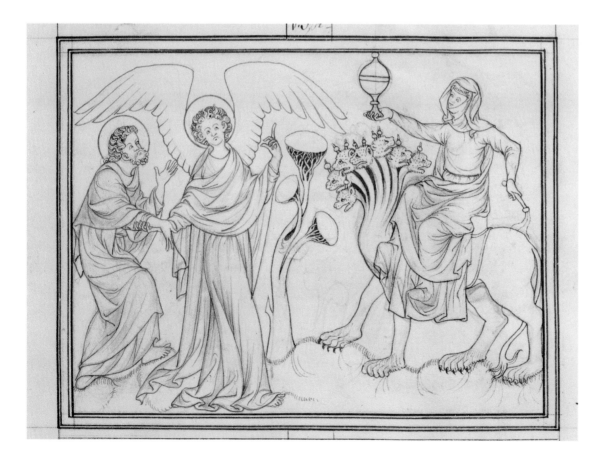

Cat. 122

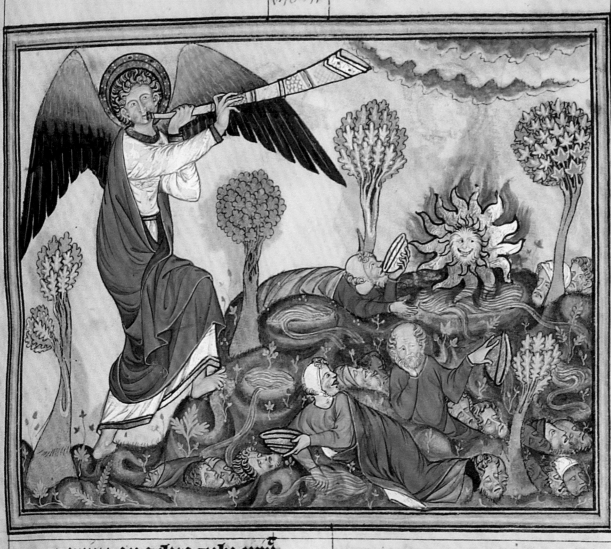

Tercius angelus tuba cecu
et cecidit de celo stella mag
na ardens tanquam facula et ce
cidit in terciam partem fluminu
et in fontes aquarum et nomen
stelle dicitur absinthium. Et fac
ta est tercia pars aquarum in ab
sinthium et multi hominum sut
mortui de aquis quia amare fce
runt. Eandem significationem ht ardens
stella quam et angelus. Significat nam
pphetas. S; querendum nobis est quomodo de ce
lo in terram cecidisse dicatur. Sancti in celum quo
dammodo conscendunt cum eos amor diuinus ad
celestia contemplanda eleuat. Cadunt in terram cu
eos amor proximorum ad yma retrahit ut predicand
ne sua peccantes ad uiam ueritatis reducant. Facula
uero accenditur ut tenebras noctis depellat. Verba igi
tur pphetarum facule fuerunt quia tenebras peccati
amenth; hominum fugauerunt. Possumus et iam p

ignem facule spiritum sanctum intelligere quo i
flammati pphete et multos ab iniquitatib; correxer.
et ea que uentura erant predixerunt. et cecidit in ter
ciam partem fluminum et fontes aquarum. per
flumina et fontes. xii. trib; cum suis familiis desig
nantur. per terciam uero partem hu qui ex eis ad
uitam eternam prescripti erant figurantur. Ceci
dit ergo stella in terciam partem fluminum. qa
illi tercinam pphetarum receperunt et in cordibus
suis plantauerunt qui ad uitam
eternam predestinati erant. Et no
men stelle dicitur absinthium.
Absinthium ualde est amarum. per absinthiu
igitur comminationes pphetarum designantur.
quas pro peccanti ingerebant. predicentes eis quod
nisi penitentiam egerint in predam et in captiuita
tem hostib; suis darentur et quod si nec sic penitere
morte perpetua
dampnarentur. Et facta est tercia
pars aquarum in absinthium.
Illi amaritudinem penitencie per comminatone
pphetarum assumpserunt quos superius per ter
ciam partem aquarum diximus fuisse designatos
id est
electi. Et multi homines. et c.

123

WILLIAM MORRIS (1834–1896)

The Story of the Volsungs and the Niblungs

c. 1871

In the hand of William Morris; historiated initial by Charles Fairfax Murray (1849–1919), borders by George Wardle (*c.* 1834–1910)
Eighty leaves, approx. 285 × 220 mm
Nineteenth-century English binding by the Doves Bindery: quarter green goatskin over vellum boards with gold-tooled yapp edges

Provenance: The artist's younger daughter May Morris (1862–1938), who bequeathed it to the Bodleian

Exhibition: Parry 1996, no. N.6

Literature: NSC 43704; P & A, vol. 3, no. 1251

MS. Eng. misc. d. 268 [fol. vii recto illustrated]

124

HORACE (65 BC – AD 8)

Odes

1874

In the hand of William Morris; historiated and other borders, initials, by Morris, Charles Fairfax Murray (1849–1919) and Sir Edward Burne-Jones (1833–1898)
In Latin, on parchment; 194 pages, 168 × 120 mm
Nineteenth-century English binding by the Doves Bindery: green goatskin

Provenance: As cat. 123

Exhibitions: Tokyo 1990, no. 42; London 1996, no. N.13

Literature: NSC 43708; P & A, vol. 3, no. 1258

MS. Lat. class. e. 38 [pp. 82–83 illustrated]

Between 1870 and 1875 Morris took a particular interest in calligraphy. He painstakingly copied out literary texts in a fine script, which were then adorned by himself and others to create illuminated manuscripts. There are twenty-one of these 'painted books', which together amount to over 1,500 pages.

Morris experimented with decorative initials and tried his hand at gold burnishing; he sought out the best-quality parchment. Above all, he worked hard at his penmanship and here, although he usually identified himself most closely with the medieval book, Morris learned from Renaissance models. When designing the first type for the Kelmscott Press he turned to another favourite volume in the Bodleian, the edition of Pliny's *Natural History* printed by Nicholas Jenson (cat. 63): '[Emery] Walker and I both think Jenson's the best model, taking all things into consideration', he told F.S. Ellis in 1889. 'What do you think again? Did you ever have his Pliny? I have a vivid recollection of the vellum copy at the Bodleian.'[1] Similarly, for his calligraphy he studied the writing manuals of the finest Renaissance scribes, of which he owned four: *La Operina* and *Il Modo de Temperare le Penne* by Ludovico degli Arrighi, *Thesauro de Scritori* by Ugo da Carpi and *Lo Presente Libro* by Giovannantonio Tagliente.[2]

Morris learned from the work of past masters but imitation was never his goal. His calligraphy has a character that is peculiarly his own. Thin, oblique strokes invigorate the script of his Icelandic saga 'The Story of the Volsungs and the Niblungs', robed musicians (one coloured, the others still in pencil) fill the margins, and a vivid opening initial shows Sigurd seated on the body of Fafnir. Interlaced initials and swirling floral borders decorate his Odes of Horace. Both manuscripts are, in fact, unfinished, but the process of making them was more important than their completion. Morris's calligraphic work has been called 'delicate and exacting to an excruciating degree'.[3] Working patiently, hour after hour, with pen and ink was the realization of one of his most profoundly held beliefs – the dignity of labour.

Notes

1 Peterson 1982, p. xxv.
2 McCarthy 1994, pp. 264–9.
3 John Nash, in London 1996, p. 296.

ERE BEGINS THE TALE AND TELLS of a man named Sigi, who was called of men the son of Odin; another man withal is told of, hight Skadi, a great man, and mighty of his hands, yet was Sigi of more might, and higher of kin, according to the speech of men of that time. Now Skadi had a thrall, with whom the story deals somewhat, Bredi was he hight, and was even named after that work that he had to do; in prowess and might of hand he was equal to men of more account, yea and better than some thereof.

Now it is to be told, that on a time Sigi fared to the hunting of the deer, and the thrall with him; day-long they hunted till the evening, and when they gathered their prey together at night-fall, lo greater and more was that which Bredi had slain, than was Sigi's prey: which thing misliked him much, and he said that great wonder it was, that a very thrall should out-do him in the hunting of deer; so he fell on him, and slew him, and buried the body of him thereafter in the snow. Then he went home in the evening, and said that Bredi had ridden away from him into the wild-wood : Soon was he out of my sight, says

me truncus illapsus cerebro

sustulerat nisi Faunus ictum

Dextra levasset, Mercurialium

custos virorum. Reddere victimas

aedemque votivam memento:

nos humilem feriemus agnam.

Carmen XVIII: de paupertate sua

Non ebur neque aureum

mea renidet in domo lacunar

non trabes Hymettiae

premunt columnas ultima recisas

Africa, neque Attali

ignotus heres regiam occupavi,

nec Laconicas mihi

trahunt honestae purpuras clientae

eripuit volucrisque Fati
Tardavit alas, quum populus frequens
laetum theatris ter crepuit sonum :
me truncus illapsus cerebro
sustulerat nisi Faunus ictum
Dextra levasset, Mercurialium
custos virorum . Reddere victimas
aedemque votivam memento :
nos humilem feriemus agnam.

Carmen XVIII : de paupertate sua

Non ebur neque aureum
mea renidet in domo lacunar,
non trabes Hymettiae
premunt columnas ultima recisas
Africa, neque Attali
ignotus heres regiam occupavi,
nec Laconicas mihi
trahunt honestae purpuras clientae

At fides et ingeni
benigna vena est, pauperemque dives
me petit : nihil supra
Deos lacesso, nec potentem amicum
largiora flagito,
satis beatus unicis Sabinis .
Truditur dies die,
novaeque pergunt interire Lunae :
Tu secanda marmora
locas sub ipsum funus, et sepulchri
immemor struis domos
marisque Bais obstrepentis urges
summovere litora,
parum locuples continente ripa .
Quid, quod usque proximos
revellis agri terminos et ultra
limites clientium
salis avarus ? Pellitur paternos

THE GIGANTIC
GENIUS OF
SHAKESPEARE

'Happely some plaies may be worthy the keeping', Thomas Bodley told his Librarian, Thomas James in 1612, 'but hardly one in fortie.' Foreign plays, he said, were written for the sake of widsom and learning; unfortunately, this was not the case with English plays. The meagre and dubious benefits they would bring were not worth the trouble, Bodley thought, and he did not want the Library stuffed with such 'baggage bookes'. Their inclusion would only bring it harm and scandal.[1]

In his strictures against plays Bodley did not distinguish between playwrights, or exempt the work of a recently retired man of the theatre, William Shakespeare, who by the eighteenth century was considered uniquely gifted. In his memoir Edward Gibbon described the 'idolatry for the Gigantic Genius of Shakespeare which is inculcated from our infancy as the first duty of an Englishman'.[2] In Bodley's lifetime, that genius was above all to be found in the living, evanescent world of the Elizabethan theatre (cat. 125), but it could also be found in print. Shakespeare never collected his plays together and had them published in the deliberate manner of his friend Ben Jonson (cat. 129); it no longer assumed, however, that he was indifferent to the printing of his dramatic work, which would have been available in the small quarto and octavo 'playbooks'. Sometimes unauthorized and often badly edited and roughly printed, these were the kind of 'baggage books' Bodley excluded from his library. Happily, a few examples are now kept in the Bodleian, thanks to collectors such as Edward Malone (cat. 126) and the purchases of much later Librarians (cat. 127), together with unique editions of Shakespeare's most popular poem, *Venus and Adonis* (cat. 128).

A copy of the most celebrated edition of Shakespeare's plays, the posthumously published 'First Folio', was acquired by the Bodleian soon after its publication in 1623 (cat. 130). By 1674, however, it had left the Library, and it has been conjectured that it was disposed of as superfluous when the Bodleian acquired a Third Folio of Shakespeare's plays in 1664. When this very copy of the First Folio reappeared under new ownership at the end of the twentieth century the Librarian launched a successful appeal to reacquire it for a vast sum.

Thomas Bodley can hardly be censured for his attitude towards plays, including those of England's gigantic genius, for it is unsafe to assume that today's Library would be any better today at recognizing the precious marks of genius of the future.

Notes
1 Wheeler 1926, letter 221.
2 Gibbon 1837, p. 46.

125

CLAES JANSZOON VISSCHER (1587–1652)

London

First issued in 1616

Inscribed on lower edge: 'CJVisscher Delineavit', and in top left corner: 'Londinium, antiquis olim regna ta Britannis, / Urbs, et quae nostro fulges clarissima seclo. / Quis tua templa canet sublimibus alta columnis, / Aëriasq, domos, magnique Palatia Regni, / Quis referet stantes Thamesino in littore Classes, / Divitias et opes, et crebro fornice Pontem, / Splendida es, et intidâ tu sub testudine cœli / Imperium Regina tenes, das jura Britannis. / Londinum'.
Copper engraving; four leaves laid on linen, each measuring approx. 420 × 540 mm

Provenance: Francis Douce (1757–1834), who bequeathed it to the Bodleian

Douce Prints a.53(2)

This panoramic view of London was first published in 1616, the year of Shakespeare's death, but from internal evidence it probably shows the city around 1600. It was engraved by C.J. Visscher of Amsterdam; an inscription states that he also made the original drawing ('CJVisscher Delineavit') but as he would have been only thirteen in 1600 it is probably based on a view by another artist.

On the north bank of the Thames are Westminster and the City, from Whitehall in the west to St Katherine's-by-the-River in the east. The old St Paul's Cathedral rises above the surrounding buildings, and the Tower of London may be seen further east. The south bank is shown from Paris Garden to beyond St Olave's in Southwark. The old London Bridge spans the north and south banks, and the southern gate is topped with the heads of executed criminals. Harrow, Hampstead, Hackney and Stepney are distant villages.

Of particular interest on the south bank are three places of popular entertainment: the Beargarden, where bear baitings and other amusements were held; and two theatres, the Swan and the Globe (a third theatre, the Rose, lay to the west of the Globe, but is not shown). Their position on the south bank put them beyond the confines, and therefore the jurisdiction, of the City. Shakespeare is most closely associated with the Globe. It

was built in 1599 by his company, the Lord Chamberlain's Men, and he was a shareholder, with several of his fellow actors.

Visccher's engraving is not always accurate – the Globe was probably a polygonal structure rather than the octagon shown here – but it does provide a rare glimpse of Shakespeare's theatre in its wider setting. The buildings were quickly built and heavily used, and their existence depended on prevailing attitudes to theatrical entertainment. They were never going to last for centuries. The original Globe burned down in June 1613 and a new theatre, built on the same site, was

opened the following year. It was closed by the Puritans in 1642 and demolished in around 1644. Indeed, a good deal of the buildings in this engraving, including St Paul's, would be lost in the Great Fire of 1666.

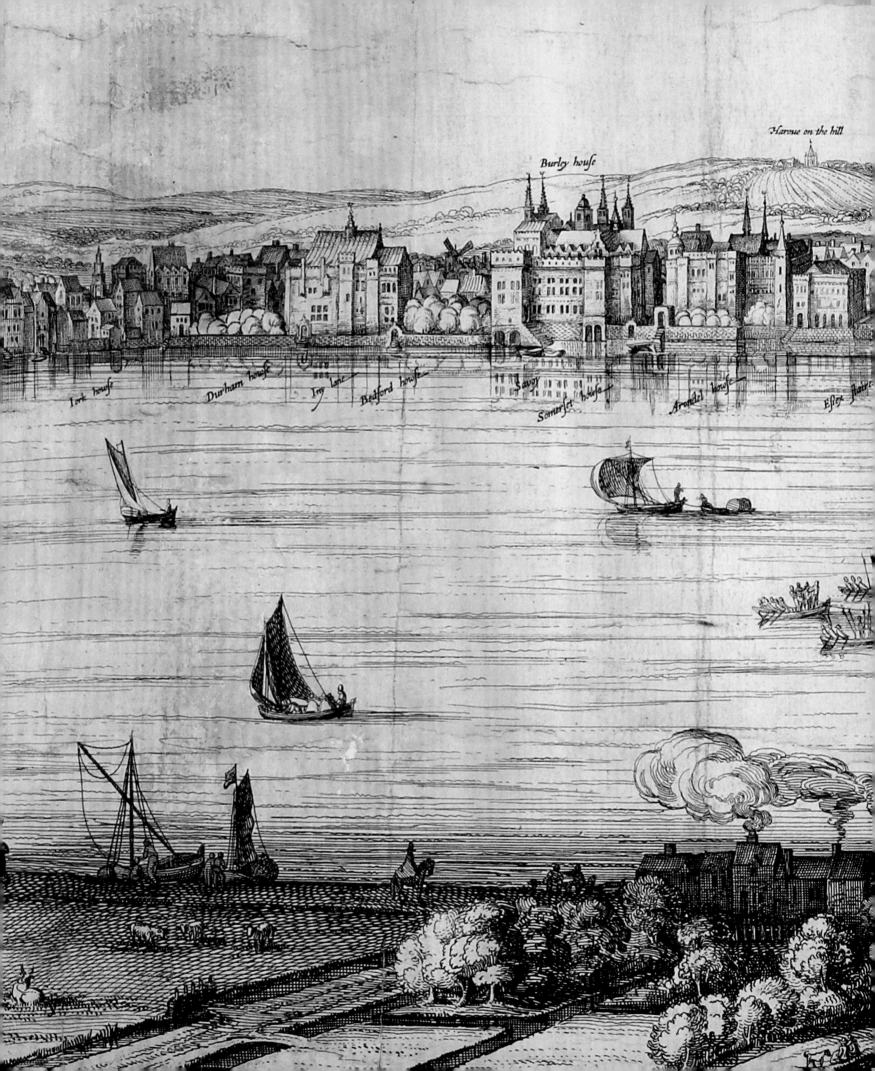

Harowe on the hill

Burley house

Iork house Durham house Iny lane Bedford house Savoy Somerset house Arondel house Essex house

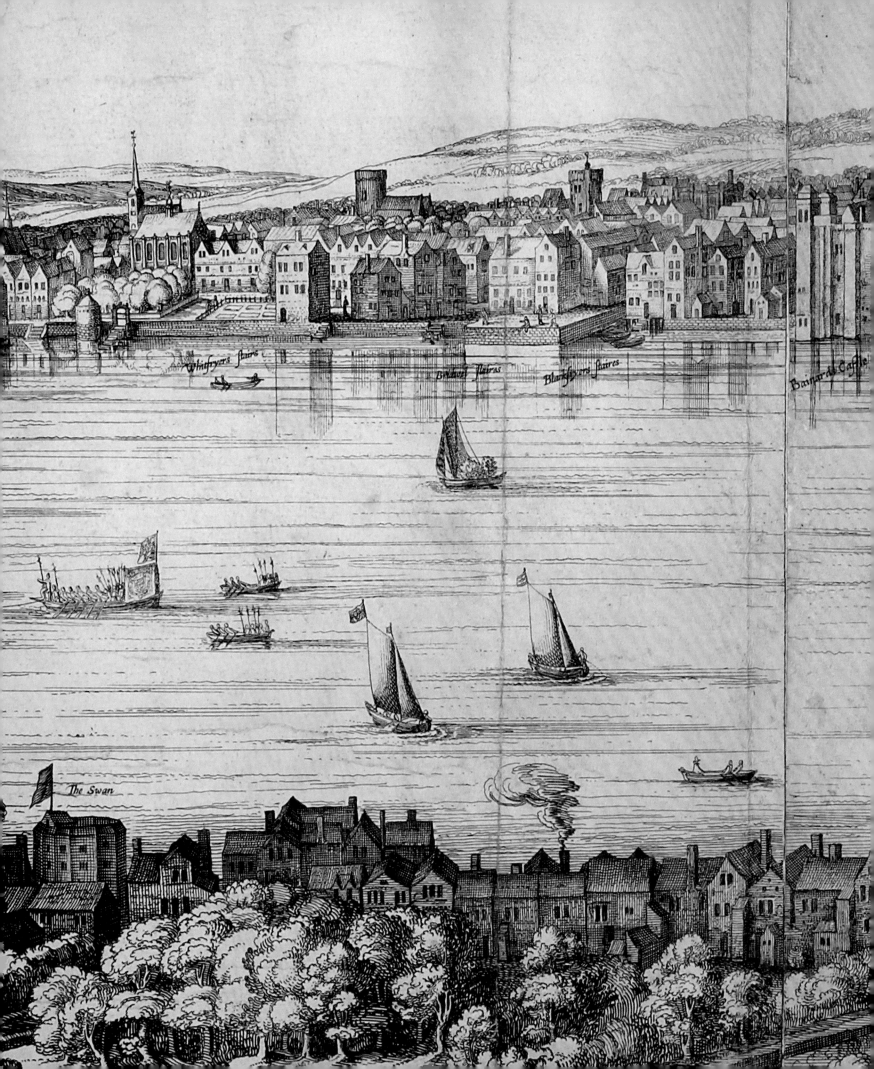

Whitefryers Staires Bridwel Staires Blackfryers Staires Bainards Castle

The Swan

THE
TRAGICALL
History of D. Fauſtus.

As it hath bene Acted by the Right
Honorable the Earle of Nottingham his ſeruants.

Written by Ch. Marl.

LONDON
Printed by V.S, for Thomas Buſhell. 1604.

P.S. Enterd in the Stationers Regr by
T. Bushell Jany 7. 1600-1. Probably
therefore there was an edn in 1601.

The original edition, at least no
earlier is now known. —
This is Marlowes original play,
of which I was not possessed when
I formed my general collection of his works
in one large volume bound in red
morocco. Large additions were
made to this play by Wm Bird and
Samuel Rowley in Nov. 1602. See
my History of th. English Stage p 32e,
edn 1790. Marlow had then
been above nine years dead;
and his play, tho' very popular
remained unpublished. On its re-
vival & these additions being
made; the possessor of a
copy of the original was indeed
... it to the press ...

126

CHRISTOPHER MARLOWE (MARLEY) (bap. 1564, d. 1593)

The Tragicall History of D. Faustus

London: Thomas Bushell, 1604

Twenty-three leaves, 170 × 116 mm
Bound at the Bodleian in April 1929: quarter brown goatskin over cloth boards

Provenance: Edmond Malone (1741–1812); bequeathed to his brother Richard Malone, Baron Sunderlin (1738–1816), who gave it to the Bodleian in 1815 (received in 1821)

Exhibition: Oxford 2002b, no. 3

Arch. A e.125 [title page illustrated]

127

WILLIAM SHAKESPEARE (1564–1616)

The Tragedy of Hamlet Prince of Denmarke

London: John Smethwicke, 1611

104 pages, 186 × 126 mm
Early nineteenth-century English binding (after 1820): brown calfskin with gold tooling

Provenance: Richard Heber (1774–1833); his sale, 1834; purchased by the Bodleian in 1837

Arch. G e.13 [title page illustrated]

128

WILLIAM SHAKESPEARE (1564–1616)

Venus and Adonis

London: William Leake, 1602 (really 1607–8)

Fifty-six pages, 140 × 82 mm
Bound with other titles in mid-nineteenth-century English binding for the Bodleian: dark red calfskin with blind tooling

Provenance: Robert Burton (1577–1640), who bequeathed it to the Bodleian

Arch. G f.3(2) [title page illustrated]

The plays of Shakespeare and his fellow playwrights came to life on the stage, where they were rehearsed, performed and reworked. From today's perspective their translation into print was fitful, complicated and badly done. In the absence of the authors' original manuscripts, or 'foul papers', the nearest we can get to what was performed is to be found in the ephemeral, cheaply produced booklets printed at the time, known as quartos. Never common (typically, editions of plays did not sell well), they are now very scarce, and in some cases they exist only in single copies.

The earliest documented performance of Christopher Marlowe's *Dr Faustus* was given by the Earl of Nottingham's company, the Lord Admiral's Men, a year after Marlowe's death. It remained a part of their repertoire until 1597. An edition of the play was included in the Stationers' Register until 1601, but the earliest edition to have survived was printed in 1604. Cat. 126 is the only known copy. The text is thought to be based on the version performed by the Lord Admiral's Men, but there is no way of knowing how close this was to Marlowe's original play. A revised and considerably longer version of *Dr Faustus* was published in 1616; again, just one copy has survived.

Hamlet was entered on the Stationers' Register in 1602, but its first appearance in print was unauthorized. A version of the play was published in 1603, 'As it hath beene diuerse times acted by his Highnesse seruants in the Cittie of London: as also in the two Vniuersities of Cambridge and Oxford, and else-where.' Known as the 'bad quarto', it is much shorter than later texts, and may have been put together from memory by actors. The second quarto, published in 1604/5, is 'enlarged to almost as

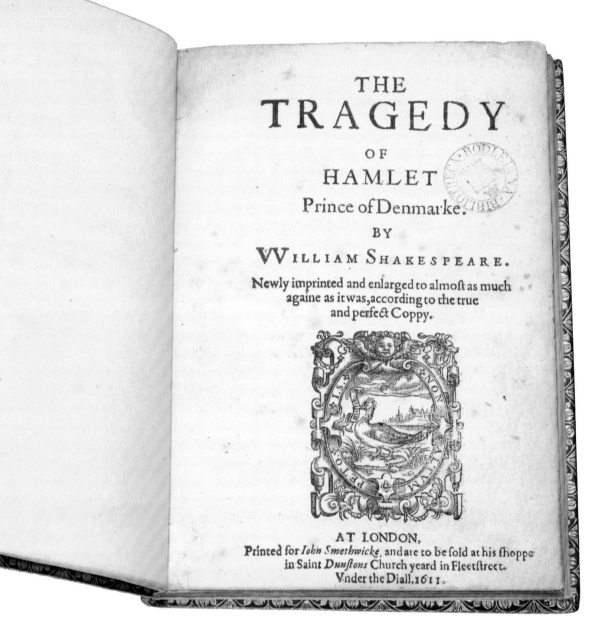

much againe as it was, according to the true and perfect Coppie'. The authoritative 'Coppie' was perhaps Shakespeare's manuscript, but the book is very poorly printed. The third quarto (cat. 127), published in 1611, is based on the second, but the text printed in 1623 in the first collected edition of Shakespeare's plays is different again. The situation is therefore a complex

one, and any edition of one of the great works of literature requires some form of editorial judgement.

Given Thomas Bodley's views on printed plays, there was little chance of the Bodleian acquiring these books when they were published. *Dr Faustus* came to the Bodleian as part of the collection of the Shakespeare scholar Edward Malone, who was the first

person to appreciate the textual importance of these fragile books and therefore the first person to collect them. He has made some notes opposite the title page. The *Hamlet* third quarto was previously owned by Richard Heber, a legendary nineteenth-century bibliophile famous for buying up entire libraries. Another Shakespeare rarity, a unique copy of *Venus and Adonis*

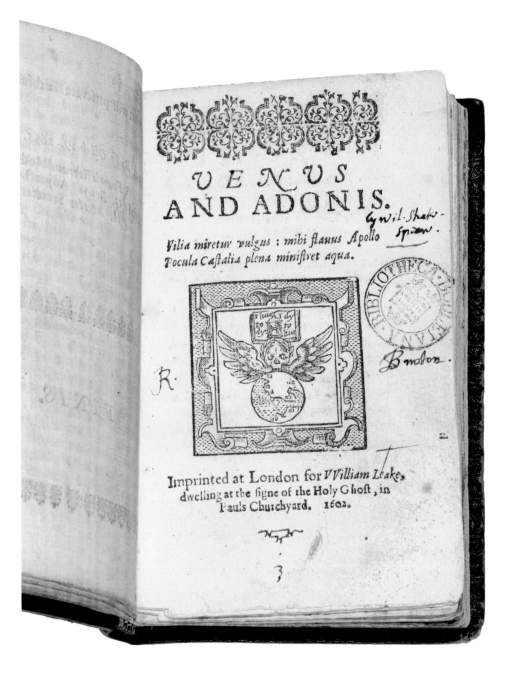

(cat. 128), once belonged to Robert Burton, student of Christ Church and author of the *Anatomy of Melancholy*, whose bequest of books to the Bodleian greatly increased the Library's scant literary holdings: 'If I have any bookes the University Library hath not let them take them', he wrote in his will.[1]

First published in 1593, *Venus and Adonis* was Shakespeare's most popular poem, and for this very reason few examples survive; copies were read and reread, lent and borrowed until they fell apart. At least fifteen further editions were published over the next forty-three years, but for many of them there is only a single witness.[2] Burton's copy of *Venus and Adonis* purports to be an edition of 1602, but is in fact a pirated edition printed in 1607–8.

Notes
1 Oxford 1990, no. 16.
2 Rogers 1991, pp. 102–3.

129

BENJAMIN (BEN) JONSON (1572–1637)

Workes

London: William Stansby, 1616

Copper engraving (title page) by William Hole (Holl) (d. 1624)
1,016 pages, 278 × 180 mm
Seventeenth-century English binding: brown calfskin with blind tooling

Provenance: Perhaps acquired by the Bodleian on publication, but it does not appear in the catalogue until 1674

Arch. A d.28 [title page illustrated]

In 1616, the year of Shakespeare's death, Ben Jonson established himself as Britain's foremost living writer. He was granted a pension by James I, making him, in effect, the first Poet Laureate, and he published this folio edition of his works. It included two collections of poems, *Epigrams* and *The Forest*, several masques (courtly entertainments that combined words with music and dance) and nine plays. The inclusion of dramatic works alongside more serious literary forms was unprecedented, and some of Jonson's contemporaries commented on it. 'Pray tell me *Ben*, where doth the mistery lurke, / What others call a play you call a work', wrote one anonymous writer; and in the preface to an edition of his play *The Fair Maid of the West* Thomas Heywood told the reader: 'my Plaeis have not beene exposed to the publike view of the world in numerous sheets, and a large volume; but singly (as thou seest) with great modesty, and small noise.'[1]

Jonson's 1616 *Workes* is not an exercise in modesty. He took a close interest in its production, by one of the country's leading printing houses,[2] and presented his literary achievements with great deliberation. Each work is dedicated to a carefully chosen patron, friend or institution. He was not looking for, or boasting of, popularity; he was a learned man addressing a learned audience, a polished writer who worked within the classical literary genres.

Jonson's intentions are laid out on the ornate title page.[3] Below the title is a quotation from Horace: 'I do not work so that the crowd may admire me, I am contented with a few readers.' Standing either side of the title, between Corinthian columns, are the figures of Tragedy and Comedy. Tragedy, on the right, is richly dressed, while Comedy is more humbly attired. Their respective actor's masks hang on the pillars beside them. Above them, in the centre, is a figure representing a newer form of drama, Tragi-comedy. To the left, holding pipes, is 'Satyr', representing the entertainments of the masque, and to the right is 'Pastor', representing pastoral poetry. The small figures to the left and right of Tragi-comedy are, respectively, Bacchus, the patron of the drama, and Apollo, the patron of the

muses. On the plinth are symbols of early classical drama: the wagon and the amphitheatre. A Roman theatre is depicted on the pediment. The frieze inscription is also from Horace and translates as 'Let each particular variety hold the place properly allotted to it' – everything should be in keeping with classical models. Wreaths, the traditional literary crown, may be seen on the pediment and in the top left and right corners.

Jonson's 1616 folio provided a model for the first collected edition of Shakespeare's plays, published seven years later. Jonson wrote in a poem included in that volume: 'Thou art a monument, without a tomb, / And art alive still, while thy book does live, / And we have wits to read, and praise to give.' Such a book was the great playwright's finest memorial, and offered the best chance for him to achieve lasting literary fame.

Notes
1 Meskill 2008, p. 183.
2 Bland 1998.
3 Corbett and Lightbown 1979, pp. 145–50.

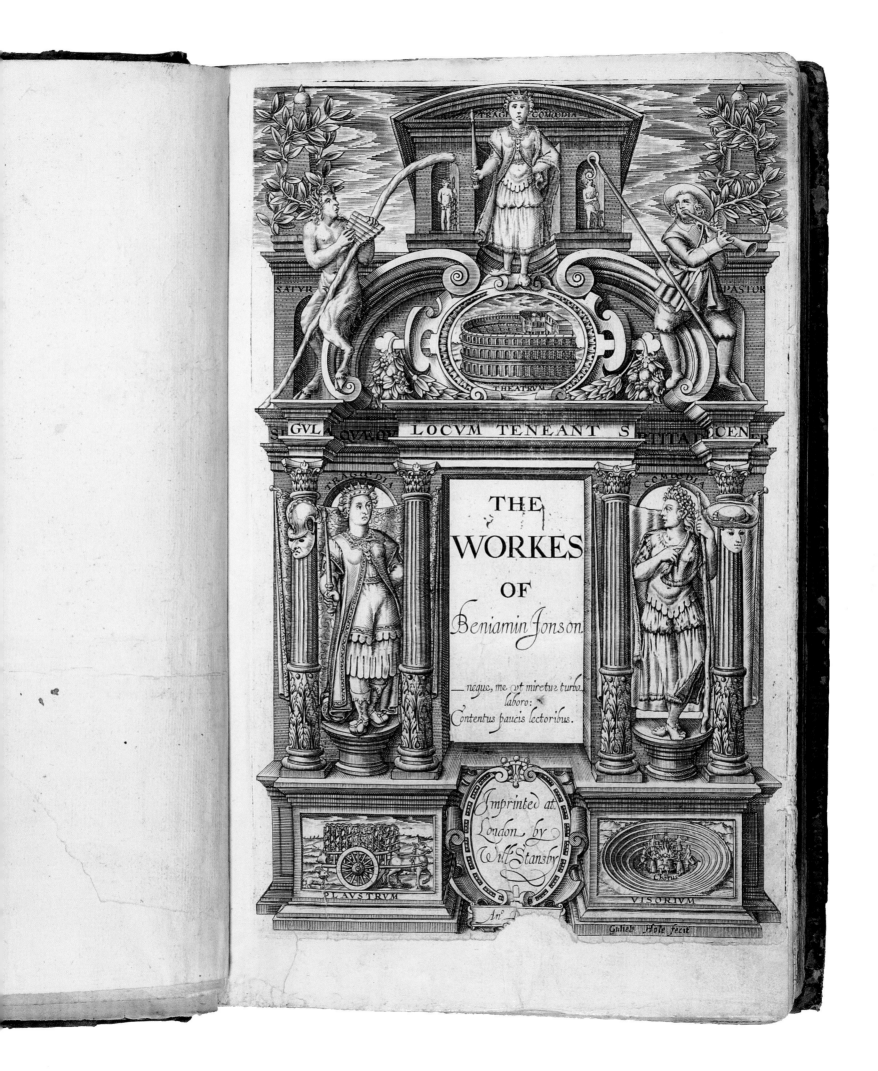

TRAGI COMOEDIA

SATYR

PASTOR

THEATRVM

SINGVLA QVEQ LOCVM TENEANT SORTITA DECENTER

TRAGOEDIA

COMOEDIA

THE
WORKES
OF
Beniamin Jonson

— neque, me ut miretur turba,
laboro:
Contentus paucis lectoribus.

Imprinted at.
London by
Will Stansby

PLAVSTRVM

Chorus

VISORIVM

An°

Guliel: Hole fecit

WILLIAM SHAKESPEARE (1564–1616)

Comedies, Histories, & Tragedies (The First Folio)

London: printed by Isaac Iaggard and Edward Blount, 1623

910 pages, 354 × 207 mm
Bound for the Bodleian by William Wildgoose, Oxford, in 1624: brown calfskin with blind tooling

Provenance: Acquired by the Bodleian on or soon after publication, perhaps as part of its agreement with the Stationers' Company; by 1674 had left the Library; later acquired by the Turbutt family of Ogston Hall, Derbyshire, passing by descent to William Gladwyn Turbutt (1853–1911), from whom it was purchased by the Bodleian in 1906

Exhibition: Oxford 2002b, no. 1

Literature: Rasmussen and West 2012, no. 31

Arch. G c.7 [title page illustrated]

This is the first collected edition of Shakespeare's dramatic works, published seven years after his death by two of his fellow actors. It prints a total of thirty-six plays, many of which would otherwise have been lost to future generations. It is not an especially rare book for the period, but it is – as its publishers intended – the principal monument to Shakespeare's towering literary achievement.

It seems that the Bodleian's copy was the only one to go straight to an institution on publication, the rest going to private libraries. It has had an eventful history which reveals much about the changing attitudes to this celebrated book. On its arrival in Oxford it was sent to a local binder, William Wildgoose, and – most unusually – it has retained this original binding. It then took its place on the shelves of Duke Humfrey's Library, where it was available for consultation by readers alongside the other chained folios. At some point before 1674 it

left the Library, for it is not listed in the catalogue produced that year. The assumption has always been that after the acquisition of the third folio edition of Shakespeare's plays in 1664 it was deemed redundant and was sold off to a local bookseller, together with other 'superfluous' titles.

In 1905 the book reappeared. It was brought into the Library for an expert opinion by one Gladwyn Maurice Revel Turbutt (*c.* 1884–1916), an undergraduate at Magdalen College and the son of its then owner, William Gladwyn Turbutt of Ogston Hall in Derbyshire. The librarian recognized it from its binding as the former Bodleian copy, and at once the Librarian, E.W.B. Nicholson, made enormous efforts to acquire it. He had a dangerous rival in the form of an anonymous American bidder (now known to be Henry Folger) who was prepared to pay a large sum of money for it. The asking price was an unheard-of £3,000 – the maximum sum the Bodleian had hitherto paid for a book was £200. 'Unless it can be recovered there will be an indelible blot on our scutcheon', wrote Nicholson in a letter to *The Times* in February 1906. The Library, he said, had been given more time to find the money ('this is regrettable and is doubtless owing to Mr Turbutt's son being at present an undergraduate at Magdalen and mixing in literary circles in the University', Folger was told by his agent[1]), but it was still some way short of the amount required. The

Bodleian had received 'hundreds of subscriptions ranging from the £100 of Lord Rosebery and Mr. S.G. Stopford Sackville to the poor man's florin'. There had been donations from as far away as Khartoum and the Transvaal, and even from Cambridge:

That after two and half centuries we should have the extraordinary chance of recovering this volume, and should lose it because a single American can spare more money than all Oxford's sons or friends who have been helping us, is a bitter prospect. It is the more bitter because the abnormal value put on this copy by our competitor rests on knowledge ultimately derived from our own staff and our own registers. But from so cruel a jibe of fortune this appeal may perhaps yet save us.[1]

Eventually, thanks to some large last-minute donations, the money was found. 'Sir, The Shakespeare is saved', Nicholson informed the editor of *The Times*. Folger's agent concluded: 'I fear we never really had any chance, even at the highest possible price, owing to its being considered a national matter.'[2] Since then, this precious First Folio has been carefully preserved in its fragile state and occasionally exhibited. It has recently been fully digitized.

Notes
1 Smith 1939, p. 260.
2 Ibid., p. 264.

An Active Swain to make a Leap was seen,
Which sham'd his Fellow Shepherds on the Green,
And growing Vain, he would Essay once more,
But lost the Fame, which he had gain'd before;
Oft' did he try, at length was forc'd to yeild
He Stove in Vain, — he had himself Excell'd:
So Nature once in her Essays of Wit,
In Shakespear took the Shepherd's lucky Leap
But over-straining in the great Effort,
In Dryden, and the rest, has since fell Short.

Under Shakespear's Picture by B: Johnson

This Figure w^t thou here se'st put,
It was for gentle Shakespear cut,
Wherein y^e Graver was at Strife,
With Nature to out-do y^e Life;
Oh, could he but have drawn his Wit
As well in Brafs, as he has hitt
His Face — The Print would y^n surpafs,
All y^t was ever Wit in Brafs:
But since he cannot, Reader looke
Not on his Picture, but his Book

MR. WILLIAM
SHAKESPEARES
COMEDIES,
HISTORIES, &
TRAGEDIES.

Published according to the True Originall Copies.

Bibliography

Bodleian catalogues

BLACK: *A Descriptive, Analytical and Critical Catalogue of the Manuscripts bequeathed unto the University of Oxford by Elias Ashmole*, by W.H. Black, Oxford University Press, Oxford, 1845

BOD-INC.: *A Catalogue of Books Printed in the Fifteenth Century now in the Bodleian Library*, by A. Coates, K. Jensen, C. Dondi, B. Wagner and H. Dixon, 6 vols, Oxford University Press, Oxford, 2005

CRUM AND WARD JONES: *Catalogue of the Mendelssohn Papers in the Bodleian Library, Oxford*, by M. Crum and P. Ward Jones, 3 vols, Hans Schneider, Tutzing, 1980–89

ETHÉ ET AL.: *Catalogue of the Persian, Turkish, Hindûstânî, and Pushtû Manuscripts in the Bodleian Library*, by E. Sachau, H. Ethé and A.F.L. Beeston, 3 vols, Clarendon Press, Oxford, 1889–1954

GARLICK: Mrs Reginald Lane Poole, *Catalogue of Portraits in the Bodleian Library*, rev. and expanded by K. Garlick, Bodleian Library, Oxford, 2004

HELLIWELL: *A Catalogue of the Old Chinese Books in the Bodleian Library*, by D. Helliwell, 2 vols, Bodleian Library, Oxford, 1983–5

LANE POOLE: *Catalogue of Portraits in the Possession of the University, Colleges, City, and County of Oxford*, by Mrs Reginald Lane Poole, 3 vols, Clarendon Press for the Oxford Historical Society, Oxford, 1912–26

NCAM-1: *A New Catalogue of Arabic Manuscripts in the Bodleian Library, University of Oxford*, vol. 1: *Medicine*, by E. Savage-Smith, Oxford University Press, Oxford, 2011

NEUBAUER AND COWLEY: *Catalogue of the Hebrew Manuscripts in the Bodleian Library*, by A. Neubauer and A.E. Cowley, 2 vols, Clarendon Press, Oxford, 1886–1906

NSC: *Summary Catalogue of Post-Medieval Western Manuscripts in the Bodleian Library, Oxford: Acquisitions 1916–1975* ('New Summary Catalogue'), by M. Clapinson and T.D. Rogers, 3 vols, Clarendon Press, Oxford, 1991

P & A: *Illuminated Manuscripts in the Bodleian Library, Oxford*, by O. Pächt and J.J.G. Alexander, 3 vols, Clarendon Press, Oxford, 1966–73

SC: *A Summary Catalogue of Western Manuscripts in the Bodleian Library at Oxford*, by F. Madan, H.H.E. Craster, R.W. Hunt and P.D. Record, 7 vols in 8 parts, Clarendon Press, Oxford, 1895–1953

Main sources

ALLINSON 2011: R. Allinson, *A Monarchy of Letters*, Palgrave Macmillan, Basingstoke, 2011

AMES 1897: P.W. Ames (ed.), *The Mirror of the Sinful Soul*, Asher & Co., London, 1897

ATIL 1981: E. Atıl, *Kalila wa Dimnah: Fables from a Fourteenth-Century Arabic Manuscript*, Smithsonian Institution Press, Washington, DC, 1981

ATLAS 1940: S.H. Atlas (ed.), *A Section from the Yad ha-ḥazakah of Maimonides: From a Holograph Manuscript in the Bodleian Library*, Ha-ittim, London, 1940

BAKER 1976: D.N. Baker, 'The Priesthood of Genius: A Study of the Medieval Tradition', *Speculum*, vol. 51, no. 2 (April 1976), pp. 277–91

BARBER 1971: G. Barber, *Textile and Embroidered Bindings*, Bodleian Library, Oxford, 1971

BARBER 1992: *Bestiary: Being an English Version of the Bodleian Library, Oxford M.S. Bodley 764 with all the Original Miniatures Reproduced in Facsimile*, trans. and ed. R. Barber, The Folio Society, London, 1992

BARBER AND DE HAMEL 2008: *Liber Bestiarum: MS Bodley 764*, trans. R. Barber, commentary by C. de Hamel, The Folio Society, London, 2008

BARKER 2001: *The Adages of Erasmus*, selected by W. Barker, University of Toronto Press, Toronto, Buffalo and London, 2001

BARKER 2003: N. Barker, *Form and Meaning in the History of the Book: Selected Essays*, The British Library, London, 2003

BARKER 2012: *Esther Inglis's Les Proverbes de Salomon*, facsimile with introduction by N. Barker, The Roxburghe Club, London, 2012

BARKER-BENFIELD 1989: B.C. Barker-Benfield, 'Shelley's Bodleian Visits', *Bodleian Library Record*, vol. 7, no. 5 (October 1989), pp. 381–99

BARNARD 2002: J. Barnard, 'Politics, Profits and Idealism: John Norton, the Stationers' Company and Sir Thomas Bodley', *Bodleian Library Record*, vol. 17, no. 6 (October 2006), pp. 385–408

BARTLETT 2004: A. Chekhov, *About Love and Other Stories*, trans. R. Bartlett, Oxford University Press, Oxford, 2004

BATE 2008: J. Bate, *The Genius of Shakespeare*, Picador, London, 2008

BEERBOHM 1899: M. Beerbohm, *More*, Bodley, London, and John Lane Company, New York, 1899

BEESTON 1952: A.F.L. Beeston, 'The Marsh Manuscript of Apollonius's *Conica*', *Bodleian Library Record*, vol. 4, no. 2 (August 1952), pp. 76–7

BENTLEY 2001: *William Blake's Writings*, ed. G.R. Bentley, 2 vols, Oxford University Press, Oxford, 2001

BERDAN AND ANAWALT 1992: F.F. Berdan and P.R. Anawalt, *The Codex Mendoza*, 4 vols, University of California Press, Berkeley, Los Angeles and Oxford, 1992

BERLIN AND NEW YORK 2011: K. Christiansen and S. Weppelmann (eds),

The Renaissance Portrait from Donatello to Bellini, exh. cat., Bode-Museum, Berlin, and The Metropolitan Museum of Art, New York, 2011

BINDMAN 2000: William Blake, *The Complete Illuminated Books*, with introduction by D. Bindman, Thames & Hudson in association with the William Blake Trust, London, 2000

BLAND 1998: M. Bland, 'William Stansby and the Production of the *Workes of Beniamin Jonson*, 1615–16', *The Library*, vol. 20, no. 1 (March 1998), pp. 1–33

BODLEY 1647: T. Bodley, *The Life of Sir Thomas Bodley, the Honourable Founder of the Publique Library in the University of Oxford*, printed for the University by Henry Hall, Oxford, 1647

BODLEY 1913: *Trecentale Bodleianum: A Memorial Volume for the Three Hundredth Anniversary of the Public Funeral of Sir Thomas Bodley March 29 1613*, Clarendon Press, Oxford, 1913

BONDANELLA AND BONDANELLA 2008: G. Vasari, *The Lives of the Artists*, trans. J. Conway Bondanella and P. Bondanella, Oxford University Press, Oxford, 2008

BRANDIN 1932: L. Brandin, 'Les Prognostications au MS Ashmole 304 de la Bodliénne', in *A Miscellany of Studies in Romance Languages and Literature presented to Léon E. Kastner*, eds M. and J. de Rothschild, Heffer & Sons, Cambridge, 1932, pp. 52–67

BRIEGER ET AL. 1970: P. Brieger, M. Meiss and C.S. Singleton, *Illuminated Manuscripts of the Divine Comedy*, 2 vols, Routledge & Kegan Paul, London, 1970 ('1969')

BROD 1992: M. Brod (ed.), *The Diaries of Franz Kafka, 1910–23*, Minerva Press, London, 1992

BROTTON 2012: J. Brotton, *A History of the World in Twelve Maps*, Allen Lane, London, 2012

BROWN 2003: C. Brown, *A Portrait of Mendelssohn*, Yale University Press, New Haven and London, 2003

BRUSSELS 1973: J.J.B. Alexander and C.M. Kauffmann, *Illuminated Manuscripts 700–1500*, exh. cat., Bibliothèque Royale Albert 1er, Brussels, 1973

BULLARD 1994: M.R.A. Bullard, 'Talking Heads: The Bodleian Frieze, its Inspiration, Sources, Designer and Significance', *Bodleian Library Record*, vol. 14, no. 6 (April 1994), pp. 461–500

BURNETT 1996: C. Burnett, 'What is the *Experimentarius* of Benardus Silvestris?', in *Magic and Divination in the Middle Ages: Texts and Techniques in the Islamic and Christian Worlds*, Variorum, Aldershot, 1996, section 17

BURROWS 1991: D. Burrows, *Handel: Messiah*, Cambridge University Press, Cambridge, 1991

BURROWS 1996: D. Burrows, 'Handel's Dublin Performances', in *Irish Musical Studies, 4: The Maynooth International Musicological Conference 1995 Select Proceedings*, eds P.F. Devine and H. White, part 1, Blackrock, 1996

BURROWS AND RONISH 1994: D. Burrows and M.J. Ronish, *A Catalogue of Handel's Musical Autographs*, Clarendon Press, Oxford, 1994

BUTT 1963: *The Poems of Alexander Pope: A One-Volume Edition of the Twickenham Text with Selected Annotations*, ed. J. Butt, Methuen & Co. Ltd, London, 1963

CAMPBELL 1982: *Greek Lyric*, vol. 1: *Sappho, Alcaeus*, trans. and ed. D.A. Campbell, Harvard University Press, Cambridge, MA, and William Heinemann Ltd, London, 1982

CANBERRA 2009: *Treasures from the World's Great Libraries*, exh. cat., National Library of Australia, Canberra, 2001

CARTER 1975: H. Carter, *A History of Oxford University Press*, Clarendon Press, Oxford, 1975

CHAMBERLAYNE 1684: Edward Chamberlayne, *Angliæ notitia, or, The Present State of England: together with divers reflections upon the antient state thereof*, 15th edn, R. Bently, London, 1684

CHAPMAN 1933: J. Austen, *Volume the First*, ed. R.W. Chapman, Clarendon Press, Oxford, 1933

CLAPINSON 2006: M. Clapinson, 'The Bodleian Library and its Readers, 1602–1652', *Bodleian Library Record*, vol. 19, no. 1 (April 2006), pp. 30–46

CLARK 1938: *Codex Mendoza: The Mexican Manuscript Known as the Collection of Mendoza and Preserved in the Bodleian Library Oxford*, trans. and ed. J. Cooper Clark, 3 vols, Waterlow & Sons Ltd, London, 1938

CLARK 1977: K. Clark, *The Other Half: A Self-Portrait*, John Murray, London, 1977

CLARK 2005: K. Clark, *Civilisation: A Personal View*, John Murray, London, 2005

COHEN AND WHITMAN 1999: Isaac Newton, *The Principia: Mathematical Principles of Natural Philosophy*, trans. I.B. Cohen and A. Whitman, assisted by J. Budenz, University of California Press, Berkeley, Los Angeles and London, 1999

COOK 1998: A.H. Cook, *Edmond Halley: Charting the Heavens and the Seas*, Clarendon Press, Oxford, 1998

COOPER 1997: Plato, *Complete Works*, ed. J.M. Cooper, Hacket Publishing Company, Indianapolis and Cambridge, 1997

CORBETT AND LIGHTBOWN 1979: M. Corbett and R. Lightbown, *The Comely Frontispiece: The Emblematic Title-page in England 1550–1660*, Routledge & Kegan Paul, London, Henley and Boston, 1979

COWELL 1904: *Life and Letters of Edward Byles Cowell*, ed. G. Cowell, Macmillan, London, 1904

COX AND FORD 2003: J. Cox and C. Ford, *Julia Margaret Cameron: The Complete Photographs*, J. Paul Getty Museum, Los Angeles, in association with the National Museum of Photography, Film and Television, Bradford, 2003

CROTCH 1928: W.J.B. Crotch (ed.), *The Prologues and Epilogues of William Caxton*, The Early English Text Society, Oxford University Press, Oxford, 1928

CRUM 1987: M. Crum, 'The Deneke Mendelssohn Collection', *Bodleian Library Record*, vol. 12, no. 4 (April 1987), pp. 298–320

CRUSE 2011: Mark Cruse, *Illuminating the Roman d'Alexandre: Oxford, Bodleian Library, MS Bodley 264: the Manuscript as Monument*, D.S. Brewer, Cambridge, 2011

CUSHING 1962: H. Cushing, *A Bio-bibliography of Andreas Vesalius*, 2nd edn, Archon Books, Hamden, CT, 1962

DE LA MARE 1982: A.C. de la Mare, 'Further Manuscripts from Holkham Hall', *Bodleian Library Record*, vol. 10 (1982), pp. 327–8

DE LA MARE AND REYNOLDS 1991–2: A.C. de la Mare and C. Reynolds, 'Illustrated Boccaccio Manuscripts in Oxford Libraries', *Studi sul Boccaccio*, 20 (1991–2), pp. 45–72

DRYDEN 1668: J. Dryden, *Of Dramatick Poesie*, Henry Herringman, London, 1668

DUFF AND DUFF 1982: J. Wight Duff and A. Duff (trans. and eds), *Minor Latin Poets*, vol. 1, Loeb Classical Library, Cambridge, MA and London, 1982

DURLING AND MARTINEZ 1996–2011: *The Divine Comedy of Dante Alighieri*, trans. and ed. R.M. Durling, introduction and notes by R.L. Martinez, 3 vols, Oxford University Press, New York and Oxford, 1996–2011

EAVES ET AL. 1993: William Blake, *The Early Illuminated Books*, eds M. Eaves, R.N. Essick and J. Viscomi, William Blake Trust and the Tate Gallery, London, 1993

ECONOMOU 1970: G.D. Economou, 'The Character Genius in Alan de Lille, Jean de Meun, and John Gower', *Chaucer Review*, vol. 4 (1970), pp. 203–10

EDSON AND SAVAGE-SMITH 2004: E. Edson and E. Savage-Smith, *Medieval Views of the Cosmos: Picturing the Universe in the Christian and Islamic Ages*, Bodleian Library, Oxford, 2004

ENGELL AND BATE 1983: S.T. Coleridge, *Biographia Literaria*, ed. J. Engell and W.J. Bate, Princeton University Press, Princeton, 1983

FAIRCLOUGH 1978: Virgil, *Eclogues, Georgics, Aeneid, Minor Poems*, ed. H.R. Fairclough, rev. G.P. Goold, 2 vols, Harvard University Press, Cambridge, MA, and London, 1978

FAIRCLOUGH 2005: Horace, *Satires, Epistles, Ars Poetica*, trans. H.R. Fairclough, Loeb Classical Library, [1926] 2005

FARMER 1968: D.H. Farmer, *The Rule of St Benedict. Oxford, Bodleian Library, Hatton 48*, Early English Manuscripts in Facsimile 15, Copenhagen, 1968

FELDMAN AND SCOTT-KILVERT 1987: *The Journals of Mary Shelley 1814–1844*, eds P.R. Feldman and D. Scott-Kilvert, 2 vols, Clarendon Press, Oxford, 1987

FELLOWES 1934: E.H. Fellowes, *The Catalogue of Manuscripts in the Library of St Michael's College Tenbury*, Éditions de l'oiseau lyre, 1934

FERDINAND 2006: C.Y. Ferdinand, 'Library Administration (*c*.1475–1640)', in *The Cambridge History of Libraries in Britain and Ireland*, vol. 1: *To 1640*, eds E. Leedham-Green and T. Webber, Cambridge University Press, Cambridge, 2006, pp. 656–9

FERRY 1998: G. Ferry, *Dorothy Hodgkin: A Life*, Granta Books, London, 1998

FITZGERALD AND WHITE 1983: *The Tabula of Cebes*, eds J.T. Fitzgerald and M.L. White, Scholars Press, Chico, CA, 1983

FORBES-LEITH 1896: W. Forbes-Leith (ed.), *The Gospel Book of St Margaret. Being a Facsimile Reproduction of St Margaret's Copy of the Gospels Preserved in the Bodleian Library Oxford*, David Douglas, Edinburgh, 1896

FOXON 1991: D.F. Foxon, *Pope and the Early Eighteenth-Century Book Trade*, Clarendon Press, Oxford, 1991

FRIES 1974: W.H. Fries, *The Double Elephant Folio: The Story of Audubon's Birds of America*, American Library Association, Chicago, 1974 ('1973')

FURNEAUX 1974: R. Furneaux, *William Wilberforce*, Hamish Hamilton, London, 1974

GAMESON 1997: R. Gameson, 'The Gospels of Margaret of Scotland and the Literacy of an Eleventh-Century Queen', in *Women and the Book: Assessing the Visual Evidence*, eds L. Smith and J.H.M. Taylor, British Library, London, and Toronto University Press, Toronto, 1997, pp. 149–71

GAMESON 2001: R. Gameson, 'Hugo Pictor enlumineur normand', *Cahiers de Civilisation Médiévale*, vol. 44 (2001), pp. 121–38

GAMESON 2006: R. Gameson, '"Signed" manuscripts from early Romanesque Flanders: Saint-Bertin and Saint-Vaast', in *Pen in Hand: Medieval Scribal Portraits, Colophons and Tools*, ed. M. Gullick, The Red Gull Press, Walkern, Herts, 2006, pp. 31–73

GANZ 1997: D. Ganz, '"Mind in Character": Ancient and Medieval Ideas about the Status of the Autograph as an Expression of Personality', in *Of the Making of Books: Medieval Manuscripts, their Scribes and Readers. Essays Presented to M.B. Parkes*, eds P.R. Robinson and R. Zim, Scolar Press, Aldershot, 1997, pp. 280–99

GARDNER 1972: H. Gardner, *John Donne's Holograph of 'A Letter to the Lady Cary and Mrs Essex Riche'*, Scolar Mansell, London, in conjunction with the Bodleian Library, Oxford, 1972

GIBBON 1837: *The Miscellaneous Works of Edward Gibbon, Esq., with Memoirs of his Life and Writings, Composed by Himself*, B. Blake, London, 1837

GINGERICH 1971: O. Gingerich, 'Apianus' Astronomicum Caesareum and its Leipzig Facsimile', *Journal of the History of Astronomy*, vol. 2 (1971), pp. 168–77

GRENFELL AND HUNT 1914: *The Oxyrhynchus Papyri*, eds B.P. Grenfell and A.S. Hunt, part 10, Egypt Exploration Society, London, 1914

HARDY AND HOLMES 2009: *Enlightening Letters 1946–1960: Isaiah Berlin*, eds H. Hardy and J. Holmes with the assistance of S. Moore, Chatto & Windus, London, 2009

HARRIS 2007: S. Harris, *The Magnificent Flora Graeca: How the Mediterranean Came to the English Garden*, Bodleian Library, Oxford, 2007

HARRISON ET AL. 2001: Apuleius, *Rhetorical Works*, trans. and eds S.J. Harrison, J. Hilton and V. Hunink, Oxford University Press, Oxford and New York, 2001

HARVEY 2012: P.D.A. Harvey, *Medieval Maps of the Holy Land*, British Library, London, 2012

HASSALL 1970: W.O. Hassall (ed.), *The Holkham Library: Illuminations and Illustrations in the Manuscript Library of the Earl of Leicester*, The Roxburghe Club, Oxford, 1970

HEALEY 1610: St Augustine, *Of the Citie of God: Vvith the Learned Comments of Io. Lod. Viues. Englished by I.H* [John Healey], George Eld, London, 1610

HEARNE 1885–1921: *Remarks and Collections of Thomas Hearne*, eds C.E. Doble, D.W. Rannie and H.E. Salter, 11 vols, Oxford Historical Society, Oxford, 1885–1921

HOLLSTEIN 1988: *Hollstein's German Engravings, Etchings and Woodcuts 1400–1700*, vol. 14, ed. T. Falk, Koninklijke van Poll, Roosendaal, 1988

HORGAN 2008: *The Romance of the Rose*, F. Horgan (trans.), Oxford University Press, Oxford 2008

HURST 1986: C. Hurst, 'The Dunston Collection', *Bodleian Library Record*, vol. 12, no. 3 (October 1986), pp. 177–204

HYNDMAN 1911: H.M. Hyndman, *The Record of an Adventurous Life*, Macmillan & Co., London, 1911

IAFRATE 2012: A. Iafrate, 'The Workshop of Fortune: St Albans and the *Sortes*

Manuscripts', *Scriptorium*, vol. 66 (2012), pp. 55–88

ING 1998: J. Ing, *Johann Gutenberg and his Bible*, The Typophiles, New York, 1988

ISBA 2006: A. Isba, *Gladstone and Dante: Victorian Statesman, Medieval Poet*, Royal Historical Society, The Boydell Press, Woodbridge, 2006

JAMES 1933: *The Romance of Alexander: A Collotype Facsimile of MS. Bodley 264, with an introduction by M.R. James*, Clarendon Press, Oxford, 1933

JOHNSON 2004: W.J. Johnson (trans.), *Bhagavad Gita*, Oxford University Press, Oxford 2004

JONES 1933: W.H.S. Jones (trans.), *Pausanias: Description of Greece*, 6 vols, William Heinemann, London, and G.P. Putnam's Sons, New York, 1933

JONES 1990: *The Julian and Maddalo Draft Notebook: Bodleian MS. Shelley adds. e. 11*, ed. S.M. Jones, Garland Publishing, New York and London, 1986

KAY ET AL. 2010: *Dante in Oxford: The Paget Toynbee Lectures*, eds T. Kay, M. McLaughlin and M. Zaccarello, Legenda, London, 2010

KELLEY AND LEWIS 1995: *The Brownings' Correspondence*, vol. 13, eds P. Kelley and S. Lewis, Wedgestone Press, London, 1995

KELVIN 1996: *The Collected Letters of William Morris*, ed. N. Kelvin, 4 vols, Princeton University Press, Princeton, 1984–96

KER 1956: N.R. Ker (ed.), *The Pastoral Care: King Alfred's Translation of St Gregory's Regula Pastoralis*, Rosenkilde and Bagger, Copenhagen, 1956

KER 1986: N.R. Ker, 'The provision of books', in *The History of the University of Oxford*, vol. 3: *The Collegiate University*, ed. J. McConica, Clarendon Press, Oxford, 1986

KER ET AL. 1969–2002: N.R. Ker, A.J. Piper, A.G. Watson and I.C. Cunningham, *Medieval Manuscripts in British Libraries*, 5 vols, Clarendon Press, Oxford, 1969–2002

KEYNES 2005: M. Keynes, *The Iconography of Sir Isaac Newton to 1800*, Boydell Press in association with Trinity College, Cambridge, Woodbridge, Suffolk, 2005

KEYNES AND LAPIDGE 1983: *Alfred the Great*, trans. S. Keynes and M. Lapidge, Penguin Books, London, 1983

KLEIN 1983: *Apokalypse, MS Douce 180, vollständige Faks.-Ausg. im Originalformat der Handschrift MS Douce 180 aus dem Besitz der Bodleian Library*, ed. P. Klein, Akademische Druck, Graz, 1983

KNOWLTON 1920: E.C. Knowlton, 'The Allegorical Figure Genius', *Classical Philology*, vol. 15 (1920), pp. 380–84

KNOWLTON 1924: E.C. Knowlton, 'Genius as an Allegorical Figure', *Modern Language Notes*, vol. 39 (1924), pp. 89–95

KNOWLTON 1928: E.C. Knowlton, 'The Genii of Spenser', *Studies in Philology*, vol. 25 (1928), pp. 439–56

LARKIN 1983: P. Larkin, *Required Writing: Miscellaneous Pieces 1955–1982*, Faber and Faber, London, 1983

LATHAM AND MATTHEWS 1970–83: R. Latham and W. Matthews (eds), *The Diary of Samuel Pepys: A New and Complete Transcription*, 11 vols, G. Bell, London, 1970–83

LAVIN 1974: I. Lavin, 'Divine Inspiration in Caravaggio's Two "St Matthews"', *Art Bulletin*, vol. 56, no. 1 (March 1974), pp. 59–81

LILLEY ET AL. 2009: K.D. Lilley, C.D. Lloyd and B.M.S. Campbell, 'Mapping the Realm: A New Look at the Gough Map of Britain (*c.*1360)', *Imago Mundi: The International Journal for the History of Cartography*, vol. 61, no. 1 (2009), pp. 1–28

LOBEL 1951: *The Oxyrhynchus Papyri*, part 21, ed. E. Lobel, Egypt Exploration Society, London, 1951

LOGAN 2011: Thomas More, *Utopia*, trans. and ed. G.M. Logan, Norton Critical Editions, 3rd edn, W.W. Norton & Company, New York and London, 2011

LONDON 1976: *William Caxton: An Exhibition to Commemorate the Quincentenary of the Introduction of Printing into England*, exh. cat., British Library, London, 1976

LONDON 1981A: S. Lambert, *Drawing, Technique and Purpose*, exh. cat., Victoria and Albert Museum, London, 1981

LONDON 1981B: D. Chambers and J. Martineau (eds), *Splendours of the Gonzaga*, exh. cat., Victoria and Albert Museum, London, 1981

LONDON 1982: J.P. Losty, *The Art of the Book in India*, exh. cat., British Library, London, 1982

LONDON 1983: R. Strong and V.J. Murrell, *Artists of the Tudor Court: The Portrait Miniature Rediscovered, 1520–1620*, exh. cat., Victoria and Albert Museum, London, 1983

LONDON 1984A: *English Romanesque Art 1066–1200*, exh. cat., Hayward Gallery, London, 1984

LONDON 1984B: J. Backhouse, D.H. Turner and L. Webster (eds), *The Golden Age of Anglo-Saxon Art 966–1066*, exh. cat., British Library, London, 1984

LONDON 1987: J.J.G. Alexander and P. Binski (eds), *Age of Chivalry: Art in Plantagenet England 1200–1400*, Royal Academy of Arts, London, 1987

LONDON 1996: L. Parry (ed.), *William Morris*, exh. cat., Victoria and Albert Museum, London, 1996

LONDON 2011: L. Syson with L. Keith, *Leonardo da Vinci: Painter at the Court of Milan*, exh. cat., National Gallery, London, 2011

LONDON AND NEW YORK 1995: J.J.G. Alexander (ed.), *The Painted Page: Italian Renaissance Book Illumination 1450–1550*, exh. cat., Royal Academy of Arts, London, and the Morgan Library, New York, 1995

MACGREGOR 1983: A. MacGregor (ed.), *Tradescant's Rarities: Essays on the Foundation of the Ashmolean Museum 1683 with a Catalogue of the Surviving Early Collections*, Clarendon Press, Oxford, 1983

MCCANN 1995: J. McCann (ed.), *The Rule of St Benedict*, Sheed and Ward, London, 1995

MCCARTHY 1994: F. McCarthy, *William Morris*, Faber, London, 1994

MCGARRY 1955: *The Metalogicon of John of Salisbury*, ed. and trans. D. McGarry, University of California Press, Berkeley and Los Angeles, 1955

MCHAM 2013: S.B. McHam, *Pliny and the Artistic Culture of the Italian Renaissance*, Yale University Press, New Haven, 2013

MESKILL 2008: L.S. Meskill, 'Ben Jonson's 1616 Folio: A Revolution in Print?', *Études Épistémè*, vol. 14 (autumn 2008), pp. 177–91

MICHAEL 2001: I. Michael, 'How *Don Quixote* came to Oxford: The Two Bodleian Copies of *Don Quixote*, part 1 (Juan de la Cuesta, Madrid, 1605)', in *Culture and Society in Habsburg Spain*,

eds N. Griffin et al., Tamesis, Woodbridge, 2001, pp. 95–123

MILLEA 2007: N. Millea, *The Gough Map: The Earliest Road Map of Great Britain?*, Bodleian Library, Oxford, 2007

MOONEY 1998: L.R. Mooney (ed.), *The Kalendarium of John Somer*, University of Georgia Press, Athens, GA, 1998

MORGAN 1982–8: N.J. Morgan, *Early Gothic Manuscripts*, 2 vols, Harvey Miller, London, in association with Oxford University Press, London and New York, 1982–8

MORGAN 2006: N.J. Morgan, *The Douce Apocalypse: Picturing the End of the World in the Middle Ages*, Bodleian Library, Oxford, 2006

MULRYAN 1981: J. Mulryan, 'Translations and Adaptations of Vincenzo Cartari's *Imagini* and Natale Conti's *Mythologiae*: The Mythographic Tradition in the Renaissance', *Canadian Review of Comparative Literature* (spring 1981), pp. 272–83

MURATOVA ET AL. 1984: *Bestiarum: Fac-similé du manuscrit du Bestiaire Ashmole 1511, conservé à la Bodleian library d'Oxford*, commentary by X. Muratova and D. Poirion, trans. M.-F. Dupuis and S. Louis, Club du Livre, Paris, 1984

MURRAY 1989: P. Murray (ed.), *Genius: The History of an Idea*, Basil Blackwell, Oxford, 1989

NARKISS AND COHEN-MUSHLIN 1985: *The Kennicott Bible*, facsimile with accompanying introductory volume, eds B. Narkiss and A. Cohen-Mushlin, 2 vols, Facsimile Editions, London, 1985

NITZSCHE 1975: J.C. Nitzsche, *The Genius Figure in Antiquity and the Middle Ages*, Columbia University Press, New York and London, 1975

NIXON AND FOOT 1992: H.M. Nixon and M.M. Foot, *The History of Decorated Bookbinding in England*, Clarendon Press, Oxford, 1992

OATES 1986: J.C.T. Oates, *Cambridge University Library: A History from the Beginnings to the Copyright Act of Queen Anne*, Cambridge University Press, Cambridge, 1986

O'KANE 2003: B. O'Kane, *Early Persian Painting: Kalila and Dimnah Manuscripts of the Late Fourteenth Century*, I.B. Tauris, London, New York, 2003

OKUDAIRA 1973: H. Okudaira, *Narrative Picture Scrolls*, trans., adapted and ed. E. ten Grotenhuis, Shibundo, Tokyo and Weatherhill, New York, 1973

OVENDEN 2006: R. Ovenden, 'The Libraries of the Antiquaries (*c.*1580–1640) and the Idea of a National Collection', in *The Cambridge History of Libraries in Britain and Ireland*, vol. 1: *To 1640*, eds E. Leedham-Green and T. Webber, Cambridge University Press, Cambridge, 2006, pp. 527–61

OVENDEN 2013: R. Ovenden, 'The Learned Press: Publishing for the Bodleian Library in the Seventeenth and Eighteenth Centuries', in *History of Oxford University Press*, vol. 1: *Beginnings to 1780*, ed. I. Gadd, Oxford University Press, Oxford, 2013, pp. 279–85

OXFORD 1968: *Fine Bindings 1500–1700 from Oxford Libraries*, Bodleian Library, Oxford, 1968

OXFORD 1971: *The John Johnson Collection*, exh. cat., Bodleian Library, Oxford, 1971

OXFORD 1975: R.W. Hunt et al., *The Survival of Ancient Literature: Catalogue of an Exhibition of Greek and Latin Classical Manuscripts Mainly from Oxford Libraries Displayed on the Occasion of the Triennial Meeting of the Hellenic and Roman Societies 28 July – 2 August 1975*, exh. cat., Bodleian Library, Oxford, 1975

OXFORD 1980: *The Benedictines and the Book 480–1980: An Exhibition to Commemorate the Fifteenth Centenary of the Birth of St Benedict*, exh. cat., Bodleian Library, Oxford, 1980

OXFORD 1981: *Doctrina Arabum: Science and Philosophy in Medieval Islam and their Transmission to Europe*, exh. cat., Bodleian Library, Oxford 1981

OXFORD 1983: *Catalogue of the Kafka Centenary Exhibition 1983*, Bodleian Library, Oxford, 1983

OXFORD 1984: *The Douce Legacy: An Exhibition to Commemorate the 150th Anniversary of the Bequest of Francis Douce (1757–1834)*, exh. cat., Bodleian Library, Oxford, 1984

OXFORD 1985: *Musical Annversaries 1985: Thirteen Composers from Tallis to Berg*, exh. cat., Bodleian Library, Oxford, 1985

OXFORD 1990: N.K. Kiessling, *The Legacy of Democritus Junior: Robert Burton*, exh. cat., Bodleian Library, Oxford, 1990

OXFORD 1992A: B.C. Barker-Benfield, *Shelley's Guitar: A Bicentenary Exhibition of Manuscripts, First Editions and Relics of Percy Bysshe Shelley*, exh. cat., Bodleian Library, Oxford, 1992

OXFORD 1992B: *J.R.R. Tolkien: Life and Legend: An Exhibition to Commemorate the Bicentenary of the Birth of J.R.R. Tolkien*, exh. cat., Bodleian Library, Oxford, 1992

OXFORD 1994: *A Continental Shelf: Books across Europe from Ptolemy to Don Quixote*, exh. cat., Bodleian Library, Oxford, 1994

OXFORD 1997: P. Ward Jones, *Mendelssohn: An Exhibition to Celebrate the Life of Felix Mendelssohn Bartholdy*, exh. cat., Bodleian Library, Oxford, 1997

OXFORD 1998: *A Cabinet of Curiosities: Unusual Items in the Bodleian Library*, exh. cat., Bodleian Library, Oxford 1998

OXFORD 1999: H.W. Lack, *The Flora Graeca Story: Oxford's Finest Botanical Treasure*, exh. cat., Bodleian Library, Oxford, 1999

OXFORD 2000: *Photography and the Printed Page in the Nineteenth Century*, exh. cat., Bodleian Library, Oxford, 2000

OXFORD 2002A: *Sir Thomas Bodley and his Library: An Exhibition to Celebrate the Four-hundredth Anniversary of the Bodleian Library*, exh. cat., Bodleian Library, Oxford, 2002

OXFORD 2002B: *Wonderful Things from 400 Years of Collecting: The Bodleian Library 1602–2002*, exh. cat., Bodleian Library, Oxford, 2002

PÄCHT 1950: O. Pächt, 'Hugo Pictor', *Bodleian Library Record*, vol. 3 (1950), pp. 96–103

PACK 1965: R. Pack, *The Greek and Latin Literary Texts from Greco-Roman Egypt*, 2nd edn, University of Michigan Press, Ann Arbor, 1965

PADERBORN 1999: *Kunst und Kultur der Karolingerzeit: Karl der Grosse und Papst Leo III. in Paderborn*, 2 vols, exh. cat., Mainz, 1999

PARIS 2009: M. Phillips and C. de Bourgoing, *William Blake (1757–1827): Le Génie visionnaire du romantisme anglais*, exh. cat., Petis Palais, Musée des Beaux-Arts de la Ville de Paris, 2009

PARIS AND NEW YORK 2007: *Venice and the Islamic World 828–1797*, exh. cat., Institut

du Monde Arabe, Paris, and Metropolitan Museum of Art, New York, 2007

PAULIN AND CHANDLER 2000: William Hazlitt, *The Fight and Other Writings*, eds T. Paulin and D. Chandler, Penguin Books, London, 2004

PETERSON 1978: W.S. Peterson, *The Kelmscott Press: A History of William Morris's Typographical Adventure*, University of California Press, Berkeley, 1989

PETERSON 1982: W.S. Peterson (ed.), *The Ideal Book: Essays and Lectures on the Arts of the Book*, University of California Press, Berkeley and Los Angeles, 1982

PETERSON 2011: W.S. and S.H. Peterson, *The Kelmscott Press: A Census*, Oak Knoll Press, Newcastle, Delaware, 2011

PHILIP 1983: I. Philip, *The Bodleian Library in the Seventeenth and Eighteenth Centuries*, Oxford, Clarendon Press, 1983

PHILIP AND MORGAN 1997: 'Libraries, Books, and Printing', in *The History of the University of Oxford*, vol. 4: *Seventeenth-century Oxford*, ed. N. Tyacke, Oxford University Press, Oxford, 1997, pp. 659–85

PHILLIPS 2011: William Blake, *The Marriage of Heaven and Hell*, ed. M. Phillips, Bodleian Library, Oxford, 2011

POPE 1960–63: *The Diary of Benjamin Robert Haydon*, ed. W.B. Pope, 5 vols, Harvard University Press, Cambridge, MA, 1960–63

PORTE AND MORRIS 2001: *Emerson's Prose and Poetry*, selected and ed. J. Porte and S. Morris, W.W. Norton and Company, New York and London, 2001

POYNTZ 1531: F. Poyntz, *The Table of Cebes*, Thomas Berthelet, London, 1531

PRINGLE 2011: D. Pringle, *Pilgrimage to Jerusalem and the Holy Land*, Ashgate Publishing, Basingstoke, 2011

PRYOR 2003: F. Pryor, *Elizabeth I: Her Life in Letters*, British Library, London, 2011

RASMUSSEN AND WEST 2012: E. Rasmussen and A.J. West, *The Shakespeare First Folios: A Descriptive Catalogue*, Palgrave Macmillan, Basingstoke, 2012

REED 2008: T.J. Reed, 'Out of the Labyrinth: The Kafka Manuscripts in the Bodleian Library', *Bodleian Library Record*, vol. 21, no. 2 (October 2008), pp. 247–56

RIGAUD 1838: S.P. Rigaud, *Historical Essay on the First Publication of Sir Isaac Newton's Principia*, Oxford University Press, Oxford, 1838

ROBINSON 1982: D. Robinson, *William Morris, Edward Burne-Jones and the Kelmscott Chaucer*, G. Fraser, London, 1982

ROBINSON 1996: C.E. Robinson (ed.), *The Frankenstein Notebooks: A Facsimile Edition*, 2 vols, Garland Publishing, Inc., New York and London, 1996

ROBINSON 2011: A. Robinson, *Genius: A Very Short Introduction*, Oxford University Press, Oxford, 2011

ROGERS 1991: D. Rogers, *The Bodleian Library and its Treasures 1320–1700*, Aidan Ellis Publishing, Henley-on-Thames, 1991

ROLLESTON 1925: M. Rolleston, *Talks with Lady Shelley*, George Harrap & Co. Ltd, London, 1925

ROLLINS 1958: *The Letters of John Keats*, ed. H.E. Rollins, 2 vols, Harvard University Press, Cambridge, MA, 1958

ROTILI 1972: M. Rotili, *I codici danteschi miniati a Napoli*, Libreria scientifica editrice, Naples, 1972

RUSHFORTH 2007: R. Rushforth, *St Margaret's Gospel Book: The Favourite Book of an Eleventh-Century Queen of Scots*, Bodleian Library, Oxford, 2007

RUSSELL AND WINTERBOTTOM 2008: *Classical Literary Criticism*, eds D.A. Russell and M. Winterbottom, Oxford University Press, Oxford, 2008

SANDHAUS 2011: *Decadence Mandchoue: The China Memoirs of Sir Edmund Trelawny Backhouse*, ed. D. Sandhaus, Earnshaw Books, Hong Kong, 2011

SCHMITZ 1962: R.M. Schmitz, *Pope's Essay on Criticism, 1709: A Study ... of the Bodleian Manuscript Text with Facsimiles, Transcripts, and Variants*, Washington University Press, St Louis, MO, 1962

SCOTT 1996: K.L. Scott, *Later Gothic Manuscripts, 1390–1490*, 2 vols, Harvey Miller Publishers, London, 1996

SCOTT-ELLIOT AND YEO 1990: A.H. Scott-Elliot and E. Yeo, *Calligraphic Manuscripts of Esther Inglis (1571–1624): A Catalogue*, Papers of the Bibliographical Society of America, vol. 84 (1990), pp. 11–86

SCULL AND HAMMOND 1995: C. Scull and W.G. Hammond, *J.R.R. Tolkien: Artist and Illustrator*, HarperCollins, London, 1995

SCULL AND HAMMOND 2006: C. Scull and W.G. Hammond, *The J.R.R. Tolkien Companion and Guide*, 2 vols, HarperCollins, London, 2006

SEZGIN 1986: F. Sezgin (ed.), *The Book of Constellations*, Publications of the Institute for the History of Arabic-Islamic Science, series C, vol. 29, Facsimile Editions, Frankfurt, 1986

SHAW 1967: W. Shaw, *A Textual and Historical Companion to Handel's* Messiah, London, Novello & Co. Ltd, 1965

SHAW 1974: W. Shaw, *Handel's Conducting Score of 'Messiah': Reproduced in Facsimile from the Manuscript in the Library of St Michael's College, Tenbury Wells*, Scolar Press for the Royal Musical Association, London, 1974

SHELL 1993: M. Shell, *Elizabeth's Glass*, University of Nebraska Press, Lincoln, NE and London, 1993

SHERIDAN 1980: *Alain of Lille. The Plaint of Nature*, trans. and ed. J.J. Sheridan, Pontifical Institute of Medieval Studies, Toronto, 1980

SMALLWOOD 2009: T.M. Smallwood, 'The Date of the Gough Map', *Imago Mundi: The International Journal for the History of Cartography*, vol. 62, no. 1 (2009), pp. 3–29

SMALLWOOD 2012: T.M. Smallwood, 'The Making of the Gough Map Reconsidered: A Personal View', *Imago Mundi: The International Journal for the History of Cartography*, vol. 64, no. 2 (2012), pp. 169–80

SMITH 1928: L.P. Smith, *Words and Idioms: Studies in the English Language*, Constable & Co. Ltd, London, 1928

SMITH 1939: R.M. Smith, 'Why a First Folio Shakespeare Remained in England', *Review of English Studies*, vol. 15, no. 59 (July 1939), pp. 257–64

SOLOPOVA 2012: E. Solopova, 'The Making and Re-making of the Gough Map of Britain: Manuscript Evidence and Historical Context', *Imago Mundi: The International Journal for the History of Cartography*, vol. 64, no. 2 (2012), pp. 155–68

SPEDDING 1861–74: *The Letters and Life of Francis Bacon*, ed. J. Spedding, 7 vols, Longmans, Green, Reader and Dyer, 1861–74

STARNES 1964: D.T. Starnes, 'The Figure Genius in the Renaissance', *Studies in the Renaissance*, vol. 11 (1964), pp. 234–44

STERN 1952: S.M. Stern, 'Autographs of Maimonides in the Bodleian Library', *Bodleian Library Record*, vol. 4, no. 3 (1952), pp. 180–201

STEWART 1809: C. Stewart, *A Descriptive Catalogue of the Oriental Library of the Late Tippoo Sultan of Mysore to which are Prefixed Memoirs of Hyder Aly Khan and his Son Tippoo Sultan*, Cambridge University Press, Cambridge, 1809

STOCKING 1995: *Letters of Claire Clairmont, Charles Clairmont and Fanny Imlay Godwin*, ed. M.K. Stocking, 2 vols, The Johns Hopkins University Press, Baltimore, 1995

SUMMIT 2008: J. Summit, *Memory's Library: Medieval Books in Early Modern England*, University of Chicago Press, Chicago and London, 2008

SUTHERLAND 2013: K. Sutherland (ed.), *Volume the First: A Facsimile*, Bodleian Library, Oxford, 2013

SWEET 1871–2: H. Sweet (ed.), *King Alfred's West Saxon Version of Gregory's Pastoral Care*, 2 vols, London, Early English Text Society, 1871–2

SWIFT 1701: J. Swift, *A Discourse of the Contests and Dissensions Between the Nobles and the Commons in Athens and Rome*, John Nutt, London, 1701

TAYLOR 1926: *Autobiography and Memoirs of Benjamin Robert Haydon (1786–1846)*, ed. T. Taylor, new edn with intro. by A. Huxley, 2 vols, P. Davies, London, 1926

TAYLOR 1931: L.R. Taylor, *The Divinity of the Roman Emperor*, American Philological Association, Middletown, CO, 1931

TERHUNE AND TERHUNE 1980: *The Letters of Edward FitzGerald*, ed. A. McKinley Terhune and A. Burdick Terhune, 4 vols, Princeton University Press, Princeton, 1980

THORPE 2010: D.R. Thorpe, *Supermac: The Life of Harold Macmillan*, Chatto & Windus, London, 2010

TODD 2003A: *The Collected Letters of Mary Wollstonecraft*, ed. J. Todd, Allen Lane, London, 2003

TODD 2003B: R.L. Todd, *Mendelssohn: A Life in Music*, Oxford University Press, Oxford, 2003

TOKOO AND BARKER-BENFIELD 2002: Tatsuo Tokoo and B.C. Barker-Benfield, *A Catalogue and Index of the Shelley Manuscripts in the Bodleian Library and a General Index to the Facsimile Edition of the Bodleian Shelley Manuscripts*, Routledge, New York and London, 2002

TOKYO 1990: *The Bodleian Library and its Treasures*, exh. cat., Tokyo Fuji Art Museum, Tokyo, 1990

TOOMER 1990: G.J. Toomer (ed), Apollonius of Perga, *Conics, Books V to VII: The Arabic Translation of the Lost Greek Original in the Version of the Banū Mūsā*, 2 vols, Springer-Verlag, New York and London, c.1990

TOPSFIELD 2008: A. Topsfield, *Paintings from Mughal India*, Bodleian Library, Oxford, 2008

TOYNBEE 1909: P. Toynbee, *Dante in English Literature: From Chaucer to Cary (c.1380–1844)*, 2 vols, Methuen & Co., London, 1909

TURNBULL ET AL. 1959–77: *The Correspondence of Isaac Newton*, eds H.W. Turnbull, J.F. Scott, A. Rupert Hall and Laura Tilling, 7 vols, for the Royal Society at the Cambridge University Press, Cambridge, 1959–77

TURNER 1971: E.G. Turner, *Greek Manuscripts of the Ancient World*, Clarendon Press, Oxford, 1971

UNGERER 1997: G. Ungerer, 'The Earl of Southampton's Donation to the Bodleian in 1605 and its Spanish Books', *Bodleian Library Record*, vol. 16, no. 1 (April 1997), pp. 17–41

VERNER 1968: C. Verner, 'Smith's *Virginia* and its Derivatives', *The Map Collector's Circle*, no. 45 (1968) (whole issue)

VICKERS 2002: F. Bacon, *The Major Works*, ed. B. Vickers, Oxford University Press, Oxford, 2002

VINCENT 2007: N. Vincent, *The Magna Carta*, Sotheby's sale cat., New York, 18 December 2007

VIRTANEN 1981: R. Virtanen, 'On the Dichotomy between Genius and Talent', *Comparative Literature Studies*, vol. 18, no. 1 (March 1981), pp. 69–90

WARK 1997: Sir Joshua Reynolds, *Discourses on Art*, ed. R.R. Wark, Yale University Press, New Haven and London, 1997

WASHINGTON 2006: M.P. Brown (ed.), *In the Beginning: Bibles before the Year 1000*, exh. cat., Freer Gallery of Art and Arthur M. Sackler Gallery, Washington, DC, 2006

WATSON 1984: A.G. Watson, *Catalogue of Dated and Datable Manuscripts c.435–1600 in Oxford Libraries*, 2 vols, Clarendon Press, Oxford, 1984

WATSON 1993: E.S. Watson, *Achille Bocchi and the Emblem Book as Symbolic Form*, Cambridge University Press, Cambridge, 1993

WATTENBERG 1967: D. Wattenburg, *Peter Apianus und sein Astronomicum Caesareum / Peter Apianus and his Astronomicum Caesarium*, Edition Leipzig, 1967

WELLESZ 1959: E. Wellesz, 'An Early al-Sufi Manuscript in the Bodleian Library in Oxford: A Study in Islamic Constellation Images', *Ars Orientalis*, vol. 3 (1959), pp. 1–26

WETHERBEE 1969: W. Wetherbee, 'The Function of Poetry in the "De Planctu Naturae" of Alain de Lille', *Traditio*, vol. 25, 1969, pp. 87–125

WETHERBEE 1973: *The Cosmographia of Bernardus Silvestris*, trans. and ed. W. Wetherbee, Columbia University Press, New York, 1973

WETHERBEE 2013: *Literary Works of Alan of Lille*, ed. and trans. W. Wetherbee, Harvard University Press, Cambridge, MA, and London, 2013

WHEELER 1926: *Letters of Sir Thomas Bodley to Thomas James*, ed. with intro. by G.W. Wheeler, Clarendon Press, Oxford, 1926

WILEY 1936: M.L. Wiley, 'Genius: A Problem in Definition', *Studies in English*, vol. 16 (July 1936), pp. 77–83

WIMSATT 1963: W.K. Wimsatt, Jr, 'The Bodleian Portrait of Alexander Pope', *Bodleian Library Record*, vol. 7, no. 2 (July 1963), pp. 87–91

WOOD 1796: A. à Wood, *The History and Antiquities of the University of Oxford, in Two Books*, ed. J. Gutch, 2 vols, printed for the editor, Oxford, 1796

WORMALD 1969: F. Wormald, 'More Matthew Paris Drawings', *Walpole Society Journal*, vol. 1 (1969), pp. 110–12

WOUDHUYSEN 2007: H.R. Woudhuysen, 'The Queen's Own Hand', in *Elizabeth I and the Culture of Writing*, eds P. Beal and G. Ioppolo, The British Library, London, 2007, pp. 1–27

YOUNG 1759: E. Young, *Conjectures on Original Composition*, eds A. Millar and R. and J. Dodsley, London, 1759

Index

Page numbers in bold refer to main catalogue entries and in italics to pictures.

Concordance of shelfmarks

Shelfmarks are followed by catalogue numbers in bold type.

Manuscripts:

MS. Abinger c. 40, fols. 209–211 (**26**);
 57, fols. 47–48 (**76**)
MS. Abinger d. 27 (**28**)
MS. Afr. s. 2305 Box 7, item 9 (**21**)
MS. Arab. d. 138 (**54**)
MS. Arch. Selden. A. 1 (**65**)
MS. Ashmole 304 (**4**); 1511 (**107**); 1758 (**73**)
MS. Backhouse 11 (**111**)
MS. Berlin 269, fols. 111–112 (**80**)
MS. Bodl. 6 (**25**); 264 (**121**); 717 (**13**);
 764 (**59**); 990 (**70**)
MS. Bodl. Or. 793 (**66**)
MS. Canon. Ital. 85 (**61**)
MS. Ch. Gloucs. 8 (**11**)
MS. Cherry 36 (**24**)
MS. D'Orville 301 (**46**)
MS. Don. e. 7 (**18**)
MS. Douce 176 (**58**); 180 (**122**); 195 (**7**);
 389 (**5**)
MS. Douce Or. a. 1 (**68**)
MS. Elliott 254 (**67**)
MS. Eng. b. 2056 (B.281) (**81**)
MS. Eng. c. 5577/3, 7–8 (**82**); /8, 2–3 (**84**)
MS. Eng. e. 3764 (**101**)
MS. Eng. misc. d. 268 (**123**); 281 (**98**)
MS. Eng. misc. e. 247 (**99**); 248 (**99**)
MS. Eng. poet. c. 1 (**10**); d. 197 (**17**)
MS. Fraser Sansk. 41 a, b (**74**)
MS. Gough. Gen. Top. 16 (**60**)
MS. Gr. class. c. 76(P)/2 (**33**)
MS. Hatton 20 (**48**); 48 (**47**)
MS. Heb. d. 32, fols. 47–56 (**14**)
MS. Holkham misc. 48 (**8**)
MS. Jap. c. 4 (R) (**71**)
MS. Kafka 6 (**16**)
MS. Kennicott 1 (**62**)

MS. Lat. class. e. 38 (**124**)
MS. Lat. liturg. f. 5 (**23**)
MS. M. Deneke Mendelssohn c. 21 (**114**);
 89 (**115**); 90 (**115**)
MS. M. Deneke Mendelssohn c. 101 (**19**)
MS. M. Deneke Mendelssohn e. 5 (**113**)
MS. Macmillan dep. c. 788, fols. 150–164
 (**22**)
MS. Marsh 144 (**49**); 667 (**116**)
MS. Ouseley 140 (**118**)
MS. Pococke 375 (**50**); 400 (**109**)
MS. Savile 39 (**102**)
MS. Shelley adds. e. 11 (**27**)
MS. Sherard 245 (**55**)
MS. Tenbury 346, 347 (**15**)
MS. Tolkien drawings 32 (**45**)
MS. Whinfield 33 (**119**)
MS. Wilberforce c. 4, fols. 76–77 (**20**)
Or. long D.77 (**6**)

Printed material:

Allen c.5 (**2**)
Arch. A c.5 (**90**); c.6 (**91**); d.28 (**129**);
 d.37 (**52**); e.125 (**126**)
Arch. AA e.23/1 (**100**)
Arch. B b.7 (**64**); b.11 (**34**); b.19 (**51**);
 e.44 (**37**); e.53 (**89**)
Arch. G a.1 (**41**); b.6 (**63**); c.7 (**130**);
 d.53 (**12**); e.13 (**127**); e.37 (**35**);
 e.41(5*) (**72**); e.42 (**40**); f.3(2) (**128**)
Arch. H c.12 (**93**)
Arch. K b.12 (**57**); K c.1,1* (**44**)
B 1.16 Med (**9**)
Backhouse 69 (**110**)
Broxb. 67.7 (**120**)
Douce D subt. 41 (**38**)
Douce BB 411 (**3**)

Douce Bib. Eng. 1583 b.1 (**69**)
Douce Prints a.53(2) (**125**)
Dunston B 9 (**75**)
Dunston B 119 (**100**); 120 (**100**); 121 (**100**);
 124 (**100**)
John Johnson collection (**85**); (**86**); (**112**)
Lister E 7 (**39**)
RR. y. 143 (**56**)
Savile B 3 (**106**); 4 (**106**); 5 (**106**); 6 (**106**)
Savile K 5 (**106**); 6 (**106**); 7 (**106**); 8 (**106**)
Savile M 8 (**106**); 9 (**106**); 10 (**106**); 11 (**106**)
Savile N 12(3) (**103**)
Savile P 9 (**117**)
Savile Q 8 (**105**)
Savile Cc 8(5) (**104**)
Sinica 88 (**108**)
Vet. E1 e.162 (**1**)

Objects:

Cons. Res. Objects no. 61 (**88**)
Shelley relics (a) (**29**); (d) (**30**); (f) (**32**);
 (g) (**31**)
W.H.F. Talbot Archive, FT 10008 (**42**);
 11198–11202 (**43**)

Portraits:

LP 26 (**36**); 73 (**87**); 99 (**94**); 186 (**97**);
 227 (**53**); 241 (**95**); 243 (**96**)

University Archives:

SEP/9/6 (**92**); UR6/HD/2B, file 1 (**78**);
 UR6/HD/6, file 8 (**79**); (**77**)

pedam.) Ab stabilitate sic est dictus, ut idem Augu
ribus innititur pedibus, & uelut fulcris. Est & uermis
dices Almum, melius, ut arbitror. nam alma & almus
eres, & terra alma. Quæ per se prosequi longum
longum est. Cõmentatores uerbi significationem pa
at, rati persequi solum dici de insectatione inimica.
Tignus, unde tigillus trabs cui tectum innititur. Ari-
ontinetur, & sistitur deum esse in mundo similem ait,
aturæ ædificiũ necesse est, ut ablato umbilico fornicis
b hoc proposito dissonum, quod Orpheus in hym-

 Et post

nim maiestate deorum.) Lib. iij.
uebãt. Dicere oppe uoluisse
s noie pecuniæ.) Omnia quæ po
deducta appellatiõ eut aiũt, Co
ut adhuc sunt multarũ gentium
Varro confirmat lib. de Lat. ling. iiij. postea ad opes
) Paradoxum Stoicum ὅτι οἱ σοφοὶ μόνοι πλᾶσιοι
nibus suadet. Idem magnis ingeniis philosophorum
m perorarunt. Quam nemo sapiens concupiuit.)
abet, quam nemo sapiens cõcupiuit, ea quasi uenenũ
minat, semper infinita & insatiabilis est, neq; copia, ue
Vt nos uocamus.

nuncupetur. Cap. XII.
em huius nominis reddiderunt, & pecunia, in-
int omnia. O magnam rationem diuini nomi-
omnia, utilissime & contumeliosissime pecunia
is sunt, quæ cœlo & terra cõtinentur, inter quæ
ius, quæ ab hominibus nomine pecuniæ possi-
nomen imposuit, ut quisquis amat pecuniam,

Quid est enim Saturnus
nium dominatus est. Nõ
uem esse mundum & eum
penes quem sationum on
qui præpositus est, acuim
habere credunt quàm mu
Iuppiter omnipotens pro
Et cum alio loco genium
los singulorum: talem aut
ranq; uniuersalis genius i
Iouem. nã si omnis genius
animus deus: quod si & ip
ter & excellenter dicant de

Q Vid est Genius.) Fest
omnium gerendarum
quo homines gignuntur, pro
ditos quis deus esset Genius
rens illius, & Genij sunt cœlo
licerta, ut ait, Parthenius. & co
ra. Quæ Græci cum σοιχεια
crobius adducit de penatibus
æther Minerua, quis tribus f
cum sole & luna sunt qui Ge
Genius, quem faciunt ei præ
siue quod in eius tutela, ut qu
gnatur nobiscum: siue etiam
multi prodiderunt ueterum
liquit. Porrò Lares quemad
ue Larundæ nymphæ. Ideo
dunt Lares, alterum bonum
scribunt oblatum M. Brut